Llyfrgelloedd Caerdydd www.caerdydd.gov.uk/llyfrgelloedd Cardiff Libraries www.cardiff.gov.uk/libraries

DRAVING DRAVING

MASTERING THE ART OF DRAWING

A complete step-by-step course in drawing techniques, with 25 projects and 800 photographs

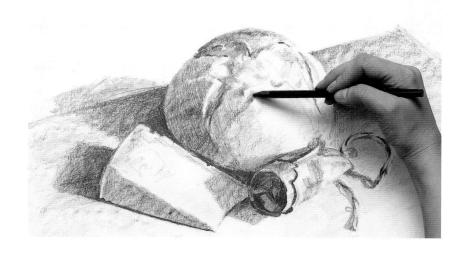

IAN SIDAWAY & SARAH HOGGETT

LORENZ BOOKS

Contents

This edition is published by Lore

Lorenz Books is an imprint of Anness Publishing Ltd www.lorenzbooks.com; www.annesspublishing.com info@anness.com Twitter: @AnnessLorenzBks

If you like the images in this book and would like to investigate using them for publishing, promotions or advertising, please visit our website www.practicalpictures.com for more information.

© Anness Publishing Ltd 2018

All rights reserved. No part of this publication may be reproduced, stored in a retrieval system, or transmitted in any way or by any means, electronic, mechanical, photocopying, recording or otherwise, without the prior written permission of the copyright holder.

A CIP catalogue record for this book is available from the British Library.

Publisher: Joanna Lorenz Editorial Director: Helen Sudell Project Editor: Sarah Hoggett Photographer: George Taylor Designer: Nigel Partridge

Project contributors: Diana Constance; Abigail Edgar; Suzy Herbert; Wendy Jelbert; Melvyn Petterson; Paul

Robinson; Ian Sidaway; Effie Waverlin Production Controller: Ben Worley

Publisher's Note: Although the advice and information in this book are believed to be accurate and true at the time of going to press, neither the authors nor the publisher can accept any legal responsibility or liability for any errors or omissions that may have been made.

Caution: Artists' pigments should be handled with care, as some of them are poisonous. Cadmium colours covered in this book could have possible dangerous effects so it is important to wash your hands carefully after blending with fingers or similar use.

Getting started	6
Monochrome media	8
Coloured drawing media	10
Pastels	12
Pen and ink	14
Supports	16
Additional equipment	18
Making marks	20
Line drawing	22
Seeing things as simple shapes	24
Understanding tone	30
Adding tone	32
Measuring systems	38
Negative shapes	40
Perspective	44
Linear perspective	46
Two-point perspective	48
Foreshortening	51
Curved forms in perspective	52
Blending with coloured pencils	54
Blending with soft pastels and	
oil pastels	58
Blending with water-soluble pencils	64
Brush drawing	66

Masking	74
Eraser drawing	78
Sgraffito	81
Drawing smooth textures	84
Drawing rough textures	88
Drawing soft textures	92
Drawing projects	96
Quick sketches of trees	98
Quick sketches of flowers	102
Trees in winter	104
Field of sunflowers	108
Flower-filled alleyway	112
Autumn leaf	116
Quick sketches of landscapes	120
Mediterranean seascape	126
Snow scene	132
Reflections in rippling water	136
Landscape on a large scale	140
Rocky canyon	144
Quick sketches of still-lifes	150
Exotic flowers	156
Metal detail	160

Still life with garlic and shallots	164
Still life with pears	168
Small objects drawn large	172
Quick sketches of buildings	176
Old wooden gateway	182
/enetian building	186
Cityscape	190
Sunshine and shadow	194
Quick sketches of animals	198
Old English Sheepdog	204
Short-eared Owl	208
Chickens	212
Swimming fishes	216
Quick sketches of people	220
Male portrait	226
Character portrait	230
Dancing couple	236
Male nude	240
Grandmother and	
young child	244
Glossary	250
Suppliers	252
ndex	254
Acknowledgements	256

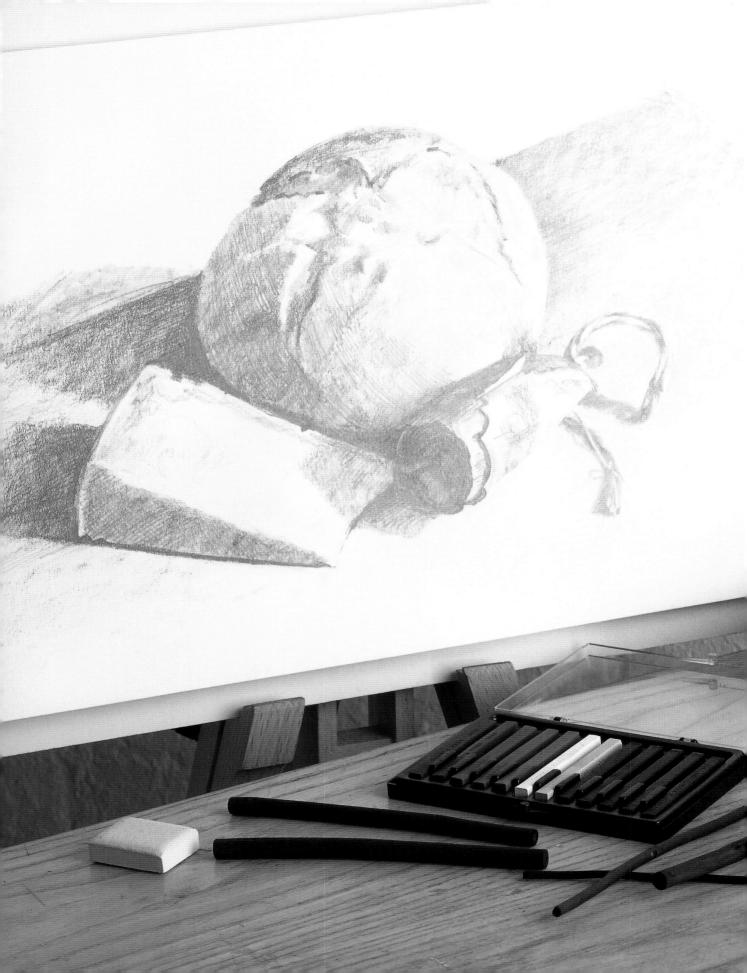

Getting Started

There's something incredibly satisfying, not to say almost magical, about being able to recreate a three-dimensional subject on paper with just a few swift lines. This section sets out all the drawing techniques you need to know, using simple step-by-step exercises that you can follow in your own home. In the process, you will be introduced to the full range of drawing mediums, from graphite pencil and charcoal to coloured pencils, pen and ink, soft pastels and oil pastels. Work through it systematically and you will acquire a comprehensive grasp of the fundamentals, which you can then apply to any subject you choose.

Monochrome media

The most commonly used drawing implement is the so-called 'lead' pencil, which is actually made not from lead but from a form of soft carbon known as graphite. The purest seams of graphite were discovered by chance in Borrowdale in Cumberland (northern England) in around 1500: after a heavy storm, local shepherds discovered that trees had been blown down, exposing large masses of an unknown black material. At first they thought it was coal, but it didn't burn; they then realized how good it was for making marks, and used it to mark their sheep. It was not long before people realized the potential of graphite as a drawing tool and it guickly spread across Europe, replacing the traditional silverpoint. To make a graphite pencil, graphite is reduced to a powder, which is then mixed with clay to make a paste; the paste is then extruded as a thin strip and encased in a wooden barrel made from a smooth-grain cedar.

The barrel of a graphite pencil may be round, hexagonal or triangular in shape. The choice of barrel shape is a personal one but, as a general rule, round barrels are easy to turn between the fingers while hexagonal and triangular ones are more stable to hold.

Pencils vary in hardness. Each grade is given a code that runs from 9H (the hardest) down to HB and F (for fine) and then up to 9B, which is the softest. The degree of hardness is determined by the relative proportions of graphite and clay: the more clay in the mix, the harder the grade. A selection of five different grades — say, a 2H, HB, 2B, 4B and 6B — should be adequate for most purposes.

Each grade of pencil is capable of making a mark of a certain density. Soft pencils give a very dense, black mark, while hard pencils give a grey, rather than a black, mark. If you require a darker mark, do not try to apply more pressure to the pencil, but switch to a softer grade.

Grades of pencil ▼

To make these marks, the same amount of pressure was applied to each pencil. You can clearly see how different grades of pencil produce marks of different density.

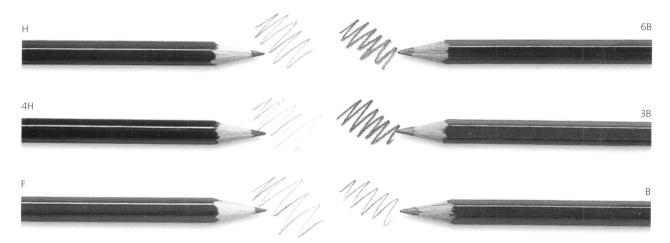

Water-soluble graphite pencils

There are also water-soluble graphite pencils, which are made with a binder that dissolves in water. Available in a range of grades, they can be used dry or worked into with a brush and water to create a range of watercolour-like effects.

Water-soluble graphite pencils are an ideal tool for sketching on location, as they offer you the versatility of combining linear marks with tonal washes. Use the tip to create fine details and the side of the pencil to cover large areas quickly.

Tips: When you are sharpening a pencil in a pencil sharpener, the shaving should come out as a long, continuous strip. If it does not, then the sharpener is blunt and should be thrown away.

You can also sharpen pencils using a craft (utility) knife. Hold the knife at a very shallow angle and stroke the blade lightly along the wood of the pencil tip. (If you dig in too deeply, the graphite strip will almost certainly break.) Replace the knife blade regularly so that the blade is always sharp.

Graphite sticks

Solid sticks of graphite are available in various sizes and grades. Some resemble conventional pencils with a round profile, while others are shorter, thicker, and hexagonal in shape. Thick, short round sticks can also be found, as can sticks with a square or rectangular profile. You can also buy irregular-shaped chunks and fine graphite powder.

Thinner strips of graphite in varying degrees of hardness are also manufactured to fit in a barrel that has a clutch mechanism. These often have a sharpener hidden in the device that is pressed to operate the clutch.

Because of their shape, graphite sticks are capable of making a wider range of marks than conventional graphite pencils. For example, you can use the point or the side of a square- or rectangular-profile stick to make a thin mark, or stroke the whole side of the stick over the paper to make a broader mark.

Square-profile graphite stick ▼

Like graphite pencils, graphite sticks come in a range of grades, with a softer grade making a denser, blacker mark than a hard grade.

Charcoal

The other monochromatic drawing material popular with artists is charcoal. Charcoal is usually made from willow, although both vine and beech charcoal can also be found. It is made by charring the twigs at a very high temperature in airtight kilns.

Charcoal comes in different lengths and in thin, medium, thick and extra-thick sticks. You can also buy large, irregular-shaped chunks that are ideal for very large, expressive drawings. Stick charcoal is very brittle and breaks easily if you press hard. It is very powdery and is wonderful for creating broad areas of tone.

Compressed charcoal is made from charcoal dust mixed with a binder and fine clay and pressed into shape. It is harder than conventional charcoal and does not break so easily. It is also less messy to use. Rectangular or round compressed charcoal sticks are made in varying degrees of hardness.

Compressed charcoal is also made into pencils that either have a wooden barrel that is sharpened in the same way as a traditional graphite pencil or are set in a paper barrel that is torn away as the charcoal strip wears down. Because the charcoal is covered, charcoal pencils are much cleaner to handle than stick charcoal. They also have a slightly harder texture. Unlike stick charcoal, charcoal pencils are ideal for detailed, linear work. However, only the point can be used, so if you want to block in large areas of the paper quickly, it is perhaps preferable to use the side of a charcoal stick.

Charcoal smudges extremely easily, so you should wipe your fingers regularly when drawing with it so that you don't leave fingerprints on the paper. As with other powdery mediums, such as chalk and soft pastels, drawings made in charcoal should be sprayed with fixative to hold the pigment in place and prevent smudging. Fixative is readily available from art and craft stores, but hairspray makes a good and inexpensive alternative.

Various forms of charcoal ▼

From top to bottom: thick charcoal stick; thin charcoal stick; compressed charcoal stick; compressed charcoal pencil.

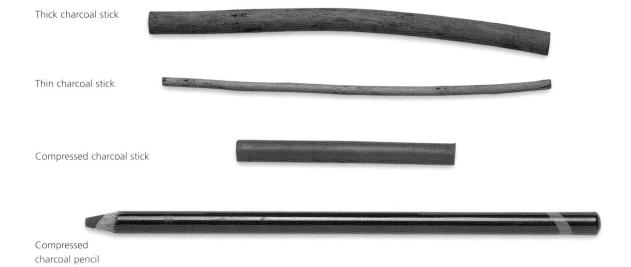

Coloured drawing media

Coloured pencils are as familiar as graphite pencils and are used in the same way. They contain a coloured pigment and clay, together with a binder. They are impregnated with wax to help the pigment hold on to the surface of the support with no need for a fixative. The coloured strip is held in a wooden barrel which, like graphite pencils, can be round, triangular or hexagonal in shape. The coloured strip can vary in diameter from one manufacturer to another, as can the wax content and hardness. Hard pencils will keep their point longer and so tend to be better for linear work or work that entails a lot of crosshatching, while a softer pencil might be better if you are working with large, loosely applied areas of colour. There are also coloured pencils that resemble graphite sticks and consist of a solid strip of pigment.

The range of colours available is extensive. Mixing takes place optically on the surface of the support rather than by physical blending. All brands are inter-mixable, although certain brands can be more easily erased than others; so always try out one or two individual pencils from a range before you buy a large set.

Coloured pencils are especially useful for making coloured drawings on location, as they are a very stable medium and not prone to smudging, so they do not need to be fixed (set).

Huge colour range Artists who work in coloured pencil tend to accumulate a vast range in different shades - the variance between one tone and its neighbour often being verv slight. This is chiefly because you cannot physically mix coloured pencil marks to create a new shade (unlike watercolour or acrylic paints). So, if you want lots of different greens in a landscape, you will need a different pencil for each one.

Water-soluble pencils

Most coloured-pencil manufacturers also produce a range of water-soluble pencils, which can be used to make conventional pencil drawings and blended with water to create watercolour-like effects. In recent years, solid pigment sticks that resemble pastels have been introduced that are also water-soluble and can be used in conjunction with conventional coloured pencils or on their own.

Water-soluble pencils ▶

Like conventional coloured pencils, water-soluble pencils are available in many colours.

Wet and dry

Watercolour pencils can be used dry, in the same way as conventional pencils, to create linear marks (below left) or blended with water to make watercolour-like effects (right).

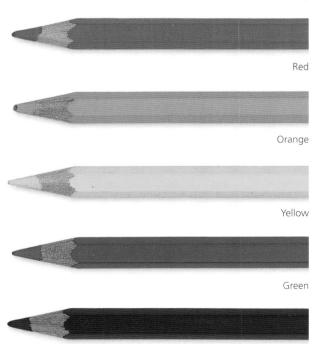

Blue

Grey

Conté crayons and pencils

Named after Nicolas-Jacques Conté, who invented them in the eighteenth century, Conté crayons are made in a range of traditional colours: white (made from chalk), sanguine (from iron oxide), sepia (from the ink of the cuttlefish) and bistre (from the soot of burnt beech wood). Terracotta, umber and black are also available, as are sets that provide a range of greys and browns. The crayons are also known as carré sticks – *carré* being the French word for 'square', referring to the square profile of the sticks.

The best way to use Conté crayons is to snap off a small section about 2–3cm (1in) long and use the side of the crayon to block in large areas, and a sharp edge or the tip to make more linear marks.

The pigment in Conté crayons is relatively powdery, which means that, like soft pastels and charcoal, it can be blended by rubbing with a finger, rag or torchon. Conté crayon drawings benefit from being given a coat of fixative to prevent smudging. However, Conté crayons are slightly harder and more oily than soft pastels, so you can lay one colour over another, allowing the underlying colour to show through.

Conté is also available in pencil form in a similar range of colours. The pencils contain wax and need no fixing (setting); the other benefit is that the tip can be sharpened to a relatively fine point.

Pencils and sticks are particularly effective when used together, the pencil being used for precision and detail and the sticks to block in wide areas of tone. Drawings made using both pencils and sticks can be seen to best advantage when made on a light-coloured paper.

Most of the colours that are available in pencil and stick form can also be found in short 'lead' form intended for use in a holder. Different manufacturers make 'leads' in different diameters, so not all are interchangeable. Many of the holders have a sharpening mechanism in the end. Similar square holders are made to hold small pieces of the broken sticks.

Conté crayons ▼

These small, square-profile sticks are available in boxed sets of traditional colours. Drawings made using these traditional colours are reminiscent of the wonderful chalk drawings of such old masters as Michelangelo or Leonardo da Vinci.

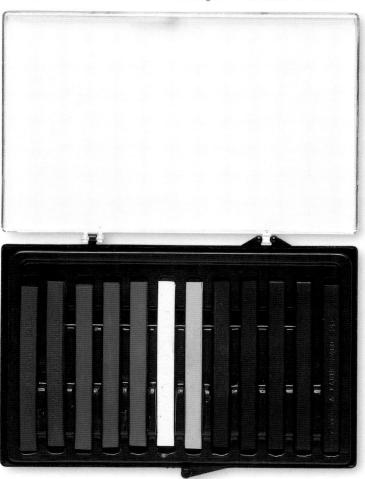

Conté pencils ▼

As they can be sharpened to a point, Conté pencils are ideal for drawings that require precision and detail.

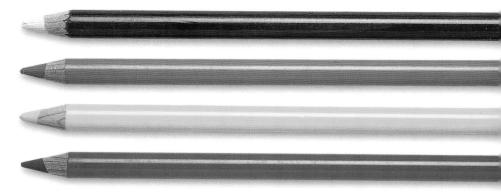

Pastels

Pastel work is often described as painting rather than drawing and it is an unusual drawing medium in that the techniques used are often similar to techniques used in painting. Pastels are made by mixing pigment with a weak binder (usually gum tragacanth) to hold the mixture together. The more binder in the mix, the harder the pastel. Various amounts of titanium or zinc white can be added to the pure pigment, resulting in a range of pastels of slightly different tints.

Soft pastels

Usually around 6cm (2½in) long and about 1cm (½in) in diameter, soft pastels can also be purchased in half-lengths (shown below), as well as a limited range of much thicker pastels that are ideal if you want to work on a large scale.

As soft pastels contain relatively little binder, they are usually quite delicate and prone to crumbling, so they are wrapped in a paper wrapper to help keep them in one piece. Even so, dust still comes off the pastels, and can easily contaminate other colours nearby. The best option is to arrange your pastels by colour type - all the blues together, all the greens together, and so on – and store them in boxes with shallow drawers. Some artists recommend putting dry rice in the drawer, too, so that any dust comes off on to the rice rather than on to the other pastels.

Because soft pastels are so crumbly, you will find that small pieces break off

as you draw. Often the pieces are so tiny that they are very difficult to hold comfortably for drawing – but don't discard them. Even tiny fragments can be used to block in areas of colour: simply put your finger over the piece of pastel and gently rub it on to the paper.

In some ways, the small amount of binder in soft pastels is a bonus, as it means they are almost pure pigment and hence the colours are very fresh and immediate.

Pastels are mixed together on the support either by physically blending them or by allowing colours to mix optically. The less blending that is done, the fresher the image looks. For this reason, pastels are made in a range of tints and shades that runs into the hundreds.

Pastels are coded for strength and colour. All brands can be mixed and used together, although the coding system used is not consistent across the different brands. The degree of softness

also varies between brands, so it's a good idea to try out a few pastels from one manufacturer's range to see whether or not you like the feel of them before you spend a fortune on buying a large set.

As pastels are a dry, powdery medium, the paper on which you draw must be textured enough to hold the particles of pigment in place. Pastel paper is specifically designed to do this, allowing you to build up several layers of colour.

Remember to spray any soft pastel drawing with fixative to prevent the colours from smudging. You can fix (set) work in progress, too – but there is a risk of the colours darkening, so don't overdo it.

Box of pastels ▼

When you buy a set of pastels, they come in a compartmentalized box so that they do not rub against each other and become dirtied.

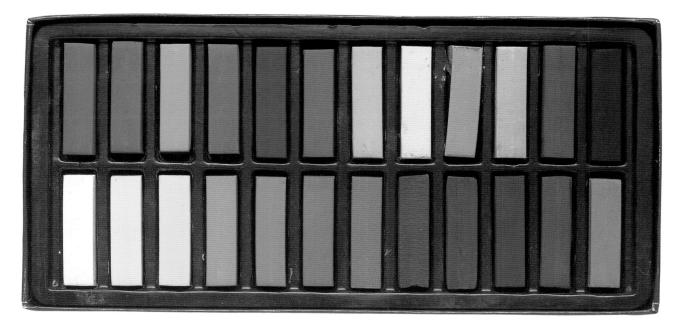

Hard pastels

Formulated slightly differently to soft pastels, hard pastels contain less pigment and more binder. They are easier to control than soft pastels and have the added advantage that they can be carefully sharpened to a point. They are found in a reasonably comprehensive range of colours, but the selection is nowhere near as great as that for soft pastels and the colours are not as pure or brilliant.

One advantage of hard pastels is that, in use, they do not shed as much pigment as soft pastels, and so they do not clog the texture of the paper as quickly. For this reason, they are often used in the initial stages of a work that is completed using soft pastels. Hard pastels can be blended together by rubbing, but not as easily or as seamlessly as soft pastels.

Pastel pencils

A delight to use, the colours of pastel pencils are strong, yet the pencil shape makes them ideal for drawing lines. If treated carefully, they do not break – although they are more fragile than graphite or coloured pencils. The pastel strip can be sharpened to a point, making pastel pencils ideal for describing detail in drawings that have been made using conventional hard or soft pastels.

Pastel pencils **▼**

Available in a comprehensive range of colours, pastel pencils are clean to use and are ideal for linear work. They can be used with both hard and soft pastels.

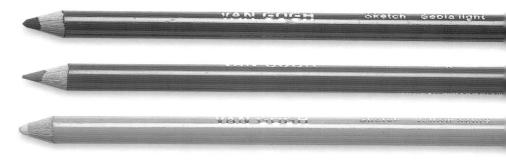

Oil pastels

Made by combining pigment with fats and waxes, oil pastels are totally different to pigmented soft and hard pastels and should not be mixed with them. Oil pastels can be used on unprimed drawing paper and they never completely dry.

Oil pastel sticks are quite fat and therefore not really suitable for detailed work or for fine, subtle blending. For bold, confident strokes, however, they are perfect – so instead of trying to work in a way the medium is not suited to, make a point of exploiting their textural qualities and work on a large scale, using vigorous strokes and building up rich, waxy colour.

Oil-pastel marks have something of the thick, buttery quality of oil paints. The pastels are highly pigmented and available in a reasonably comprehensive range of colours. If they are used on oil-painting paper, they can be worked into using a spirit solvent such as turpentine or white spirit (paint thinner), which you can apply using either a brush or a rag. You can also smooth out oil-pastel marks using your fingers. Wet your finger first: as oil and water are not compatible, a damp finger will not pick up colour.

As with the other types of pastel, oil pastels can be blended optically on the support by hatching or scribbling one colour on top of another.

You can also create a wide range of textural effects by scratching into the pastel marks with a sharp implement – a technique known as sgraffito.

Oil pastels ▼

Less crumbly than soft pastels, and harder in texture, oil pastels are round sticks and come in various sizes. They are sold in a paper wrapper, which helps to keep the pastel intact and the artist's hands clean. Tear away the wrapper as the pastel wears down.

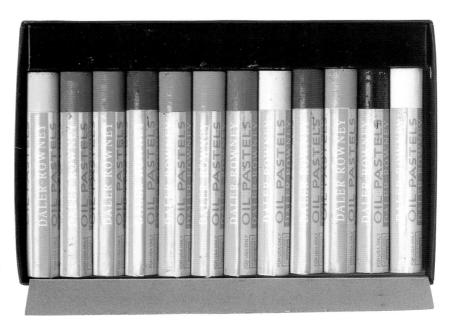

Pen and ink

Working in pen and ink can be a rather frightening prospect for beginners as, if you make a mistake, it's difficult to erase. However, with so many types of pens and colours of ink available, not to mention the possibility of combining linear work

with washes of colour, it is an extremely versatile medium and one that is well worth exploring.

Begin by making a light pencil underdrawing of your subject – but beware of simply inking over your pencil lines, as this can look rather flat and dead. When you feel you've gained enough confidence, your aim should be to put in the minimum of lines in pencil, simply to ensure you've got the proportions and angles right, and do the majority of work in pen.

Inks

There are two types of inks used by artists – waterproof and non-waterproof. Waterproof inks can be diluted with water, but they are permanent once dry, which means that line work made using waterproof ink can be worked over with washes without any fear of it being removed. They often contain shellac and thick applications dry to leave a slight sheen,

Liquid acrylic

which can be slightly distracting. Perhaps the most well-known waterproof ink is so-called Indian ink, which is not from India at all, but from China. Indian ink makes beautiful line drawings. Although it is a deep black when it is used straight from the bottle, Indian ink can be diluted to give a beautiful range of warm greys. Waterproof inks are also available in a limited range of basic colours that can be mixed prior to application.

Non-waterproof inks are more difficult to find, but they are worth the effort as they can be worked into once dry. Work can be lightened and corrections made. As with waterproof inks, the colour range is limited.

Finally, do not overlook the potential of liquid acrylics and watercolours. Both are found in bottles and can be used with pen and brush, just like ink. The colour range is slightly more extensive.

Water-soluble ink

Waterproof ink

Dip pens and nibs

A dip pen does not have a reservoir of ink; as the name suggests, it is simply dipped into the ink to make marks. Drawings made with a dip pen have a

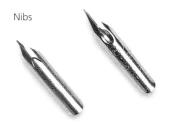

unique quality, as the nib can make a line of varying width depending on how much pressure you apply. You can also turn the pen over and use the back of the nib to make broader marks. As you have to keep reloading the pen with ink, it is difficult to make a long, continuous line – but for many subjects the rather scratchy, broken lines that are produced are very attractive.

When you first use a new nib it can be reluctant to accept ink. To solve this, rub it with a little saliva.

Range of nibs

Dip pen barrels take a range of different shapes and sizes of nib. Each nib makes a different range of marks – and the more flexible the nib, the more variety you can achieve in the thickness of line. To put in a new nib, simply push the end into the slot in the barrel, taking care not to bend it. Not all nibs fit every pen, so make sure you buy nibs that are compatible with your pen barrel. The barrels are made from wood or plastic and are inexpensive to buy.

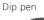

Bamboo, reed and quill pens

Cut from a short length of bamboo, bamboo pens vary in thickness. Some pens are cut so that a different sized nib is at each end. The nib of a bamboo pen is inflexible and delivers a slightly 'dry', rather coarse line that is

completely different to one made using a dip pen.

Reed pens are flexible and deliver a subtle line that does vary in thickness. The nib end breaks easily, although it can be reshaped using a sharp knife. Quill pens can be made from any reasonably large feather – turkey, swan or goose, for example. The line quality is full of character, making a quill pen a joy to use. The cut nib can break easily but, like reed pens, can be re-cut.

Sketching pens, fountain pens and technical pens

Sketching pens and fountain pens make ideal sketching tools and enable you to use ink on location without having to carry bottles of ink. Use only water-soluble ink in fountain pens, or they will quickly become blocked.

Technical pens deliver ink through a tube rather than a shaped nib, so the line is of a uniform width. If you want to make a drawing that has a range of line widths, you will need several pens with different-sized tubular nibs

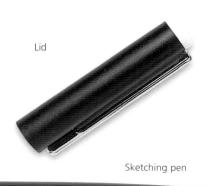

Ink cartridges for sketching pens ▼ Sketching pens hold a cartridge that contains a specially formulated drawing ink that will not clog the nib.

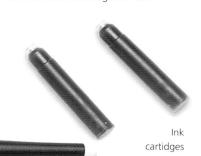

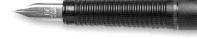

Rollerball, fibre-tip and marker pens

All these types of pen are readily available from both art supply stores and normal stationery stores. Drawings made using a rollerball pen can have a rather mechanical feel to them, as the line does not vary in width, but, by working quickly, you can make a light line by delivering less ink.

Fibre-tip and marker pens nowadays come in an extensive range of tip widths from super-fine to calligraphic style tips and also in a wide range of colours.

While these types of pen may not be suitable for finished artworks, they are certainly very useful tools for working out ideas in sketchbooks and for making preparatory studies. One of the main benefits is that they are so easily portable, as you do not need to carry separate bottles of ink.

Fibre-tip pen ▼

The advantage of fibre-tip pens is that they come in a range of tip widths, so you can use broad tips to block in large areas of tone and fine tips for delicate details. The colour range is also extensive, so they are great for making quick colour notes on reference sketches. Like rollerball and technical pens, they tend to give a drawing a rather mechanical feel.

Fibre-tip pen and lid

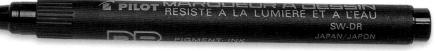

Rollerball pen ▼

For making quick reference sketches or thumbnail compositional sketches on location, rollerball pens are a good option as they are easy to transport and clean to handle.

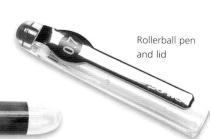

Supports

The general name for the surface on which you draw is the 'support' – usually, but not always, some kind of paper. There are a number of types and qualities of paper available and the

one you choose will depend on both your own personal taste and the subject you are drawing, as well as the medium in which you are working.

White paper

Drawing papers vary enormously in quality and cost, depending on whether the paper is handmade, machine-made, or mould-made.

The thickness of a paper is described in one of two ways. The first is in pounds (lbs) and describes the weight of a ream (500 sheets). The second is in grams (gsm), and describes the weight of one square metre of a single sheet. Sheets vary in size.

Many papers can also be bought in roll form and cut to the size required. You can also buy pads, which are lightly glued at one end, from which you tear off individual sheets as required. One of the benefits of buying a pad of paper is that it usually has a stiff cardboard back, which gives you a solid surface to lean on when working on location and means that you don't have to carry a heavy drawing board around with you. Sketchbooks have the same advantage.

The most common drawing paper has a smooth surface that is suitable for graphite, coloured pencil and ink work. Papers intended for use with watercolour also make ideal drawing supports. These papers come in three distinctly different surfaces – HP (hotpressed) papers, which are smooth; CP (cold-pressed) papers, also known as NOT, or 'Not hot-pressed' papers, which have some surface texture; and rough papers which, not surprisingly, have a rougher texture.

Art and illustration boards are made from cardboard with paper laminated to the surface. They offer a stable, hard surface on which to work and are especially useful for pen line and wash, but can also be used with graphite and coloured pencil. They have the added advantage of not buckling when wet, as lightweight papers are prone to do, and are available in a range of sizes and surface textures, from very smooth to rough.

Drawing paper ▼

A medium-weight paper is suitable for most purposes, but if you are planning to use water-soluble pencils in combination with water, a heavier paper is best. For fine, detailed work, choose a smooth paper. For charcoal and pastel work, a paper with some 'tooth' to pick up the pigment is generally best.

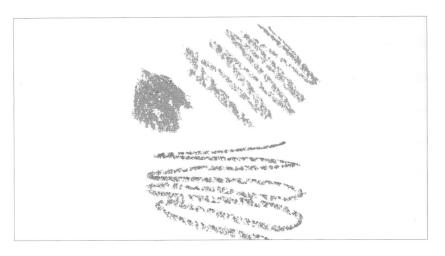

Sketchbooks ▼

Available in a wide range of formats and containing all the above-mentioned papers, sketchbooks are invaluable for working out ideas and for drawing on location. Spiral-bound, stitched or glued, the sketchbook is perhaps the most important piece of equipment for anyone who draws.

Coloured paper

The main advantage of making a drawing on coloured paper is that you can choose a colour that complements the subject and enhances the mood of the drawing. Coloured papers can be used with all drawing mediums. Some of these papers are laid rather than woven. Laid papers can be identified by the network of parallel lines that runs through the paper, which you can see by holding it up to the light.

Some papers are manufactured specifically for use with dusty, pigmented drawing materials such as pastel, chalk and charcoal. They are normally tinted in a range of pleasing natural colours that complement the pastel colours and give an overall colour harmony. Several brands are also available as boards, which makes them relatively easy to use on location.

Pastel papers **▼**

Papers for use with pastels are coated with pumice powder or tiny cork particles that hold the pigment and allow for a build-up of colour.

Coloured papers ♥

Available in a wide range of colours with a good, even surface texture, coloured papers can be used with all drawing mediums.

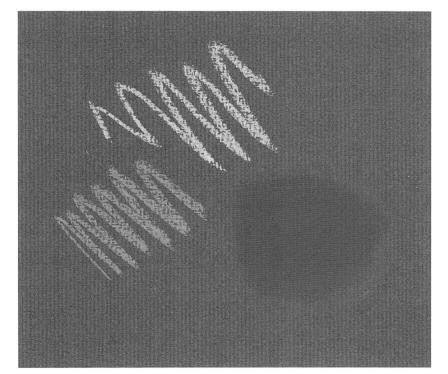

Preparing your own surfaces

It is both satisfying and surprisingly easy to prepare your own drawing surfaces. Acrylic gesso, a kind of primer that is used to prepare a surface such as canvas or board when painting in oils or acrylics, can also be painted on to paper to give a brilliant white, hard surface that receives graphite and coloured pencil beautifully.

To make a surface that is suitable for pastels, you can mix the gesso with pumice powder.

To create a toned or coloured ground, simply tint the gesso by adding a small amount of acrylic paint in the appropriate colour.

Additional equipment

In addition to drawing tools and paper, there are a number of other pieces of equipment that you will need – erasers, tools to sharpen your pencils, blending tools and easels. If you work in very soft mediums, such as charcoal, you will also need fixative. With the exception of easels, most are inexpensive and readily available from both art supply stores and general stationers.

Erasing tools

After tools that make marks, perhaps the next most used pieces of drawing equipment are tools that erase them. Erasing marks is not only a way of making corrections, but also a markmaking technique in its own right.

Kneaded erasers are good for cleaning up areas of a drawing. You can knead them to a point and even pull off small sections for delicate areas of a drawing. They do, however, get dirty very quickly, especially when used with charcoal or pastel.

India rubber, vinyl and plastic erasers are harder and able to erase precise,

fine marks. Large soap-gum erasers are used for cleaning up areas of white paper, as are cleaning pads, consisting of a bag of rubber granules that is rubbed over the paper surface. Erasing knives can be used to scrape mistakes away gently, but they need to be used with care.

Types of eraser ▶

A plastic eraser (top) is hard and unyielding and can be used very precisely to erase small marks and areas. A kneaded eraser (bottom) is pliable and can be pulled to a point.

Sharpening tools

In order to sharpen your drawing tools and to repair and re-cut pen nibs, you will need a sharp craft (utility) knife. There are several types on the market, from those that require replaceable blades to models with retractable blades that break off to expose a new sharp section. Whichever type you use, keep plenty of spare, sharp blades to hand. Using a blunt knife will not only not sharpen your drawing implement well, but it is also dangerous.

Pencil sharpeners are also useful, provided the blade is sharp. Abrasive-paper blocks are another good way of keeping the points of pencils and chalks shaped and sharp.

Hand-held pencil sharpener ▼

Small, hand-held pencil sharpeners are useful but make sure they are large enough to hold the barrel of the pencil.

Craft/utility knife ▼

This knife has a retractable blade. When one section of the blade is blunt, simply snap it off and push the lever on the knife handle to expose the next section.

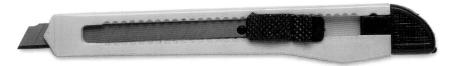

Battery-powered sharpener ▼

This battery-powered pencil sharpener is ideal if you do a lot of graphite or coloured-pencil work, as it sharpens quickly and evenly.

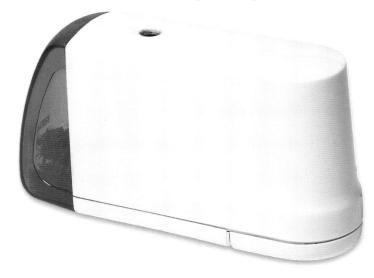

Fixative

Made from resin dissolved in a colourless spirit solvent, fixative is applied to drawings made with dusty, pigmented materials such as charcoal and soft pastels, to prevent smudging. Fixative is used not only on finished drawings, but also on work in progress to make it possible to build up layers of marks and to preserve areas of a drawing that you are happy with. Fixative is available in aerosol cans (like hairspray which can also be a cheap alternative), bottles with a mechanical spray mechanism or a mouth spray diffuser.

Blending tools

In order to blend marks and manipulate pigment or move it around on the support, you will need to acquire some torchons – also known as paper stumps, or tortillons. These are made from rolled or pulped paper fashioned into a point at one or both ends. They get dirty quickly, but can be cleaned by being rubbed on a sheet of glass paper.

Of course, you can also blend marks with a clean rag or piece of kitchen paper (although this method is best for large areas such as skies), or with your fingertips.

Torchons ▼

Invaluable for blending dusty, pigmented materials such as charcoal and soft pastels, torchons (also known as tortillons or paper stumps) come in a range of sizes. They are made of tightly rolled paper and have a tapered end (for working on large areas) or a pointed end (for small details).

Drawing boards and easels

If you are working on loose sheets of paper, you will need a drawing board. You may find it worthwhile buying two in different sizes. Boards are made from plywood, which makes them relatively light and easy to use on location. Paper is fixed to the board by means of clips, drawing pins (thumb tacks) or masking tape; clips (see below) are easy to use and do not tear or puncture the paper.

The type of easel that you choose depends on your budget, the space in which you work, the type of work that you intend to do, and whether or not you plan to work on location. Table easels hold a medium-size drawing board and can be positioned so that the drawing surface is anything up to about 45 degrees above the horizontal. They do, however, need to be placed on a flat surface, so are not suitable for location work.

There are two main types of free-standing easel – those that are portable and those that are not. Portable easels are good for location work. Make sure you buy one that is stable when erected and can easily hold the size of support on which you intend to work, at a comfortable angle. Studio easels are a major investment; only buy one if you have room for it. There are two main shapes: an A frame and an H frame. The larger H-frame easels are on castors to make them easier to move and may have a ratchet or winding system to raise or lower the support.

the paper.

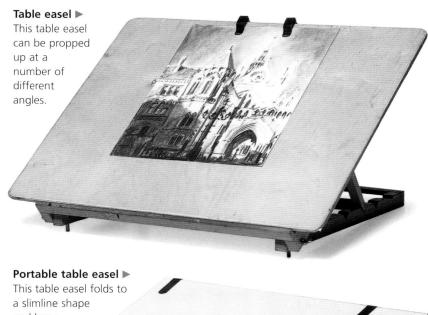

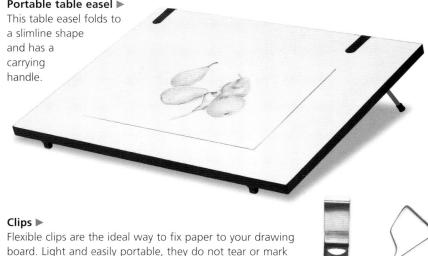

Making marks

The success of your drawings depends on your ability to make as wide and as varied a range of marks as possible. This allows you to exploit the potential of your chosen material to the full. With practice, every drawing tool – even the simple graphite pencil – can be made to produce a surprisingly wide range of marks. Mark-making is something that you can practise whenever you have a few minutes spare; time that you spend doodling on a scrap piece of paper is never wasted.

Several things affect the quality of a mark, including pressure, direction, speed, and the angle at which the drawing tool is presented to the support. Marks made when drawing are used to represent three distinct things: line, tone

and texture. Line is mainly used to describe the shape of a thing. In reality, these lines don't exist, but in the hands of an artist they are a graphic device that indicates where one thing ends and another begins. By varying the quality of a line, however, you can show much more than just the shape of something. You can also convey light, shade, and even the texture of the object.

Tone indicates how light or dark something is, the direction and strength of the light, and the form of the subject. Tone can be applied in several ways. Suffice to say here that being able to indicate tone in a controlled way is very important if you want to portray your subject in a way that looks convincing. Textures indicate the surface quality of

an object and are directly affected by the quality and direction of the light. When a subject is lit from overhead, the texture of its surface can look flat and uninteresting; when lit from the side, that same surface will look dramatic and full of interest. In order to make these different types of mark, you will need to learn how to hold the drawing tool in a variety of different ways. These may feel slightly awkward at first, but with practice they will become second nature.

The shape of the drawing tool dictates the type and range of marks you make. Remember that, with all drawing tools, by turning them in your fingers you can use not only the point but also the side and the edge, allowing it to come into contact with the support in many different ways.

Controlling the point of a pencil By gently cradling a pencil between your fingers, you can manipulate the point of the tool very precisely by using just your fingers and wrist.

Making heavy marks with a pencil By holding a pencil between the tips of your fingers and your thumb, you can bring the side of the lead into contact with the support and make thicker, heavier marks.

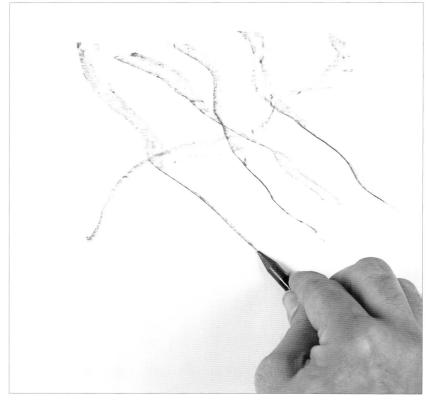

Altering the angle at which you hold a graphite stick

By holding a stick of graphite in the same way and altering the angle of the stick in relation to the support as you work, you can create a fluid line that varies in thickness from being as wide as the tapered section of the stick (shown at the top of the image above, and created by pressing the tapered section flat on to the support) to a crisp, thin line made using just the tip of the stick.

Textural marks

By jabbing the dull, blunted end of a thick stick of graphite on to the support, you can make textural marks that vary in tone, depending on how much pressure you apply.

Using the full width of a Conté or carré stick

Here the width of a Conté stick is pressed on to the support to create a broad, dense mark.

Using the sharp edge of a Conté or carré stick

By holding the stick between the tips of your fingers and your thumb and pulling it lengthways along the sharp edge of one side, you can make a straight line that gradually becomes thicker as the stick wears down.

Using the point of a Conté or carré stick

Conté and carré sticks and chalks can be sharpened to various degrees in order to make lines of varying thickness similar to those made with a pencil.

Using the flat side of a Conté or carré stick

By pulling the side of a Conté or carré stick across the support, you can lay down a broad area of dense pigment.

Twisting a Conté or carré stick

By holding the stick between the tips of your fingers and your thumb, pulling it lengthways along the sharp edge of one side, and turning it back and forth, you can create a wave-like line that varies in width from thin to thick and back again.

Line drawing

Lines around an object are merely a graphic device that artists use to describe the shape of things. A good line drawing will guide the eye over and around the subject, inviting you to 'feel' its shape. In order to use line in this way, you need to be able to alter its density and its width. When using dry pigmented materials like graphite, you can make a line darker by

increasing the amount of pressure that you apply. To increase the width of a line, angle the drawing tool so that more of it comes into contact with the support. The quality of a line is also influenced by the speed with which it is made; a line applied with speed and confidence will look strong and fluid, whereas a line applied in a hesitant way looks laboured.

If it is used well, the line can be made to describe light, shade and the texture of your subject. It can also be used to describe internal contours. If an object is drawn in outline only, all you will see is a silhouette-like shape – but if you use line to indicate internal contours, you will have a much better idea of the form of the object that you are drawing.

Practice exercise: Simple line drawing

You can adapt the approach used here to any subject you choose, and it is well worth setting aside ten or fifteen minutes every day to make a sketch like this as there is nothing better for improving your powers of observation and eye—hand co-ordination.

Whatever subject you choose, think of your eye as a laser, moving along the contours of the object and cutting it out. Try to move your eye and your pencil at the same speed, as this will make it easier for you to get the size of different parts of the subject right without having to measure anything. Work slowly to begin with, increasing your speed as you get more confident.

As a variation on this exercise, draw something without looking down at the paper. Don't worry if your lines don't join up: the point is to train yourself to really look at your subject and put down on paper the shapes you can see.

Materials

- Smooth drawing paper
- 4B pencil

The subject

Here, the artist selected a trainer (sneaker) as her subject. The laces and the decorative lines within it help to convey the shape of the shoe.

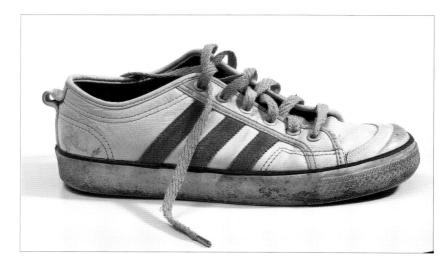

1 Working slowly and carefully, begin drawing the top of the trainer, looking at where the laces form the outer line of the silhouette. Try to think of the laces as being part of the overall shape of the shoe, rather than just things that are attached to it.

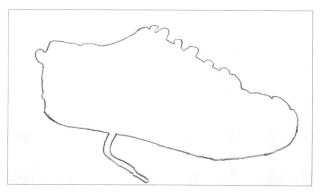

2 Continue around the base of the shoe, concentrating hard. It's very easy to draw something the way you think it ought to look, rather than putting down the shapes that are actually there. Note how the lace breaks the outline. Try to complete Steps 1 and 2 without lifting the pencil from the paper.

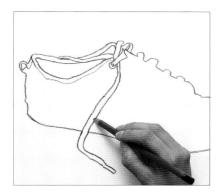

3 Once the outline is complete, you can begin to put in some of the internal lines such as the lace holes and the long lace that trails over the side of the shoe.

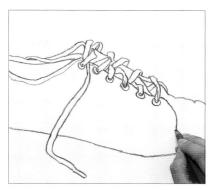

A Now draw the laces, observing carefully how they twist and turn over one another. Also draw the decorative band on the side of the lace-hole panel.

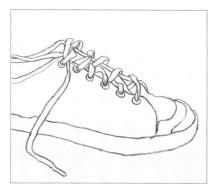

5 Next you will need to put in the broad lines across the toe of the shoe as well as along the raised tread around the base. This helps to give some sense of form.

The finished drawing

The decorative detailing completes the drawing. This is a simple sketch of an ordinary household object, but with just a

few lines the artist has managed to convey both the shape and something of the form of her subject.

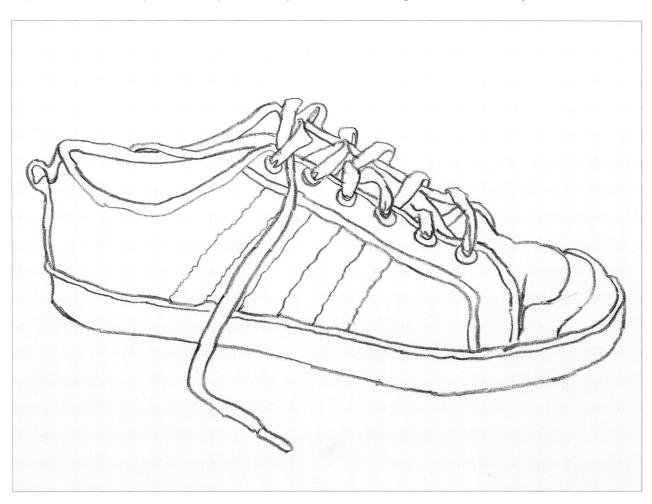

Seeing things as simple shapes

When you first look at your subject, the amount of information that you need to take in and assimilate can seem quite daunting. The answer is to simplify what you see into a series of simple geometric shapes. The shapes most commonly used are the cone, the cylinder, the cube and the sphere – all three-dimensional objects. They may be elongated or compacted, but essentially the shapes remain the same.

Make your initial sketch using these four shapes, or combinations of them, as appropriate. All these shapes are relatively easy to draw in perspective, which will help you to orientate and position the elements within the drawing quickly and correctly. Then you can elaborate, redefine the shape and gradually add tone and detail.

The illustrations on these two pages show how simple geometric shapes (the red lines in the illustrations) can be used as a starting point for drawing a number of ordinary household objects. Adopt the same approach when drawing other subjects; you will find it surprisingly beneficial.

Straight-sided bottle ▼

The shape of this bottle was established by first drawing a simple elongated box in perspective. The top of the bottle was then indicated by drawing a tall cylinder.

Bottle with round base ▼

The round-based bottle shown below was drawn by first creating an egg shape (an elongated sphere). The long neck of the bottle was then added, using a simple cylinder.

Wine glass ▼

The shape of this glass is contained within a cylinder. The bowl of the glass was made using a sphere. Make sure you draw the ellipses for the top rim and the base at the correct angle.

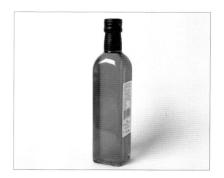

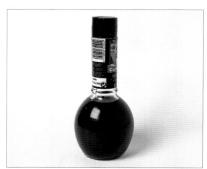

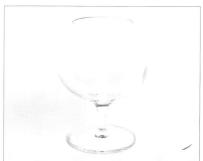

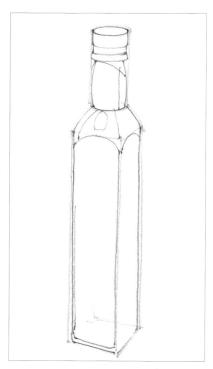

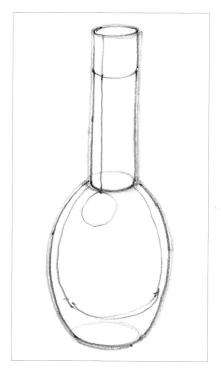

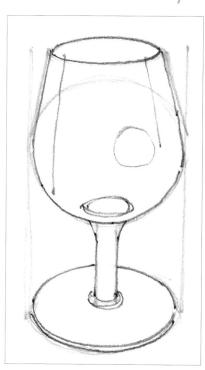

1

Olive oil pourer 1 ▼

This olive oil pourer was drawn by first sketching a tall cone surmounted by a short cylinder. The spout and handle were added last.

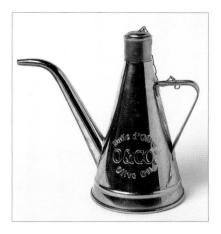

Tip: Even with apparently quite complex-looking objects such as teapots, coffee percolators and oil pourers, keep in mind the four most common geometric shapes: the cone, the cylinder, the cube and the sphere.

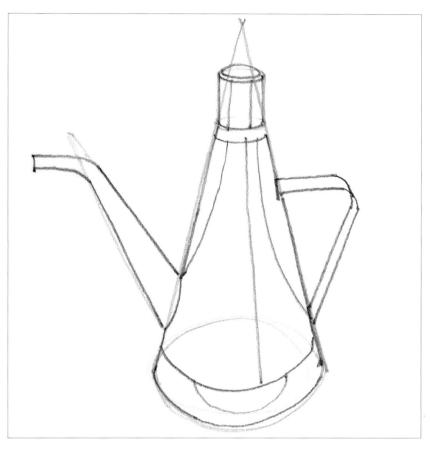

Olive oil pourer 2 ▼ For this pourer two cylinders were drawn, one on top of the other.

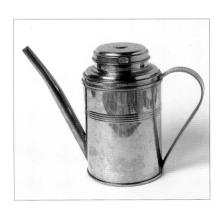

Practice exercise: Reducing a simple still life to basic shapes

Set up a still life with both rounded and straight-sided shapes. Thinking of your subject as a variation on a basic geometric shape will make it easier for you to draw it correctly. It is relatively easy to construct the basic shape of man-made objects using geometric shapes, as these things invariably started life on a drawing board as the same simple shapes that you are using to draw them now.

Materials

- Smooth drawing paper
- HB pencil

The set-up

For this exercise, the artist selected a range of objects from his kitchen that exemplify three of the main geometric shapes – the sphere (an apple), the cone (a coffee pot and a pear) and the cylinder (a coffee cup).

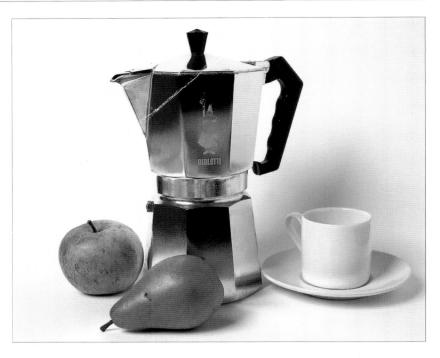

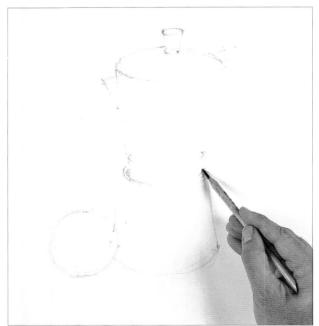

1 Lightly sketch the objects, thinking of them as simple geometric shapes. Indicate the position of the apple with a circle. The coffee pot consists in essence of two cones, one inverted on top of the other, with a short cylinder at the 'waist' and a small cone for the knob (on the lid). Put in a line across the top of the coffee pot to suggest the axis along which the spout and handle are positioned.

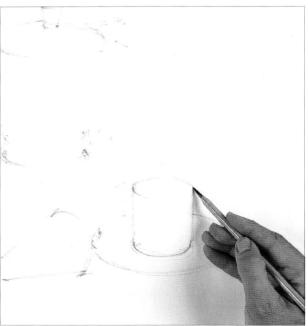

2 You need to indicate the position and shape of the pear by starting to draw a cone. Position the cup and saucer, drawing a cylinder to represent the cup. Note that the lines should be tentative at this stage. All you are doing is trying to search out the essential forms while still thinking of them as basic geometric shapes – the details can be revisited and refined later.

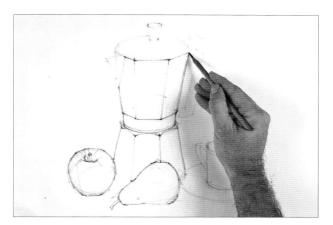

Once you have established the approximate shape and position of the elements, you can begin to refine the objects by drawing over the basic geometric shapes. Make a series of short, straight lines, for example, to establish the different facets of the coffee pot, which has straight sides. Position the stem at the top of the apple. Immediately the objects begin to look three-dimensional.

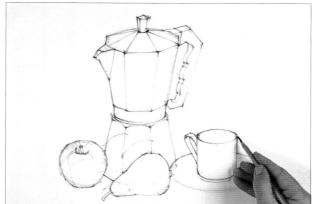

4 Complete the facets of the coffee pot and put in the ellipses that form the saucer and the top and bottom of the coffee cup.

The finished drawing

Add a few internal contour lines, which indicate the direction and angle of some of the surfaces, to complete the drawing.

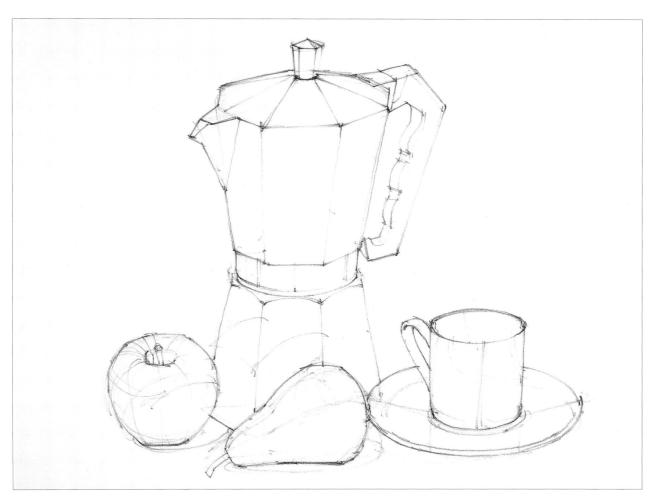

Practice exercise: Simple landscape viewed as geometric shapes

With natural subjects, such as elements of a landscape, it can be slightly more difficult to assign simple geometric shapes to objects. The answer, of course, is not to be too literal. See trees as spheres or cones: the cypress trees in this scene are basically conical in shape, for example, whereas the overall shapes of other trees such as oaks are more rounded. Try to think of any landscape that you are drawing as a series of interconnecting shapes. To practise this, make a series of quick sketches setting down your subjects as rough overall shapes, so that you can fine-tune your eye to this method of working.

Buildings are somewhat easier to deal with, as they are usually designed as geometric shapes in the first place. Most buildings are simply a series of interconnecting rectangles or cubes arranged around one another.

Your aim in the exercise below is not to produce a perfectly finished landscape, but simply to get used to analysing the shape of the things you are drawing.

Materials

- Smooth drawing paper
- 2B pencil

The scene

This is a simple landscape scene of a church in rural Italy surrounded by tall cypresses and shorter, more rounded trees.

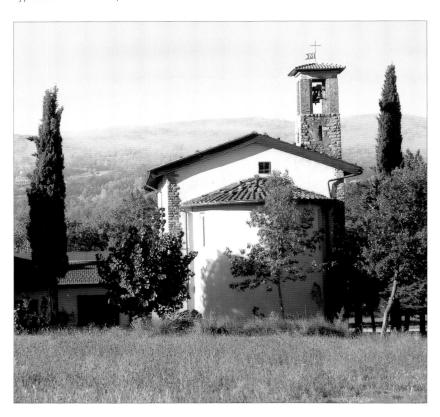

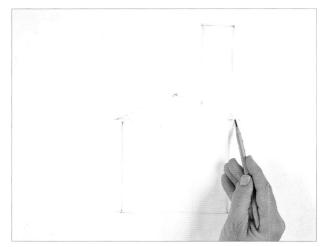

1 First, draw the position and shape of the church. It consists of a rectangle surmounted by a triangular shape that is, in turn, surmounted on one side by the long, thin rectangle of the bell tower. Make sure that the relative proportions of these three shapes are correct.

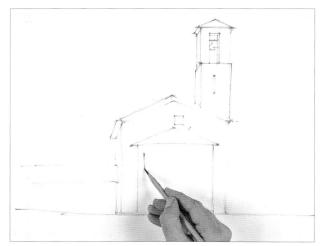

2 Draw the long building that lies to the left of the church as an elongated cube and put in the roof of the tall bell tower. Indicate the apse of the church by lightly drawing another rectangle, surmounting it with a triangle with a slightly curved base.

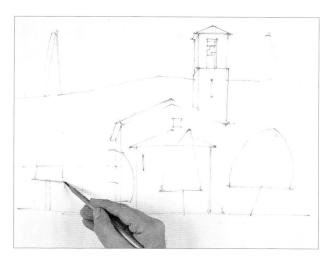

3 Next, indicate the position and shape of the trees. Although they do not conform strictly to any geometric shape, with a little imagination they can be simplified.

The finished drawing

With the addition of a little tone, the image comes to life. The tone not only begins to suggest the forms, but also covers up

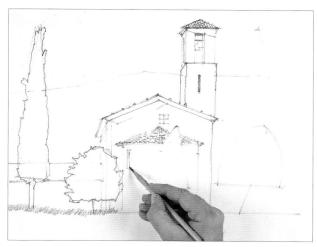

4 Once you have sketched the position and proportions of all the different elements in the scene, use the simple geometric shapes as a guide to refine your drawing.

many of the construction lines that you used to search out the basic geometric forms.

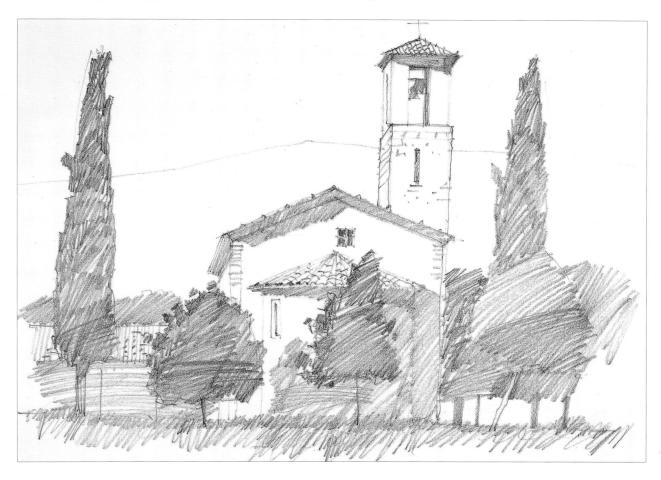

Understanding tone

The term 'tone' describes the degree of dark or light values that the artist uses to create the illusion of form and space in a picture. While it is possible to draw representational images with line alone, this is a more difficult process. Linear drawing encloses plain shapes that may appear to be flat if they are not observed very accurately. The most serviceable method of conveying form, or the threedimensional nature of the subject, is tone. It is the fall of light across the surface of the objects, figure or landscape being drawn that reveals promontories, contours and the negative shapes of space. Even abstraction requires artists to create illusory picture space by using tone.

There are as many methods of creating tone as there are artists, and each beginner must devise a personal method of shading the paper to his or her satisfaction. Examine the works of the great masters for outstanding examples of the use of various media to create tonal values. Try studying the hatched pen drawings of Rembrandt, the wash drawings of Tiepolo, the chalk work of Seurat or pencil studies by Matisse. Whether you study them in books or in galleries, note how tonal density was achieved and choose a preferred method to enable you to find a starting point for toning work.

Once you have devised a way of creating tone, the quality and direction of lighting will also determine the character of the picture. For example, a sunlit rendition reveals the sparkling mass of a rocky outcrop, while storm light enlivens the boiling sea in coastal works. A dramatically lit stage will have more contrast than the calm, steady quality of a day-lit domestic interior.

The illustrations here show a plastercast head of the French writer and philosopher Voltaire, lit from different directions. Where light falls directly on the subject, very little detail is discernible. But on the sides that are turned away from the light, strong shadows are formed – and it is these shadows that show up the muscle formation and bone structure, making the cast look three-dimensional.

Light from the left, almost full profile

Here, the light was positioned to the left of the plaster cast and slightly above it. As a result, the forehead is brightly illuminated: the artist left the paper untouched in this part of the drawing. A few faint lines under the left eye hint at the bone structure, but the face is so brightly lit that few shadows are formed here.

On the left side of the head, however, (the right side as we look at it), a mid-tone is used to draw deep shadows that reveal the sunken cheekbones and indentations in the skull. The slab of the neck is drawn using a tone that is even darker, as virtually no direct light hits this part of the cast.

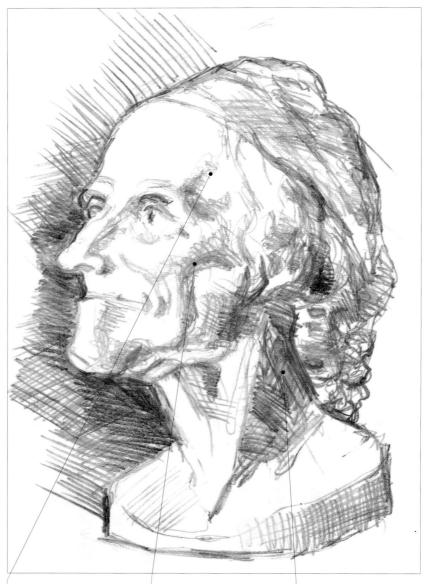

Light pencil marks indicate the change of plane from the brightly lit front of the skull to the side. A mid-tone reveals the structure of the cheekbones, which are in moderate shadow. Very little direct light reaches the side of the neck and so a very dark tone is used here.

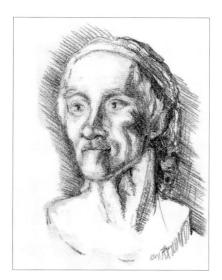

Light from the left, almost full face Here, the head was turned to show more of the face. The light is from the left, so everything on the other side of the rather prominent nose is in shadow.

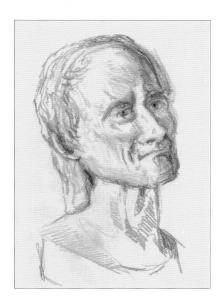

Light from the left, threequarter view

Here, the light was again positioned to the left of the cast – but slightly lower down than in the previous two images, almost level with the cast, and the cast was turned further to the right. Again, every feature to the right of the nose as we look at the image is cast into deep shadow – but changing the angle of the cast emphasizes different features.

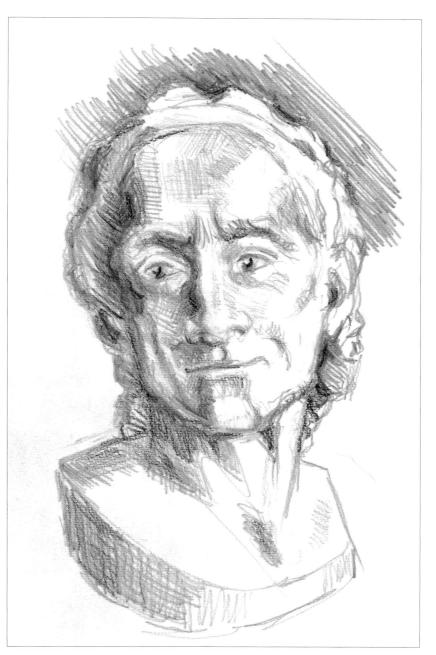

Light from the front, full face

Here the light was positioned in front of the cast – although, to make the drawing more interesting, the artist arranged it slightly to the right instead of placing it centrally, in line with the nose. As a result, the right side of the face (the left as we look at the image) is slightly shaded. The artist used mid-tones to convey this. (Compare this image with the other two on this page, where the light is from the side and the shadows are darker and more intense.)

Note, too, how the frontal lighting has the effect of flattening out some of the features: the cheekbones, in particular, look more rounded and less angular, although this is partly due to the fact that we are viewing the face full on, rather than from the side.

Adding tone

In drawing, the application of tone is sometimes referred to as 'shading', as in 'light and shade'. It is this tone or shading that describes the form of a thing and makes it appear three-dimensional.

The range of tones visible in an object depends entirely on the amount and quality of the light illuminating the subject. A very bright, directional light-source results in a range of tones that run from very dark to very light, with emphasis placed less on the mid-tones and more on the darker and lighter tones. An even but subdued light results in an equally wide tonal range, but with the mid-tones far more evident than strong darks or bright lights. In order to give your two-dimensional drawing the illusion of having the added dimension of depth, you will need to render light and shade convincingly. Fortunately, there are several ways of doing this.

Charcoal: dots and dashes

With soft materials such as charcoal or soft pastels, you can use dots and dashes to create tone. To make the tone darker or lighter, apply more or less pressure.

Charcoal: blending

With very soft, highly pigmented drawing materials, the drawn tones can be blended together using your finger, a torchon or a rag. Drawings like these are quite delicate and need to be fixed to prevent them from being smudged.

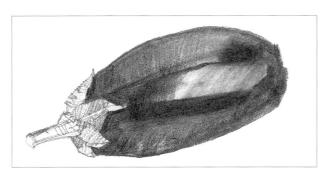

Graphite: scribbled tone

With a graphite pencil, you can scribble on tone. For a darker tone, vary the direction of the marks and the amount of pressure.

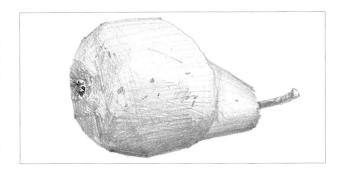

Graphite: contour shading

In contour shading, simple linear marks are made to follow the form of the object. This is sometimes called bracelet shading and can be seen on many old master drawings.

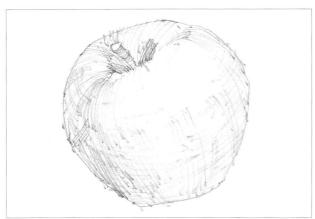

Graphite: crosshatching

With pens and pencils, you can create tone by drawing a series of parallel lines. Crosshatching consists of another series of lines drawn across the first set at an angle. To darken the tone, draw lines closer together and apply more pressure.

Chalks on a mid-toned ground

With chalks or charcoal, a particularly efficient way of achieving a tonal drawing is to work on a mid-grey ground (a ready-toned paper). Establish the mid- and dark tones first before bringing the whole thing to life by adding the lighter tones and the highlights.

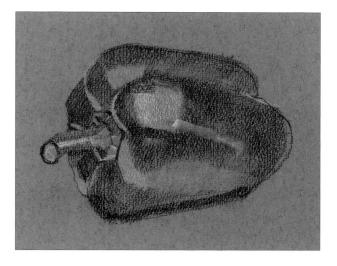

Ink: controlled hatching

When using a pen with a fixed-width nib, you can create tone by using hatched and crosshatched lines. To build up the depth of the tone, simply draw the lines closer together. For light areas and highlights, leave the paper untouched so that the white of the support stands for the brightest areas.

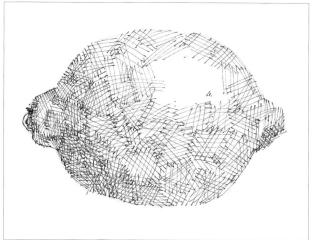

Ink: pen and wash

You can create tonal washes by diluting ink with clean water to differing degrees. These ink washes can be used on their

own to build up the drawing or contained by linear work made using a dip pen.

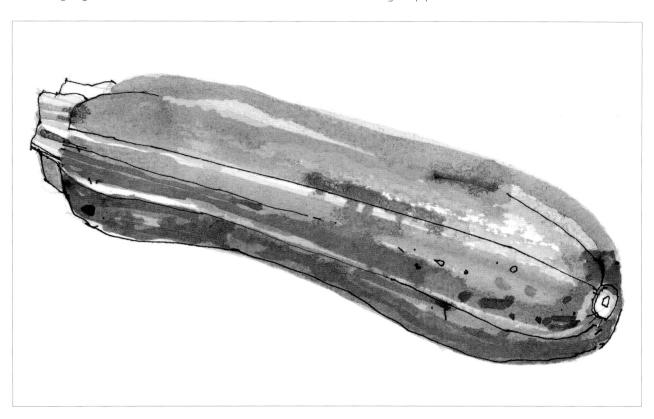

Practice exercise: Shading straight-sided objects

For your first practice exercises in shading, select straight-sided subjects and light them strongly from one side, as this makes it easier to see where changes in tone occur. You can find lots of suitable subjects around the home; books, stacked boxes in varying sizes, a pile of CD cases arranged so that they cast shadows on the table top and background, or children's play bricks would all make good subjects.

Start with a monochromatic object. As soon as you introduce different colours things become more complicated, as you are distracted by the colour and will probably find it harder to work out how light or dark the tones need to be.

Materials

- White pastel paper
- Thin charcoal

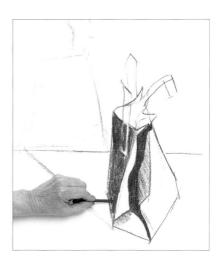

Half close your eyes to assess the tones and work out which areas of the bag are the darkest. (In the set-up shown here, you can see that the back of the bag and the cast shadow in the folded side of the bag are the darkest.) Roughly block them in, using the side of the charcoal stick. Don't make them too dark, however: if necessary, you can always darken the drawing later once the mid- and light tones are in place, but if you make it too dark to begin with, you will find that it's much more difficult to lighten it.

The set-up

The subject chosen for this exercise is a brown paper bag, which has a number of creases and folds within it. The lighting from the side creates interesting cast shadows on both the table top and the wall behind.

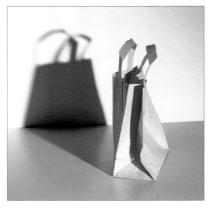

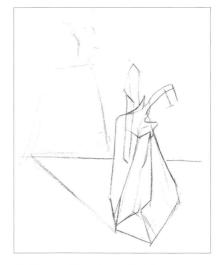

1 Using a thin charcoal stick, map out the composition, making strong lines for the bag and lighter ones for the cast shadows.

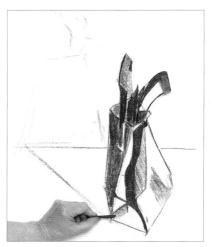

Put in the darkest tones and the mid-tones on the handles. The handles are twisted, so different facets catch the light in different ways, hence the differences in tone. Again using the side of the charcoal stick, put in the dark and mid-tones on the front and side of the bag. You can see how shading provides us with information about the form of the bag: without these subtle differences in tone, we would have no way of knowing how the handles are twisted or where the creases in the bag occur.

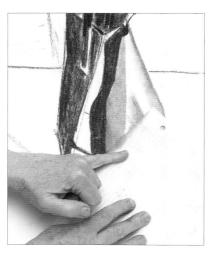

Line up a piece of scrap paper along the bottom edge of the bag and hold it firmly in place. Gently smooth out the mid-tones. (Use your little finger, as it is the coolest and driest part of your hand.) The scrap paper helps you to maintain a crisp edge to the bag; if your finger goes beyond the edge of the bag when you're blending, the charcoal will dirty only the scrap paper and not the background to the drawing. Blending also gets rid of the harsh, drawn line around the edge of the bag.

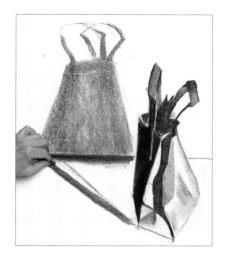

5 Using the side of the charcoal stick, block in the cast shadow on the wall. Block in the cast shadow on the table top, making it darker than the shadow on the wall.

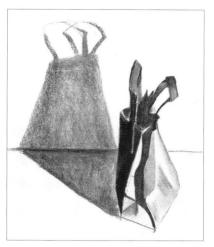

6 Using your fingertips, smooth out the cast shadow on the table top to create an even tone. Do not blend the cast shadow on the wall: the texture of the paper adds interest to the drawing.

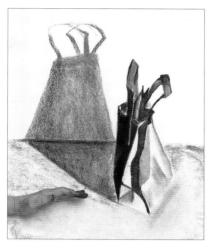

Zusing the side of the charcoal, apply a very thin covering over the table top. Blend it with the side of your hand, using a circular motion, to create an even, pale grey tone.

Draw in the very thin cast shadows underneath the bag on the table top to anchor the bag and prevent it from looking as if it is floating in space.

The finished drawing

The drawing looks convincingly three-dimensional, and the tones range from a very dense black on the back of the bag to a very pale grey (barely darker than the paper) in the most brightly lit areas. Note the use of finger blending – a good way of creating areas of smooth tone when using a powdery medium such as charcoal or soft pastel.

The texture of the paper is visible in parts, adding interest to the drawing.

In a tonal drawing, the darks are almost always darker than you expect them to be. The darkest areas are a very dense black.

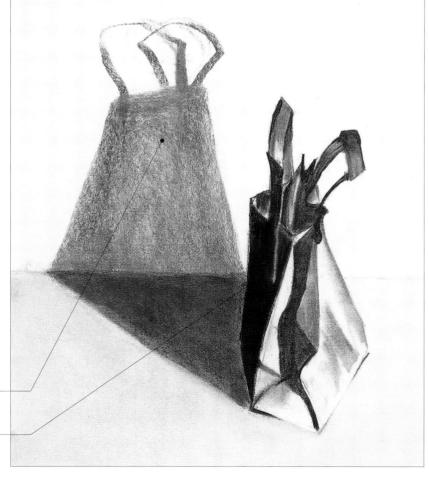

Practice exercise: Shading rounded objects

Straight-sided objects have very clearly defined planes and it is easy to see the sudden fall-off of light. With rounded objects it is much more difficult, as there is no immediate transition from one tone to another. Nevertheless such a transition does occur, even though it happens very gradually. Look for the extremes of tone – the very lightest and darkest areas – and then let your eye travel over the rounded form to assess the degree of change that will be required.

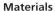

- Smooth drawing paper
- Graphite pencils: HB, 4B
- Graphite stick

The set-up

The overall composition of this grouping is triangular in shape. The wedge of cheese and the salami point towards each other, drawing the viewer's eye into the scene. The large, rounded loaf of bread balances the smaller objects.

1 Using an HB graphite pencil, lightly sketch the composition. Don't attempt to put in any shading at this stage. Instead, think of the objects as simple geometric shapes and concentrate on getting the sizes and shapes right. Also put in the cracks in the top of the loaf of bread.

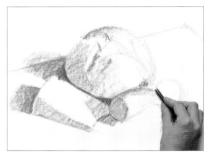

2 Using the side of a graphite stick, block in the mid-tones on the items and the cast shadows. As the loaf is rounded, the transition in tone from the front to the back is gradual. Putting the mid-tones in at this stage makes it easier to judge how light and dark the rest of the drawing needs to be.

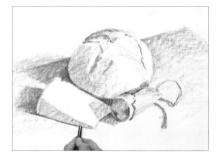

3 Still using the side of the graphite stick, shade the darkest parts of the wooden board behind the bread. Using the tip of the stick, reinforce the dark cracks in the top of the bread and put in the string of the salami and the deep shadow under the wedge of cheese.

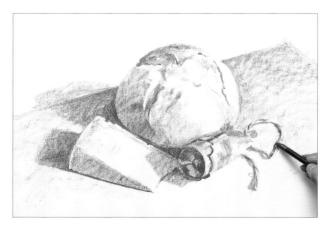

4 Using the tip of the 4B pencil, carefully darken the shaded areas between the objects. In addition to telling us about the quality and direction of the light, these areas also help to anchor the objects on the surface. Put in more linear detail on the salami and its string.

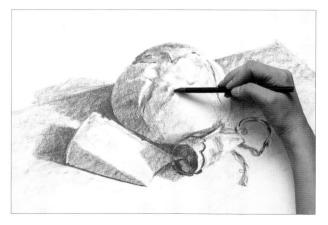

5 Shade the wooden board within the loop of string. Note that this area is lighter in tone than the board behind the bread. Go over the darkest part of the bread again, drawing fine hatching lines close together. Don't bring the lines too far forwards, as the front of the bread is very light in tone.

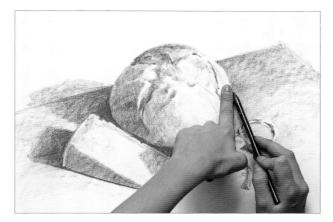

Repeat the hatching process on the shaded side of the cheese. Darken the board up to the edge of the bread by placing your finger on the curve of the bread and shading right up to your finger. This allows you to maintain the curve of the loaf without having to draw a harsh line around the edge. (You will have to move your finger around the loaf, following the edge very carefully.)

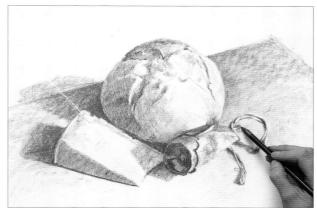

Put in any final linear details on the salami wrapper and its string. Finally, use the 4B pencil to put in the small shadow cast by the string on the wooden board, so that it is clear that the string forms a loop that is raised up above the surface of the board.

The finished drawing

A number of shading techniques have been used in this drawing, including loosely scribbled tone using the side of a pencil or graphite stick on the wooden board and cheese, and hatching on the darkest areas of the loaf. There is a very marked difference in tone between the light and the

shaded sides of the wedge of cheese. The transition from dark to light tone on the rounded objects (the loaf and the salami) is much more gradual, but it has been very carefully observed to make them appear convincingly three-dimensional.

Parallel lines hatched close together form a dark tone on the shaded side of the bread.

The very brightest areas on the front of the loaf contain hardly any tone; the paper is left blank.

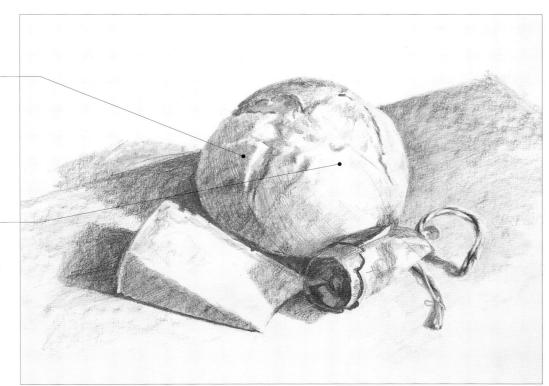

Measuring systems

Getting the proportions and relative size of your subject right is essential in representational art and, unless you have some means of checking measurements, it's almost inevitable that you will make some mistakes. There are a number of well-established measuring systems that you can use and two of the most common are described here.

The most important thing is to learn to trust your measurements rather than your instincts or prior knowledge of a subject. You may be surprised to find when drawing a portrait, for example, that the base of the eye socket is generally about halfway down the face – but if you don't actually measure the distance, you'll probably draw the eyes too high up.

Your viewpoint in relation to your subject and the angle at which the subject is positioned can also make a huge difference to how things appear. Say, for example, you're drawing an avenue of trees receding away from you into the distance. They may be roughly the same height and spaced the same distance apart, but the ones that are furthest away will appear to be smaller and the gaps between them will appear to decrease with distance - so you must measure the relative sizes and follow your measurements. Similarly, if you look at something like a table, you might be tempted to draw it as a rectangle, because you know that's what shape it is - but if you're looking at it from the other side of a room, you'll be seeing it in perspective, rather than from above, and so its shape will be very different.

Get into the habit of taking measurements of everything you draw, whether landscape, still life or portrait. It may seem complicated at first, but as you gain experience measuring techniques such as these will become second nature. It's also important to keep re-checking measurements as you work on your drawing. As you refine a drawing it is very easy to emphasize one element at the expense of another, but a little time spent double-checking that the proportions are still correct could save you a lot of trouble in the long run.

Using a grid

When working from a photograph this is relatively easy. Simply divide the photograph into a grid of squares, and divide your paper into the same number of squares, making the squares larger if you want your drawing to be larger than the photograph and smaller if you want it to be smaller than the photograph. Then copy the image one square at a time.

You can use the same principle when working from reality. Cut a rectangle out

of the middle of a piece of card (stock) and stretch a series of rubber bands across the aperture to form a grid, spacing them evenly. Draw the same grid on your paper at the size you wish the drawing to be, and then position the grid so that you can look through it at your subject. In order for this to work, you must position the grid so that it lines up with the subject in exactly the same way every time you look through it.

1 Using a craft (utility) knife and steel rule on a cutting mat, cut a rectangle out of the middle of the card (stock).

2 Stretch rubber bands across the width of the aperture, making sure they are evenly spaced.

 ${\bf 3}$ Do the same across the height of the aperture, spacing the bands the same distance apart as in Step 2.

Using a pencil to measure

An alternative method is to use a measuring device – usually the instrument with which you are drawing. Hold the pencil out at arm's length, so that you can see past it to your subject. Choose a part of your subject to measure; this can be the whole length or width of the subject or just a small section. Align the top of the pencil with one end of the distance you are measuring and move your thumb up or down the shaft of the pencil until it is level with the other end of the distance being measured. Now transfer these measurements to your drawing; a small guide mark is sufficient, as you will add detail later once you are sure the proportions are correct. For your first attempts at measuring using this method, work so that you can put marks down directly on the paper at their actual size, without having to scale them up or down to fit.

When using this method, it's absolutely vital that you keep your arm straight, so that the pencil remains a constant distance from the subject. Close one eye to make it easier to focus, and concentrate on looking at the pencil rather than at the subject.

The subject (right)

Here, we used a small statue as the subject, but the principle remains the same whatever subject you are drawing.

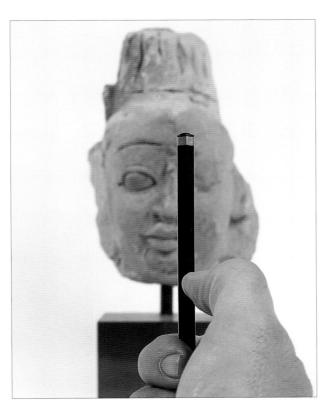

1 Holding the pencil at arm's length, measure the chosen section of your subject – here, the distance from the statue's eyebrows to the base of the chin. Then transfer this unit of measurement to the paper.

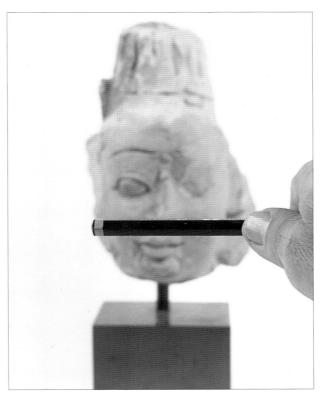

2 Use the same unit of measurement to compare the size of other parts of the subject. Here, the distance across the widest point of the statue is the same as the measurement taken in Step 1.

Negative shapes

The term 'negative shapes' is used in art to mean the spaces between objects in a composition or between different parts of an object. But how does this help you when drawing? It's all about making yourself really look at your subject, rather than relying on your preconceptions about how things should look.

A lot of this has to do with the way that the different hemispheres of the brain work. The left side of the brain is concerned primarily with verbal skills, and it is this side that is dominant in many adults, as we're brought up to express ourselves verbally rather than visually. This means that when we look at something we tend to concentrate on the things we can name – the 'positive' shapes. So if we're looking at a tree, our brain registers things like the trunk and the branches rather than the spaces between the branches, which have no name.

Looking at the negative shapes forces us to switch our thinking from the left side of our brain (the verbal side) to the right side (the visual side). Instead of concentrating on the things we can give a name to and thinking, for example, 'I'm going to draw that square table', we have to say, 'I'm going to draw that straightsided shape'. So we're much more likely to observe and put down correctly the relative shapes and sizes if, instead of being distracted by our knowledge of the fact that all four legs of the table are the same size and shape, we really look at the shapes of the spaces between the legs. Because we're looking at the table in perspective, they appear to be different sizes and positions in relation to one another - and you need to get this across in your drawing in order for it to look realistic.

In the following exercises, you will draw by looking only at the negative shapes. To prepare for them, spend plenty of time looking at the subject before you put pencil to paper. Really force yourself to look at the spaces instead of at the objects. It takes a lot of concentration, but if you try hard you'll find that these negative shapes suddenly 'pop' out at you – rather like a camera lens shifting focus from subject to background.

Practice exercise: **Drawing a straight-sided object using negative shapes**

In this exercise, your task is to draw using only the negative shapes – the spaces around and between the different parts of the chair. It's an artificial way of working (in practice one would alternate between the negative and positive shapes), but it will help fix the principle in your mind. It doesn't matter whether you draw the negative spaces around the outside the chair first and then those within it, or vice versa.

Materials

- Smooth drawing paper
- Graphite stick

The subject

With a straight-sided subject such as this folding chair, the negative shapes are relatively simple to draw.

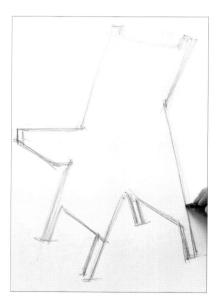

1 Look at the space to the left of the chair and concentrate until you feel you are able to see it as a shape in its own right, rather than an area of nothingness with the chair along one edge. Then begin drawing the outline of the negative shapes that you can see, concentrating on getting the angles of the shapes and the length of each side of each shape right.

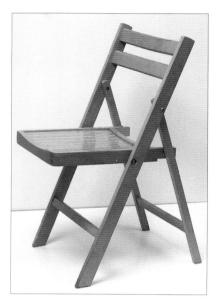

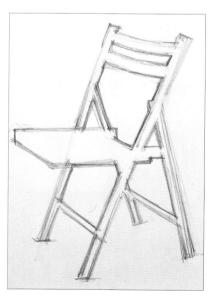

Now move on to the negative shapes within the chair itself – the spaces between the bars of the backrest, the space between the backrest and the seat, and the spaces under the seat between the supporting side bars. Provided you've made your measurements accurately, drawing the negative spaces defines the shape of the subject – the chair.

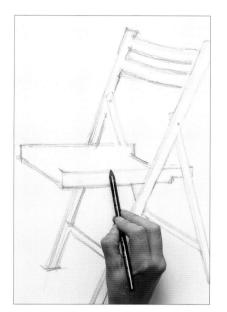

When you've laid down the basic negative shapes, you can begin to refine the drawing and look at the positive shapes – the different planes of the seat of the chair, for example.

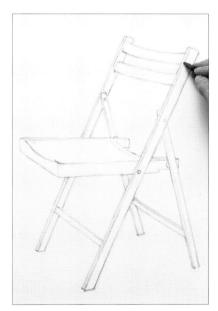

4 Put in the remaining positive shapes, such as the rivets that connect the side supports to the seat, and detailing, such as the tongue-and-groove effect on the seat. Also carefully draw in the different facets of the side bars and the connecting struts so that the chair looks three-dimensional.

The finished drawing

The subject is simple, but it still requires concentration to draw the relative angles and sizes of all the components accurately. As the chair has straight sides the negative spaces, too, are straight-sided – which makes it easier to see and measure them accurately. Even though no shading or tone has been used, careful measuring of the different elements has resulted in a drawing that looks three-dimensional.

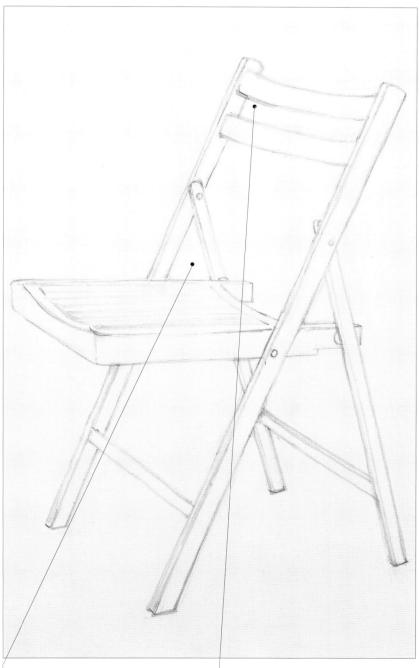

The negative shapes are mostly four-sided or triangular, which makes them simple to measure.

Drawing the negative shapes makes it easier to get slopes and angles right.

Practice exercise: Drawing rounded objects using negative shapes

Use the same approach for this exercise, drawing the spaces between the Chinese lanterns rather than the lanterns themselves. This time the objects are not straight-sided, so this drawing is a little more complex, but the theory remains the same. Again, begin by concentrating on the negative shapes until you feel you see them in their own right and the lanterns appear to recede away from them.

Materials

- Smooth drawing paper
- Soft pastel

The subject

Arrange your subject on a plain background (a large sheet of white paper will do) so that there is nothing that will distract you from looking at the shape of the spaces. If necessary, twist the twigs and Chinese lanterns so that the spaces between them form more interesting shapes.

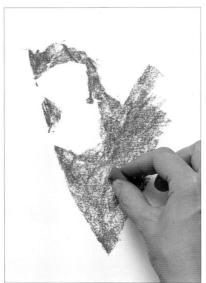

1 Using the side of a soft pastel, block in areas of colour for the shapes of the negative spaces. Here, the artist is working to the right of the twig that runs down the left-hand side of the composition. The triangle formed where the two twigs meet is a strong negative shape to start with.

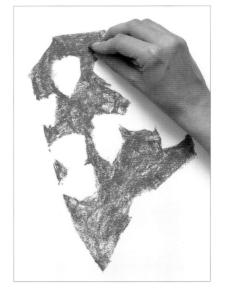

Working slowly and methodically, continue blocking in the negative shapes using the soft pastel, while making sure that you leave the correct amount of space for each positive shape (the lanterns). Here the artist is working along the top area of colour.

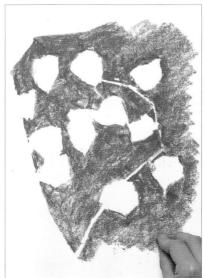

Build up the drawing methodically, remembering to measure the all negative spaces carefully. Look at where the negative spaces butt up to the edge of the twigs, in particular, and concentrate hard to ensure you don't make the twigs too thick.

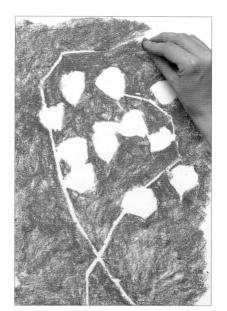

4 Continue until the only areas untouched by pastel are the positive shapes. Use the side of the pastel, rather than the tip; if you use the tip, it's more likely that you'll be tempted to draw the stalks rather than the spaces on either side of them.

5 To complete the drawing, put in the striatians on the papery outer covering of the lanterns. Look carefully to see how they twist and turn, as this is what will make the lanterns look three-dimensional.

The finished drawing

The shapes of the lanterns stand out clearly. Even without putting any tone or shading on the drawing, a few simple curved lines on the lanterns are enough to give them some form.

The Chinese lanterns are irregular in shape, so the negative shapes are irregular, too.

The stems are thin and slightly gnarled. Observe the negative shapes leading up to them very carefully.

Perspective

One of the major challenges in learning to draw is how to create the illusion of spatial depth on the flat, two-dimensional surface of a piece of paper. For example, if you're drawing a landscape with a boulder in the foreground and a mountain range in the distance, how do you make it look as if the boulder is near by and the mountains are far away?

Over the centuries, many different drawing systems have been devised to help create the illusion of spatial depth. One approach is to employ a vertical arrangement, with the most distant elements of the scene at the top of the picture space. For example, traditional Chinese brush-drawn landscapes place mountains at the top, with forested lower

slopes under the peaks and a lake or river, perhaps with a boat, in the lower portion.

In Western art, changes in tone and scale are usually employed to create the impression of distance. Whole books have been written about the technicalities of perspective, but the basics are relatively easy to understand. Keen observation of your subject is the key to success.

Aerial perspective

Aerial, or atmospheric, perspective exploits apparent differences in tone between nearby and distant objects to create a sense of depth and recession. When seen from close by, dark-coloured objects or areas cast in shadow appear strong in tone. In the middle distance, darker areas appear less sombre. Further off, rich darks will be perceived

as more muted; and from a great distance, they will acquire a pale, bluish tinge. This filtering effect is caused by the dust, motes, moisture particles and other pollutants in the atmosphere, which cloud the air with tiny particles and partially obscure the far distance. This device has been much used in Western art.

Tonal differences for distance

Note how effectively differences in tone create the impression of distance in this drawing. Looking along the strand, the nearest beached boats are the darkest in tone. Further along the foreshore, distance softens strong tonal values, and most distant still, the coastline and ocean are much lighter in tone.

Softly-toned haze

In damp, misty weather, or when a heat wave has drawn moisture up as a heat haze, landscapes will show the softening, or blueing, of distant strong tones. In this scene the shadowed trees and foliage framing this old house which would appear sombre were they close at hand, are seen as relatively softly toned in the middle distance and pale when viewed from afar. The transitions in tone are subtle, but essential in creating an impression of distance.

Tips: If you are working in colour, you also need to think about the temperature of the colours you use.

- Distant objects tend to look 'cooler' and bluer in tone than those that are nearer.
- Skies generally appear paler near the horizon of a scene.
- Include more texture in the foreground of a scene for example, spiky grasses in the foreground of a landscape; the viewer will assume that the textured areas are in front.

Vertical perspective

In this sketch, after the Japanese artist Hiroshige's 'Winter: Scene on the Sumida River', the illusion of depth is created by means of vertical perspective, or placing the most distant elements at the top of the picture space. The boatman is placed on a raft low on the torrent, creating the impression that he is in the foreground, while the near-distant trees are higher in the picture and the far-off mountain is above them, conveying a plausible sense of recession.

Linear perspective

Objects appear to be smaller the further away from you they are. You can use this effect in your drawings to create the illusion of distance.

Linear, or one-point, perspective applies when all the receding planes are aligned and parallel. To see this, look straight down a road where only one façade of the buildings on each side is visible. The horizontal planes of the upper floors above eye level will appear to slope down through the length of the street, although, in fact, they do not get lower. Horizontal lines below eye level will be seen to slope upwards, while in reality the planes remain level. These are the illusions that must be reproduced if the viewer of the picture is to be convinced that the road is receding into the distance.

To determine the correct slant for the horizontal planes, one-point perspective may be plotted to a notional spot known as the vanishing point. A person of average size, looking straight ahead on the flat, will see the horizon at

about 3 miles (5km) away. To make a perspective drawing, plot the imaginary horizon at eye level and mark on it the vanishing point – the place at which all the horizontal lines would meet if they were extended as far as the horizon. Adhere carefully to the plotted lines and you will create the effect of recession. Note that this rule affects only the horizontal elements: verticals must remain upright.

Street scene in single-point perspective

In this scene, all the horizontal elements above eye level (for example the roof lines and the tops and bottoms of the windows) appear to slope down towards the vanishing point, while those below eye level seem to slope up – although, in reality, the planes remain level along the road. If the houses were shown with equidistant planes (that is, without the lines of the roof and road appearing to slope towards the vanishing point), they would not look as if they were parallel to the viewer.

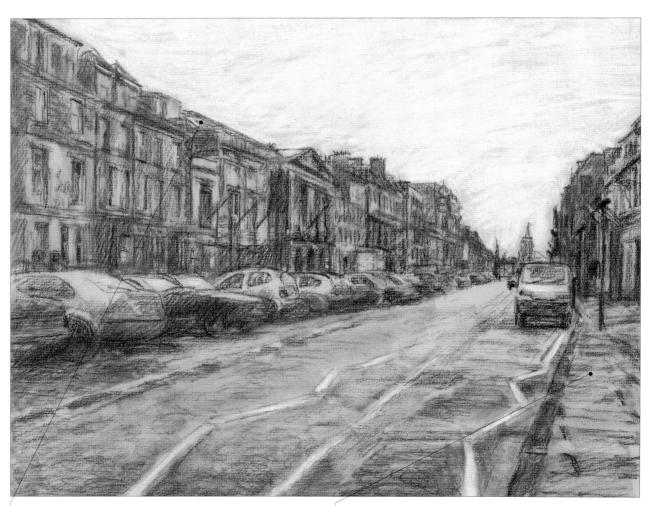

The roofs and many of the windows are above eye level and appear to slope down as the street recedes.

The pavement is below eye level and therefore appears to slope upwards as the road recedes.

Single-point perspective with right angles

Here, too, single-point perspective is used to plot the lines of the buildings and indicate distance. The people furthest away are also drawn smaller than those in the foreground. At the end of the road, another street runs at right angles to the street on which the drawing is made; as this second street is parallel to the picture plane, it has no vanishing points. If the sides of the neoclassical-style building on this second street were visible, the extensions of the horizontal planes would converge on the same single vanishing point as the road from which the scene is viewed. If further streets at right angles to the road were visible, decreasing size and softer tones would also give clues to distance.

Vertical elements remain vertical: only horizontal lines converge on the notional vanishing point.

This road is parallel to the picture plane and therefore has no vanishing points.

The single point pespective combined with a larger structure.

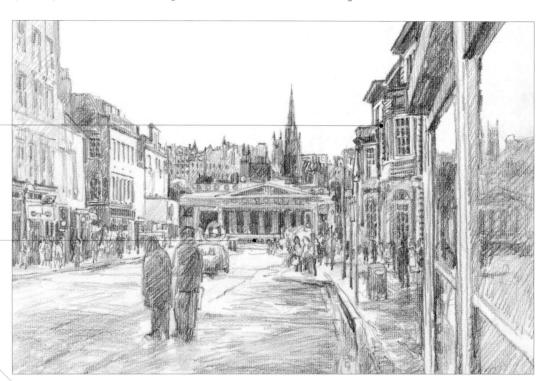

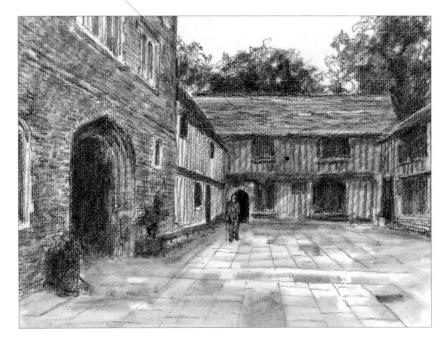

Creating drama

Dynamic compositions can be achieved when single-point perspective is combined with larger structures that are parallel to the picture plane. In this example (left), the design focuses attention on the junction between the brick-and-timber gatehouse wing, on the left of the picture, and the half-timbered block at the back of the courtyard.

The courtyard background appears four-square to the viewer, while the sloping lines of the gatehouse wing (which is seen in single-point perspective) help to direct the viewer's eye through the scene.

In a similar fashion, the lines of the courtyard paving stones, which are also drawn in single-point perspective, help to guide our eye to the figure standing towards the far end.

Two-point perspective

Few constructed environments make interesting compositions unless they involve more than one vanishing point. Once you have tried and understood single-point perspective, you will soon find that multi-sided buildings, or those whose elevations are not all in the same parallel plane, hold more exciting design possibilities. In single-point perspective, the apparent size of forms reduces evenly, as do the spaces between. While this is also true of two-point, or multi-point, perspective, different avenues of vision receding in less depth or at differently oblique angles may appear to diminish to differing degrees.

Remember that in plotting the vanishing points in two- or multi-point perspective, not all the points will fall within the picture space. Clearly, those that are four-square to the picture must be drawn as rectilinear, but those close to square on will have vanishing points far beyond the edge of the image. To discern these, you may need to make a preliminary sketch on a small scale and affix it to a large sheet on which you can plot the angles of recession to the vanishing points. You can then transpose the correct angles from the thumbnail sketch on to the larger-scale support on which you intend to draw for the finished work.

Several vanishing points in the same scene

Multi-point perspective will be used if a building is viewed at a tangent, as the different sides of the building on view will have horizontal planes that extend to different vanishing points. In this example, both vanishing points are out of the picture; the moat façade, diminishing sharply, has a vanishing point close by, but the front elevation with the bridge is viewed at a less oblique angle and has a vanishing point that is further out, far to the left of the picture area.

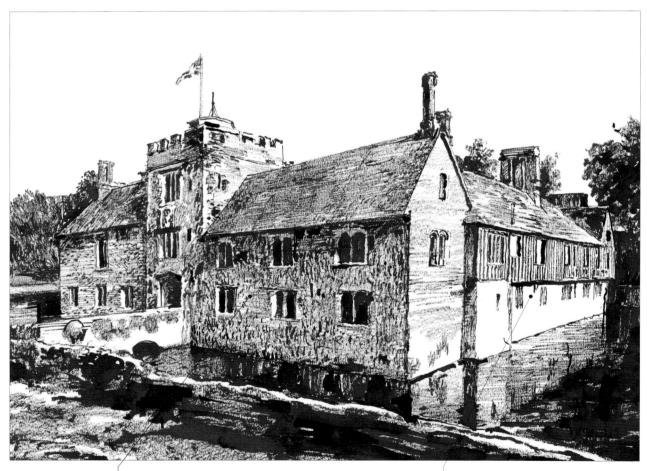

This side of the building is viewed from only a slight angle and so the horizontal lines recede only very gradually towards the vanishing points; the vanishing points themselves are far outside the picture area.

This side of the building recedes into the distance; the horizontal lines recede much more steeply, but the vanishing points are still outside the picture area.

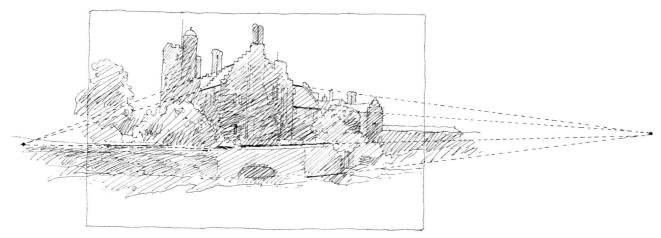

Sketch plotting the vanishing points

The sketch above shows the horizontal planes extended to the vanishing points, which are not visible within the image itself. The greater the angle at which a plane is turned from the vertical, the further out the vanishing point will be. Only horizontal planes angled relatively close to vertical are likely to have vanishing points within the picture space.

Different vanishing points on each side of the subject

To make the drawing shown below, the artist selected a viewpoint that enabled her to see two sides of the building, as this creates a much more dynamic and interesting image than a flat façade viewed square on. Note how the line of the roof, which is above eye level, appears to slope downwards on each side, while the wall, which is below eye level, seems to slope upwards – just as in the examples for single-point perspective on the preceding pages. The difference here is that each side disappears to a different vanishing point (see the sketch above).

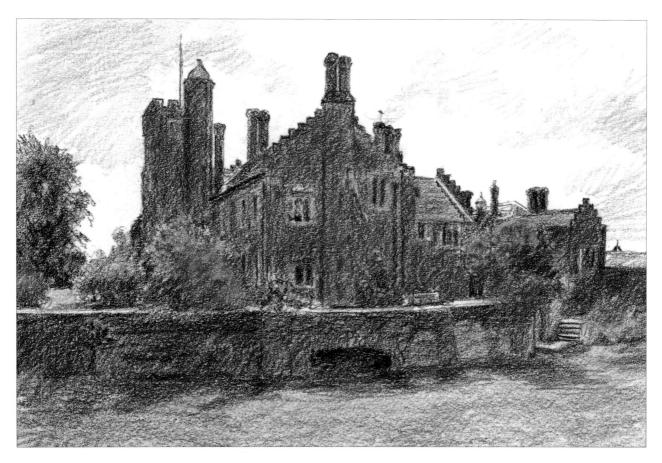

Multiple vanishing points

Multi-point perspective is also used when not all the horizontal elements in view could have their planes extended to the same single vanishing point. In architectural drawings, this may occur if there are several structures built at various different angles to the picture plane. If one large structure – for example, a country house – has wings or outbuildings added at disparate angles to the main building, the planes are also extendible to multiple vanishing points.

However, it is very easy to get so caught up in the technicalities of perspective that you lose sight of your drawing as a whole. Although you could choose to plot every single horizontal line to its notional vanishing point, the chances are that you would produce a very tight, laboured drawing as a result — it would become a technical exercise rather than a spontaneous response to your subject. Once you've mastered the basic principles of perspective, learn to trust your observational skills. Hold a pencil out in front of you to assess the angle of any horizontal lines as they recede towards their vanishing point. Now measure the distances between different elements of your subject carefully, ignoring any preconceptions that you may have about the relative sizes of things.

Check - and check again

Careful observation and measuring are the only ways you will be able to tackle a complicated, multi-point perspective subject such as this. We are looking down on the scene; the horizontal lines of the roofs of the foreground buildings appear to converge inwards towards a vanishing point, while

those of the buildings on the far side of the street slope upwards. Note, too, how the inclusion of buildings at different angles to the main house adds interest to the drawing: as well as creating a sense of depth, they also help to lead the viewer's eye towards the main centre of interest.

Foreshortening

You must also gauge the phenomenon of foreshortening in perspective drawing. This term is used to describe the effect of looking along a subject at a tangent, where the length appears shortened but the width is seen as relatively unchanged. Long spans appear much curtailed from the foreshortened viewpoint. For example, viewing a tall person reclining from a vantage point just beyond and above the head shows the long legs and torso taking up little vertical space, while the trunk and limbs are relatively wide. Different degrees of foreshortening may be evident in all the various directions in landscape multi-point perspective work, especially if elements are not on the level.

Foreshortened figure

Figure work often calls for the rendering of foreshortening, as the head, body and limbs are seldom all viewed in profile together, except in simple standing poses. Note that, when seen at a tangent, any element will appear diminished in length or telescoped, while the width is little affected along the span. With extreme foreshortening, you can expect to see some overlaps: for example, a foreshortened head seen from above might show the chin overlapped by the nose. Initially, you may find that it helps to draw a faint box, or cube, in perspective around your subject and plot the vanishing points, just as you would in an architectural drawing.

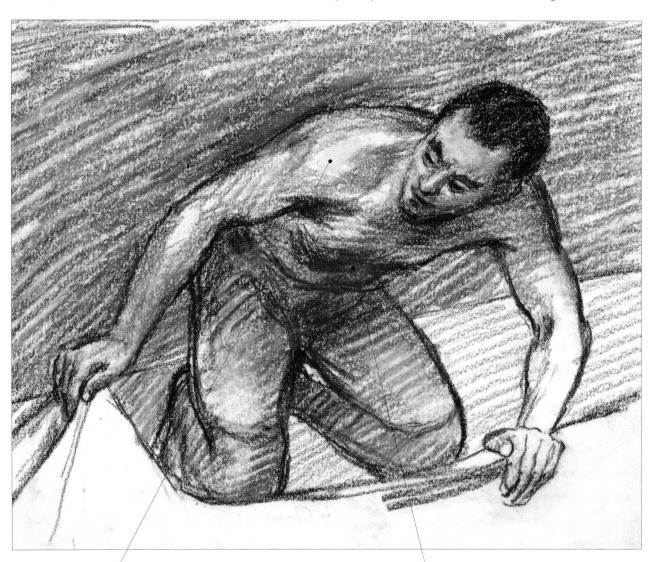

From this viewpoint, the model's right shoulder appears much broader than the left – though they are, of course, the same size.

Viewed from a relatively high eye level, the torso appears shortened in relation to the legs.

Curved forms in perspective

The eye level of the observer determines the distance to the horizon on which the vanishing point or points are fixed. This is the boundary of the visible land or sea, marking the point at which the curvature of the earth turns away so that the continuing surface is no longer seen. Although it is possible to look for some distance on flat land, an even greater vista is possible from a height – for example, a hill or mountain top. From an aeroplane, vast tracts of land are visible before the horizon.

Eve level determines the way circular objects are seen, too. Viewed from above, they appear completely round. When you lower your viewpoint, the same circular form appears to be elliptical, because the span across it is foreshortened, decreasing the apparent length of the diameter in relation to the width. The lower your viewpoint, the narrower the ellipse will appear, but at the extremes the edges are always curvilinear. This is because no round form can have sharp corners, so a curve always defines the width, however tight the turn. Only when the eye level coincides with the profile view of circular objects will the shapes appear flat and show angles at the periphery. Test this for yourself by placing a glass on a table and viewing it from different eye levels - first standing directly overhead so that the top of the glass appears as a complete circle, then sitting down so that the top of the glass appears as an ellipse, and finally crouching on the floor, so that your eyes are level with the top of the glass.

Tall curved forms in real space also appear flatter at eye level and more curved when above or below it. Castles, lighthouses or buildings with circular towers demonstrate this: the base appears flat when viewed at ground level and the upper floors show increasing curvature as they rise above. Knowledge often impairs perception, so guard against the tendency to flatten the bases of smaller circular objects when seen from above, as the base will display more curvature than the top if it is viewed from a higher point.

Circular perspective in a wine glasses

The perspective of circular forms is easier to see if the objects are transparent and the full ellipses, in perspective, are visible. Clear glass is an excellent example and if the glass, dish or vase contains liquid, this too will have to conform to the length and width of ellipse required at that level. Remember that any contents such as flower stems may appear distorted by the curved glass and should be drawn as seen.

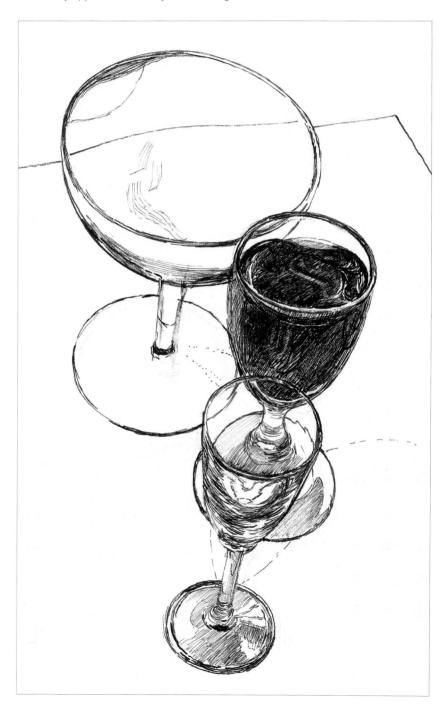

Large circular forms in perspective

Exactly the same principles apply when drawing large circular or cylindrical forms: when they are viewed in perspective, they will appear as ellipses. How flat or round the ellipses are depends on your viewpoint, or eye level – and in a large-scale subject such as the one shown below, the ellipses will vary in different parts of the image because some parts of the subject are above your eye level while others are below it. Here, the round towers of the castle are seen as nearly flat at water level; the bases appear as shallow ellipses. When looking up from the moat, the round tower battlements appear to be most curved, with the stonework between showing gradually increasing curvature as the courses rise. All the rectilinear horizontal planes of the walls and towers in between have vanishing points to the left, far out of the picture space.

- **Tip**: One common mistake that people make when drawing ellipses is to make the ends pointed.
- To avoid this, lightly sketch (or at least imagine) a square enclosing the ellipse.
- Then find the centre of the square by drawing diagonal lines from corner to corner; the two halves of the square will be different measurements, because the parallel lines of the square will converge towards the notional vanishing point.
- Draw a horizontal and a vertical line through the centre of the square in perspective to work out the halfway point along each side of the square.
- Finally, draw the ellipse, using the intersection as a guide to drawing the curve accurately.

The tops of the towers are above eye level and the curves of the ellipses appear more pronounced.

The bases of the curved towers, which are only slightly below eye level, appear as very shallow ellipses.

Blending with coloured pencils

Unlike pastels, coloured pencils cannot be mixed physically. Each colour keeps its integrity when applied, so the only way to blend or mix colours is to allow this to happen in the eye, optically.

This can be achieved in several ways, and a combination of techniques may be used in the same image. One way is to apply the colour so that it sits in layers, one over the other, rather like a thin watercolour wash or glaze. The reason for applying thin layers is that coloured pencils contain wax, which can build up on the paper surface and make it difficult

to apply further layers. Colour can be applied dark over light or light over dark; the resulting effect and colour mix will differ depending on whether the darker or the lighter colour is applied first.

Colour can also be applied as a series of crosshatched lines – parallel lines that run across one another at an angle. Where the colour comes into contact with the support, it remains bright; where it crosses another colour, the two mix optically. Colours can also be scribbled loosely on to the support, in an action that mixes the first two techniques.

Depth of colour is achieved by increasing the density of the marks – by making them closer together or increasing the amount of pressure on the pencil.

Finally, coloured pencil marks can be made to mix and blend together optically on the support by adopting a technique used by the Pointillists, whereby colour is applied as tiny individual dots. It is the proximity and density of these marks that gives the depth and quality of the colour. This technique is time-consuming and is best used on relatively small drawings.

Dark over lightA layer of blue applied over yellow results in a dark green.

Light over darkA layer of yellow applied over the same blue results in a light green.

Crosshatched lines in two colours Red lines crosshatched over yellow mix optically to make orange.

Crosshatched lines in three colours Add blue and the overall effect is that the swatch appears brown – yet all the applied colours have kept their individual integrity.

Loose scribbles
Colours can also be mixed optically by
loosely scribbling one over another.
Here, red is applied over green to make
a brown.

Rich optical blends
As each colour retains its integrity when blended in this way, the result is likely to look much more lively than an application of a single colour.

Practice exercise

To practise blending coloured pencils, choose a simple subject that contains a limited range of colours. Here, the artist selected a red and green apple – a good subject to begin with, as the colour and surface texture are naturally uneven, so you need not be as precise as you would when drawing a very smooth, evenly coloured surface.

Spend plenty of time looking at your subject to work out where one colour shifts into another. Above all, apply the colour loosely and lightly so that underlying colours can show through, creating lively and interesting optical mixes. To build up the necessary depth of colour you will need to apply a number of thin, light layers — a slow process, but one that merits the effort.

Materials

- Heavyweight smooth drawing paper
- 2B pencil
- Coloured pencils: zinc yellow, bright green, pale vermilion, deep vermilion, deep cadmium yellow, raw umber, Vandyke brown, olive green

The subject

The greens in this apple range from a very yellowy green on the right-hand side to quite a bright mid-toned green in the centre. Similarly, the reds range from a delicate blush to a rich red at the top and side.

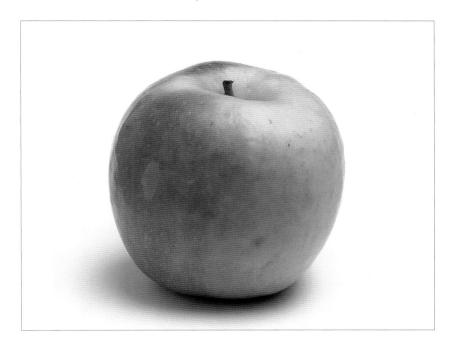

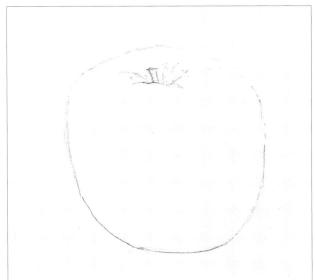

1 Using a 2B pencil, outline the shape of the apple, remembering that it is a rounded form. Put in the stalk, observing the angle. The stalk forms a central axis that runs all the way through to the base of the apple; if you bear this in mind you will find it easier to get the shape at the base right. Also put in the recessed area around the stalk.

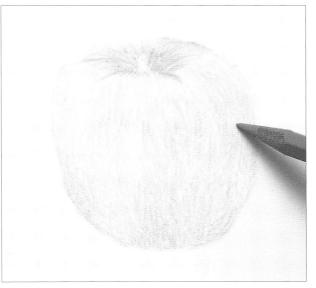

2 Lightly fill in the whole of the apple, using a zinc yellow pencil. This colour will stand for even the brightest highlights; leaving the paper white for the highlights would look too stark. Apply a bright green over all the areas that will be green in the final image. Use light strokes that follow the form of the subject.

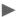

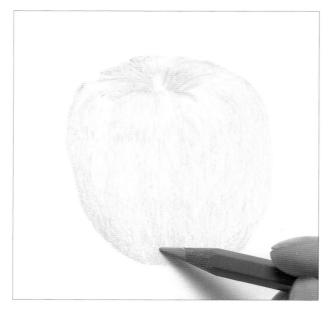

3 Using a pale vermilion pencil, lightly put in the first reds on the apple. Note that the apple itself is not completely smooth in texture or even in tone, so apply the colour unevenly, allowing some of the underlying yellow and green that you applied in Step 2 to show through. Again, make sure your pencil strokes follow the form of the apple.

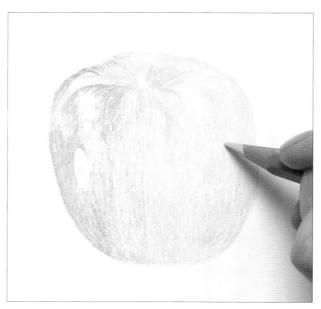

4 Working around the very brightest highlights, strengthen the reds by applying deep vermilion, noting how the colour combines optically with the underlying zinc yellow to make an orangey red. Now look for the more yellow areas of green on the apple, and go over them with a deep cadmium yellow pencil.

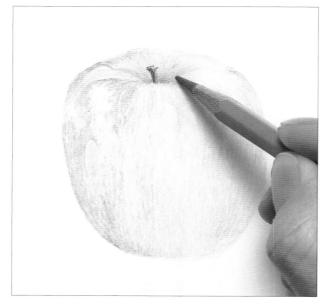

5 Now colour in the stalk. It is a darker brown on one side than the other, because of the way the light hits it, so alternate between raw umber for the paler brown areas and Vandyke brown for the darker areas. Using an olive green pencil, lightly draw the indentations in the skin around the stalk. As a result of this shading, the apple is beginning to develop some form and depth.

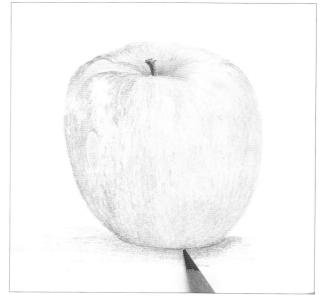

6 Still using the olive green pencil, put in the darker areas of green on the apple and the shadow underneath it. The shadow helps to anchor the subject on a surface: it no longer looks as if it is floating in mid-air. Some colours from the apple (red and brown, in particular) are reflected in the shadow, so put these colours in very lightly to give some visual continuity to the picture.

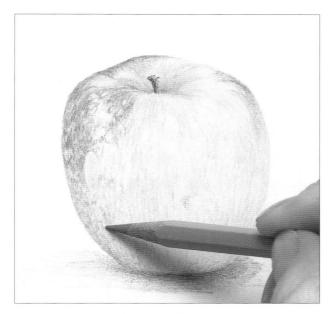

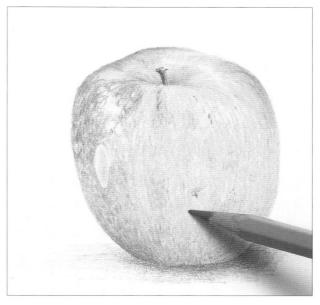

8 Working slowly and methodically, continue building up the density of colour, using the same colours as before and light pencil strokes. Finally, use the olive green pencil to put in the dark, mottled patches on the apple skin and add some texture to the drawing.

The finished drawing

At first glance, this is a deceptively simple drawing – but note how effectively the artist has built up the layers of colour to create a beautifully textured surface in which the colours combine optically into a seamless whole. Coloured pencils are the perfect medium for conveying the mottled coloration of the apple skin: they can be used to cover both broad areas and precise points of detail.

The contrast between the very bright highlight and the dark red of the apple skin helps to make the fruit look shiny.

Thin strokes of the pencil allow the underlying colours to remain visible.

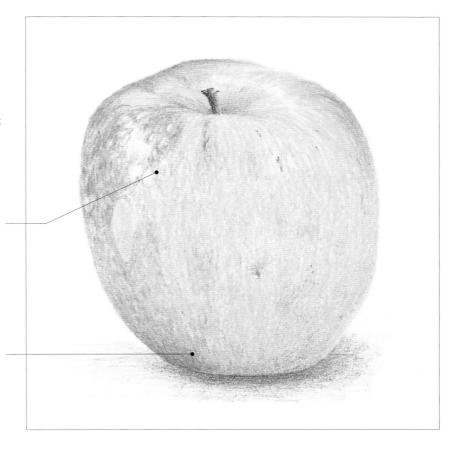

Blending with soft pastels and oil pastels

Soft pastels can be blended both physically and optically; more often than not, a combination of techniques is used in a drawing. The dusty, loose pigment that is left on the support after a mark has been made can be manipulated in a number of ways. The handiest tool for blending colours is your finger - but make sure that your hands are clean and free from grease. Your little finger is usually the coolest and driest part of the hand and hence the best one to use. For larger areas such as skies, you can use the side of your hand in a light, circular motion. A rag or piece of kitchen paper can be used in the same way and a cotton bud (cotton swab) is ideal for intricate areas. However, the tool intended for the job is the torchon. Made from rolled or compacted paper pulp, it is used to move the pigment

around the surface of the support. Torchons get dirty very quickly, but you can clean them by rubbing them on fine abrasive paper.

Harder pastels and chalks can be used in the same way, but they can be sharpened to a point so you can mix colours by using scribbled and hatched marks, as with coloured pencils. Both hard and soft pastels can also be blended by lightly glazing one colour over another. Success depends on how much loose powder is already on the support; you may find it advantageous to apply a thin layer of fixative between applications of pastel, to prevent the colours from smudging.

Oil pastels can be blended with the finger, but the results are not as satisfactory as with soft pastels. They can also be mixed simply by working one colour into another. Take care not to build

up too much pastel on the support, as this can prevent you from applying more. Oil pastel drawings made on oil paper or on a paper prepared using gesso can be blended together using a solvent such as white spirit (paint thinner) or turpentine.

Finger blending

The easiest and most convenient way to blend soft pastels is to use your finger.

Blending with a torchon

A torchon can be used to blend soft pastels in the same way. As it has a pointed end, it is good for small areas.

Pointillist approach

Optical mixes can be achieved by applying dots of pure colour, in the same way as the Pointillist painters.

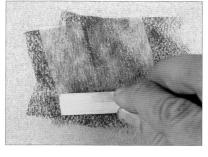

Applying a glaze

Soft pastels can also be mixed by applying a thin glaze (covering) of another colour.

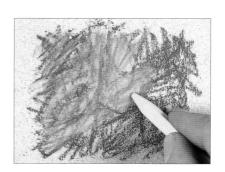

Crosshatching

Hard pastels can be sharpened to a point and used to create mixes by scribbling in layers and hatched or crosshatched lines.

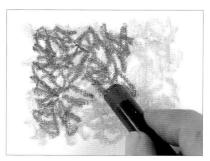

Layering

Oil pastels can also be mixed and blended by working in scribbled layers.

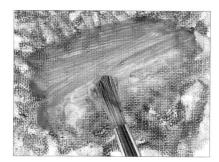

Blending with a solvent

Oil pastels can be blended by working into the applied colour with a spirit solvent such as white spirit (paint thinner) or turpentine.

Practice exercise: Seascape in soft pastels

Drawing skies and clouds is the perfect way to practise blending techniques in a powdery medium such as soft pastel or charcoal: because the precise shapes are not important, you can practise moving the pigment around on the paper without having to worry about getting the detail exactly right.

This exercise is also a good lesson in restraint! If you overblend the colours in the water and clog up the tooth of the paper with pigment, you will end up with a flat, lifeless image. Similarly, if

you overblend the colours on the rocks you will end up with a muddy-looking mess with no discernible tonal variation. The rocks will appear as silhouettes against the brightness of the sea.

Materials

- Pastel paper
- Grey pastel pencil
- Soft pastels: mid-grey, dark grey, black, reddish brown, mid-green, pale grey, mid-blue, dark brown, fawn, pale yellow

The scene

This is a moody and atmospheric seascape, with storm clouds billowing overhead and sunlight glinting on the water. Although the colour palette appears limited at first glance, there are a number of different tones within the clouds and rocks and these need to be blended smoothly. The artist used two reference photos for this exercise – one for the detail of the foreground rocks and one for the stormy sky and sunlight sparkling on the water.

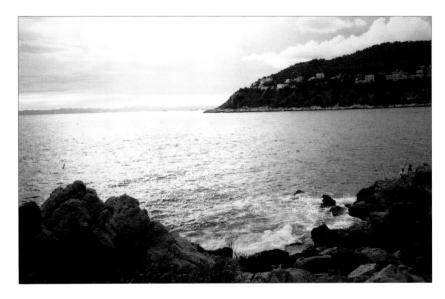

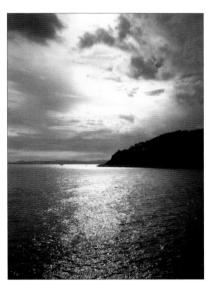

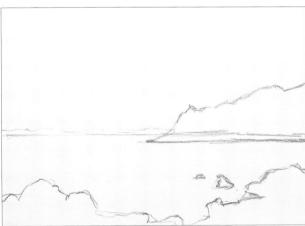

1 Using a grey pastel pencil, outline the headland and foreground rocks. The artist has changed the composition to make it more dynamic: in the photo, the horizon line is in the centre – but here it is positioned lower down.

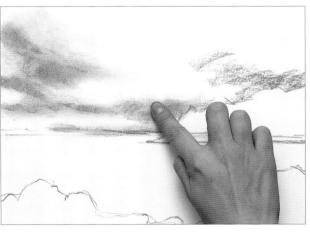

2 Using the side of a mid-grey soft pastel, block in the darkest tones in the sky and blend with your finger. Allow some areas to remain darker than others, as there is a lot of tonal variation in the clouds.

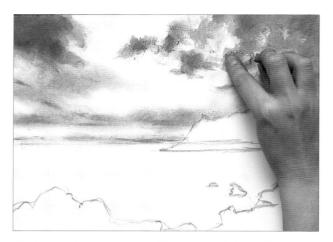

Apply a darker grey pastel for the clouds immediately overhead. (The difference in tone helps to convey a sense of distance, as colours tend to look paler towards the horizon.) Build up the very darkest areas of cloud with more dark grey and black, blending the marks with your fingers as before. Remember to leave some gaps for the white of the paper to show through, to create the impression of sunlight peeping out from behind the clouds.

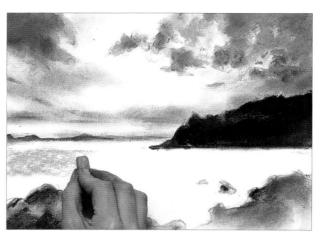

A Block in the headland with a dark reddish brown and smooth out the pastel marks with your fingers. Use the same reddish brown for the foreground rocks, then overlay the brown in both areas with a mid-green, blending the colours only partially with your fingers so that both colours remain visible. Gently stroke the side of a pale grey pastel across the water area, leaving the central, most brightly lit, section untouched.

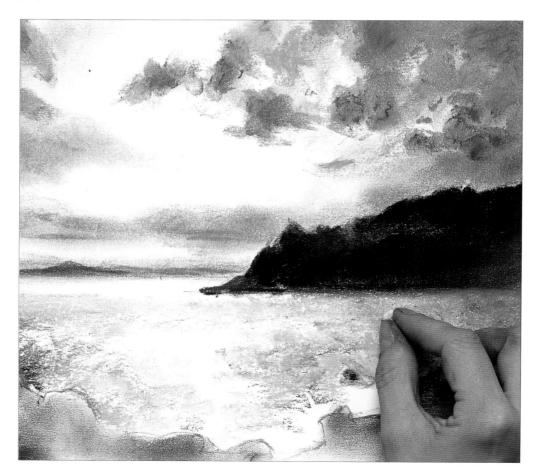

Darken the water **D** by overlaying touches of a dusky mid-blue, green and black. Do not overblend the marks or apply them too heavily: it's important to see some differences in colour within the water and to allow some of the white of the paper to show through to create the impression of light sparkling on the water.

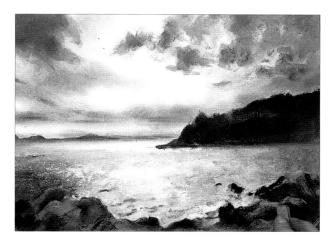

6 Now build up more of the texture on the foreground rocks. Loosely block in the darkest areas (the shaded sides of the rocks) in reddish brown, then overlay dark brown and green and blend the colours slightly with your fingers. For the lighter sides of the rocks, use greys and fawns. Immediately the rocks begin to look three-dimensional.

The finished drawing

This drawing uses a number of blending techniques. In the sky, softly blended marks create the impression of swirling clouds. The texture and form of the rocks in the foreground are achieved by overlaying several colours, allowing each one to retain its integrity, and adding a few linear marks as the

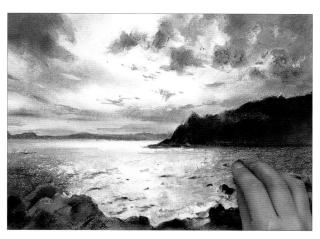

Zightly draw a pale yellow line along the horizon and add touches of yellow in the sky to warm it up, blending the marks with your fingertips or a clean rag. Using the tip of a mid-grey pastel, put tiny dashes and dots for colour into the sea to create the impression of wavelets and a sense of movement in the water.

finishing touch. Our overall impression of the water is that it is a dark blue-grey, but on closer inspection we can see a number of different colours and tones within it – optical mixes that enliven the scene and also imply the movement of the waves in the sea.

Although little detail is discernible in the distant headland, some tonal variation is essential in order to prevent it from appearing as a solid silhouette. The tonal variations also tell us something about the form of the land.

It is important not to overblend the marks in the water or to obliterate the white of the paper completely.

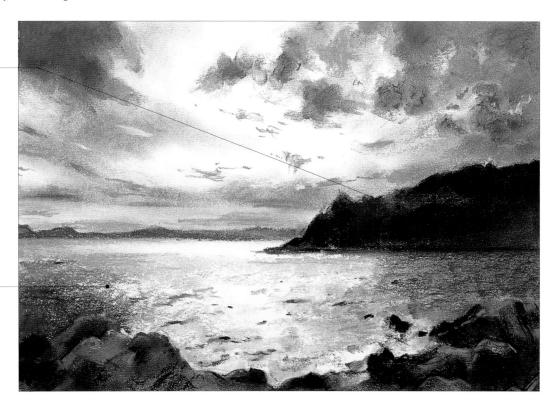

Practice exercise: Still life in oil pastels

In this exercise, you can practise two very different ways of blending oil pastels – by using your fingers and also by working colours on top of one another so that they blend optically. In the final stage of the drawing, you will also see how to brush a tiny amount of solvent over oil pastel to dilute the colour and create a smooth texture.

The range of oil pastel colours is not as extensive as that for soft pastels, so you can't always achieve realistic-looking colours. Instead of worrying about it, go for a more decorative approach.

Materials

- Oil painting paper
- Oil pastels: pale grey, yellow, dark green, pink, purple, dark red, orange, bright green, pale green, blue, dark blue
- Craft (utility) knife
- Flat brush
- Turpentine or white spirit (paint thinner)
- Kitchen paper

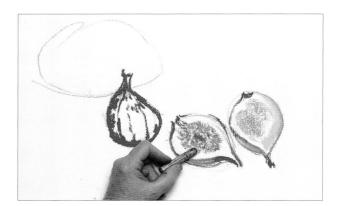

1 Using a pale grey oil pastel, outline all the fruit, then outline the figs in yellow and green and lightly block in the inside of the cut fig in pink. Put in the purple markings on the skin of the uncut fig. Apply a little yellow around the edge of the fleshy interior of the cut fig. Dot dark red on to the cut surface and add some orange around the edge.

3 With your fingertips, gently smooth out some of the pastel marks on the pink interior of the cut fig.

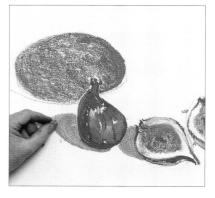

The set-up

This simple still life of a mango and two figs contains lively colours and interesting textures. The fruits were arranged on a white background and lit so as to cast shadows on the table, which stops them looking as if they're floating in thin air.

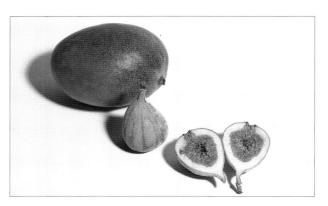

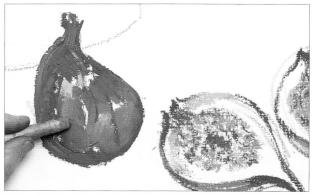

Apply very bright green oil pastel over the purple of the uncut fig and a little yellow in the brightest parts, making sure you leave a few small areas of white paper for the highlights. Then add some pale green over the top, again reserving the highlights. Note how the colours blend together optically, creating a very lively-looking mix.

A Roughly scribble red over the mango, allowing some of the white of the support to show through. Apply a little more pressure on the top half of the mango for a more dense coverage. Although the bottom half of the mango is green, some red can still be seen in this area – so lightly scribble dark green over the red, making sure you don't obliterate the red completely. The two colours combine optically to give a dark, red-tinged green. Lightly block in the shadows cast by the figs in blue.

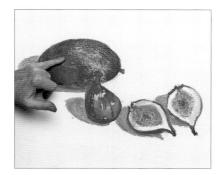

5 Apply more dark green over the bottom half of the mango, still allowing some of the red pastel and the white of the paper to show through. Add a little dark blue, as some of the red is so dark that it is almost purple, and a little pink over the centre, to soften the transition from green to red. Blend the marks just a little; it is easy to end up with a flat, muddy mix that retains none of the liveliness of individual colours.

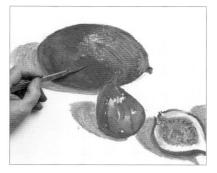

6 Using the tip of a craft knife or other sharp-tipped object, lightly scratch a series of thin, parallel lines over the mango to create the soft bloom on the surface of the fruit. 'Draw' the lines close together and angle the knife so that you don't dig into the paper and damage the surface. Apply tiny dots and dashes of red oil pastel around the interior of the cut fig to create the rich, red seeds and add more texture.

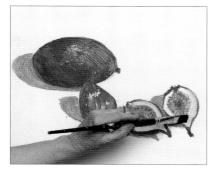

Dip a flat brush in turpentine or white spirit, dab off any excess on kitchen paper and carefully pull down a little yellow oil pastel from around the edge of the cut figs to reduce the starkness of the paper.

Tip: Keep dabbing the brush on kitchen paper or a rag between strokes to avoid dirtying the support.

The finished drawing

This is a simple still-life exercise, but it demonstrates the different effects that can be created using oil-pastel blending techniques. The optical colour mixes on the mango are much

livelier than a flat application of a single, physically mixed colour could ever be. Finger blending and scratching into the oil pastel with a knife create lovely textures.

A combination of finger blending and optical colour mixing enlivens the surface of the mango.

Solvent dilutes the colour, while the brush marks create a smooth texture for the soft flesh of the fruit.

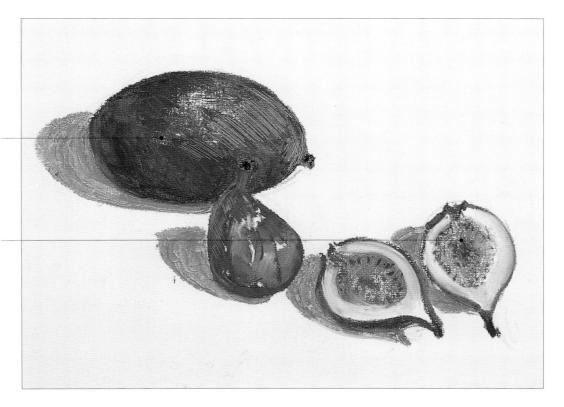

Blending with water-soluble pencils

Water-soluble coloured pencils behave in exactly the same way as non-soluble coloured pencils and you can use exactly the same techniques of scribbling, hatching and glazing to blend them. The difference is that when you apply water, the dry pigment breaks down and becomes liquid colour – and then behaves in the same way as watercolour paint.

Applications of colours look clean and bright when applied dry, because each applied colour, in effect, remains separate from those around it. Once water is applied and the colours mix together physically, however, the colour

may look dull and dirty. The answer is to keep to simple, two-colour mixes.

Remember that once water has been applied and the colours blended, the image can be dried and further applications of dry colour applied over the top. These, in turn, can be worked into and the process repeated several times, just as when painting in watercolour.

An alternative way of applying watersoluble pencils is to apply a wash of clean water to the support and work into it, taking care not to damage the surface by digging the sharp pencil tips into the softened paper fibres.

Applying water-soluble pencilsWater-soluble pencils are applied in exactly the same way as conventional coloured pencils.

Applying water

When water is applied, the coloured pencil work is converted into watercolour.

Muddy mixes

Beware of combining too many colours, as the mixes can look dirty when water is applied.

Varying the tone

To lighten the tone, add more water or lift off wet pigment with the brush or a piece of kitchen paper.

Practice exercise: Bananas

This exercise allows you to use watersoluble pencils in a linear fashion to draw the shape and facets of the bananas, and as a kind of watercolour, by brushing with clean water.

When you set up an exercise like this at home, the key is to keep it simple! If you choose a complicated group of objects with too many colours, the chances are that when you add water to the pencil work, your washes will look muddy.

Materials

- HP watercolour paper
- Water-soluble pencils: yellow ochre, mid-green, burnt sienna, bright yellow, dark brown, violet
- Brush
- Clean water

The set-up

A plain background provides a contrast in colour without detracting from the main subject. Here, a light was placed to one side of the bananas so that some facets were in shadow. The difference in tone between the light and the dark facets is what will make the subject look three-dimensional.

1 Lightly sketch the bananas using a yellow ochre water-soluble pencil. (This is the mid-toned yellow of the bananas. The hard line will disappear when you brush over clean water in the later stages of the drawing.) Indicate the different facets of the fruit as well as the outline shape.

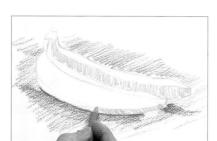

2 Block in the background with a mid-green water-soluble pencil, applying more pressure for the shaded area under the fruit. Apply yellow ochre to the shaded facets of the bananas.

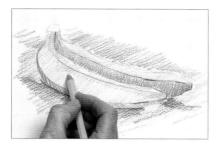

3 Loosely hatch the darkest parts of the bananas with burnt sienna, allowing some of the underlying colour to show through. Apply bright yellow loosely all over the bananas.

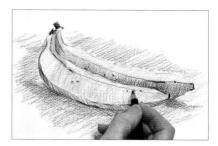

Praw the stems with a dark brown water-soluble pencil and dot in some dark marks on the bananas. Apply more burnt sienna over the most deeply shaded facets.

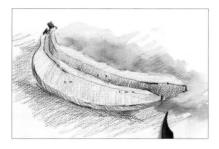

5 Dip a brush in clean water and carefully brush over the background, making sure you do not brush any of the background colour on to the bananas. You can move the pigment around on the support in exactly the same way as you can with watercolour paint. Leave to dry. (If you wish, you can use a hairdryer to speed up the drying process.)

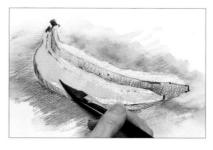

 $6^{\,\text{Clean}}$ your brush and brush over the bananas. Take care not to apply too much water, or it may spread on to the background.

Tip: If you want to vary the tone in

parts, dab off pigment with a piece

of kitchen paper.

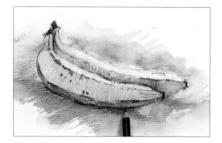

While the paper is still wet, take a dark brown pencil and darken the stem. Also dot in some stronger marks on the bananas. The pencil marks will blur a little on the damp paper, so you end up with a soft spread of colour rather than a sharp point. Add a touch of violet in the most deeply shaded area and put in more of the shadow cast by the bananas in the same colour.

The finished drawing

This simple little study demonstrates the potential of water-soluble pencils very well by combining linear marks with simple washes. By limiting the number of colours used, the artist has kept the colours bold and bright.

Linear detail is still visible. If you accidentally destroy linear marks that you want to keep, draw them again once the water has dried.

Washing over the hatched lines of burnt sienna with water has softened the marks to create a darker tone on the shaded facets.

The background is a soft wash of colour, against which the bananas stand out clearly.

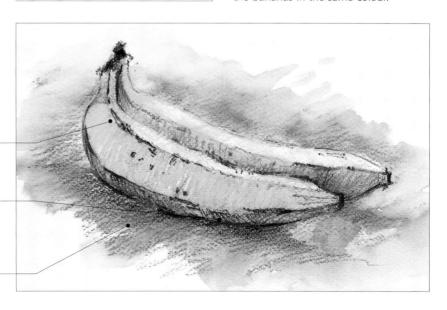

Brush drawing

Although we tend to associate brushes with painting techniques, they are extremely versatile drawing tools and are capable of producing tremendously expressive lines.

Soft-haired brushes, of the kind used in watercolour painting, are best for this kind of technique. You can also use Chinese brushes, which are designed for calligraphy. They hold a lot of ink or paint, so you don't need to keep stopping to reload the brush, and the tip comes to a fine point so you can vary the width of the line with ease. The hairs of both Chinese and watercolour brushes are very flexible, making it easy to alter the direction of the line you are making; with a brush, you can round corners smoothly in situations where you might falter with a pen or pencil. Experiment with different types of brush and compare the marks that you can create with each one.

Also experiment with the way you hold the brush. If you hold it on or near the ferrule (the metal part that holds the hairs of the brush in place), you will have a great deal of control. This is great if you are making small, short marks, but longer marks may look tight and laboured, as you control the brush primarily with your fingers, which can move only a limited distance. Holding the brush about halfway down the shaft, or even near the end, allows you to make longer, sweeping strokes from your wrist, so you get a much more flowing line. Similarly, try the side of the brush as well as the tip to see what difference that makes.

You can use either ink or paint with this technique. Waterproof ink can be brushed over once it is dry without the risk of it spreading, but the blurring that occurs with water-soluble ink is an attractive effect in its own right; the choice is yours. If you want to use paint, watercolour, gouache or acrylic (all of which are water-soluble) are all suitable.

You can make brush drawings on virtually any support – paper, board or canvas. If you use ordinary drawing paper, opt for a reasonably heavy type so that the wet ink or paint does not soak through and tear the support. However, unlike watercolour painting, there is no need to pre-stretch the support; you are not flooding it with water or paint, so it is not likely to cockle.

One key drawback of brush drawing is that if you make a mistake in paint or ink, it is much harder to erase than a pencil mark. For this reason, it is always a good idea to map out the main lines of your subject first by making a very light pencil underdrawing – at least until you feel confident enough of your drawing skills.

Short marks and dotsHold the brush perpendicular to the paper and touch the tip on to the surface.

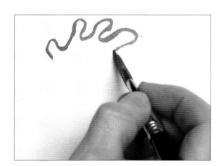

Short, undulating linesFor greater control, hold the brush on the ferrule; you can change the direction of the brush simply by moving your fingers slightly.

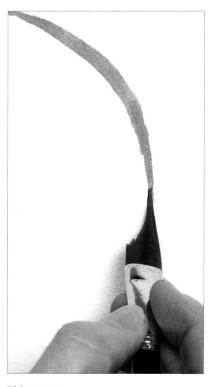

Thin curves
For thin, relatively short curves, hold the brush on the ferrule so that you can control it easily and apply only the tip to the support.

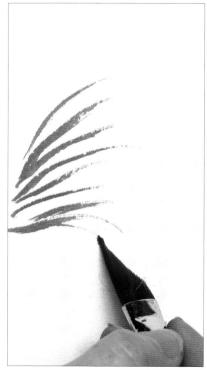

Short lines that tail off
Lift the brush up from the support as
you near the end of the stroke so that
only the tip is touching when you reach
the final part of your mark.

Lines of varying widths

Use the side of the brush, pressing the hairs on to the support, to make broad strokes; on the upstroke, lift the brush so that only the tip is touching the support to create a thinner line.

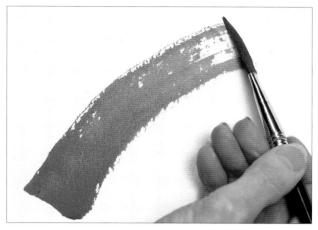

Broad strokes

Hold the brush further up the handle, press the full length of the hairs on to the support and use a sweeping motion to pull the brush across the paper.

Practice exercise: Poppies

These flowers are a wonderful subject for brush drawings. When the flower heads are fully open they are floppy, with slightly frilled edges, which you can depict by means of flowing, expressive lines. The stalks, too, twist and turn in interesting ways. They are covered in tiny hairs and, while it is neither possible nor desirable to draw them all, you can convey the texture with a few swift flicks of the brush. The leaves give you the opportunity to make spiky, linear marks of different thicknesses, using the tip of the brush for the veins.

Materials

- Pre-stretched watercolour paper
- 2B pencil
- Watercolour paints: cadmium red, olive green, ivory black, ultramarine blue
- Brush

The set-up

Fresh poppies wilt quickly so, for this exercise, the artist used artificial poppies. She decided to simplify the composition to include just one full bloom, one bud and a few leaves. This gives an uncluttered picture that allows us to appreciate the shapes of the flowers to the full.

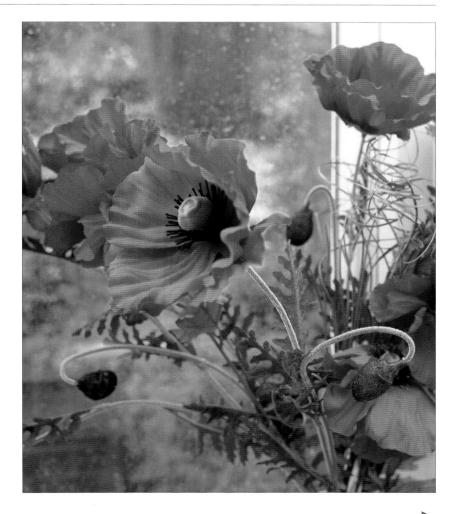

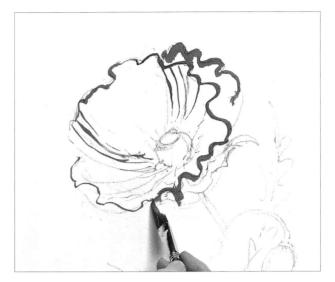

Lightly sketch your subject in pencil. If you're confident, you could omit this stage and put in the initial lines of the flowerhead using a brush and paint – but to begin with, it's best to ensure you get the basic structure right. Use a medium-size brush and cadmium red watercolour paint to outline the shape.

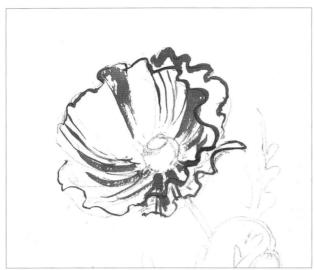

2 Put in the main striations in the petals of this large flower. The flowerhead consists of several overlapping layers of petals. Indicate the petal overlaps by giving them thicker brushstrokes, using the side of the brush to achieve this effect rather than resorting to painting them using just the tip.

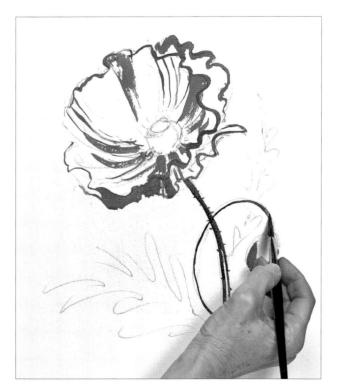

 ${\bf 3}$ Rinse your brush in clean water. Using olive green paint and the tip of the brush, draw the stem. Flick the tip of the brush sideways to draw the tiny hairs along the stem. To get a lighter shade of green, add a little more water.

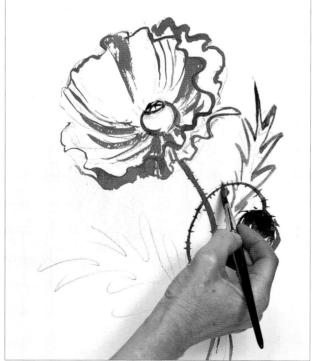

4 Block in the olive green of the poppy bud and the centre of the main bloom. Outline the leaves. Draw the stalk of the bud in the same way as in Step 3, again adding a few little hairs along its length to create a different texture.

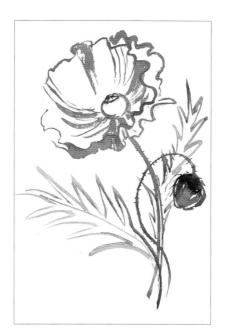

5 Complete the outline of the leaves and put in the vein that runs down the centre of the largest leaf.

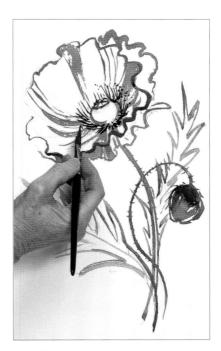

6 Mix a dark blue-black from ivory black and ultramarine blue (black on its own tends to look 'dead'). Using the tip of the brush, draw the tiny stamens around the centre of the large flower. Load the brush sparingly so you don't flood the paper.

The finished drawing

This is an energetic brush drawing, full of flowing lines that capture the characteristics of the flower extremely well. The artist has used a wide range of brushstrokes, from delicate flicks of the brush for the hairs on the stems to lines of varying width for the spiky leaves and broad marks for the overlapping petals. Even though much of the paper is left white, she has put in just enough detail to convey the shapes and textures.

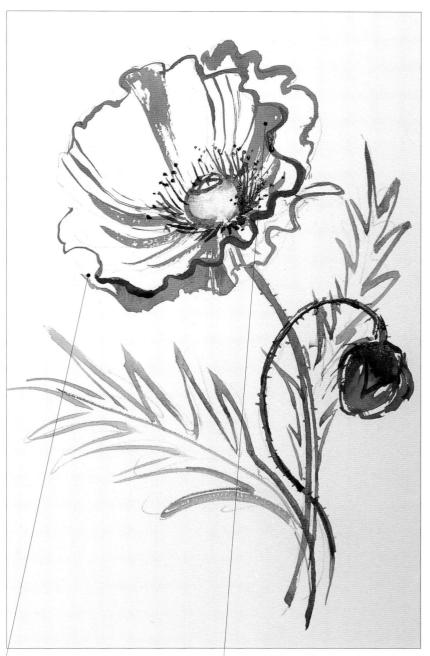

Thin, flowing lines made using the tip of the brush convey the attractively frilled edges of the petals.

Broader strokes, made using the side of the brush, imply the way petals overlap one another in this large flower.

Line and wash

The term used to describe a combination of pen-and-ink work and watercolour or ink washes is line and wash. Pen and ink is often employed for subjects that contain a lot of linear detail, such as buildings and architectural details, but can result in a somewhat mechanical feel - particularly if you are using a technical drawing pen, which does not allow you to vary the width of the line. The advantage of using line and wash is that by brushing clean water over watersoluble ink to dissolve the lines, or applying a wash of dilute ink or watercolour paint over lines drawn in permanent ink, you can soften the overall effect and create areas of tone that contrast well with the detailed pen work.

The key is not to make your work too detailed. The best line-and-wash drawings allow the viewer to infer much of what is being shown. Be selective and pick out the essential details of your subject – a good discipline, whatever medium you are working in.

Think, too, about the quality of line that you want to create and choose your pen accordingly. Technical drawing pens give a very even, regular line, but can be too rigid and regular for some people. Dip pens give a lovely quality of line, and you can vary the width by turning the pen over and drawing with the flat back of the nib — but you do have to keep stopping to re-load the pen with ink and some find this disruptive to their drawing. Many artists prefer so-called sketching pens, which are loaded with a cartridge that holds a considerable amount of ink.

Finally you need to choose whether to use waterproof or water-soluble ink. Once it has dried waterproof ink, as the name implies, will not run if a wash is applied on top of it. With water-soluble ink, on the other hand, you can brush over the marks with clean water to dissolve them and create an area of tone. You can, of course, use both types of ink in the same picture, provided you plan things in advance and work out which areas you want to blend with water and in which ones you want to retain the detail of the line work.

Brushing over waterproof ink

When you brush over dry waterproof ink with clean water, the linear work remains and the quality of the drawing is not altered in any way.

1 Scribble a few lines using permanent ink, and allow to dry.

2 Brush over the lines with clean water. The lines will remain.

Brushing over water-soluble ink

When you brush over dry water-soluble ink with clean water, the linear work is dissolved to create an area of tone.

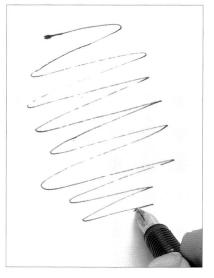

1 Start by scribbling a few lines using water-soluble ink, and allow these lines to dry.

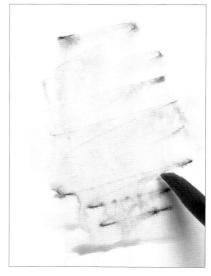

2 Brush over the lines with clean water. The water will dissolve the ink, creating an area of pale tone.

Creating dark tone

To create a darker area of tone, simply apply more ink to the paper by making the lines closer together.

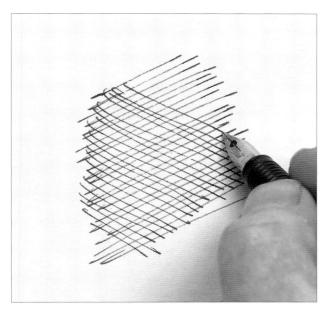

1 Hatch, or crosshatch, a series of lines close together, using water-soluble ink.

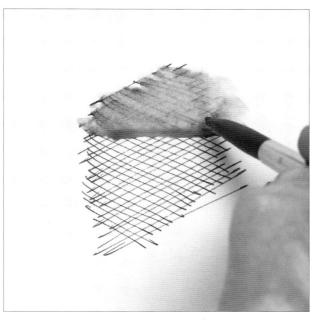

2 Brush over the lines with clean water. As before, the water will dissolve the ink – but because the lines were drawn close together, more ink has been applied to the paper and the resulting area of tone will be darker.

Practice exercise: Combining permanent and water-soluble inks in the same drawing

This exercise uses crisp, permanent ink work for the details of the wrought-iron gate and some areas of foliage, and water-soluble ink brushed over with clean water to create areas of tone in the foliage and brickwork.

Take plenty of time over your initial pencil sketch to make sure you've got the elaborate scrollwork details and proportions right. Only then should you start going over the lines in pen and ink. Much of the right-hand side of the gate will be obscured by foliage in your final drawing, but a good underdrawing will ensure you've got the structure right and the gate symmetrical.

Materials

- Heavy drawing paper
- HB pencil
- Technical drawing pen loaded with permanent black ink
- Sketching pen loaded with watersoluble black ink
- Brush

The scene

This late nineteenth-century wrought-iron gateway is partially covered by greenery and it is hard to see the intricate detail. In a drawing, however, you can subdue certain elements and emphasize those on which you want to focus attention.

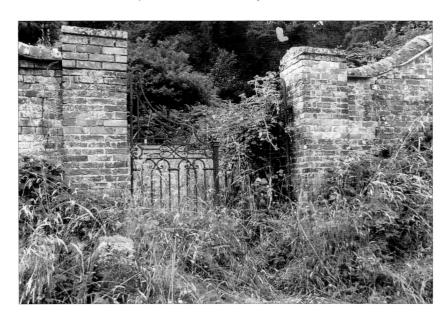

1 Using an HB pencil, lightly sketch the scene, using single lines for the bars of the gate to be sure you've got the placement and proportions right. Once you've got this stage right, you can go over the gate in pencil again, putting in a double line for each bar. A loose impression of the foliage shapes is sufficient. Similarly, you don't need to draw every individual brick.

2 Using permanent black ink, go over those areas of the gate in which you want to retain detail. Draw the bricks in permanent ink, too.

Tip: Work from top to bottom or from left to right to avoid smudging what you're already done.

Continue working on the gateway, using permanent black ink. Loosely scribble in the top of the grasses below the gate in permanent ink. Switch to water-soluble ink and begin outlining the tendrils of foliage that hang over the gate. Working on the foliage will make it clear which parts of the gate are obscured by leaves and do not need to be drawn in permanent ink.

4 Continue working on the foliage and the vegetation in front of the gateway, using both permanent and water-soluble inks for the foreground area. Try to capture the general pattern of growth, without putting in every detail.

5 Using water-soluble ink, lightly shade the left-hand side of the right-hand brick pier to show which direction the light is coming from. Hatch the darkest areas of foliage in the background trees so that you begin to develop some form in this area.

6 Hatch the darkest areas of the foreground vegetation, in front of the gate, in the same way. Erase any remaining pencil marks. Using permanent black ink, fill in the scrollwork on the wrought-iron gate so that it stands out from the background.

Thanks to the loose hatching done in the previous stages, the drawing is now starting to look three-dimensional. Stand back and assess whether any areas need to be darkened with more hatching before you go on to the next stage.

Should be paintbrush with clean water and lightly and rapidly brush over the foliage area behind the gate, leaving some areas untouched. The water-soluble ink will dissolve, creating areas of tone that contrast well with the linear work on the gate.

Repeat the process on the foreground vegetation and gently pull some of the wet ink (across) on to the brickwork to make it look less stark. If necessary, go back over some of the foliage in pen and ink (once dry) to create more texture and density of tone.

The finished drawing

If this drawing had been made using pen and ink alone, the result would have been very harsh. It would also have been hard to differentiate between the different parts of the image, as the foliage and gate are very similar in tone. Brushing clean water over carefully selected areas of water-soluble ink has softened the image, allowing the gate – which is the main focus of interest in the drawing – to stand out clearly. Although black ink was used throughout, the artist has created a number of tones by varying the density of the hatching and by working back over the washes to add more detail.

The background foliage to this gateway is suggested, rather than drawn in detail.

Permanent black ink was used for the gate; even if water was accidentally brushed on to these areas, the lines would remain.

The foreground vegetation was darkened and given more texture by drawing back over the wash.

Masking

Although it is usually associated with painting and the application of fluid colour, masking can be put to excellent use with dry drawing materials. One of the traditional uses of masking in painting is to prevent paint from getting on to an area where it is not wanted. Masks can be used in this way in drawing, too.

The main application of masking in drawing, however, is to create an interesting edge that might be difficult to achieve by other means. The technique can be used with all drawing materials.

There are a number of materials that can be used as masks. Perhaps the most common and well known is masking tape, which can be cut or torn to the required shape. Take care when removing it from the paper, however, as it can easily tear soft-surfaced papers. It is also difficult to apply masking tape over areas that have been worked on using powdery materials, such as pastel or charcoal. Masking film (frisket paper) is another option.

Paper and card (stock) can easily be cut or torn to shape. Thick watercolour paper makes an excellent mask, as it tears in interesting ways. For straight edges, nothing is as quick as scribbling colour or tone up to the edge of a thick piece of card, although you can also use the edge of a ruler in the same way.

Paper and card masks can either be held in place or fixed with masking tape. But even if you tape the mask in place, it is a good idea to take the added precaution of holding it down while you are working so that there is no chance of it slipping out of position.

Masking to create straight lines

There are many occasions when you need to apply colour or tone right up to the edge of a straight-sided subject – when blocking in a sky behind a building, for example. Holding a mask along the straight edge allows you to work right up to the edge without risking accidentally applying colour over the area you want to protect.

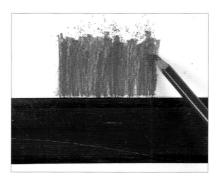

1 Hold the edge of a ruler or a cut piece of card along the straight edge and apply colour or tone. It doesn't matter if you scribble over the mask as the mask is there to protect the area underneath.

When the ruler is removed, the straight edge along the base of the area of colour is evident. It would be difficult to achieve such a crisp edge working freehand, and you can work much more freely with this technique.

Using a mask to create a shaped edge

Masks can also be cut or torn to create interestingly shaped edges.

Practice exercise: Using torn and cut masks

This is a fun exercise in using masks made from torn and cut paper to make a sketch of broccoli stems and florets. You don't need to be terribly precise about the shape of the mask as the florets have irregular edges.

Materials

- Smooth drawing paper
- Scrap paper
- Thin charcoal stick
- Scissors

The set-up

Place a stalk of broccoli on a white tablecloth or a piece of white paper and adjust the leaves and stem until you have an attractive composition. This particular variety of purple sprouting broccoli has attractive leaves with serrated edges, which add another texture to the drawing. Position a small table lamp to one side to create shadows that you can incorporate into the composition.

Take a piece of scrap watercolour paper and roughly tear a jagged, curved shape for the broccoli florets. Watercolour paper is fairly heavy and tearing it produces lovely, irregular edges that are perfect for this kind of subject.

2 Hold the mask firmly in position on the paper and, using a thin stick of charcoal, make a series of short, vertical marks around the torn edge. With the mask still in place, blend the marks with your fingers.

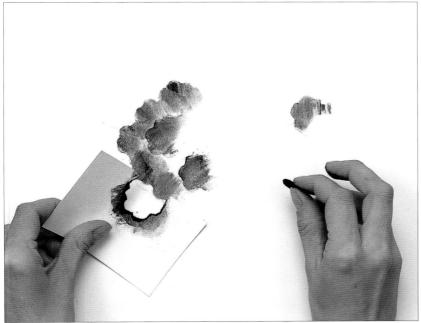

Remove the mask. You will see that you have made a semi-circular shape with irregular edges. Move the mask further along the paper and create a second floret in the same way. Continue working around the broccoli, creating a series of overlapping florets, until you have completed the head.

4 Outline the leaves and stem. Put in the leaf veins with long, flowing strokes and blend with your fingertips.

5 The edges of the leaves are slightly jagged – unlike the more rounded forms of the broccoli florets. Cut a second mask for the leaves, keeping the cuts random in shape and size.

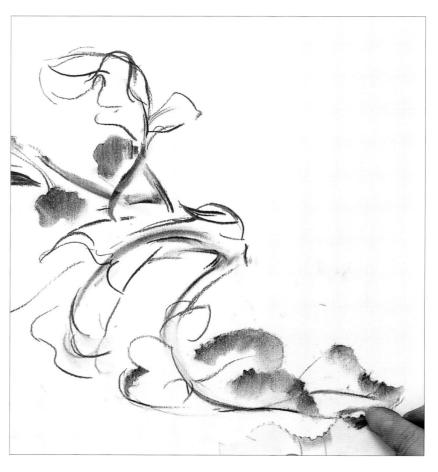

6 Place the leaf mask in position and apply charcoal up to and over the edge, as in Step 2. Use different sections of the mask, or turn it upside down, to create the shapes you want, lifting and replacing it further along the stem as you work around the leaves.

Tip: Use a kneaded eraser to clean the mask at regular intervals, so that you don't accidentally transfer smudges to the drawing.

Continue working around the stem of broccoli until all the leaves are in place. Note how the leaves flop and twist over one another and the stalks.

8 Use the side of the charcoal to block in more tone on the leaves where necessary, gently blending the marks with your fingers as before. With confident, flowing strokes, using the tip of the charcoal stick, put in the most prominent veins on the leaves. These strong, linear marks contrast nicely with the blended tone on both the leaves and the florets. The drawing is really taking shape now.

Overy lightly stroke charcoal on to the background, following the shape of the cast shadows, and blend with your fingers. The shadows need to be much softer and lighter in tone than the broccoli, so you will not need to apply much charcoal; you may even find that your fingers are already covered in so much charcoal that you can use them as a drawing tool in their own right!

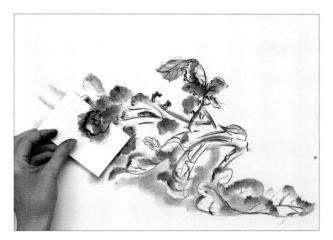

10 Place the broccoli floret mask that you used in Steps 2 and 3 in position again and go back over the shapes, making a series of small dots and dashes to create some texture. Don't blend the marks this time.

This is a very lively drawing, full of vitality and movement. Masks have been used to create random, irregular edges on

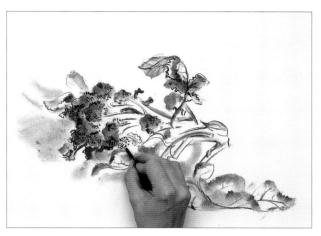

1 1 Add more detailing and texture to the broccoli florets by making a series of short, hook-shaped marks with the tip of the charcoal. These dark marks stand out well against the smoothly blended charcoal base.

both the florets and the leaves, complementing the flowing, calligraphic-style lines of the stems and veins.

Short, linear marks on top of the smudged charcoal create the texture of the broccoli florets.

The mask was turned upside down to create leaves of different shapes.

Eraser drawing

Erasers can be used for far more than simply making corrections: they are also a powerful drawing tool in their own right. The difference is that they are used to remove marks, rather than to add them. The technique works best with high-contrast subjects that contain both very dark and very light tones. It is also a good way of picking out highlights as by using the tip of the eraser or a cut edge, you can wipe out very precise marks.

Erasers can be used with graphite, coloured pencils, charcoal, pastel and chalks, as well as with all types of pigmented artists' pencils. Different erasers produce different marks, and some perform less well than others with certain materials. Kneaded erasers can be moulded to shape, making it possible to work into tight, precise areas. However, they become dirty very quickly and are of limited use with pastel or charcoal. Vinyl and plastic erasers are harder and do not

become dirty so quickly. They can be used with softer drawing materials without becoming completely clogged and unusable. Use only clear or white erasers, as coloured erasers can leave a mark on white paper. When an eraser does get dirty, you can clean it by rubbing it on a scrap piece of paper or by cutting away the dirty edges with a craft (utility) knife. Use the sharp edges of a cut eraser to draw sharp, precise lines and the blunter edge for working into wider areas of colour or tone. If the eraser picks up colour or pigment as you use it, take care not to transfer that colour on to an area where it is not wanted.

You can also use masking techniques with erasers, by working up to the edge of a piece of card (stock) to create a precise edge or by working over torn paper to create a more random edge. As an alternative to commercially available erasers, try rolling a piece of soft, white bread into a ball and using it to clean up white areas of paper or lighten an area of tone.

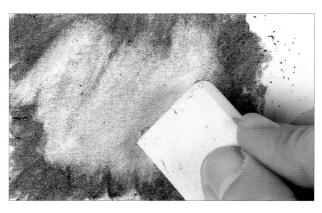

Kneaded eraser

Graphite can easily be removed using a kneaded eraser, but loose, pigmented materials such as charcoal and pastel will clog the eraser very quickly, making it unusable.

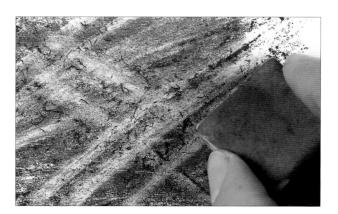

Using the cut edge of an eraser

To wipe out precise marks or shapes, use the sharp edge of a cut eraser. Use only white or clear erasers to ensure that you don't leave any scuff marks.

Shaping erasers

Erasers of all kinds can be cut into pieces with a craft (utility) knife and discarded when they are too small or dirty. Kneaded erasers can be pulled to a point for working in small areas.

Using a mask with an eraser

To create precise edges, place a straight-edged mask over the edge of the area to be erased, hold it down firmly, and erase right up to the edge.

Practice exercise: Still life

In this exercise, erasers are used to wipe out highlights and enhance the threedimensional feel of the drawing. The papery skin of the garlic is full of tiny crinkles, the ridges of which catch the light. If you were to draw these individually, the chances are that your drawing would look somewhat laboured and tight – but using the cut edge of an eraser allows you to wipe out a line that is slightly uneven and much more sympathetic to the subject. For broader highlight areas, the flat side of the eraser is used. As with all textural techniques, your eraser strokes should follow the form of the object.

As a variation on this exercise, cover the paper with graphite or charcoal and use an eraser as a drawing tool.

Materials

- Smooth drawing paper
- 9B graphite stick
- Plastic and kneaded erasers

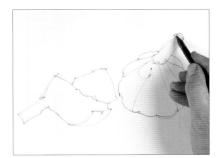

1 Using a 9B graphite stick, outline the bulbs of garlic.

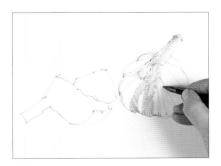

2 Put in the internal lines in the garlic skin, following the contours of the individual cloves beneath. Using loose hatching marks, apply some tone.

The set-up

In this simple set-up, a bulb of garlic and a twisted section of peeled garlic skin were arranged on a dark marble background, creating a composition that contains strong contrasts between very dark and very light areas. The stalks were carefully angled to create a diagonal line that makes a dynamic composition.

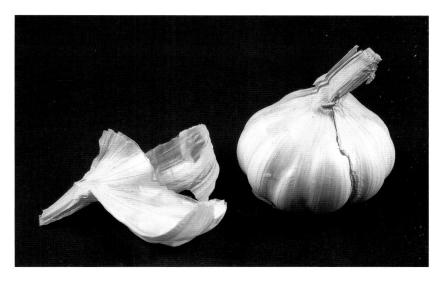

 $\bf 3$ Continue adding tone to the garlic, using loose hatching marks. Note how the form of the garlic immediately becomes more evident, as the more deeply shaded areas reveal both the contours of the individual cloves and the ridges in the papery outer covering.

Applying reasonably heavy pressure to the graphite stick, scribble in the dark background. Work carefully up to the edge of the garlic, redefining its shape as you work.

5 Using the sharp, cut edge of a plastic eraser, wipe out fine lines on the garlic skin. These thin, bright lines help to show the crinkled, papery texture of the skin.

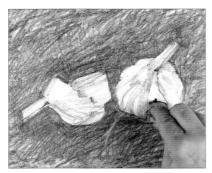

6 Using the flat side of a kneaded eraser, wipe out larger areas of tone to reveal the highlights on the garlic. If you accidentally wipe off too much, just hatch over the affected area again.

This simple still life relies for its impact on the contrast between very dark and very light areas. Using an eraser to wipe out the highlights has resulted in loose, natural-looking lines that capture the crinkled texture of the garlic skin, and has produced a more integrated drawing than could be achieved by positive applications of pigment alone.

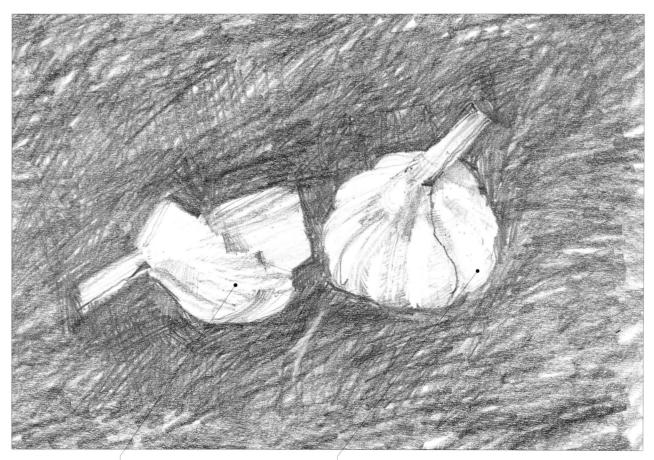

The sharp, cut edge of the eraser creates fine highlight lines.

Broader areas are wiped out using the flat side of the eraser.

Sgraffito

The technique of using a sharp implement to expose an underlying layer of paint or pigment, or the support, is called Sgraffito. Although it is perhaps more commonly associated with painting, it can also be used with certain drawing materials as a way of creating texture.

Sgraffito is especially successful with thick applications of soft pastel or oil pastel. You can use any sharp implement to make the marks – a craft (utility) knife, scissor blades, paper clips, even your fingernails. If you want to scratch through just one layer of soft pastel to

reveal the layer beneath, fix the lower layer before you apply the top one.

Work confidently and quickly to create a sense of energy in your work — but remember to scratch through the pastel rather than cut into it, otherwise you risk damaging the support.

Scratching into oil pastel

Oil pastel on oil sketching paper can be removed or scratched into using a sharp craft (utility) knife.

Scratching into soft pastel

To remove one layer of soft pastel to reveal the layer underneath, use the flat of the blade.

Scratching into charcoal

Any soft, pigmented drawing material can be scratched into. Here, linear sgraffito work is made into charcoal.

Practice exercise: Woodland scene

Woodland thickets, which are full of tangled undergrowth and spiky twigs and branches, are the ideal subject for practising the sgraffito technique, as you can scratch off pigment to reveal underlying colours and create thin, energetic lines that capture the profusion of growth to perfection.

For this exercise, the artist chose a dark brown oil pastel paper the same colour as the branches of the trees and scratched off pigment to reveal the colour of the support. She also used sgraffito in other areas, scratching off only the top layer of pigment to create interesting textural effects and colours in the foliage and grasses.

Materials

- Dark-toned oil pastel paper
- Oil pastels: dark brown, black, violet, dark green, white, bright yellow, dark blue, reddish brown
- Scraperboard tool

The scene

Here the artist selected elements from two photographs. Don't follow your reference photo too closely: try instead to capture the spirit of the scene and the direction of growth. Woodland scenes can look very jumbled and confusing, so always make sure there is a strong centre of interest. Here, it is provided by the large, solid tree trunk towards the left of the image, which the artist positioned 'on the third'.

Roughly indicate the main trunks and branches, using dark brown, black and violet oil pastels. Scribble in the main patches of foliage in dark green. Using the side of a white oil pastel, block in the light areas of sky between the trees.

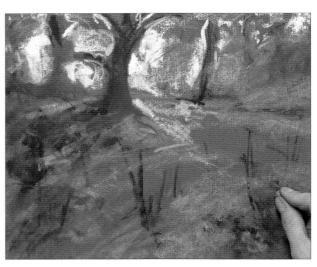

Put in the areas of very yellow foliage with a bright yellow ∠ oil pastel. Now look for the shadows: using a dark blue oil pastel, scribble in the deepest shadow areas on the ground and the shaded sides of the tree trunks.

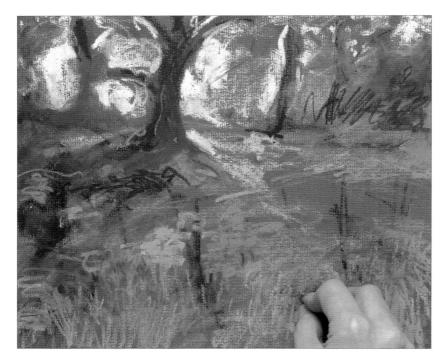

3 Put grasses in the foreground using jagged, vertical strokes of blue, green and yellow, making the colours brighter and warmer in the immediate foreground to help bring this area forwards in the scene and create some sense of recession. Cover the support and get enough pigment down to be able to scratch into it.

Tip: You may find that it helps to half-close your eyes so that you see the scene as patches of colour rather than as individual stems and grasses.

4 Using a scraperboard tool, scratch off thin lines across the white of the sky to reveal the underlying paper colour and create the thin and spindly branches of the background trees.

5 Add the sunlit, dead foliage in reddish brown, and patches of sunlight in yellow.

6 Continue building up the colours in the foreground, then use the scraperboard tool to scratch across this area and create the impression of tall, thin grasses and stalks. Scratch horizontally and vertically, following the direction in which the grasses grow, and also use a scribbling motion to create a tangle of intertwined leaves and twigs.

Here, the artist has used the sgraffito technique to create a lively, highly textured drawing that captures the tangled undergrowth and the spindly branches to perfection.

Continue scraping into the foreground, using a variety of marks – dots, dashes, vertical strokes and zig-zag lines – to suggest the patterns of growth in the vegetation. For dark areas of shadow, you can use the scraperboard tool to smear thick applications of oil pastel across the support as well as to remove it.

There is a good balance between marks made with the oil pastels, such as the larger trunks and branches, and sgraffito marks for things such as the spiky grasses and twisted stems.

Lines scratched into the white of the sky reveal the underlying support and create the impression of thin branches.

Energetic, vertical scratches reveal the colour of the underlying layer of oil pastel and create movement.

Drawing smooth textures

Smooth surfaces are often hard and include things such as glass and plastic, metal, polished wood, stone and marble. Hard, smooth surfaces are often reflective. They may not always be mirror-like, but they do reflect any directional light source and pick up and reflect colours from objects that are near by.

Hard surfaces can cover extremely complex shaped objects such as a corkscrew or a coffee percolator. On curved surfaces, reflections are often distorted, which can make the smooth surface appear far more complex than it really is. Some smooth-surfaced objects such as polished marble also have a surface pattern, and in order

to reproduce the true quality of the object, this will need to be rendered, too.

Work on a paper that is appropriate to the subject. Hard, smooth objects have a clean, smooth outline with clearly defined crisp edges, and a smooth, hot-pressed or NOT paper will help you to achieve the correct feel.

Practice exercise: Smooth leather ball

In this exercise, the smooth surface of the ball is created by building up layers of soft pastel and blending out the marks with either your fingertips or a torchon

Although it is not highly reflective, the leather ball is shiny enough to reflect the light source. Such highlights can be drawn by leaving the paper white or, when working in a soft, powdery medium such as the pastel pencils used here, by wiping off pigment with a kneaded eraser.

Materials

- Smooth drawing paper
- Pastel pencils: ochre, red, dark brown
- Torchon (optional)
- Kneaded eraser

The subject

A ball was lit from the front to create a bright highlight near the top. Note the gradual change in tone from the front of the ball to the back, as the light falls off.

Apply the lightest colour first. Using an ochre pastel pencil, scribble on the pigment using multi-directional strokes. Leave the white paper to represent any highlights.

2 Blend the pastel pencil work, using your finger or a paper torchon. The pigment does not have to be completely smooth; blend it just enough to soften any of the scribbled lines that show too clearly.

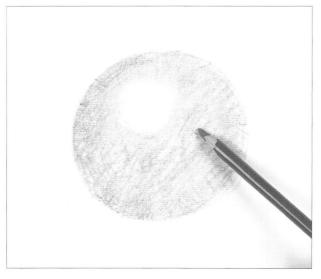

Repeat the process, using a red pastel pencil; the two colours blend together to create the rich, reddish-brown of the leather. Apply lighter strokes around the highlights and blend the colour slightly using your finger or a torchon.

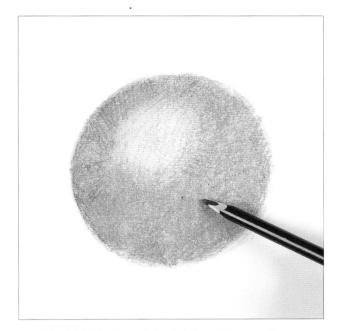

4 If the highlight is too light, lightly scribble over the area using the ochre and red pencils. Next apply the dark brown pastel pencil over everything except the highlight.

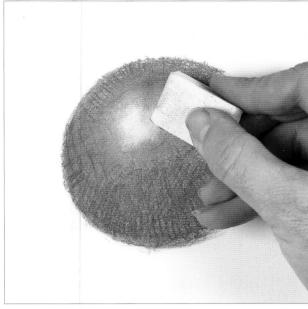

5 Once you have applied all the colour, you can re-establish the highlight if necessary by gently lifting off pigment with a kneaded eraser.

Leather reflects the light that is positioned above it, so careful observation of the size and shape of the highlight is the key to the success of this drawing. Working on a smooth paper also helps, as does blending the pastel marks to obtain a smooth, even coverage.

The bright highlight tells us that the subject is both smooth and shiny.

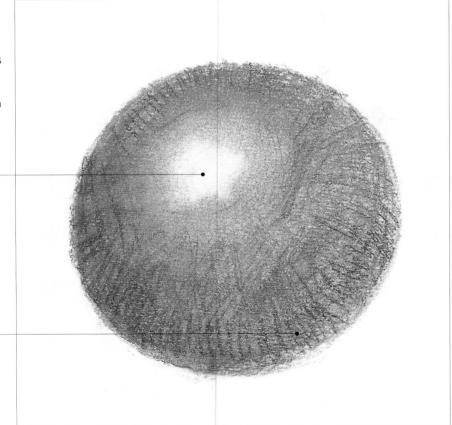

The smooth surface texture of the ball is conveyed by means of light, blended pastel strokes.

Practice exercise: Stainless steel olive oil pourer

When you're drawing metal, remember that it is a hard substance and that the edges of metal objects, even if they are irregular in shape, are very clearly defined. Metal is a highly reflective surface, although the reflections may be distorted. Metal tends to pick up very bright highlights, which will help you to convey the form of the object you are drawing. Finally, remember that all metals (and metals such as silver and stainless steel in particular) take much of their colour from objects that are reflected in the surface – so look at the surroundings as well as at the objects that you are drawing.

Materials

- Smooth drawing paper
- Charcoal pencil
- White chalk

The subject

In terms of its shape, this is a relatively simple subject to draw – but in order for it to look convincing you will need to recreate the smooth, shiny texture.

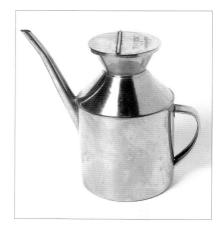

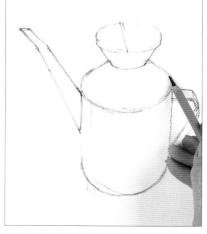

1 You need to establish first the shape of the olive oil pourer using relatively light lines made with a charcoal pencil.

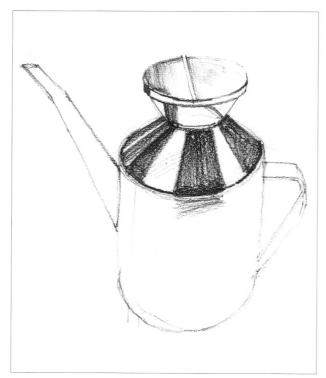

2 Establish the darkest reflections using heavy charcoal work, carefully working around any areas that reflect the light. Note how putting in these dark reflections immediately tells us something about the shape of the object: although the lid of the oil pourer is not faceted, the shapes of the reflections do help to imply that it is gently curved.

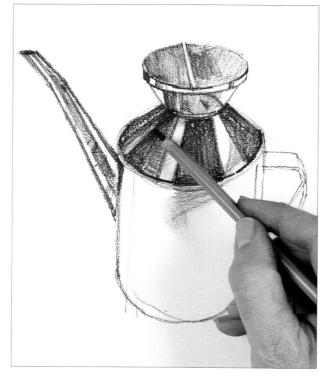

3 Consolidate the darkest areas, such as the very dark lip of the lid and the inside of the tip of the spout, and begin to draw in the mid-tones using light pencil work. Blend the pencil marks by using your fingertips or a paper torchon: the surface of the oil pourer is smooth, so try to ensure that no pencil marks are visible.

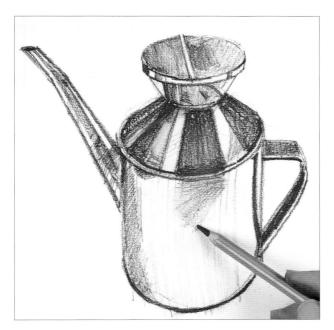

 $\bf 4$ Continue to work the mid- and light tones on the cylindrical body of the pourer, using pencil marks that follow the contours of the object.

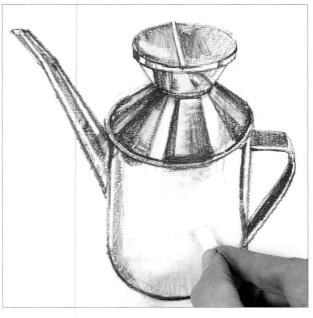

5 In order for the hard, shiny, reflective surface to read correctly, the marks need to be precise and sharp. Use a white chalk to sharpen the highlights.

This metal's smooth and shiny surface is achieved by building up the layers gradually and by observing the shape, position and tone of the highlights carefully.

Note how the edges of the metal object are very clearly and crisply defined.

The light catches the outer edge of the handle, creating a very bright highlight, while the inside of the handle is in deep shadow.

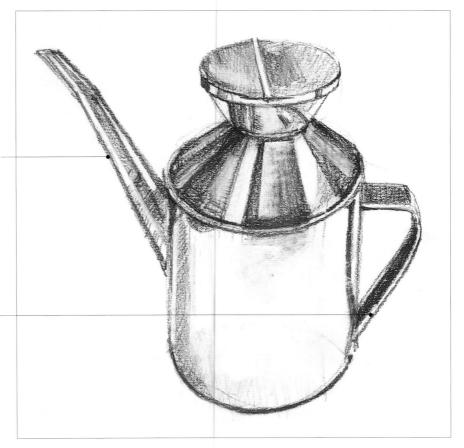

Drawing rough textures

For an artist, rough textures are perhaps the most fun to draw as they allow you to use a whole range of calligraphic and textural marks. The types of rough surface that you will come across include pitted stone and rock, brickwork, weathered wood and bark, certain animal skins such as elephant and rhino, and some types of fabric (hessian, for example).

With a rough-textured subject, working on a surface that has some

texture to it will help the mark-making process – but beware of choosing a support in which the texture is too dominant, as no amount of mark-making will prevent it from showing through.

Many rough textures are repetitive over a large area – but this does not mean that you have to draw in the texture so that it covers the area. You can suggest the texture in places and, if this is done successfully, the viewer will mentally fill in the missing bits. In fact, it can be a mistake to draw in textures too comprehensively as they can easily overpower a drawing and make it appear lifeless.

The degree to which a rough texture shows up depends very much on the quality and direction of the light. In bright light that hits the object at an angle, the texture will appear to be quite pronounced; in flat light, the same texture will appear less evident.

Practice exercise: Weathered driftwood

With a subject such as this, you can explore a wide range of marks to convey the texture – flowing, linear strokes for the main lines of the wood grain, short dots and dashes for little indentations in the surface, and smudged marks for dark areas of tone.

Materials

- Rough watercolour paper
- Charcoal stick

The subject

This piece of weathered driftwood has lots of tiny cracks and crevices within it, as well as a deeper recess in the centre. Lighting it from the left casts a shadow to the right of the wood and also helps to reveal the texture.

1 Establish the shape of the piece of driftwood using stick charcoal on a sheet of rough watercolour paper. It helps to put in the most obvious cracks as guidelines.

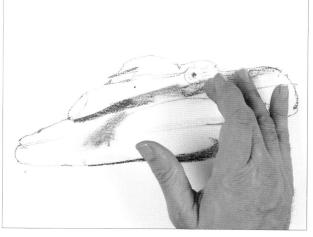

2 Once you have drawn the main shape, put in the darker areas of tone using the side of the stick. Blend the pigment and push it into the paper surface using your finger.

3 Continue building up lines and tones on the driftwood surface. Note how the texture of the paper reads through these marks and helps suggest the pitted, weathered surface.

Once you have drawn the main tones and flowing lines of the wood grain, put in the darker areas deep in the splits and holes using heavy pressure and firm, deliberate marks.

5 Complete the sketch with light, flowing texture lines and put in a dark shadow beneath the object, smoothing out the marks with your fingers.

This is a lively drawing in which a combination of confident linear marks and soft blending of the charcoal creates the texture of the wood. Note how the linear marks follow the direction of the wood grain. The cast shadow anchors the piece of wood on the surface and provides an interesting shape in its own right.

Practice exercise: Pitted stone

The stone has very obvious indentations of differing sizes in the surface and this irregularity is something that needs to come across in the drawing. At the same time it is hard and unyielding, so your marks need to convey this. Blend the colours to create the overall background colour and then apply dabs of oil pastel on top for the holes.

Materials

- Oil sketching paper
- Oil pastels: dark brown, ochre, mid-grey
- White spirit (paint thinner)
- Paintbrush

The subject

Note the slightly jagged, irregular outline of the stone – very different from the smooth outline of surfaces such as metal. This is one of the keys to conveying its rough texture.

1 Establish the shape of the stone and the position of the pitted marks using a dark brown oil pastel.

2 Build up the colours within the rock using an ochre and a mid-grey pastel. Make loose, directional strokes that follow the contours of the stone.

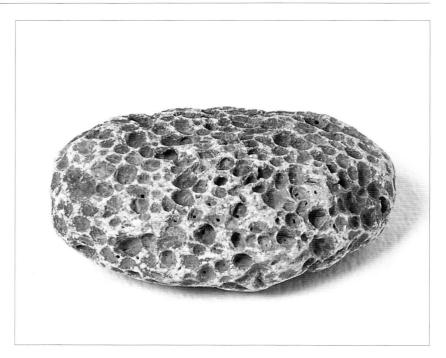

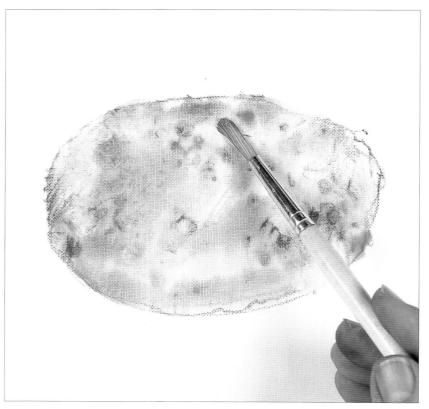

Apply white spirit to dilute the pastel work and distribute it over the image surface, allowing some of the linear work to show through in places.

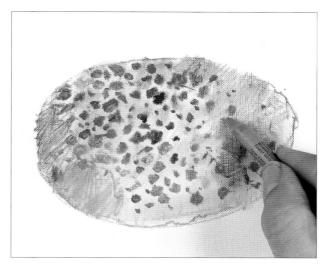

4 While the surface is still wet, use various colours to reestablish the contours and dark holes on the stone's surface, keeping the work fluid and loose.

Blending the oil pastel with white spirit enabled the artist to smooth out the tone to create the relatively even coloration

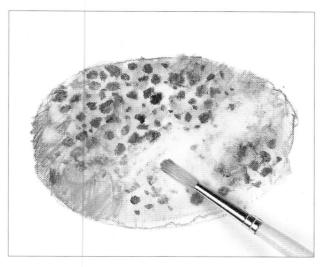

5 Finally, work into areas of the stone that are still smooth, brushing on a little more white spirit to blend the pastel colours together where necessary.

of the stone, while stronger dots of colour on top effectively convey its hard, pitted texture.

Drawing soft textures

Soft textures include skin, animal fur and feathers, and fabrics. These types of texture are often affected by an underlying structure (for example, the skeleton in the case of an animal or bird). Sometimes, they are covered in a pattern or design, and the design or pattern on a surface can tell us about the shape of that object, as the way lines flow or a pattern is distorted indicates the structure that lies underneath.

The texture of soft objects is, more often than not, relatively smooth. Even animal fur and birds' feathers, when viewed from a distance, appear smooth and unruffled.

As with rough textures, when you are drawing fur or feathers it is neither necessary nor advisable to put in every hair and every feather. Skin needs to be treated with care, as any texture is barely noticeable; even in elderly people, where

the inevitable wrinkles can be seen, you should take care not to overdo the effect.

Unless they are really coarse, the texture of fabrics is virtually imperceptible from all but the closest distance. More often than not, it is revealed by the quality of any surface pattern or decoration. It also depends on the quality of the lighting: strong, directional light will make the surface folds and creases far more apparent than flat, even lighting.

Practice exercise: Folded fabric

Most fabrics are soft in texture. Sometimes you can use the distorted lines of the pattern to show how the folds and creases in the fabric fall; at other times, particularly if the fabric is a uniform colour, they are revealed by variations in tone. Look for both these things when drawing fabric.

Materials

- Smooth drawing paper
- 2B pencil
- Soft eraser

The subject

Here, a man's handkerchief was folded and rucked up slightly at one side to create interesting creases and shapes within the fabric

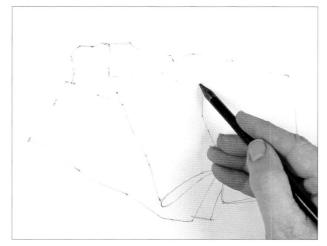

1 Establish the shape of this crumpled handkerchief using a 2B pencil. Use light, flowing lines to suggest not only the shape but also the position of any shadows.

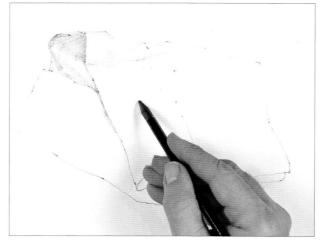

2 Begin to put in the tones, using scribbled pencil marks that follow the contours of the fabric. Use light pressure for the very light tones, holding the pencil high up the shaft.

3 Continue steadily searching out the contours and the relevant tones.

Gradually the form of the object becomes apparent.

4 Give the area surrounding the handkerchief a dark tone. 'Draw' in any light creases on the fabric using a soft eraser.

5 Finally, draw the patterned lines that are woven into the fabric of the handkerchief, carefully following the shape of the contours.

Note how careful observation of the subtle differences in tone, from the white of the paper for the most brightly lit areas to a pale covering of grey elsewhere, reveals the gentle folds in the fabric. More abrupt folds are indicated by the changes in direction of the pattern woven around the edge of the handkerchief.

Practice exercise: Feathers

When you are drawing a bird, it is neither necessary nor advisable to put in every single feather - particularly if you are drawing a front view, as the chest feathers tend to be relatively small. Look instead for the blocks of feathers and think about their function: are they strong, primary feathers that are used for steering and to produce the power of flight as the wing is brought down through the air, or the softer, more pliable secondary feathers that lie above the primary feathers? Also think about the skeleton that lies underneath the feathers, as this will make it easier for you to get the shape of the body and head right.

Materials

- Smooth drawing paper
- Fine liner pen

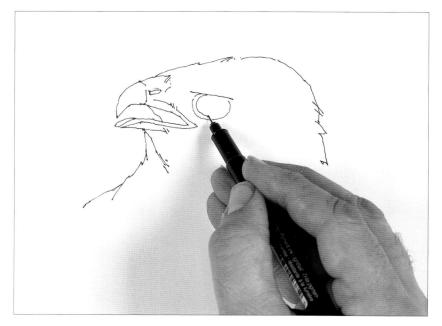

1 Using a fine liner pen, map out the main shape and features of the bird of prey's head. Use small, jagged strokes around the edge to convey the texture of the facial and neck feathers.

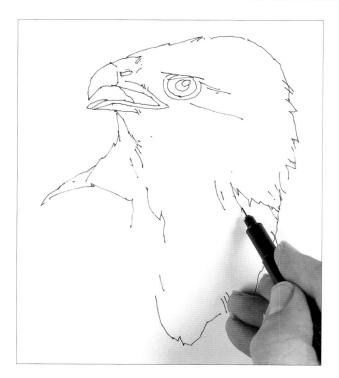

2 Draw in the position and shape of the main feather groups – the feathers at the base of the head and on the bird's chest.

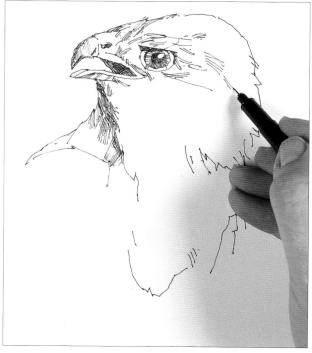

 $\mathbf{3}$ Elaborate the main feather groups, defining some feathers more clearly than others. Colour in the eye, remembering to leave the highlight untouched.

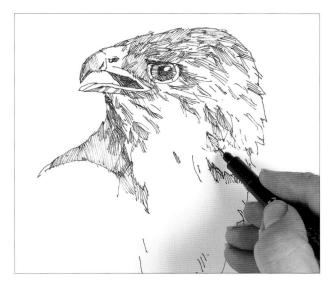

4 Build up the tones by increasing the density of the pen lines, carefully following the surface contours of the underlying body structure.

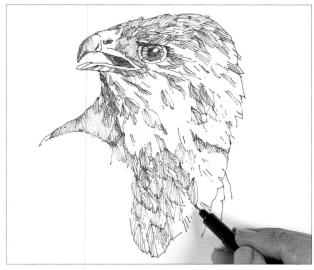

5 Finally draw the cluster of feathers that runs from the bird's neck over its chest. They help to give the subject a sense of solidity.

Using a liner pen can give a drawing a rather mechanical feel if you're not careful, and the trick is not to put in too much detail. Here, the artist has created the soft texture by drawing pen lines that follow the direction of the individual strands within the feathers.

Make sure the beak looks hard and slightly shiny.

Even though some areas are left almost blank, the viewer's eye fills in the missing details.

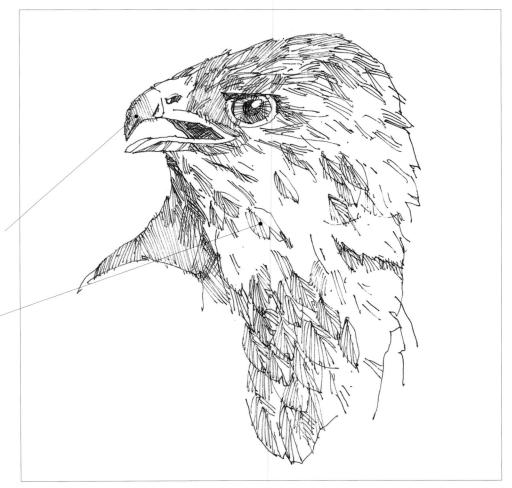

Drawing Projects

In this section, you get a chance to put into practice all the drawing skills you have learned, in a series of step-by-step projects specially commissioned from leading professional artists. Each project begins with a full list of the materials you will need and a photograph of the scene that the artist chose to draw – so you can either copy the project exactly or use it as a starting point for your own artistic explorations. Packed with useful tips, it is full of ideas that will inspire you to create works you will be proud to hang on your wall.

Quick sketches of trees: Damaged tree

Trees are a delight to draw – particularly old trees that have gnarled bark and twists and splits in their trunks – as they allow you to explore a wide range of textural techniques and approaches to making marks. Monochrome sketches are perhaps the most interesting and satisfying of all as, without the distraction of colour, the textures and shapes really start to come into their own.

It's important to try to convey a sense of trees as living, growing organisms, and you should always examine the shapes of the trunk and branches carefully before you start to draw: some trees, such as the silver birch, have thin, relatively smooth trunks, while others, such as ancient olives that have been cultivated for many decades, have gnarled trunks with distinct grooved patterns in the surface. If you're sketching *in situ*, try running your fingers over the trunk to get a feel for the texture and the pattern of the bark: does the pattern run up and down in fairly straight lines or does it go round in nobbly circles?

Look at how the branches grow out of the main trunk: do they spread out straight, or veer upwards in a v-shaped pattern on either side of the trunk, or

5-minute sketch: graphite pencil

After putting down the outline with slightly jagged pencil strokes, the artist then scribbled in the darkest areas of tone, such as the undersides of the branches and the shaded interior of the split in the trunk. Even in a quick five-minute sketch such as this, you can begin to capture something of the form of the tree.

droop downwards? Finally, think about how you're going to draw the leaves. For small leaves, a few loose dots and dashes may be sufficient; for larger leaves you may need to be more precise about the shape — but don't overdo the leaf detailing, or you'll detract from the shape of the tree as a whole.

The scene

This tree was badly damaged in a winter gale. The artist came across it when she was out for a walk in the country and was attracted by the shapes made by the broken and contorted branches and by the gnarled texture of the bark.

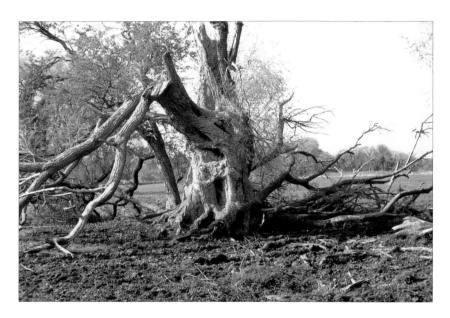

10-minute sketch: graphite pencil

In a slightly longer sketch, you can begin to refine the detail, putting in tones that range from a mid-grey on the shaded parts to a much denser black in the hollowed recess near the base. In addition to providing information about the light and shade, the tone is applied in such as way as to hint at the pattern of the bark.

15-minute sketch: graphite pencil

The shading is more highly developed in this sketch and the tree looks more three-dimensional. Although the background is not drawn in detail, putting in the horizon and blocking in generalized shapes for the trees and bushes in the distance sets the tree in context.

25-minute sketch: graphite pencil plus pen and ink

Confident, scribbled pen lines over an initial pencil sketch give this drawing a real sense of energy and capture the character of the tree very well. Note the use of a wide range of marks, from simple hatching on the trunk to tiny flecks and dashes for the small leaves.

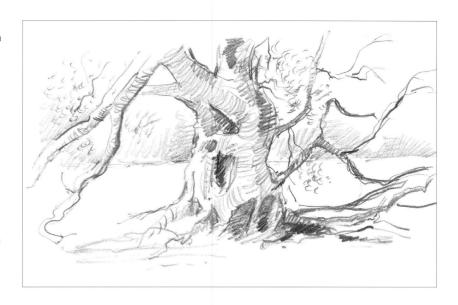

Quick sketches of trees: Foliage masses

Trees form an important part of many landscapes and can also be used as a compositional device, to lead the viewer's eye into the scene or to provide a natural 'frame'. Different types of foliage, however, require different artistic approaches. One of the most common mistakes is to attempt to put in too much detail. Start by looking at the shape of the tree: is it conical or rounded? Then look at the shapes of the leaves within the foliage mass: are they large with a distinctive shape, such as a maple or horse chestnut, or are there many small leaves clustered tightly together, as in the example on these pages? Finally, look for the differences in tone that will make the foliage masses look three-dimensional. Even in dull lighting, as here, some areas will be lighter than others; half closing your eyes as you look at the scene will make it much easier to assess this.

The scene

The dark mass of the tree on the left forms a natural 'frame' for the mountainous, wooded landscape beyond and helps to give a sense of scale. The artist elected to make a number of studies of this single tree in order to capture its character.

5-minute sketch: charcoal

Start by loosely blocking in the overall shape using the side of the charcoal stick, then work into this shape with the tip of the charcoal, scribbling and dotting in the darkest parts of the foliage mass to create some variation in tone so that the tree begins to look three-dimensional. Smooth out the charcoal with your fingertip or a torchon.

15-minute sketch: 4B pencil, black ballpoint pen

Graphite pencils and ballpoint pens are perfect for reference sketches on location as they are easily portable and not messy. The artist roughly blocked in the shape with a 4B pencil, which makes a lovely, dense mark, before hatching in the darkest areas with a black ballpoint pen. The closer together the hatched lines, the darker and denser the tone will be.

30-minute sketch: coloured wax pencils

With wax pencils you can quickly build up areas of broken colour and create lively optical mixes that capture the full range of tones within the foliage mass. Start with the lightest colour first – a pale, yellowy green. Then add progressively darker greens until you achieve the effect that you want, using a carefully controlled scribble. Some areas are very dark

indeed, but beware of using a solid black as it can 'deaden' the overall effect; instead, use dark, reddish browns that complement the greens and give some warmth to the scene. (Look closely at any subject and you will often see that the shadow areas contain a dark colour that is complementary to the colour of the main subject.)

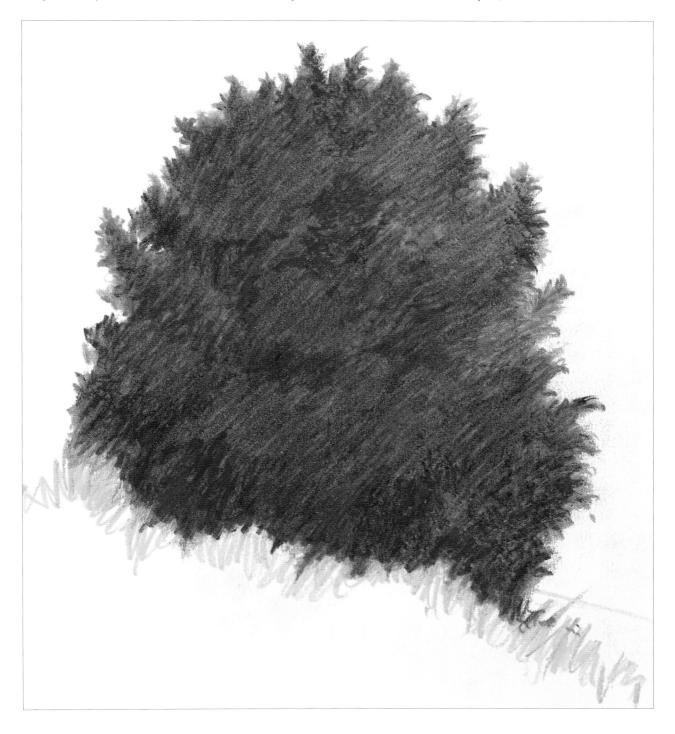

Quick sketches of flowers: Poppies

Some flowers, such as bedding plants in a municipal park, grow in straight, regimented lines. Others grow in untrammelled profusion, their stems twisting and turning over one another, the flower heads flopping in all directions. When you draw or paint flowers, allow the natural growth pattern to dictate your artistic approach so that you can capture the essential character of the plant.

These poppies seem to rise and pop up almost at random. Artistically, the rich colours and ruffled shapes call for a free, impressionistic approach. The translucent petals provide plenty of opportunity to explore tonal contrasts and colour mixes, as deeper tones are created where petals overlap or cast shadows on neighbouring petals. Powdery media such as charcoal and soft pastel are perfect for this subject. The black centres and seed heads offer interesting contrasts of colour and shape; here, you can make stronger, linear marks.

5-minute sketch: black and white soft pastels

If you only have five minutes or so to spare, you will not have time to sketch more than one or two individual blooms. Nonetheless, this is a good loosening-up and observational exercise. Here, loose, light white pastel lines recreate the frilly edges of the poppy petals, with more controlled marks being made for the seed heads. Finally, the artist has scribbled in black pastel for the very dark flower centres.

The scene

The artist came across this patch of poppies growing in a corner of her garden and wanted to create the feeling of random, spontaneous growth. Deliberately cutting off the edges of some of the poppies in her sketches helps to convey this: such a subject should not appear too neat and tidy!

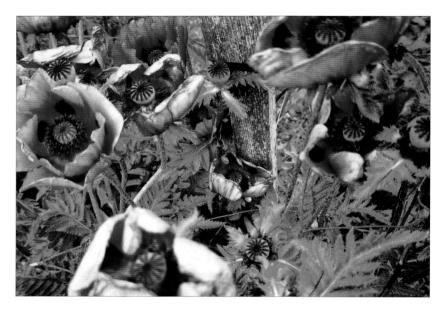

10-minute sketch: charcoal

In a very quick sketch like this one, you need to concentrate first on capturing the shapes of the flowers and the individual petals within them. At the same time, try to keep your marks loose and spontaneous. Don't worry if the shapes are not completely perfect because the main aim is to get the general feeling right. Here, the artist used free-flowing, calligraphic marks to delineate the shapes of the petals, smudging the charcoal to create the darkest tones on the flowers.

15-minute sketch: inks, dip pen and brush, and rollerball pen

Pen and ink is a good medium for sketching the spiky texture of the poppy leaves – but again, in order to create a feeling of spontaneity, you should try to keep your pen marks fairly loose and jagged. The artist first sketched the outlines with the dip pen. Then she brushed varying dilutions of coloured inks over the top, to create the petals, with the darker tones being used where the translucent petals overlap one another. She used a rollerball pen for details such as the stamens, as it gives a less crude line than the dip pen. Note how effective it is to leave much of the image uncoloured. Blocking in every single petal could easily have produced a rather tight and laboured image that failed to capture the character of the flowers.

30-minute sketch: soft pastels

Soft pastels are a lovely medium for the translucent petals, as you can blend the colours to create lively optical mixes and subtle transitions in tone. At the same time, you need to make sure that the edges of the petals are clearly delineated, which you can do using the tip of a slightly lighter-coloured pastel. The artist used a cool blue pastel paper because this is an appropriate colour for the background and allows the flowers themselves – which are much warmer in tone – to come forwards in the image. Flowing, calligraphic marks capture the character of the flowers in a similar vein to the other quick sketches on these pages.

Trees in winter

Monochrome media such as charcoal or graphite are perfect for wintry scenes; there is relatively little colour so you can concentrate on tone and texture. With the coming of winter the underlying shape of deciduous trees, which is largely disguised by leaves in other seasons of the year, becomes apparent. In some species such as willow, the main boughs droop down; chestnut trees spread in a gentle arc, while some pine trees are basically conical in shape. It's a good idea to look for the overall geometric shapes first and sketch them in very lightly before you add any detail.

One of the most important things to remember when drawing trees is that the branches are not mere appendages, stuck on as an afterthought in the way they might be in a young child's drawing, but an organic part of the tree as a whole. Look at each tree in its entirety, instead of drawing the trunk first and adding the branches later. Look at the negative shapes – the spaces in between – as well as at the positive shapes of the branches.

Branches are such solid, heavy things that it may strike you as odd to draw them in outline and leave them as white shapes, as the artist does here. Look closely at this scene, however, and you will see that they are actually lighter in tone than the mass of ivy leaves behind. If you were to block them in with a midtone of grey, they would not stand out clearly. In areas where they are silhouetted against the bland white sky, you can use dark pencil marks.

Materials

- Smooth drawing paper
- 6B pencil

The scene

A group of trees is starkly silhouetted against the white sky and the snow-covered ground, with just a few exposed patches of earth adding texture to the foreground. The trees are very near the centre of the image, which is generally not considered advisable, but in this case, the central placement is one way of conveying the calm, still mood of the scene.

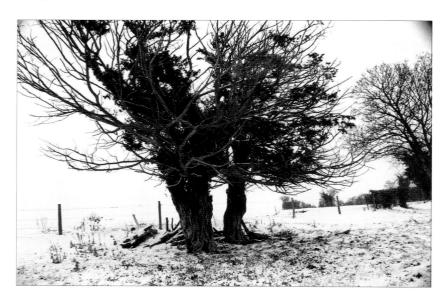

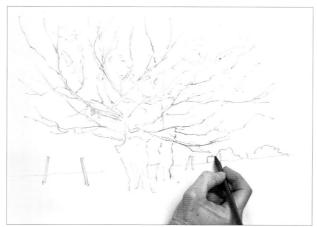

1 Using a 6B pencil, which makes a strong, dense mark, put in the main lines of the trees. Remember to look at the negative shapes – the spaces between the branches – as well as at the branches themselves. Also indicate the fence posts and a few small bushes in the middle distance, remembering to make the posts smaller as they recede.

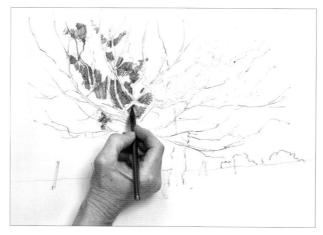

2 Loosely block in the main areas of ivy so that you begin to establish the structure of the trees. Don't try to put in individual leaves or any texture at this stage – this will come later. Remember to leave spaces where the branches lie over the top of the ivy and keep checking to make sure you're not covering any major branches that need to be left white.

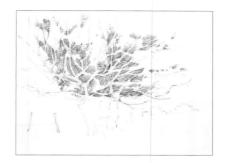

3 Continue working on the negative spaces between the branches of the trees until you have blocked in all the clumps of ivy.

A Now shade in the trunks, making short, jagged pencil marks with the tip of the pencil to convey the texture of the bark. Note that the trunk of the foremost tree is split; darken one side of the split to make it clear that one part of the tree stands in front of the other part. Even though there is no textural detail in the foliage, and the branches have simply been left as white shapes, the trees are already beginning to take shape.

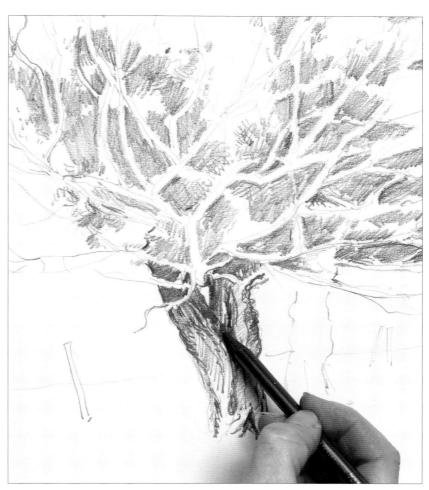

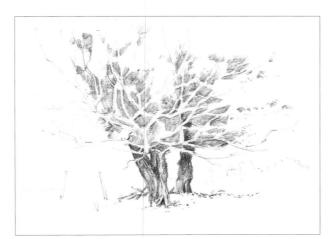

 $\mathbf{5}$ Block in the trunk of the second tree in the same way and dot in fallen leaves and exposed clumps of earth in the foreground. As you work, pay careful attention to where the main branches jut forwards in front of the trunk; allow them to remain white so that their position in relation to the dark trunk behind is clear.

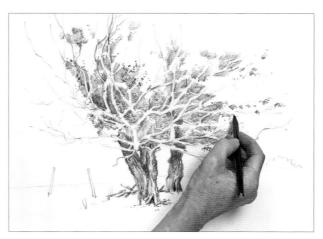

6 Now that the clumps of ivy have been blocked in, you can begin to put in more texture, by adding loose scribbles over the main blocks and dotting in some of the smaller clumps and individual leaves towards the extremities of the branches. Don't be too precise about the placing of the leaves – try to create a general impression of the way the ivy grows.

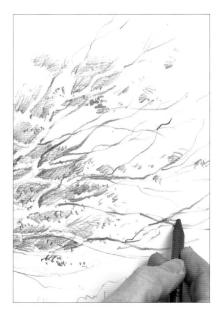

At the extremities, reinforce the lines of the branches in front of or parallel to the trunks with strong pencil marks, applying more pressure than you have done so far. There are lots of kinks and twists in the branches; make sure you convey this in your line work. Leave the largest branches in front of the trunks as white negative shapes so that they stand out against the darkness of the bark and the ivy.

Assessment time

The trees are taking shape well and the differences in tone help us to see where one trunk or branch is positioned in relation to others, with the darker elements appearing to advance towards us while lighter ones appear to be farther away. However, at this stage the trees seem almost to be floating in a void; you need to anchor them within the landscape by adding more detail to the fence posts and the bushes in the middle distance.

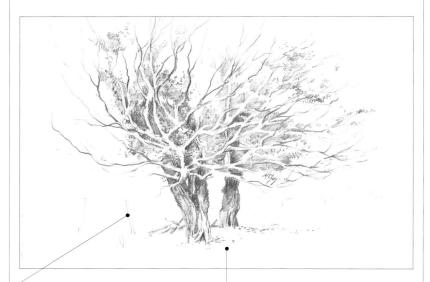

Strengthening the fence posts will make the setting clearer and help to lead the viewer's eye through the picture.

Adding more texture to the ground in front of the trees will help to set them in the context of the landscape.

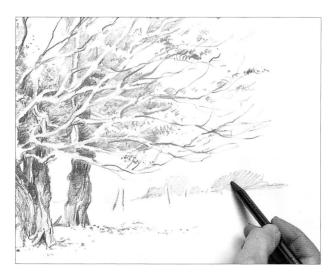

Because the bushes in the middle distance are further away than the trees, they appear to be lighter in tone. Block them in, applying medium pressure to the pencil so that you create a mid-tone rather than the very dense, solid greys and blacks used for the trees.

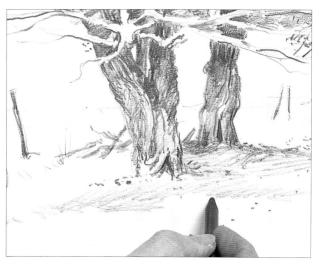

9 Block in the fence posts, making the two posts on the left of the image very dark and the others less so, so that you create a feeling of recession. Put some light shading in the foreground; even though it is covered in snow, the shadows reveal the undulations in the ground.

The finished drawing

Against the white sky, the starkness of the trees makes for a bold, graphic image. With flowing, confident pencil lines, the artist has created an image in which the branches grow organically out of the tree trunks, twisting and turning over

one another. There is just enough detail around the trees, in the form of the fence posts, a few small bushes, and some textural detail in the immediate foreground, to hint at the landscape in which they are situated.

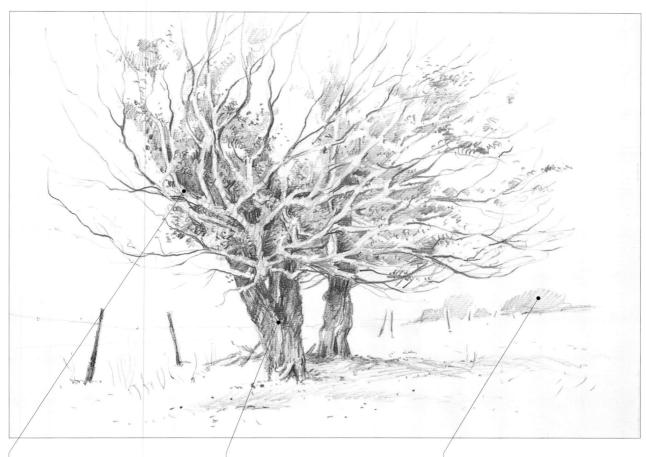

Confident, flowing lines capture the trees' growth pattern beautifully.

Jagged pencil marks convey the texture of the bark.

Soft mid-tones in the middle distance help to create a sense of recession.

Field of sunflowers

A field of bright yellow sunflowers in full bloom is a dazzling sight and one that has attracted many artists and photographers. But although the colour is the first thing that attracts your eye, it isn't necessarily enough to make a successful drawing: you also need to make sure that there's a focal point to the image, so spend plenty of time choosing the right viewpoint. Select a place where some flowers are face on and others are partially turned away, as this allows you to examine the structure of the flowers and introduce some variety into the way that you draw them. Also make sure that the flower heads are at different heights, so that you don't get a straight line running across the image.

The background is important, too – both the fields in the distance and the spaces between the plants. Although it's relatively indistinct in this scene, it sets the sunflowers within the context of the landscape. Half-close your eyes to assess which tones and colours to use – and don't be too literal in your rendition. Aim, instead, to create lively mixes of colour on the support by applying several layers of thin colour. Also make sure that the background hangs together as a whole and that no one part jumps forwards too much in the scene.

This is a complicated scene, with lots of different elements. To prevent yourself from getting bogged down in too much detail, concentrate on the negative shapes between the flowers. It's often easier to see these shapes than it is to draw the positive shapes (the flowers themselves).

Materials

- Good-quality drawing paper
- Coloured pencils: a selection of pale, mid-toned and dark blues and greens, burnt sienna, canary yellow, lemon yellow, yellow ochre, light brown and lilac

The scene

Although this scene might look a little confusing on first glance, the artist selected her viewpoint carefully to ensure that the sunflower heads made interesting shapes and were positioned at different heights within the picture area.

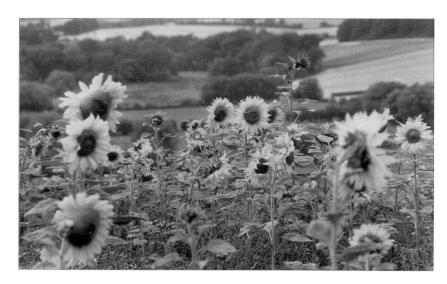

1 When you've chosen your viewpoint, lightly sketch the scene using burnt sienna for the sunflowers and pale blues for the shapes of the fields in the background. Look at the spaces between the flowers, and at where they overlap one another, as well as at the individual flower heads.

2 Loosely colour in the background fields with a range of blues and greens, with touches of burnt sienna in places for the exposed patches of earth, getting slightly darker as you move towards the foreground. As you reach the sunflower field, begin to fill in the negative shapes between the stems.

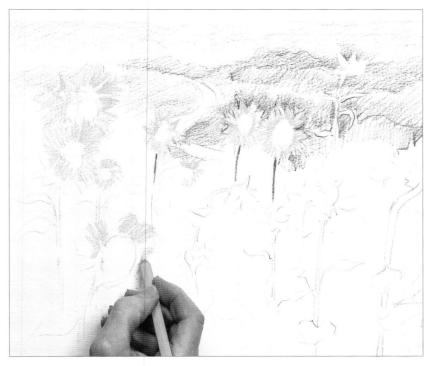

3 Start blocking in the yellow petals of the largest sunflowers using a canary yellow pencil for the darker yellows and lemon yellow for the brighter yellows.

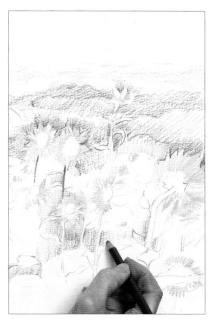

4 Continue blocking in the yellows, varying the tones as appropriate. Block in the negative shapes in the immediate foreground in blue, using loose scribbles.

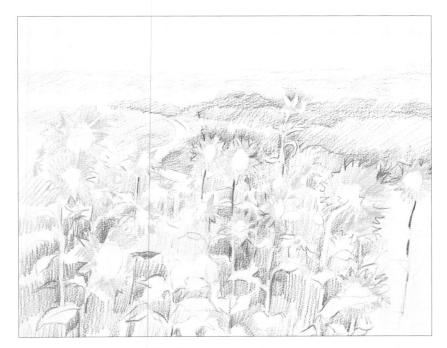

5 Continue the process of blocking in the negative spaces between the sunflowers that you began in Step 2, using a range of blues and greens as appropriate. Note that the colour is not uniform: look for differences between the warm and the cool tones, as some areas are cast into shadow by the sunflower leaves and flowers while others are in bright sunlight.

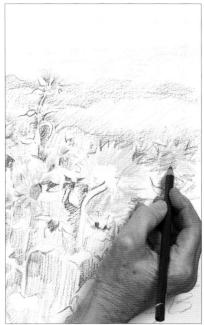

Work over the background fields again, gradually darkening them.

Colour in the flower centres. Note that some are darker than others: alternate between yellow ochre and burnt sienna.

Assessment time

Achieving the correct tonal values is a gradual process and one that cannot be rushed, but now that all the elements are in place you should take the time to stand back and look at the drawing as a whole to assess how much more needs to be done. You can see that the drawing is too pale overall and that more contrast between the lightest and darkest areas is required. In addition, more modelling is required on the main subject – the sunflowers.

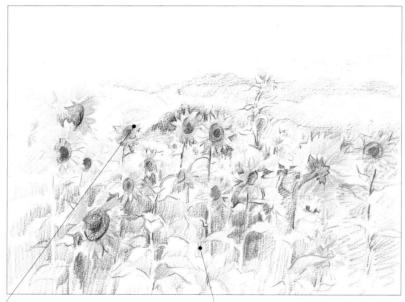

The sunflowers look rather flat and somewhat two-dimensional.

The leaves do not stand out clearly against the background.

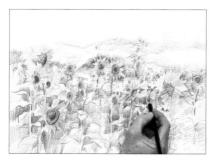

Vising dark blue block in the bluer tones of the background fields with vertical scribbles, getting darker as you come towards the foreground.

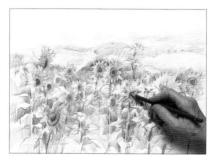

Apply brown over some of the brighter background greens to soften them. Block in some of the brown stalks. Some flowers are partially turned away from the sun: apply brown pencil over these areas.

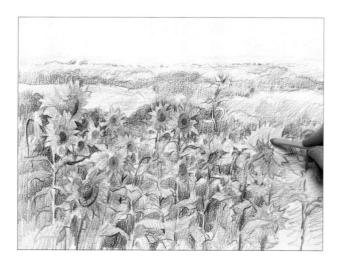

D Loosely scribble blue over the sky. Work on the background, trying to develop some texture and a range of shapes and tones. Work on the negative spaces between the flowers again, delineating the edges with dark greens and blues, and darken the yellows of the sunflowers.

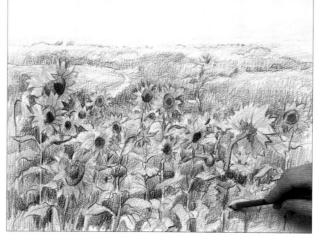

10 Adjust the colours and shading across the image as a whole, applying touches of warmer colours such as lilac in the foreground to make this area seem closer to the viewer. Using the tip of the pencil, apply some veining to the leaves in the immediate foreground.

The finished drawing

With the flower heads and leaves turning and twisting at different angles, this drawing is full of interest. There is just enough of the landscape in the background to convey

something of the setting, while the spaces between the plants in the foreground provide a darker backdrop against which the leaves and flowers can stand out.

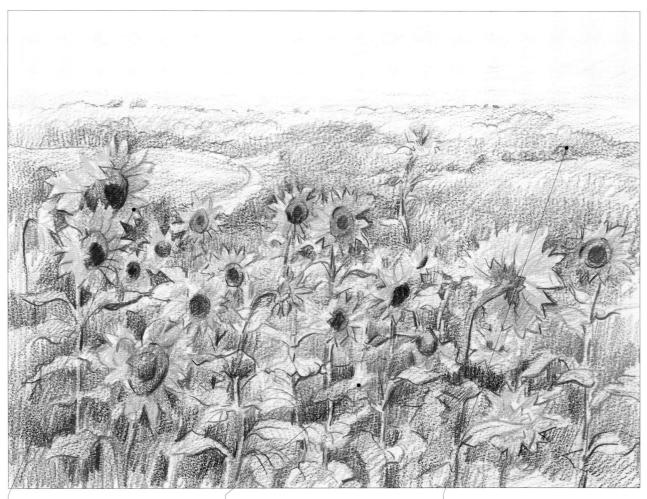

Simple shading makes the flowers look three-dimensional.

The leaves stand out well against the dark negative spaces between the plants.

The colour is paler on the distant fields, creating a convincing sense of recession.

Flower-filled alleyway

Scenes of alleyways with whitewashed buildings adorned with brightly coloured plants are commonplace in Greece, Spain, Portugal and other Mediterranean countries and are the perfect reminder of an enjoyable holiday.

When drawing flowers you have to choose between a very detailed drawing which is botanically accurate in every respect, or a more impressionistic approach that captures the mood of the scene, as the artist does here. Oil pastels are an excellent medium for this approach. With their broad tips they are not suitable for precise linear details, but they can be used for bold spots of colour.

The key to this scene is to make sure there is enough contrast between the very dark and the very light areas. Here, the brightest areas are created by using the white of the support: as you can't make the light areas any lighter than this, the only way to ensure sufficient contrast is to make the darks really dark. At the same time, you need to maintain some textural detail in the areas of shadow.

1 Using a pale grey oil pastel, sketch the main lines of the scene – the buildings, with their windows and doors, and the large wedge-shaped shadow that juts across the alley from the left. Measure the proportions and angles carefully; if you're unsure, put in the lines lightly in pencil first, as pencil is much easier to erase than oil pastel.

Materials

- Oil sketching paper
- Oil pastels: pale grey, turquoise blue, mid-brown, purplish blue, bright green, reddish brown, orange, grey-black, dark green, crimson, cadmium yellow deep, mid-green, black, white, olive green
- Turpentine or paint thinner and clean rag

The scene

A wedge-shaped shadow on the left directs the viewer's eye towards the flowers scrambling up the wall on the right-hand side. The pale-coloured stonework acts as a foil for the bright flowers and adds an interesting contrast of texture.

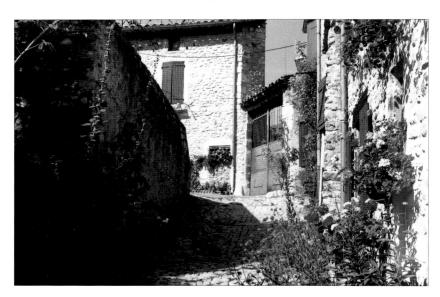

2 Using a turquoise blue oil pastel, block in the sky. Block in the shadow with a mid-brown oil pastel and go over it with purplish blue and turquoise. (Shadows are never a single, uniform colour.) Using the purplish blue and turquoise pastels, block in the shadows cast on the right-hand wall by the flowers.

3 Using the side of a pale grey pastel, loosely block in the sides of the buildings that are in shadow and the long, thin shadows that run across the foreground. Don't press heavily on the pastel or the coverage will be too thick, making it difficult to apply subsequent layers and achieve lively, interesting colour mixes in the shadows.

4 Dip a rag in turpentine or in white spirit and rub the rag gently over the sky and shadows to blend the pastel marks to a smooth colour.

Tip: Use a clean section of rag for each area that you blend, so as not to muddy the colours.

5 Using a bright green oil pastel, loosely scribble in the lightest green of the foliage and the iron gates at the end of the alleyway. Don't make your marks too specific, as you will refine the shapes and colours later; these loose strokes give the impression of uncontrolled growth. Use a reddish brown pastel to block in the shape of the large terracotta pot on the wall.

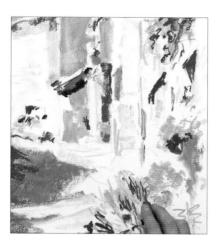

6 Using a reddish brown oil pastel, put in the door and woodwork. Soften the colour in places by adding a little orange over the top, blending the colours on the support by rubbing them together. Add grey-black for the tiled roof between the buildings. Scribble in very dark green throughout the scene for the darkest foliage. The image is now beginning to take on some depth.

Block in the red flowers in crimson and the lighter flowers in cadmium yellow deep. Both are warm colours, so the flowers immediately jump forwards in the scene. Scribble in the mid-tones of the foliage using a bright mid-green. The range of foliage tones helps to give the image depth as the light and dark tones hint at shadow areas within the leaves. Although the leaves are not drawn in detail, the use of different colours shows that there are several types of foliage in the scene.

The large shadow on the left is an important part of the composition, but now that the rest of the picture is beginning to take on some form, it appears too pale and flat. Add a little blue, green and purple to this area and blend the colours with a rag soaked in turpentine or white spirit. Keep the coverage patchy, however, to help create the texture of the ground. Draw the cracks in the paving in black oil pastel, making strong linear marks of varying degrees of intensity.

Block in the metal gate in the background in mid-green and use fine vertical lines of dark green for the individual bars. Draw the flowers on the background building, dotting in the general shapes and moving between light and dark tones to create a sense of form. Lightly apply pale grey over the shaded side of the background building. Indicate some of the horizontal courses in the stonework using grey and orange overlaid with white for a pinky terracotta colour.

Using the tip of the pastel and making jagged, spiky marks that jut out from the main stems, apply strokes of dark olive green to the stems in the foreground.

Tip: These spiky, linear marks create more detail and texture in the immediate foreground, which is one way to create a sense of depth in a drawing.

Assessment time

Now that the drawing is very nearly complete, you should take some time to assess the overall balance. Ask yourself, for example, if there is enough contrast between the very bright sunlit patches on the ground and the very dense shadows. Is there enough detail in the flowers and stems in the immediate foreground? Even very small adjustments at this stage can make a difference.

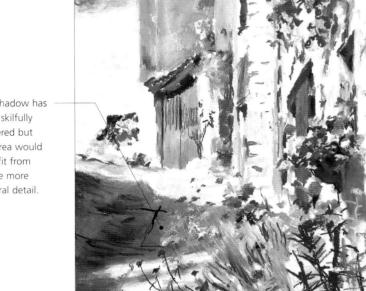

The shadow has been skilfully rendered but the area would benefit from a little more textural detail.

Even within an area that appears, at first glance, to be very dark, some texture should be evident. Where necessary, add a few small linear marks using a black pastel but take care not to overdo it.

12 Working lightly and quickly, add very thin vertical strokes of white, grey and yellow to the grasses in the immediate foreground to create more depth and enhance the spiky texture.

There is a lovely sense of light and shade, and of warm and cool areas, in this drawing. Note how the artist has left some areas of the paper almost untouched, so that the white of the support is allowed to stand for the dazzling patches of sunlight. Bold dashes of colour for the flowers and leaves combine with smoothly blended passages such as the sky and the large foreground shadow, creating a generalized impression of the scene, rather than a detailed rendition in which every flower or crack in the wall can be seen. The overall effect is very lively and appealing - the perfect reminder of a holiday in a sunny clime.

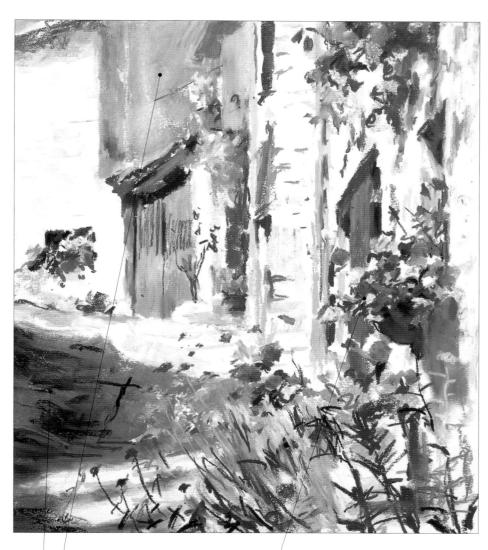

Although we cannot see the building on the left, its presence is implied by the very strong shadow, which also serves to lead the viewer's eye into the scene.

The smoothness of the sky (created by blending the pastel marks with a rag dipped in a solvent) contrasts well with the texture of the buildings and plants.

Although the individual leaf and flower shapes are not drawn precisely, the use of a range of tones creates a convincing three-dimensional feel.

Autumn leaf

From delicate yellowy-golds through to rich russets and reds, autumn leaves contain a wonderful range of colours. Even a single leaf can make a very attractive study. If you're new to working in soft pastels, this is the ideal project to start with. As the colours merge together in a random way, you can practise blending colours without having to worry too much about exactly where you place each one.

Use some artistic licence when it comes to drawing the background. You can choose between lightly sketching some generalized leaf shapes or laying down an overall colour, rather like out-of-focus leaf litter. Whatever you decide, try to get some variety and interesting blends into this area as a flat application of a single colour can look very bland and boring.

Pastel papers come in a wide range of colours. Here, the artist has used a pale peach-coloured pastel paper, which is much more sympathetic to the glowing autumn leaf than stark white paper.

Materials

- Pale peach pastel paper
- Soft pastels: pale cadmium yellow, lemon yellow, cadmium yellow, light red, burnt sienna, burnt umber, cadmium orange, white, yellow ochre, ultramarine blue

The leaf

It is the lighting that makes this leaf so interesting: it allows the veins on the leaf to stand out prominently. Note how the stem is on the diagonal, which makes the image more dynamic than if it were straight.

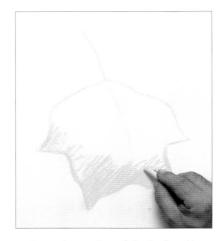

1 Draw the outline of the leaf and its stem in pale cadmium yellow pastel, putting in the central vein as a guide to help you judge where things are. Using a lemon yellow pastel, loosely scribble over the whole leaf. Although this will be modified by subsequent colours, it establishes the overall base colour.

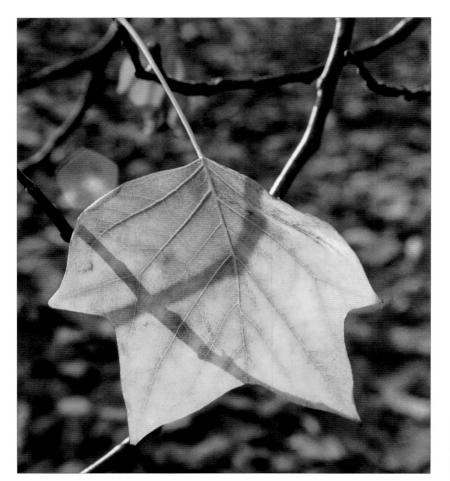

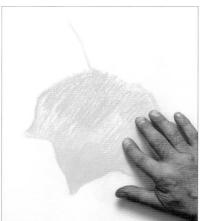

Make the lemon yellow pastel coverage looser in the centre. Scribble cadmium yellow (be aware this is poisonous) around the edges and blend with your fingers so that the individual pastel strokes cannot be seen.

Tip: Use the tip of your finger and work inwards, towards the centre of the leaf, so that you don't push pastel on to the background.

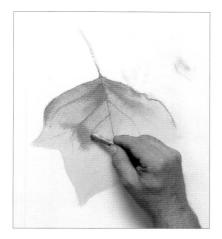

3 Stroke light red over the top of the leaf, where the reddest tones occur, and blend with your fingers. Touch burnt sienna into the darkest areas at the top of the leaf and blend. Draw the veins in burnt sienna.

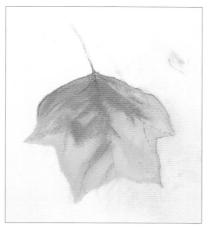

Continue using burnt sienna at the top of the leaf, blending the marks with your fingers as you go. Reinforce the veins with burnt umber. Blend cadmium orange over the top of the leaf and around the veins.

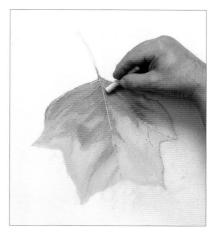

5 Now that the main colours are in place, you can start to add some detail. Using the tip of the pastel, carefully draw along the veins in white to begin to highlight the leaf's delicate framework.

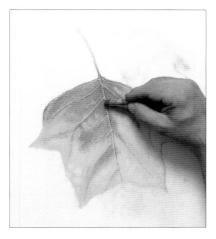

Apply pale yellow over the lightest parts of the leaf and the main veins. Blend small spots of lemon yellow over the lower half of the leaf so that it starts to take on a rich, warm glow. Using the tip of the pastel, draw along the shaded sides of the veins in burnt umber. Note how the veins are beginning to stand out from the rest of the leaf.

Assessment time

Draw around the edge of the leaf in burnt umber to define it. This helps to make the shape clearer, but the leaf still looks a little flat and two-dimensional. You need to build up the form and put in some kind of background so that the leaf really comes forward in the scene.

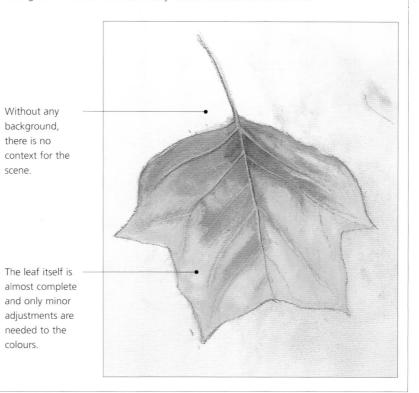

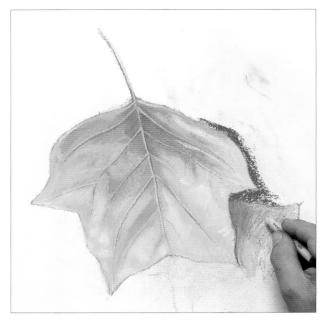

Z Start to put in the background by roughly sketching the shape of other leaves behind. Draw around the top right of the leaf in burnt umber to imply the bark of the tree behind. Scribble yellows, oranges and reds over the background, making the colours next to the leaf quite dark so that it looks as if the leaf is casting a shadow on those behind.

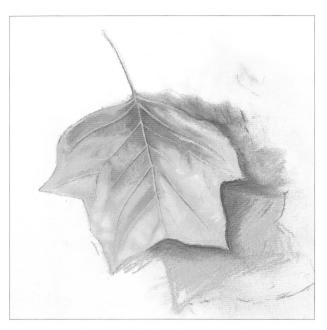

8 Your scribbles have helped to bring the leaf forwards in the scene. Now apply more colour to the background to imply that there are leaves in this area, too – yellow ochre, a little burnt umber, and any other colours in the same colour range. Blend the colours lightly with your fingers, so that the coverage is fairly smooth but some textural marks are still visible.

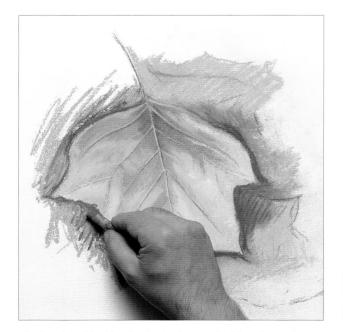

 $\mathbf{9}$ Continue blocking in the background with yellow ochre and other colours, and add a little ultramarine blue and burnt umber, so that the background is darker than the leaf. Blend the area with your fingertips.

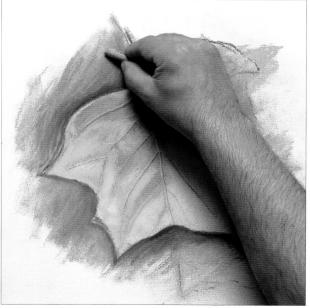

10 Continue working on the background, using the same range of colours as before and blending the marks with your fingers, until you're satisfied with the colours and the overall balance.

The finished drawing

This is a relatively simple exercise, but it demonstrates the potential and versatility of soft pastels. The pastel marks have been smoothed out to create almost imperceptible transitions from one colour to another, and the leaf has a luminous glow

that is characteristic of late-afternoon sunlight in autumn. The careful application of light and dark tones on the veins has made them look convincingly three-dimensional and these crisp, unblended lines add another texture to the study.

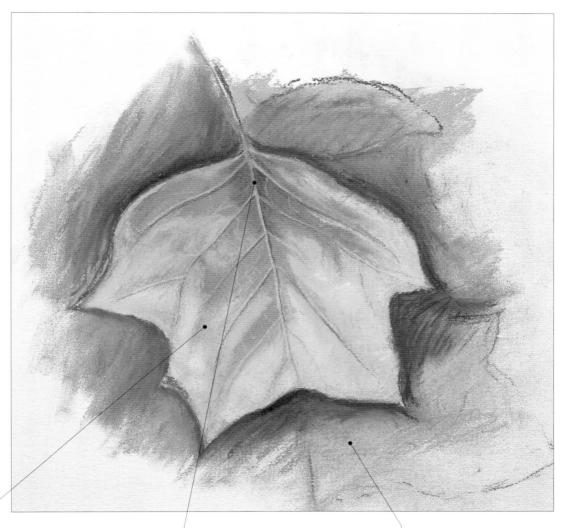

The pastel marks on the leaf have been blended on the support to create smooth areas of colour.

The crisp detail given to the leaf veins adds contrasting interest and a focus to the leaf structure.

Vague leaf shapes in the background suggest the natrual woodland setting that lies beyond.

Quick sketches of landscapes: Riverbank

A riverside setting has lots of potential for interesting landscape sketches. If the river runs swiftly, there will be splashes and swirling eddies as the water breaks around rocks and other objects. Gentle ripples create a different mood, slightly distorting any reflections. Occasionally, you come across a hidden pool in which the water appears to be completely still, where the reflections are sharp and crisp. Each requires a different approach, from dynamic, energetic marks for rapidly flowing water to a more measured, controlled approach for very still water and reflections.

Whatever the mood of the river, it is often a good idea to use it as a compositional device to lead the viewer's eye through the picture. Bear this in mind when you position yourself on the bank to take a reference photo or make a sketch. A view along a river, so you can see how it meanders its way through the surrounding area, is almost always more satisfying in compositional terms than one looking straight across from one bank to the other as, in the latter case, the river will form a broad horizontal band that cuts the composition in two and blocks the viewer's eye from moving any further through the scene.

When you're drawing water, always remember that it takes its colour from surrounding objects – although the colour is generally slightly more muted in the reflection than it is in the object itself. In a riverside setting the greens and browns of nearby trees may be reflected in the water; alternatively, there may be patches of sky that are so bright that you need apply virtually no colour whatsoever.

The scene

Here, the river forms a gentle curve that leads our eye through the scene to the buildings on the horizon. The sky is very bright and bland, with no dramatic cloud formations to add interest to the scene, so the reflections of the trees along the bank provide a feature in what would otherwise be a completely empty area.

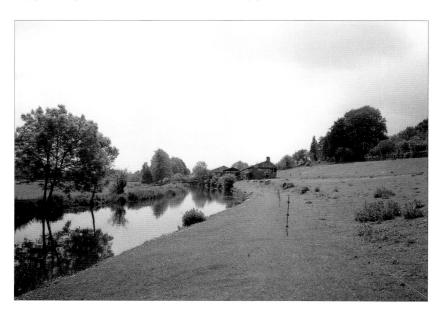

5-minute sketch: sepia water-soluble pencil

Five minutes is plenty of time for you to work out a composition for a larger drawing. Make a quick thumbnail sketch, roughly outlining the shapes of the main elements (including the reflections).

10-minute sketch: sepia water-soluble pencil

A tonal study will require a little more time. Here, the artist lightly brushed a little clean water over some of the pencil marks to blend them to a tonal wash, leaving the brightest areas untouched.

15-minute sketch: sepia watersoluble pencil

In this sketch, more textural detail is evident. It is created by using the water-soluble pencil dry (on the grass on the near bank, for example) and on slightly damp paper, so that the marks spread a little (on the large tree on the far bank).

30-minute sketch: sepia watersoluble pencil

In the longest sketch of the series, the scene is beginning to look more three-dimensional. Note how some elements, such as the large tree on the far bank and the grass in the foreground of the near bank, are given more textural marks, which helps to indicate that they are nearer the viewer and create a sense of recession in the scene.

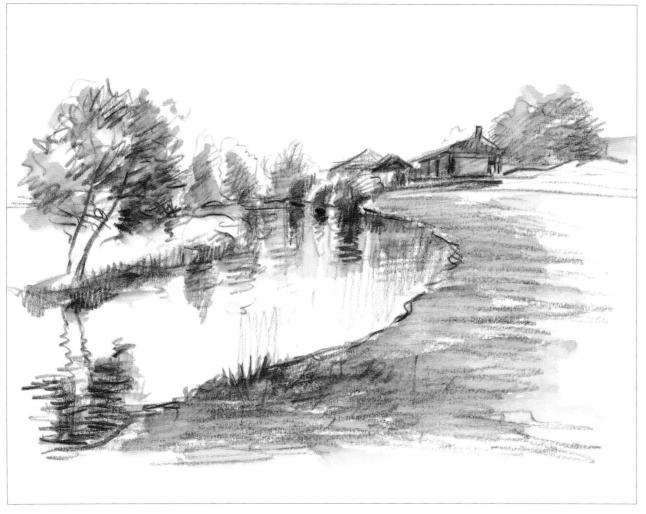

Quick sketches of landscapes : Mountain track

When you're drawing or sketching on location, particularly when you're faced with a panoramic view, it's very easy to get carried away by the grandeur of the setting and lose sight of the fact that your image needs to work as a composition. Always look for something that you can use as a focal point, such as a large boulder or a tree, and place it at a strong point in the picture space so that the viewer's eye goes immediately to it. Look for lines (real or imaginary) that lead the viewer's eye

through the scene – maybe a wall or a fence, a line of bushes or, as here, a stony track leading into the distance.

To convey the scale of the scene and create a convincing sense of recession, you must also remember the rules of aerial and linear perspective: objects that are further away should appear smaller and paler in tone than those that are close by. Having more texture and detail in the foreground is another way of making this part of image appear closer.

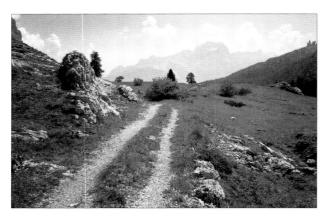

The scene

The track directs our attention to the mountains in the distance, while the rocks on the left provide a much-needed focal point.

5-minute sketch: charcoal

Compositionally, the track is an obvious way of drawing our attention to the backdrop, as are the wedge-shaped slopes on the left and right. Once she had worked out the composition, the artist scribbled down some very rough, linear marks for the pebbly track and rocks, and smudged charcoal to create broad areas of dark and mid-tone. The mountains were largely left untouched, so that they are paler than the foreground areas, which helps to create a feeling of recession.

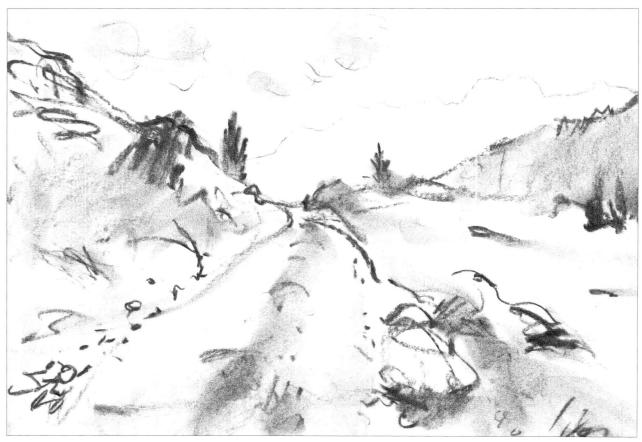

15-minute sketch: chisel-tip pen

You may never have thought of using an ordinary fibre-tip pen as a drawing tool but, although it is not the most sophisticated of implements, it can be very useful for making quick sketches on location as it is easily portable and clean to handle. By adjusting the angle at which you hold it and by applying differing amounts of pressure, you will also find that it can make a surprisingly varied range of marks. Here, the artist used spiky vertical marks to convey the texture of the grasses, while rough circles describe the pebbles on the track and wispy curves imply the fluffy clouds overhead. The chisel-shaped tip of the pen was used to block in larger elements such as the trees, bushes and boulders, creating a convincing sense of solidity in these areas. Note how the amount of visible detail decreases with distance: apart from a few sketchy lines to indicate the contours, the distant mountains are left blank.

30-minute sketch: soft pastels

A cream pastel paper gives an underlying warmth to the image; the tooth of the paper also has an effect, as it helps to convey the texture of the pebble-strewn ground. Note how many different greens and yellows the artist has used. She has overlaid them to create lively colour mixes and blended them in parts so that areas of soft grass contrast effectively with the hard texture of the rocks.

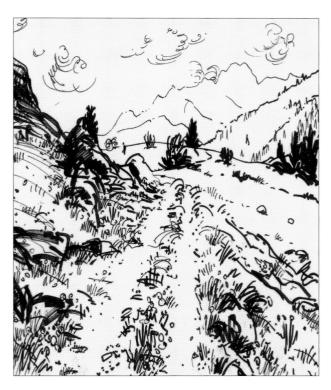

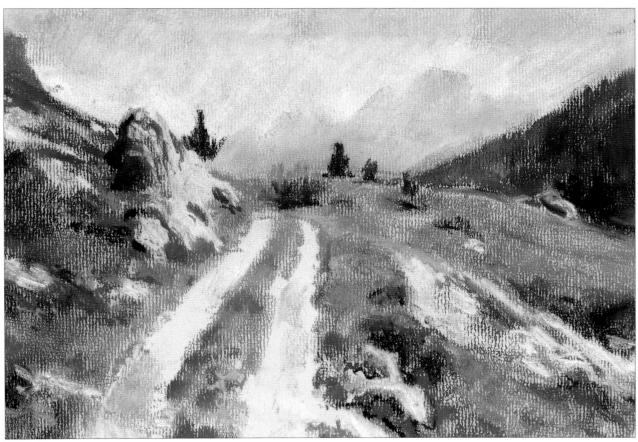

Quick sketches of landscapes: Field of rape

Don't ignore the potential of man-made landscapes such as arable crops: they can provide you with subjects that are every bit as colourful and intriguing as wild, rugged scenes. Start by looking for something that you can use as the main centre of interest in your drawing – a lone tree, farm machinery rusting away in a corner, or a distant farmhouse, for example – and place it at a strong position in the picture space. If there is no obvious focal point, as in the images on these two pages, decide what it is that makes you want to draw the scene. Here, it is obviously the mass of brightly coloured flowers. In a situation such as this, where almost all the plants are the same height, select your viewpoint carefully and pay attention to the negative spaces in between the plants in order to create a well-balanced composition.

5-minute sketch: ballpoint pen

This is a compositional sketch: the converging lines of the hedgerow on the left and the line of trees in the background create strong, dark lines against which the lighter flowers will stand out clearly. The artist has indicated the darkest areas within the flowers by means of swiftly hatched lines, leaving the paper white for the densely packed mass of flowers in the bottom left of the image.

The scene

Meadows and fields of crops such as this rape in flower make colourful subjects for landscape drawings and paintings. Here, the artist selected a relatively low viewpoint, which gave a large mass of flowers in the bottom left of the image. The hedgerow on the left and the line of trees in the background jut up above the field, providing much-needed vertical elements in the composition. Their dark, straight lines also help to concentrate the viewer's attention on the flowers.

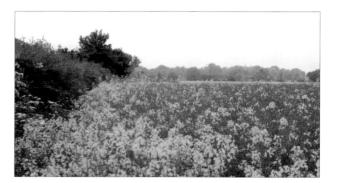

15-minute sketch: 4B graphite stick

This is a slightly more elaborate sketch than the one on the previous page: the artist had time to begin exploring the range of tones within the scene. Once he had established the dark, solid lines of the hedgerow and trees, he concentrated largely on the negative shapes – the dark spaces between the stems – scribbling them in with the tip of the graphite stick.

30-minute sketch: pastel pencils

Pastel pencils are a lovely medium for this subject, as the pigments can be blended both optically and physically. Look carefully at the scene and you will be amazed at how many different greens and yellows you can discern. Here, the artist has created an impression of the stems blowing in the breeze. Note how the warm, orangey yellows in the foreground make this area seem closer to the viewer.

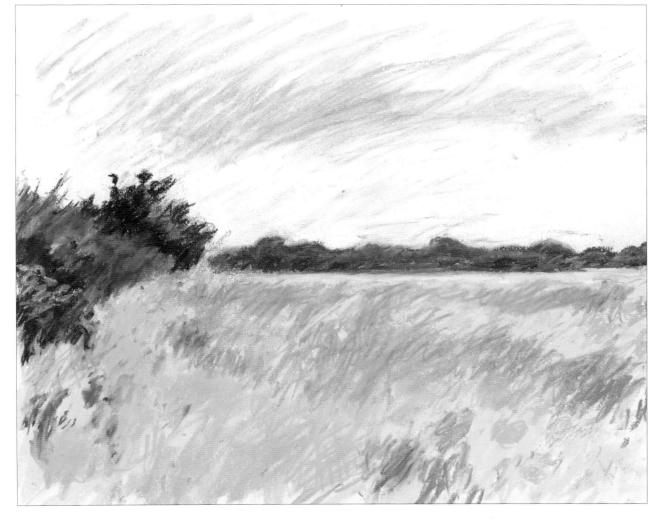

Mediterranean seascape

This tranquil scene of waves lapping a Mediterranean shore is full of sunshine and light. Although the composition is simple there is plenty to hold the viewer's attention, from the partially submerged rocks in the foreground through to the town in the distance.

The main interest, of course, is the rippling sea itself, with its myriad tones of blue, green and even violet - and soft pastels are a wonderful medium in which to portray this. It's surprising how many colours you can see in the water. Water takes its colour from objects in and around it - the sky, rocks, seaweed and algae, and so on - so look at the surroundings, as well as at the water, as this will help you assess which colours are required. Half-close your eyes when you look at the scene, as this makes it easier to assess the different colours and tones. It's hard to be precise about which colours to use in this project, as soft pastels are available in such a huge range of colours, but put together a selection of blues, greens, violets and browns, from very pale to very dark.

Remember that the rules of both linear and aerial perspective apply to sea and sky just as much as they do to objects on land. Distant waves, for example, appear smaller than those close at hand. Colours also appear lighter with distance and texture is less pronounced – so smooth out your pastel marks on the sky and the most distant part of the sea by blending them lightly with your fingers or a clean rag.

Observe your seascape very carefully before you draw. Look at any sea scene for a while and you will see that the waves follow a regular pattern, with incoming waves building to a peak and then falling back. Note how high they go and how far back they fall when they break around a rock or crash on to the shoreline.

Materials

- Cream pastel paper
- Neutral brown or grey pastel pencil
- Soft pastels: a selection of blues, greens, blue-greens, turquoises, violets, browns, oranges, ochres and white
- Soft rag

The scene

The dark wall on the left forms a diagonal line at its base which directs the viewer's attention towards the town in the distance. The town itself is positioned roughly 'on the third' – a strong position in any composition.

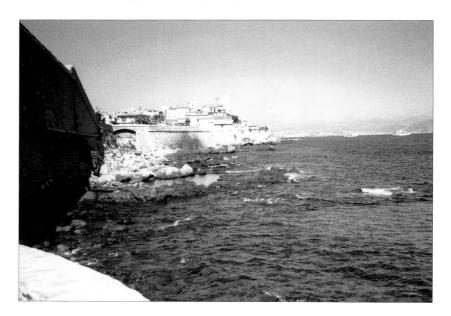

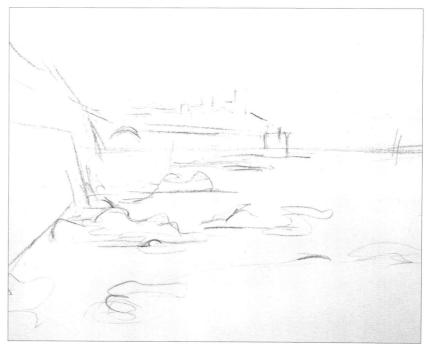

1 Using a neutral-coloured pastel pencil, put in the lines of the headland and horizon and the dark, submerged rocks in the water. Note that the artist decided to make the headland and rocks more prominent in the scene and omitted the light-coloured concrete walkway in the bottom left of the reference photo.

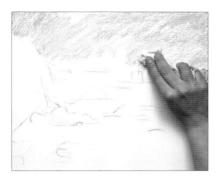

2 Roughly block in the sky with a mid-blue pastel and blend with a clean rag to smooth out the marks.

Tip: Keep the coverage slightly uneven, to give some texture to the sky. If the colour is completely flat and

uniform, it will look rather boring.

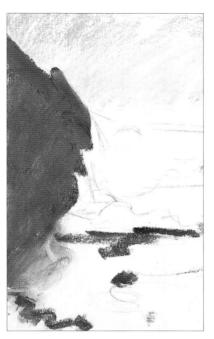

Block in the wall on the left with a mid-brown pastel and smooth out the marks with a rag or your fingers. Scribble in the partially submerged rocks using the same colour.

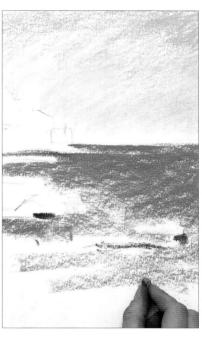

A Block in the sea using a turquoise pastel, leaving some spaces for the breaking wavelets. Note that the sea has some areas that are lighter than others, so apply less pressure here.

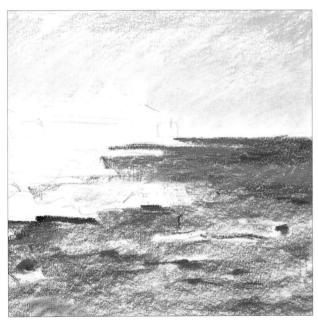

 $\mathbf{5}$ Apply a few light touches of a darker turquoise to the darkest parts of the sea in the background. Loosely scribble jade green over the foreground water to pick up the green tones, varying the amount of pressure you apply to get some variety of tone.

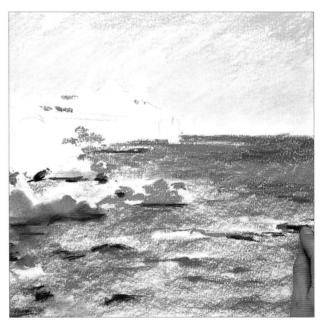

6 Looking carefully at their rough, uneven shapes, apply burnt orange over the tops of the exposed rocks in the sea near the base of the wall, switching to a reddish brown for their bases. Blend the marks gently with clean fingertips.

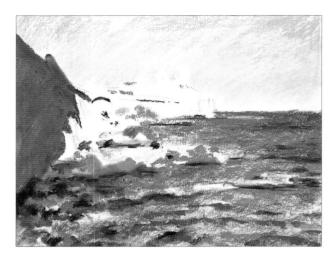

Z Look at the colours in the water. The underside of breaking wavelets contains some surprisingly dark greens and blues. Stroke these in lightly, making sure your strokes follow the direction in which the waves are moving. Gently smooth the marks a little with your fingertips – but don't overdo the blending, as allowing some of the underlying paper colour to show through helps to create a sense of movement in the water.

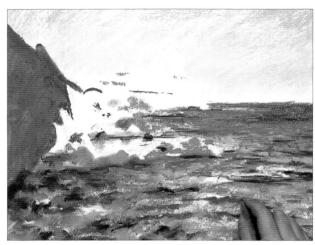

8 Continue building up different colours in the water, using dark greens and blues and dots of light spring green.

Tip: Remember to keep referring to your reference photo. It's easy to get carried away with building up the colours and forget to look at the shades that are actually there.

Assessment time

There is a lovely sense of movement in the sea and a good range of different tones and colours. However, the rocks

themselves are nothing more than flat blocks of colour and need to be made to look three-dimensional.

The wall is a flat expanse of brown

— it needs to look rough in texture
and three-dimensional.

The rocks are little more than patches of colour and lack form.

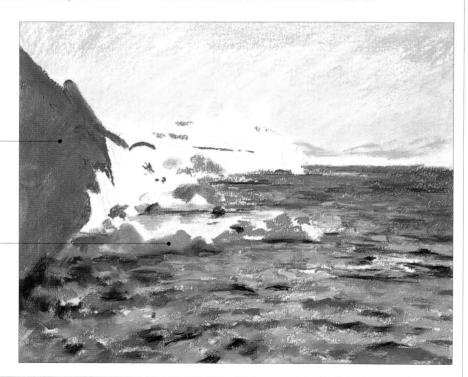

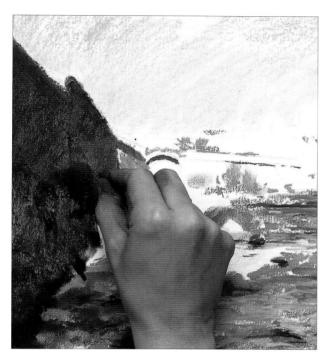

Start to build up some tone and texture on the wall by scribbling on dark greens and browns, making horizontal strokes that suggest the blocks that it is built from. Smudge the colours with your fingers, allowing some of the underlying mid-brown that you put down in Step 3 to remain visible.

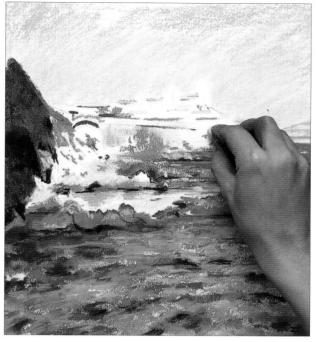

10 Repeat the process on the rocks surrounding the partially enclosed still pool, scribbling a reddish brown over the orange to build up the form. On the distant headland, put in the darkest colours of the buildings – the browns and terracottas of the roofs. Apply pale yellow ochre to the white of the headland so the paper doesn't look so stark.

1 1 Dot some light and mid-toned olive greens into the headland for the distant trees. Apply pale blue and midtone turquoise over the sky to darken it towards the top (skies generally look paler close to the horizon).

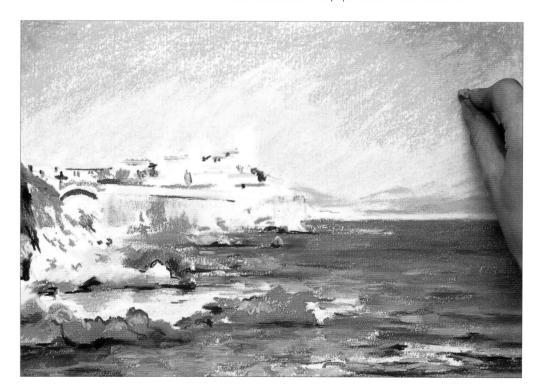

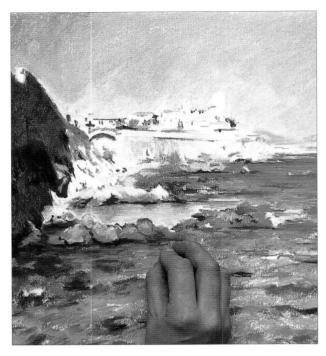

12 Although little detail is visible in the distant town, you need to give some indication of the buildings. Look for the dark tones under the eaves of the roofs. Making small horizontal strokes, apply pale blues and greens over the most distant part of the sea and smooth them out with your fingers. Apply thin lines of dark brown around the bases of the partially exposed rocks.

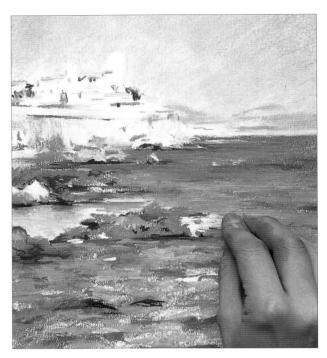

13 Having now given the rocks some solidity, return to working on the foreground seascape again, and put in the white of the wavelets as they break around the partially exposed rocks. Use the tip of the pastel and dot in white here and there around this area. The softly lapping sea has only a gentle swell, so take care that you don't make the wavelets too big.

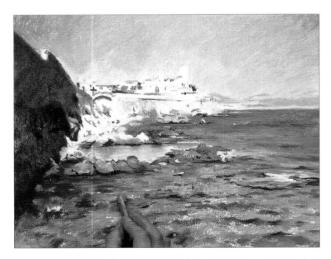

14 Continue adding texture to the foreground sea, making sure that the dark greens, blues and purples in this area are dark enough. Don't smooth out your marks too much: it is important to have more texture in the foreground of a scene than in the background, as this is one way of creating a sense of recession.

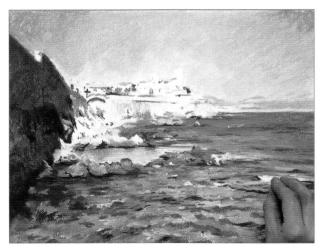

15 Continue building up form on the exposed rocks, using a range of dark oranges and browns as before. It is now time to put in the final touches – more tiny strokes of white for the breaking wavelets and horizontal strokes of dark greens and blues in the foreground sea, wherever you judge it to be necessary.

The finished drawing

There is a lively sense of movement in the sea: one can almost feel the ebb and flow of the waves and hear them lapping around the rocks. Note how allowing some of the paper to show through the pastel marks creates the effect of sunlight sparkling on the water. There is just enough detail in the

distant headland for us to know that there is a town there; more detail, however, would draw the viewer's attention away from the sea in the foreground and destroy the illusion that we are looking almost directly into the sun, our eyes dazzled by its brilliance.

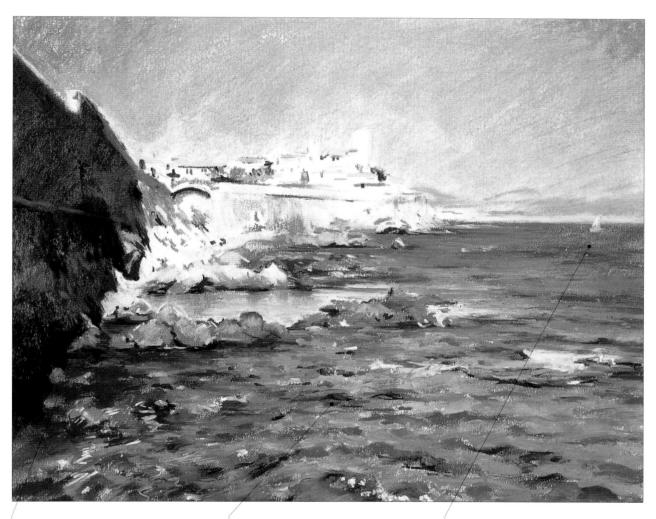

The wall provides solidity at the edge of the picture area and helps to direct the viewer's eye through the scene.

Small horizontal strokes of blues, greens and purples are used to convey the many different shades in the water.

Detail diminishes with distance, and so the pastel marks in this area of the sea are smoothed out to give less texture.

Snow scene

Here's an interesting challenge: how do you draw a bright, white subject such as snow using charcoal, which is one of the densest and darkest drawing mediums available? The answer is not to attempt to draw the snow at all: allow the white of the paper to stand for the brightest parts of the snow and use the charcoal for the mid- and dark tones. Focus your attention on the clumps of earth that poke up above it and the thicket of trees on the right of the image, rather than on the powdery, white covering on the ground.

Also, note that the snow is not a uniformly pure, unsullied white. The ground undulates, forming little peaks and shaded troughs. Tones of grey are required to make this distinction smooth, pale tones without any sharp edges. To give the drawing impact, you also need to contrast the heavy, solid forms of the trees and background ridge with the much softer and less substantial shapes of the clouds and shadows. Use all the blending techniques at your disposal: smudge lines with your fingertips or (for larger areas) the side of your hand, or blend marks with a torchon, a sponge or a piece of tissue paper, as this allows you to build up areas of tone without creating a hard line.

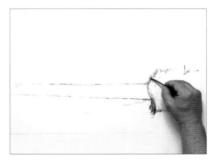

1 Using a thin charcoal stick, map out the proportions of the scene. Look for specific points from which you can measure other elements. Here, the artist used the clump of trees as a starting point. When he measured it, he discovered that the distance from the base of the clump to the base of the ridge in the distance is roughly the same as the distance from the base of the trees to the base of the image.

If you get accidental charcoal smudges, don't worry. This is an unavoidable part of charcoal drawing and you can always wipe off powder with an eraser. A kneaded eraser gives a soft, smooth finish; for sharp edges, cut a plastic eraser or pull a kneaded eraser to a fine point. For an cheaper alternative, try small pieces of soft white bread.

Materials

- Smooth drawing paper
- Willow charcoal sticks thin and medium
- Kneaded eraser
- Compressed charcoal stick
- Large torchon
- Plastic eraser, cut to give a sharp edge
- Small sponge

The scene

Here is a typical winter scene across a ploughed field. The thicket of trees on the right provides a focal point while the clumps of earth poking up through the snow form diagonal lines across the field that lead the viewer's eye through the composition.

2 Using the side of the charcoal, roughly block in the wedge-shaped area of land in the middle distance and the thicket of trees on the right. Make jagged, spiky marks for the top of the thicket to convey the texture of the trees. Note also that some areas are darker in tone than others; although you will elaborate this later, it's a good idea to get some tonal variation into the drawing even at this early stage.

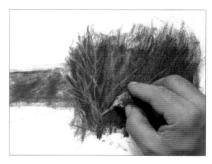

3 Using the tip of a medium charcoal stick, draw the darkest areas within the thicket of trees. Look for the negative shapes – the spaces between the branches rather than the branches themselves. Switch to a thin charcoal stick for the branches that stick out at the sides and top of the main mass. Using a kneaded eraser, lightly stroke off charcoal for the lighter-toned branches within the clump.

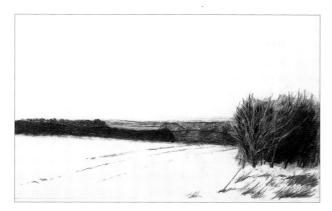

A Start to introduce some form into the wedge-shaped area of land in the middle distance. The trees at the front of this area are very dark in tone, so build up the tone with heavy, vertical strokes. Use a thin charcoal stick to start dotting in the exposed clumps of earth peeping up above the snow in the field and make thin vertical strokes for the grasses on the right-hand side of the image.

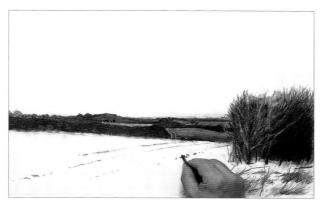

5 Using a stick of compressed charcoal, put in some very dark blacks in the trees in the middle distance so that you gradually begin to build up texture and tone. Also use the compressed charcoal to draw more of the exposed clumps of earth that run across the field, making small, dotted marks of varying sizes and making the marks darker as you come towards the foreground.

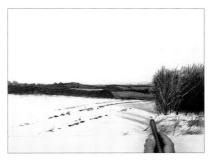

6 Rub some charcoal on to a scrap piece of paper and press the end of a large torchon into the resulting powder. Gently stroke the torchon over the snow that leads down to the clump of trees to create soft shadows.

Zusing a plastic eraser, wipe off some of the charcoal to create the snow on the edges of the fields in the middle distance. By cutting the eraser you can get a crisp, sharp-edged line.

Assessment time

The main elements of the composition are in place, but the contrast between the sky (to which no charcoal has been applied so far) and the dark, dense tones of the trees is too extreme. Even so, the thicket of trees on the right still needs to be darkened in places. Your task now is to develop texture and tone across the whole image. In order to do this, you will need to continually assess the tonal balance of the drawing as a whole, to ensure that no one part becomes too dominant.

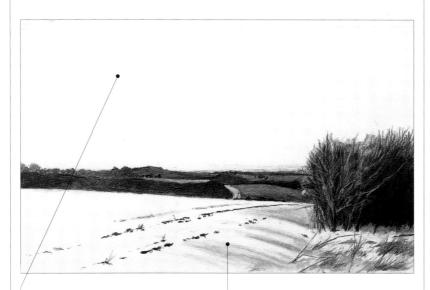

As yet there is no detail in the sky, which forms roughly half the image.

With the exception of a few foreground shadows, there is no texture or detail in the snow areas.

Wipe the side of a medium stick of charcoal over the sky area. Note how the coverage is uneven, creating lovely dappled marks.

9 Using a circular motion, vigorously rub a small sponge over the sky to smooth out the charcoal marks.

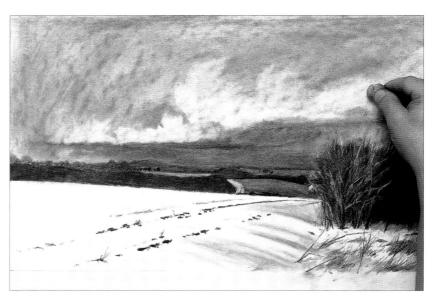

10 There is a band of blue in the sky above the land and below the mass of clouds. Block this in using the side of a medium charcoal stick and blend it to a mid-grey with a torchon, making it darker in tone than the rest of the sky. Using a kneaded eraser and a vigorous circular motion, lift off shapes for the looming storm clouds. Don't worry about the tones within the clouds at this stage; just try to get the approximate shapes. Note how putting some detail in the sky has changed the mood of the drawing from a tranquil winter scene to something much more dramatic, in which the threat of a storm is imminent.

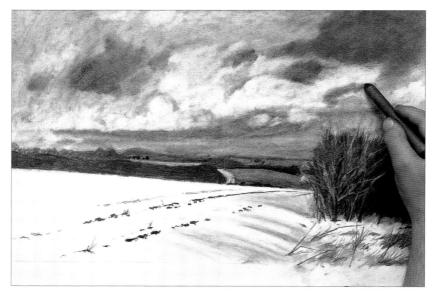

1 1 Put in some very dark storm clouds and blend the charcoal with your fingertips or a sponge. Immediately, the scene looks much more dramatic; note how the dark areas of sky balance the thicket of trees on the right of the image. Scribble some charcoal on a piece of scrap paper to get some loose powder, as in Step 6. Dip a torchon in the powder and gently stroke it over the sky to create softly blended areas of mid-tone between the clouds. This allows the white areas of the clouds to stand out more clearly.

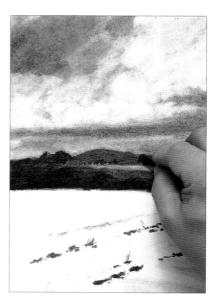

12 The sky is now quite dark, so you may need to darken the land mass to make it more dominant. Compressed charcoal gives a very rich, intense black. Note how the snow also seems to sparkle and stand out more once the land mass has been darkened.

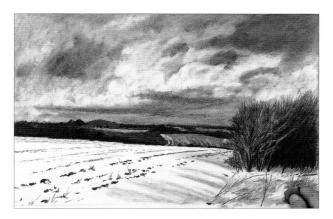

 13° Using a thin charcoal stick, put in any remaining exposed clumps of earth on the field. Re-assess the whites in relation to the rest of the image. You may need to use a kneaded eraser to lift off some charcoal in the grasses on the right.

The finished drawing

This drawing demonstrates the versatility of charcoal. It can be blended to give a smooth, even coverage, as in the mid-toned areas of the sky, or used to create bold, highly textured marks, as in the clump of trees. The success of the image is due largely to the contrast between the very light and the very dark areas. In scenes like this, the key is often to darken the dark areas rather than to lighten the lights.

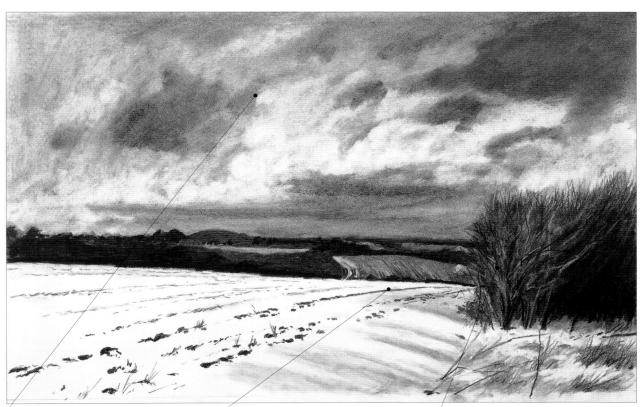

Charcoal is softly blended with a sponge to create the clouds.

The exposed clumps of earth are paler in the distance, creating a sense of recession.

'Drawing' some of the branches with an eraser creates fine, crisp-edged lines.

Reflections in rippling water

Shimmering reflections are great fun to draw. Perfect reflections, however, do not necessarily make the most interesting subjects, as part of the fascination lies in seeing how familiar shapes and objects are distorted when reflected. In this project, your challenge is not only to draw the reflections convincingly but also to capture a sense of movement in the gently rippling water.

Before you start drawing, spend time looking at both the shapes and the sizes of the ripples. There are two distinct types of ripple in the scene – horizontal ripples, which are caused by a very slight breeze, and circular ripples in front of the ducks as they move through the water. Look out for these shapes and alter your pencil strokes accordingly, using a curving or swirling motion for the circular ripples. And remember the rules of perspective: in order to create a sense of distance, foreground ripples need to be larger and further apart than those in the background.

Coloured pencils are used for this project – the perfect opportunity for you to practise optical colour blending. The water, of course, takes its colour mainly from the trees and foliage on the bankside – and even though the trees are not actually included in this scene, you need to provide enough information

for the viewer to be able to infer something of the country park setting.

The first stage is to colour in the background. This makes it easier to gauge how to treat the birds. If you were to colour the birds first, you could easily find that you'd made them too dark – an irreversible mistake. When you're drawing white objects, remember that they are never pure white, even though our eyes perceive them as such. Some shading, however slight, is essential for them to look three-dimensional.

Materials

- Smooth drawing paper
- Coloured pencils: turquoise-green, range of greens, yellow, dark blue, pale blue, violet, light orange, dark red

The scene

Placing the birds almost in the centre of the image helps to create a calm, peaceful mood that is appropriate to the subject. The rippling water adds interest to what might otherwise be a fairly bland scene.

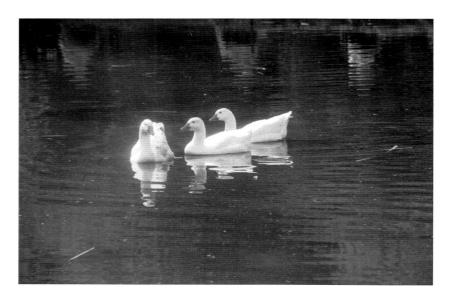

1 Using a turquoise-green pencil, outline the ducks and their reflections and indicate the main ripples. If you're worried about colouring in the birds when you start to work on the water in Step 2, use masking fluid for the outlines.

2 With green and yellow pencils (yellow for the right-hand side, which receives a little more light than the rest of the scene), lightly colour in the water around the birds, using a zig-zag motion to echo the shape of the ripples.

Apply more yellow over the lower half of the water, below the birds, and dark green behind them, again using a zig-zag motion of the pencil and leaving some gaps so that the underlying colours remain visible. Note that the water that lies between the birds is very dark indeed, so you can afford to apply a little more pressure with the pencil here.

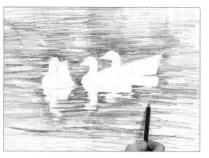

Apply dark green in front of the birds. Now that you've established much of the base colour of the water, you can begin to create more of a sense of movement – so switch from a zigzag motion to curved marks and swirls to capture the ripples. Remember the rules of perspective: make the foreground ripples larger and further apart than those in the background.

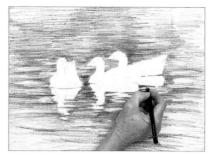

5 In areas where the foliage is reflected in the water, apply more yellow over the green, still using curved marks and swirls to maintain the movement of the ripples in the water. Apply dark blue in the very darkest areas – particularly under the birds. Remember to maintain an even but light pressure so as not to give too much emphasis to one particular area.

Assessment time

The water takes its colour from the things that are reflected in it – the trees on the bankside. Already we can see a range of colours, but the water is still too light overall. We are also beginning to get a feeling of movement, as the ripples flow outwards from the birds, and this needs to be enhanced. Finally, of course, the birds themselves need to be drawn in detail – something that is much easier to do now that we have a clearer idea of how dark the darkest areas need to be.

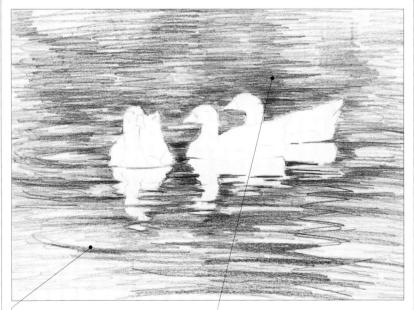

Curved pencil marks create the ripples in the water.

The water needs to be darker overall, but the base colours have been established.

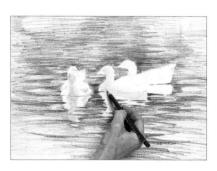

6 Using a pale blue pencil and horizontal strokes, lightly put some shading on the birds' white feathers.

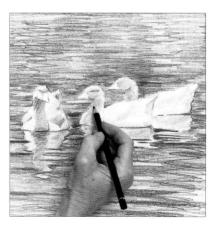

Zusing a violet pencil, lightly hatch over the blue to darken it slightly. Lightly indicate the position and angle of the birds' eyes.

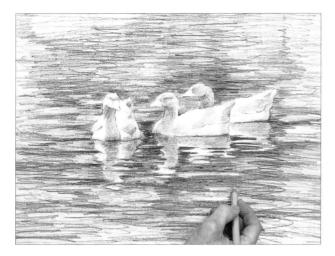

Continue working on the foreground water, putting in dots and dashes of violet, bright green and yellow. Keep referring to your reference photo to see where the yellow highlights, which are formed where the lightest bits of foliage are refected in the water, occur and what shape and size the ripples need to be.

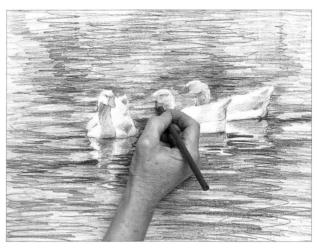

Darken the water with a dark blue pencil, still using zigzag and swirling motions so that you don't lose the ripples and the sense of motion in the water. By bringing the blue right up to the birds, you can sharpen their outlines. Colour in the beaks and reflections with a light orange and overlay with dark red on the lower beaks.

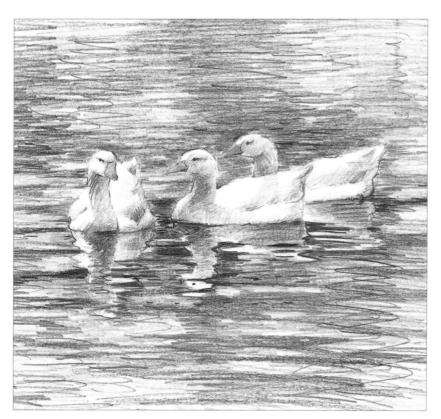

10 The divide between the birds and their reflections is not clear. Gently stroke dark green over the reflections to subdue them and push them back into the water. Using a dark blue pencil, draw around the backs and necks of the birds so that they stand out from the water.

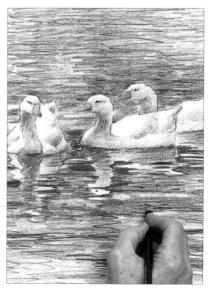

Adjust the colours in the water until you feel you've got the balance right; it helps to take a short break from the drawing at this point, as it will enable you to look at your work more objectively. Make sure the darkest parts are dark enough (add more blue if necessary), and that the yellows are not too bright (yellow ochre is a less harsh alternative). Note that the reflections are broken by the ripples in the water – but the overall shapes are still very clear.

The finished drawing

By using curved and zig-zagging pencil strokes for the ripples, the artist has created a lovely sense of movement in the water. Note that the ripples are larger in the foreground than in the background, which helps to create a sense of distance. The reflections are slightly broken by the ripples and more subdued in colour than the birds themselves.

The artist has also made the scene slightly sunnier than it was in reality, by using brighter colours and including more yellow. Although the birds are centrally placed in the picture area, the two birds on the left have their heads turned towards one another, which helps to draw our attention in to the centre of the scene.

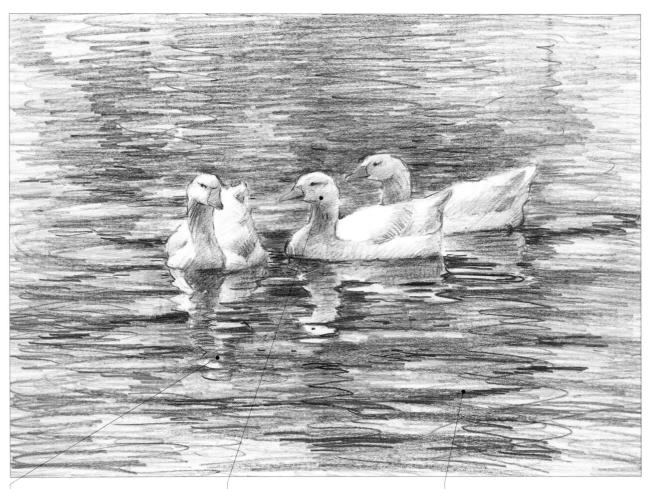

The reflections are broken by the ripples and more subdued in colour than the birds.

The angle of the birds' heads directs our attention to the centre of the scene.

The foreground ripples are larger than those in the background.

Landscape on a large scale

Drawing on a large scale is very liberating, both physically and mentally. Physically, it allows you to use the full stretch of your arm and hand to make bold, sweeping marks that are full of energy. Mentally, you have to simplify things and stop yourself getting bogged down in unnecessary detail. Try to get back to the essence of the scene – the aspects that made you want to draw it in the first place.

Charcoal is the perfect medium for a project such as this, as it is so versatile and easy to apply. You can drag the side of the charcoal across the support to cover large areas quickly, blend it using a variety of techniques, or use the tip to make expressive, linear marks.

If you can't find sheets of purpose-made drawing paper large enough, a roll of lining (liner) paper from a DIY store makes an inexpensive alternative. Pin it to a drawing board (or attach it with masking tape), and then place the drawing board on a studio easel or hang it on a wall.

The composition of large-scale drawings needs careful thought and planning. Before you embark on the actual drawing, it's a good idea to make a schematic sketch of the composition, working out where the centre of interest falls and making sure that the viewer's eye is led to that point.

Materials

- Drawing paper 1 x 1.25m (3 x 4ft)
- Charcoal: thick and thin sticks
- Kneaded eraser

The scene

The rocky escarpment is surmounted on the left by a wooded area that echoes the bands of trees at the base of the escarpment and in the fields below. A narrow track leads the eye into the scene along the line of trees and up to the rocks.

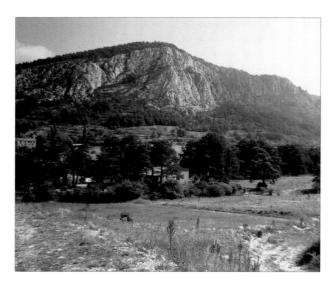

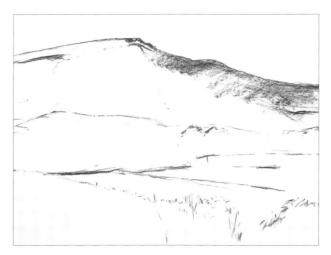

1 First, decide how much of the scene you want to include in your drawing and map out the positions of the main elements. To make this process easier, divide the scene into quarters (either mentally or by making light marks at the edges of the paper) and mark out where things fall in each square. Use light marks at this stage, just to establish where everything goes. Lightly block in the slope of the cliff to give yourself a visual guide to where to position the trees that stand at its base.

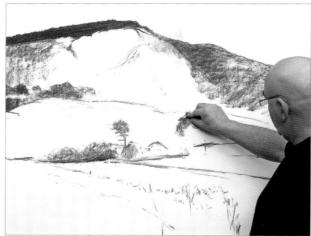

Work out where the darkest areas of tone are going to be and roughly block them in with a thick charcoal stick. The wooded mass on the top of the cliff is very dark, so you can apply a lot of pressure to the charcoal for this area. However, it's not a solid, straight-edged wedge shape: look closely and you will see that the tops of the trees are gently rounded. Outline the trees at the back of the fields with light dots and dashes, then block them in with the side of the charcoal stick.

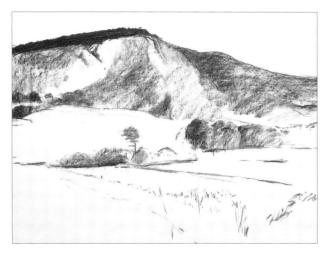

Turn your attention back to the cliffs and look for differences in tone: the contrasts between dark, shaded gullies and crevices and the more brightly lit areas that are in full sunshine give the cliffs some sense of form. Block in the larger areas of tone using the side of the charcoal stick and moving your whole arm, not just your hand, keeping the coverage fairly uneven so that some of the paper texture shows through. Note that the brightest areas are barely touched by the charcoal. Continue blocking in the band of trees at the back of the fields, putting in nothing more than generalized shapes at this stage.

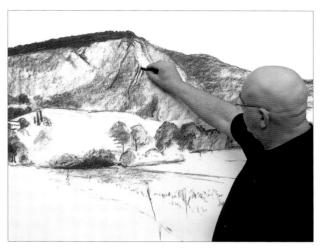

4 Outline the trees at the base of the cliff, then sketchily develop some tone within them. Note the number of different shapes – the tall, elongated cypress trees and the more rounded shapes elsewhere. Start to put in some jagged, linear marks on the cliff to create some texture.

Tip: Continually check the size of the trees and the distances between them and other elements of the scene. It's very easy to make the trees too big and destroy the scale of the drawing.

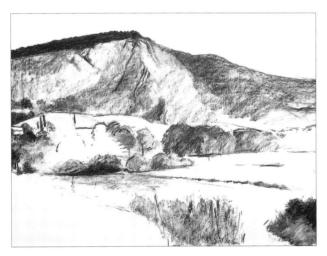

 $\mathbf{5}$ Finish outlining the shapes of the band of trees that runs across the middle of the drawing. Now you can begin to develop the foreground a little. Put in the foreground grasses, using both the tip of the charcoal and the side.

Tip: Work across the drawing as a whole, rather than concentrating on one area. This makes it easier to get the tonal balance of the drawing right.

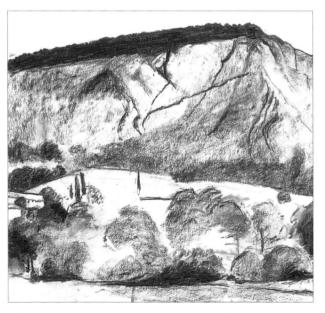

6 Continue working on the trees in the middle of the drawing, concentrating on the overall shapes. Add more tone to the trees at the base of the cliff so that they begin to stand out more. Using the tip of the charcoal, put in more jagged, linear marks on the side of the cliff. These dark fissures help to create a sense of form and texture.

Assessment time

Details in the image are taking shape, but it requires much more tonal contrast and texture. The trees are little more than generalized shapes at this stage and do not look truly three-dimensional; you need to develop more tone within them and also to put in the shadows that they cast. We are beginning to see the different facets of the cliff, but the darkest marks are not yet dark enough to give us any real sense of form.

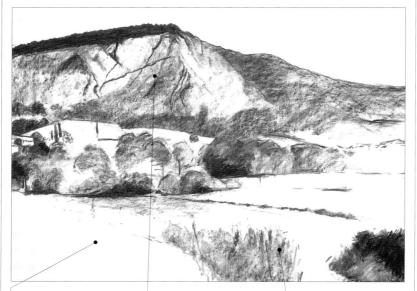

Very little work has been done on the foreground. It is too bright in relation to the rest of the image.

The linear marks on the cliff need to be developed further to create a sense of form.

The foreground grasses are too indistinct. More texture is needed here.

Very gently stroke the side of a thin charcoal stick over the foreground to create some tone and texture. Note how using the charcoal in this way gives a slightly uneven coverage. Press slightly harder on the charcoal to put in the sides of the track that zig-zags its way through the scene. Also indicate the shadows cast by the trees.

Tip: Smooth out the long cast shadows with your fingertips, in order to make them less textured than the trees themselves.

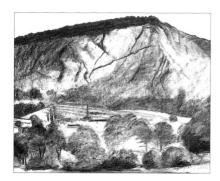

Nery gently make a series of horizontal marks over the fields immediately below the cliff, pulling the full length of the charcoal stick over the paper to create the effect of ploughed furrows. Using the tip of the charcoal and pressing down firmly, put in the dark trunks of the trees in the centre of the image.

The trees are now taking real shape. Look at how the light catches them. Darken the shaded sides, using the side of the charcoal to create broad areas of tone. Immediately the trees begin to look more three-dimensional as you add the shadows they cast. Developing this tone takes them away from generalized shapes.

10 Using a kneaded eraser, gently lift off some of the charcoal from the side of the trees that catches the light. If you lift off too much, simply go over the area in charcoal again. Using the tip of a thin charcoal stick, introduce more texture into the foreground grasses by making crisp, dark, vertical marks.

Working on a large scale has allowed the artist to use the full stretch of his arm to make bold, sweeping marks that give the drawing a very energetic, lively feel. He has concentrated on the essentials of the scene, rather than trying to put in every

single detail, but his clever use of tonal contrasts gives the image a convincing sense of form. The foreground track leads our eye through the scene to the trees and cliff beyond – a classic compositional device.

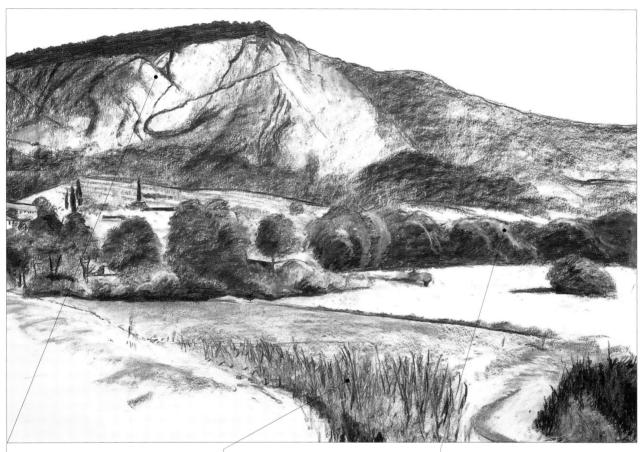

Note how the contrasts between light and dark areas reveal the different facets of the cliff face.

Detail diminishes with distance; the amount of detail that we can discern in the grasses tells us that they are in the foreground.

Lifting off charcoal from the most brightly lit sides of the trees shows us which direction the light is coming from.

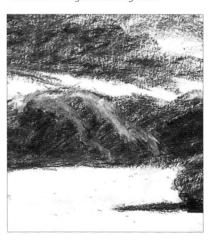

Rocky canyon

This is one of the best-known and most distinctive of all land-scapes in the USA – Bryce Canyon in south-western Utah. The colourful rock formations, a series of eroded spires, are best viewed in early morning and late afternoon, when they glow in the sunlight.

When you're drawing formations such as these, look for tonal contrast within the rocks as this is what shows the different planes and makes it look three-dimensional. If a rock juts out at a sharp angle, there is a clear transition from one plane to another and

the difference in tone between one side and another is very obvious. If the rock is smooth and rounded, the transition in tone is more gradual.

Drawing the many fissures and crevices also shows the form of the subject. If the shadows in these crevices are very deep, you might be tempted to draw them in black – but black can look very stark and unnatural. Instead, use a dark complementary colour for the shadows – so if the rocks are a reddish-brown, as here, try opting for a purple-based shadow colour.

Materials

- Pastel paper
- Thin charcoal stick
- Soft pastels: pale and dark blue, grey, violet, browns, cadmium orange, pale pink, greens, yellow ochre
- Clean rag or kitchen paper
- Kneaded eraser
- Conté stick: brown
- Blending brush

The scene

Trees in the foreground provide a sense of scale: without them, it would be hard to estimate how tall the rocks are.

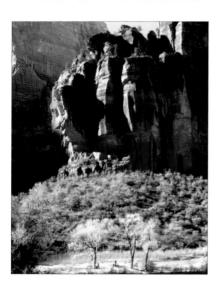

Tip: If you're working from a photograph, you may find that it helps to grid up both the photograph and your drawing paper and then work systematically one square at a time until all the elements are in place.

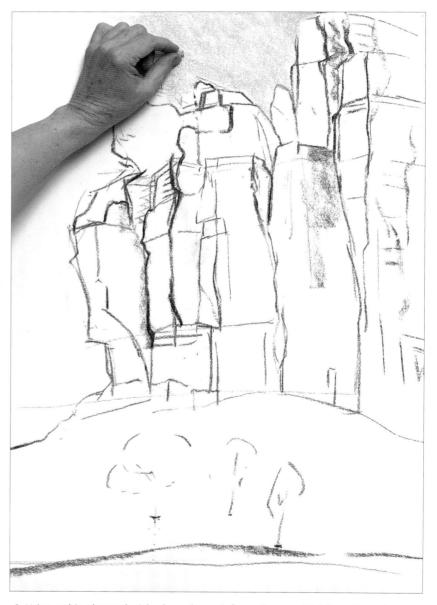

1 Using a thin charcoal stick, draw the rock formations and lightly indicate the main areas of shade. Using the side of a pale blue pastel, block in the small patch of sky that is visible above the rocks.

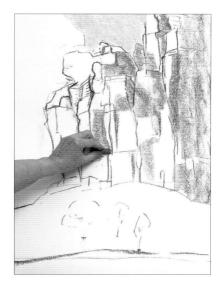

2 Using a cool grey pastel on its side, block in the darker, shaded areas of the rock formations. This gives the rocks some form and establishes the direction from which the light is coming.

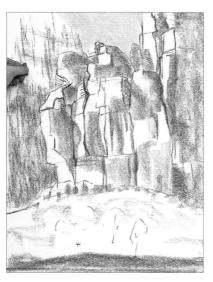

3 Using a violet pastel on its side, put in the strata of the background rock-face. Note how the diagonal lines within this rock-face reveal the structure and add drama to the composition.

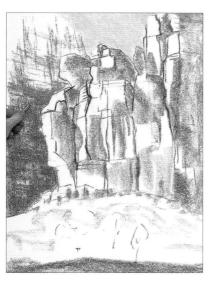

Again using the side of the pastel, strengthen the horizontal strata on the background rock, applying light blue at the top of the rock and a darker blue at the base.

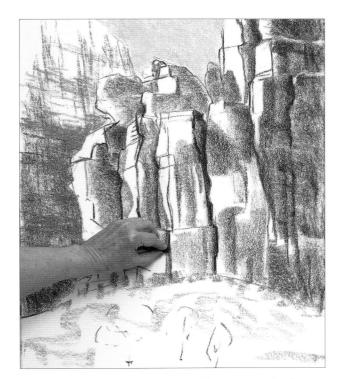

 ${f 5}$ Begin applying colour to the rock formations, using brown and dark violet in the shadow areas, using the edge of the pastel to define the divisions between the sections. The crevices between the rocks are dark and deep: a deep violet provides the necessary dark tone and is a warmer and more lively colour than black.

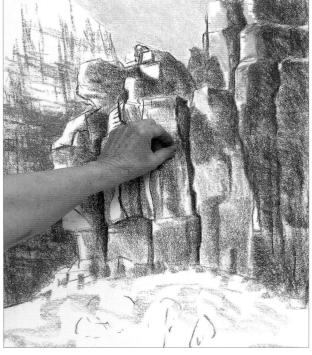

6 Apply cadmium orange to the rock formations. On the shaded facets, where the orange is overlaid on the violet, a rich optical colour mix ensues. On the more brightly lit parts of the landscape, the orange represents the naturally warm, sun-kissed colour of the rock. The colour combination is sympathetic but striking.

Assessment time

The structure of the rock formations is beginning to emerge, but the contrast between the shaded and the more brightly lit facets is not yet strong enough. The rock formations also need to be brought forwards in the scene, so that they stand out from the background cliff.

The main rock formations look rather flat.

It is hard to tell that this cliff is some distance behind the main rock formations.

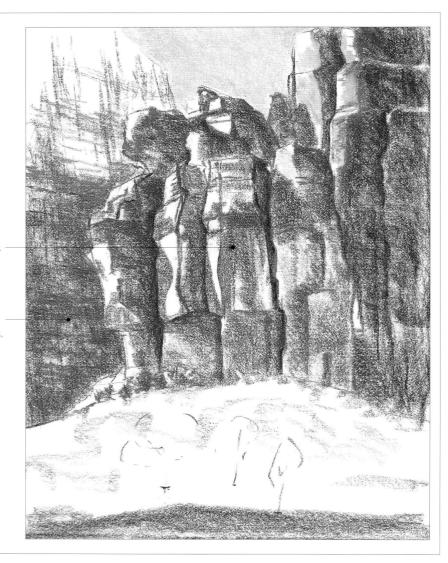

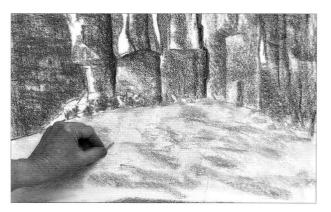

7 Lightly apply pale grey and pink over the foreground scrubland. Use grey for the shaded areas and pink for those illuminated by the late-afternoon sunlight.

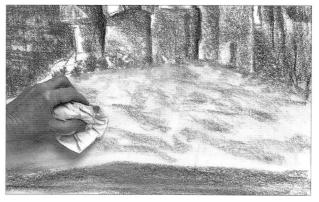

Apply touches of pale green to the scrubland, then soften the whole area by blending the colours with a clean rag or piece of kitchen paper, using a gentle circular motion.

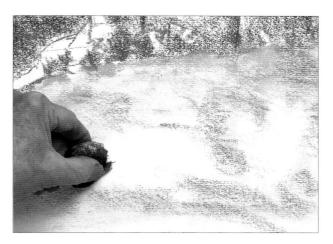

9 Using a kneaded eraser, wipe off the shapes of the trees in the foreground. If you accidentally wipe off too much, simply repeat Steps 7 and 8 for the right background colour.

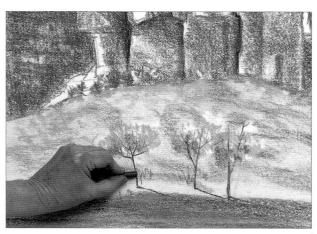

10 Draw the trees, using a brown Conté stick for the trunks and their shadows, and bright green to roughly block in the masses of foliage.

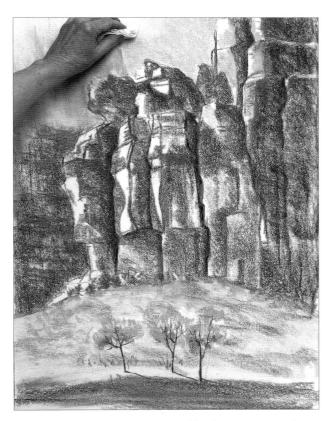

1 Wipe a clean rag or a piece of kitchen paper over the top of the background rock-face and the sky to lift off excess pastel dust and soften the colour.

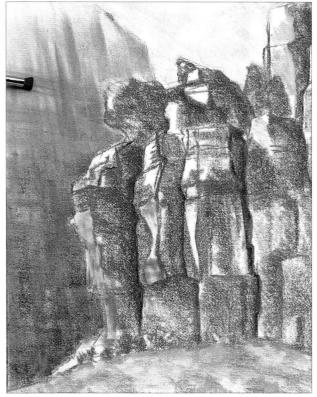

12 Soften the violet on the lower part of the background rock-face by using a blending brush, brushing it both horizontally and vertically. If you haven't got a blending brush, you could use your fingers or a torchon, but the bristles of the brush create very fine lines in the pastel dust, which are perfect for the striations in the rock. Although this rock-face is in the distance, it is important to create some subtle texture here.

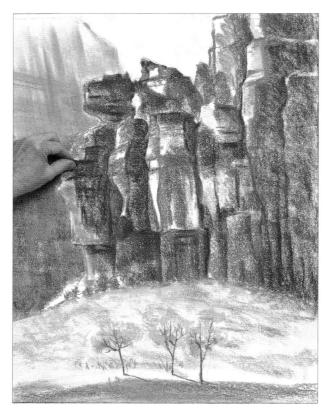

13 Add more detail to the main rock-face, using the side of the deep violet pastel to overlay colour and the tip to draw on short horizontal and vertical lines to emphasize the different facets within the rock.

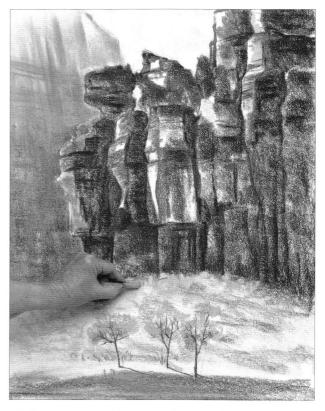

14 Now start working on the foreground scrubland. Using a pale green pastel on its side, roughly scribble in the base colour of the scrubby bushes that cover the ground immediately below the rock-face.

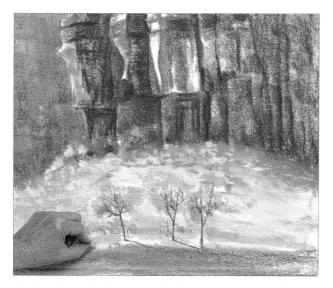

15 Build up the foreground foliage, using a range of pale and mid-toned greens and grey-greens. A general impression of the shapes is all that is required. Put in the roadway with a warm ochre pastel.

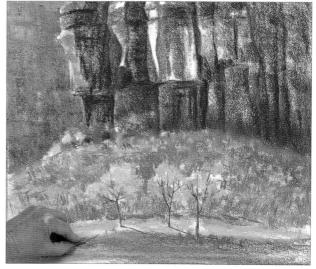

16 Define the edges of the roadway in brown. Also add a range of browns to the scrubland, using jagged, vertical strokes of dark brown for the thickest stems and branches. Make sure your pastel strokes follow the direction of growth.

This colourful drawing captures the heat and the mood of the scene very well. Warm oranges and purples predominate and are perfectly suited to the arid, semi-desert landscape. The artist used bold linear strokes to capture the striations and jagged texture of the rocks and the drawing is full of energy. Although some texture is evident on the background cliff, blending out the pastel marks in this area has helped to create a sense of recession. For the foreground scrubland, the artist opted for an impressionistic approach, describing the overall shapes and textures with dots and dashes of greens and greygreens. This contributes to the liveliness of the scene and concentrates attention on the rocks, which are the main point of interest.

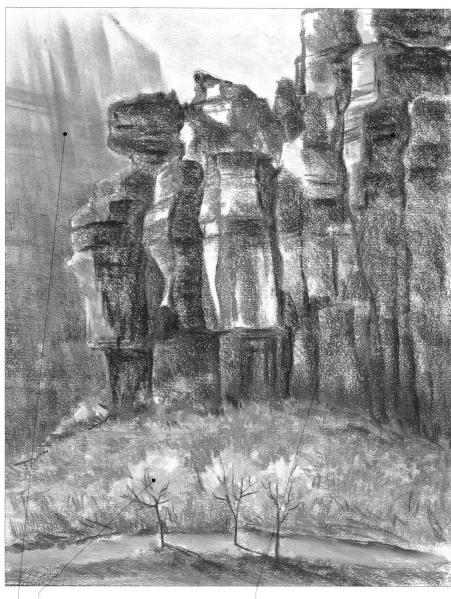

As the background cliff is less textured, it appears to be further away.

The trees are dwarfed by the rocks that tower above, and give a sense of scale.

Tonal contrasts reveal the different facets of the rocks.

Quick sketches of still-lifes: Potted plant

Although we normally think of a still life as being an item, or a group of items, that the artist has deliberately arranged, there are also what are known as 'found' still lifes, which are things that the artist has come across by chance.

As with any subject, you need to think about your viewpoint and position carefully. If the object is heavy, it may not be possible to move it – but you can easily adjust your own position to give a more pleasing composition. Your eye level is important, too: in the examples shown on these two pages, the artist's eye level was above the plant, enabling her to look inside the pot and see how the leaves grow out of the main stem. If the pot had been at eye level, so that she was looking at it horizontally, this kind of information would have been hidden from view.

The background is also an important element of a still life and you need to decide how to treat it. One of the delights of drawing and painting is that you have the freedom to interpret things as you wish, and to omit or alter things that you do not like. If you find that the background detracts from the subject, or prevents the subject standing out clearly, simplify it to a tonal wash.

The scene

Here, the artist discovered a potted plant in a corner of a friend's garden and was intrigued by the sculptural shapes of the leaves and the arching shadows that they cast on the gravel beneath the pot.

5-minute sketch: graphite pencil

In a five-minute sketch, you can only explore the basic shapes of the subject. Looking at the negative shapes can be a great help when you are drawing objects that are irregularly shaped. Here, the artist blocked in the negative shapes on the left with loose scribbles, as this made it easier to see the shapes of the leaves themselves. A context and three-dimensional feel were also suggested by sketching in the cast shadow.

10-minute sketch: graphite pencil and water-soluble sepia ink

In this sketch, the artist explored ways of treating the background, using both washes of water-soluble ink between the leaves to provide a dark background and loose pen-and-ink shapes to imply the presence of other plants.

15-minute sketch: graphite pencil, water-soluble sepia ink and water-soluble pencils

The plant itself was treated in the same way as in the 10-minute sketch, opposite. While the ink was still damp, water-soluble pencils were used to add detail on the pot and shadows. As the paper was damp, the colours spread.

25-minute sketch: graphite pencil, masking fluid, water-soluble sepia ink and water-soluble pencils

Here, masking fluid protected some of the daisy-like flowers in the background from the washes of ink. When the other details were complete, the masking fluid was removed and the centres of the flowers drawn in with an orange water-soluble pencil.

Quick sketches of still-lifes: Patio table

Still lifes can sometimes benefit from a helping hand. If you find a potentially interesting subject, take time to think about ways you might improve on it. You could perhaps rearrange the different elements so that they make a more balanced, or a more dynamic, composition. Look at the spaces between the objects, as well as at the objects themselves, and experiment with different combinations, adding or removing items until you are happy with the way things look. Also think about the relative scale of the objects: although you can create some dramatic images by extreme contrasts, it is usually better if the items in a still life are on a similar scale.

When sketching glassware, remember that it takes on the colour or tone of objects around it. Look at the background and at nearby objects before you sketch the glass itself. Against a pale background, the edge may not be entirely visible. For example, look at the glass on the left in the sketch below.

5-minute sketch: water-soluble sketching pencil

Once she was sure she had drawn the ellipses of the glasses correctly, the artist blocked in tone for the red wine, paying careful attention to the highlights reflecting off the glasses in order to convey their smooth shininess. The shadows on the metal table were created by brushing clean water over the water-soluble pencil marks, providing an effective contrast with the linear marks used for the hard glass.

The scene

The artist was attracted by the lovely dappled light on the table and the colourful gourds and grapes, but felt that something was missing. She decided to add the two glasses of wine to provide some extra colour and to introduce a vertical element into the composition. They also give the still life more of a story, implying that the cut grapes will be made into wine later.

15-minute sketch: chalk and charcoal pencil

In a scene full of contrasts such as this, where there are very bright highlights and dense shadows, it often helps to use a toned ground so that you can start from a mid-tone. Here, the artist worked on dark-blue pastel paper to create a simple but effective tonal study. White chalk was used for the wrought-iron chair and table, with the side of the chalk being used for the tabletop and the highlights scribbled in with the tip of the chalk. The darkest elements of the still life – the bottle, glasses and fruit – were sketched in charcoal pencil.

15-minute sketch: ballpoint pen

For this sketch, the artist removed some of the grapes to give a less cluttered arrangement and positioned the glasses on opposite sides of the table to create a more balanced composition. Although you cannot vary the width of the lines you make with a ballpoint pen, you can create a surprisingly wide range of marks and tones by hatching and crosshatching. Note how the tones range from the very dark fig on the right to the very bright tone of the table in areas where no shadows are cast. Note, too, how shading the background allows the lines of the white wroughtiron chair on the left to stand out.

30-minute sketch: oil pastel

To create the reflective surface of the wrought-iron table, the artist applied colour with oil pastels and softened the marks with a rag dipped in turpentine.

Quick sketches of still lifes: Old tools

Still lifes don't have to be 'pretty'. Functional items, such as old tools, kitchen utensils or garden implements, can make a graphic composition. The more time you spend working out the arrangement, the better. Think about the relative scale of the objects: something like a tiny nut or bolt will simply have no impact if it's placed next to a large object such as a mechanical vice or other large industrial tool. Think about the background, too: it's generally best to go for something fairly neutral, which doesn't detract from the subject. A plain, painted wall or a scratched wooden workbench, grimed through years of use, will both make good backgrounds for this kind of still life.

The set-up

Here, the artist selected a few battered items from his workshop and set them up against a plain white background to allow the shapes to stand out clearly. He chose three items of similar size, as odd numbers of items tend to work compositionally. The composition is well balanced, with both the scraper and funnel placed 'on the third'.

5-minute sketch: charcoal

Here, the artist began by outlining the shapes of the objects before blocking in the darkest areas, such as the reflection of the old bottle in the metal scraper, with the side of the charcoal stick. He then smudged the marks on the scraper and funnel with his finger to soften them and create the effect of a smooth, metallic surface. Note how the charcoal is applied roughly and unevenly, helping to convey the texture of the rather battered funnel and bottle.

15-minute sketch: ballpoint pen

You can't cover large areas quickly with a ballpoint pen, so any subject that requires a lot of shading, as here, is likely to take longer. Here, the shaded areas were hatched, with the lines being drawn closer together or even cross-hatched for the darkest sections. As always with a subject such as this, it is essential that you observe the highlights accurately in order to convey the form; it's easy to get so engrossed in the rather mechanical and repetitive business of shading that you lose sight of the drawing as a whole.

30-minute sketch: pencil

As in the ballpoint pen sketch, above, the artist made use of hatching to shade the darkest areas but the beauty of using a soft pencil is that you can combine linear work (to outline the shapes and get crisp edges) with softly blended areas that convey the smooth metallic surfaces. The result is a less mechanical-looking sketch than the ballpoint pen version shown above. And, with more time at your disposal, you can concentrate on subtle changes in tone that convey the somewhat pitted surface of the funnel and bottle.

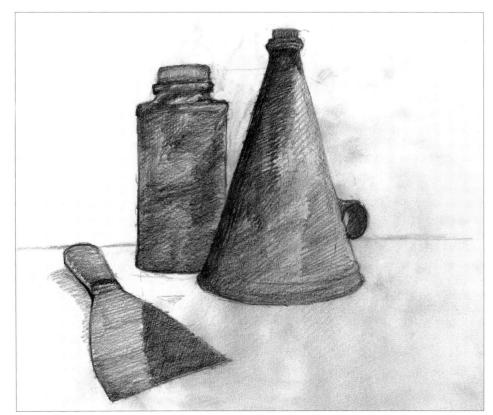

Exotic flowers

Many exotic flowers are readily available from good florist's shops. They are wonderful things to draw and make a simple still life to set up at home. The bright yellow or orange flowers of *Strelitzia* burst out of a boat-shaped bract like head feathers on an exotic bird, giving rise to one of the flower's common names – the bird of paradise flower.

This project gives you the opportunity to exploit the potential of soft pastels. The colours are vibrant and perfectly suited to this subject, and soft pastels have a smooth texture which is ideal for the flowers and leaves. The bold, graphic shapes of the flowers and leaves require strong, flowing marks, which can be easily blended.

Materials

- Paper or board
- Soft pastels: pale green, yellow ochre, bright yellow, greyish green, reddish brown, dark green, grey, pale pink, ultramarine blue, cadmium yellow, cadmium orange, bright green, vermilion, deep red, Naples yellow
- Hard pastel: cadmium red
- Pastel pencil: Hooker's green
- Rag or kitchen paper

The set-up

The flowers were placed in a tall glass vase, with the leaves acting as a dark background. The vase does not form part of the final drawing, but it keeps the flowers upright.

1 Using a pale green soft pastel, map out the main lines of your subject, including the main veins of the two large leaves.

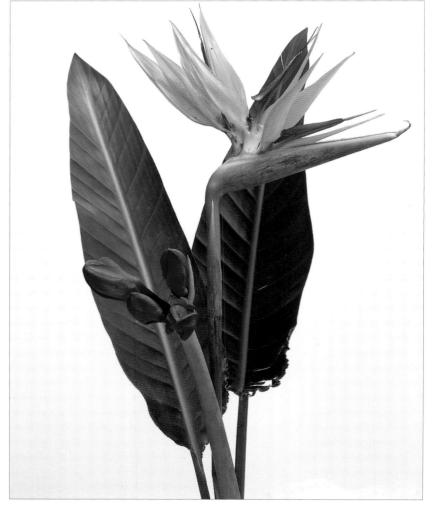

Put in the main veins of the leaves with a yellow ochre pastel. Use a bright yellow and a greyish green pastel for the *Strelitzia* bract, smoothing out the join between the colours with your fingers. Outline the leaves in reddish brown (the colour will barely be visible in the finished drawing, but the edge of the leaves needs to be clearly defined).

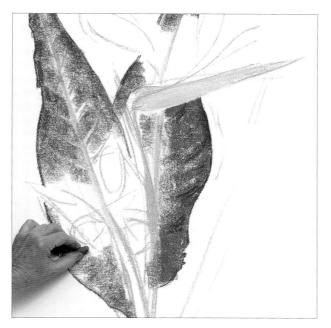

 $\mathbf{3}$ Draw the veins on the background leaf in the same reddish brown. Fill in the spaces between them with a dark green, using the side of the pastel. Repeat the process on the foreground leaf, using yellow ochre for the veins and filling in the spaces in grey.

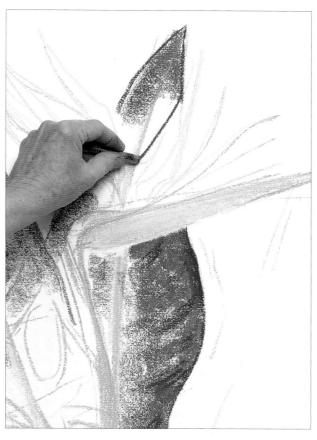

4 Outline the individual *Strelitzia* flowers in pale pink and the tongues in ultramarine blue.

5 Fill in the flowers in cadmium yellow and cadmium orange soft pastel, and define the line between the petals with a cadmium red hard pastel.

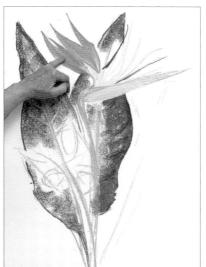

6 Blend the flower colours with your fingertips to give a smooth, waxy texture, making sure you don't pull any colour on to the background.

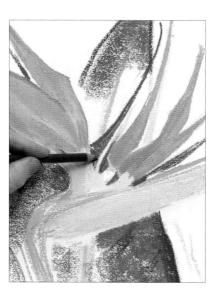

7 Use a Hooker's green pastel pencil to define the tiny triangular areas of leaf that lie between the bases of the flowers.

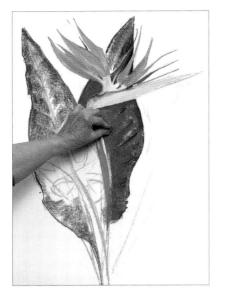

8 Block in the stem of the *Strelitzia* flower with a light, bright green, overlaid with a little cadmium yellow in places for the highlights. Block in the rest of the background leaf in dark green, using the side of the pastel.

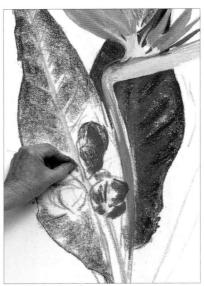

Deaving the brightest highlights in the drawing untouched for the moment, block in the red flowers with vermilion and ultramarine blue. Use ultramarine blue for the dark, shaded parts of the flowers.

Tip: The highlights are an important part of the picture, so observe their shape carefully.

They show us how glossy the surface is and tell us which direction the light is coming from.

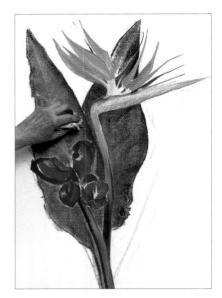

10 Still working around the highlights, overlay deep red on the ultramarine blue to create a rich, almost black, red. Carefully blend the colours on the leaves with the side of your hand or a clean rag, smoothing out the pastel marks to give a waxy finish to the leaves. Work on one section at a time, making sure you retain something of the linear marks of the veins.

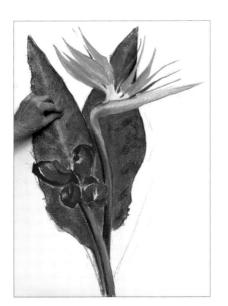

1 1 Using the side of the pastel, apply dark green to the foreground leaf between the veins to begin to add texture to the plant.

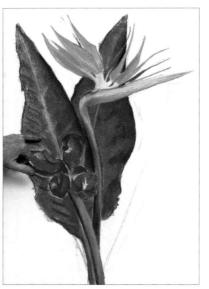

12 The leaves are firm and waxy in texture, so blend the dark green with your fingertips to get a smooth, even finish.

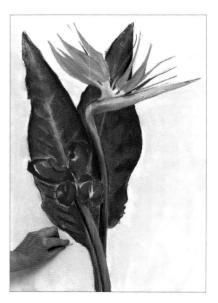

13 Using the side of the pastel, apply pale Naples yellow over the white background so that it does not look so bright and stark.

This is a vibrant and colourful drawing that exploits the characteristics of soft pastels to the full. They are the perfect choice for this subject: the colours are very vibrant and the thick sticks ideal for covering large areas, while blending the marks creates the smooth, almost waxy texture of the flowers and leaves. Note how the foreground leaf is lighter and more textured than the background one, which helps to bring it forwards in the image.

Soft blending of the marks makes the veins an integral part of the leaf.

The warm yellow background complements the orange flowers, which look striking against the dark green of the leaves.

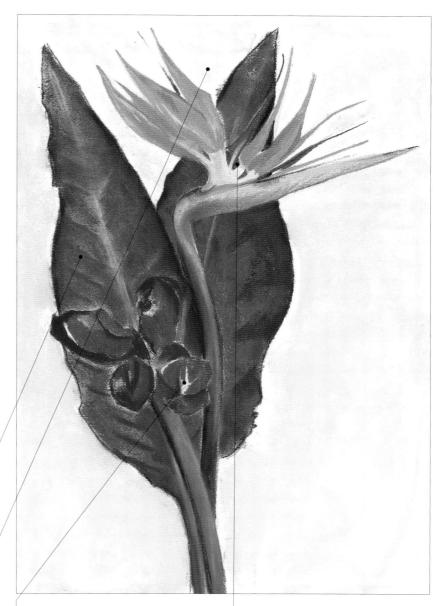

The untouched white highlights reveal the direction of the light.

The sharp tip of a pastel pencil is used for small areas where precision is required.

Metal detail

In this project, coloured pencils are used to draw the distinctive Rolls-Royce 'Spirit of Ecstasy' motif, creating a smooth, metallic-looking sheen. As always with this kind of detailed coloured-pencil work, you need to put down a number of very light layers of pigment. If you apply too heavy a layer, the wax in the pigment clogs up the tooth of the paper so subsequent layers of colour will not go on as smoothly or as evenly.

Try to maintain an even pressure, using the side of the pencil so that the coverage is perfectly smooth and there are no obvious pencil marks. You can get away with a few imperfections when you are drawing a more uneven surface, but not when you are trying to convey perfectly smooth metal.

It is also very important to assess the tones carefully. The figurine is smooth and rounded, and it's sometimes hard to work out exactly where changes in tone occur – but these changes in tone are the only real clue you have to the form of the object. Look for a darkening of tone as the figure curves away from the light. It happens so gradually that it may seem barely perceptible when you first look at a subject like this, but at some point a darkening does occur and you need to render it in your pencil work.

The surface is also highly reflective. There are many different facets in the figurine, so you don't see complete reflections in the same way that you would in a flat plate-glass window, for example. Nonetheless, the green of the foliage and the red of the car can be seen in the silver of the figurine. Details like this, tiny though they may be, add verisimilitude to your work.

Materials

- Smooth, heavy drawing paper
- HB pencil
- Craft (utility) knife and cutting mat
- Masking film (frisket paper)
- Kitchen paper or clean rag
- Coloured pencils: bottle green, olive green, mineral green, scarlet lake, gunmetal grey, blue-grey, burnt umber, indigo, geranium lake, deep vermilion

The subject

The viewpoint has been chosen so that the head and wings of the 'Spirit of Ecstasy' figure stand out against the dark background foliage and the distinctive Rolls-Royce logo is clearly evident.

1 Using an HB pencil, lightly sketch the car indicating the main area of mid-tone within it. Using a craft knife on a cutting mat, cut a mask out of masking film to place over the metal figurine and the car bonnet (hood). Peel off the backing paper and stick it in place, smoothing out any wrinkles by rubbing over it with a piece of kitchen paper or a clean rag.

2 Using a craft knife, shave tiny slivers of pigment off a bottle-green pencil over the foliage background. Repeat with olive and mineral greens so that you get a number of shades of green in the foliage. Finally, add a few flecks of scarlet lake; a complementary colour to the green, this gives more variety to the foliage and provides a subtle visual link with the colour of the car bonnet.

3 Take a piece of kitchen paper, scrunch it up, and gently wipe it over the pencil shavings to blend them on the paper. This is an effective way of covering a large area quickly.

Tip: Make horizontal strokes. This creates a streaked effect, which gives the impression of movement.

A Remove the mask. (You may need to use the tip of a craft knife to lift up the edge.) Alternating between a gunmetal grey and a blue-grey pencil and using very light strokes, put in the darkest parts of the metal figure. You may find it easier to assess the tones if you half-close your eyes.

5 Continue the process on the base of the figurine and the top of the radiator grille, still using very light strokes. Note that some of the foliage is reflected in the metal towards the back of the base; put this in using whichever greens you feel are appropriate.

Go over the lettering in gunmetal grey. Block in the most deeply shaded parts of the radiator grille in burnt umber, then overlay indigo in the same area. The optical mix creates a richer, more varied colour than you could achieve using only black.

Vising a scarlet lake pencil and horizontal strokes, apply the first thin layer of colour to the car bonnet, leaving the very brightest highlights untouched. Where there is a change of plane, define it with a slightly heavier pencil line.

8 Go over the scarlet with geranium lake. With the application of this second layer, the colour is beginning to look closer to the way it should look, as the two reds mix optically on the paper. The coverage is also more dense and is beginning to take on a metallic sheen.

Assessment time

The red section of the car needs to be more intensely coloured. Go over it again with a deep vermilion pencil. We can see how smooth the metallic front and top of the car is, but it does not yet look shiny enough. We are beginning to see the different planes of the image, but more differentiation is needed between them. Building up the layers of a coloured-pencil drawing is a slow, meticulous process that needs to be done.

The figure needs to be darkened very slightly.

The front of the bonnet needs to be darkened, so that it is obvious that it lies on a different plane to the top of the bonnet.

More layers of red are needed to achieve a really smooth, deep sheen on the bonnet (hood) of the car. The radiator grille is too pale; more tone is needed here.

Apply a light layer of gunmetal grey to the thin metal strip that runs along the length of the bonnet, behind the figurine. This strip catches the light, so only a little colour is needed. Overlay very pale olive green on the rounded end, which is slightly in shadow. Darken the tone on the front of the radiator panel with a blue-grey pencil, using the side of the pencil rather than the tip.

10 Re-assess the tonal values of the picture as a whole, reinforcing the darks wherever necessary. Also continue building up the red of the bonnet, alternating layers of scarlet lake and geranium lake, until you reach the right density of colour.

In this drawing the metalwork looks so smooth that you almost feel you could reach out and touch it! The artist has paid very careful attention to the highlights and shadows, as these are what convey the form of the object and make it look threedimensional. She has built up the colour by applying several thin layers, allowing them to mix optically on the support to create a rich finish. You could put more detail into the background if you wish, but this simple approach allows the subject to stand out.

The plain background allows the subject to stand out.

Bright highlights on the figure tell us which direction the light is coming from.

Variations in the density of the red convey the curve of the bonnet (hood).

Still life with garlic and shallots

Try to get into the habit of drawing every day — even if it's only for ten minutes during your lunch break. One of the most wonderful things about drawing is that you can create images anywhere, from anything that you have to hand. Paper clips and a pencil sharpener from your desk at work, a piece of fruit that you're going to eat for your lunch, a coffee cup or a few children's toys — anything will do, so long as you spend time observing and drawing.

The project shown here is a good example of this approach. The artist constructed a simple still life using nothing more than a wooden chopping board, a bulb of garlic and a couple of shallots from the kitchen. For drawing equipment, he deliberately restricted himself to just two graphite pencils and a torchon. It's well worth setting yourself an exercise like this one, as limiting the number of drawing tools that you use allows you to experiment and become familiar with the range of marks that each one can create. Here, for example, the torchon is used not only to blend graphite marks but also to 'draw' soft marks that add an interesting texture to the image.

No doubt you've heard it before, but we make no excuse for repeating it here: odd numbers of objects (three, five, seven) invariably make more satisfying still-life compositions than even numbers. When you're setting up a still life, look at how the objects relate to one another. Look at the overall shape that the assembled objects make, as well as at the shape of each item within the group. Remember that the spaces between them are, compositionally, as important as the objects themselves, as are any shadows. Try different viewpoints: the spatial relationships will change if you look down on (or up at) your subject. Above all, try out different arrangements until you find one that seems to work.

Materials

- Smooth drawing paper
- · Graphite pencils: HB and H
- Torchon
- Kneaded eraser

The set-up

Shadows almost always make a scene more interesting, as they allow you to exploit the differences between the light and the shaded areas of your subject. Here, the artist set up a table lamp to one side of his still life, so that the objects cast strong shadows to the left of the image.

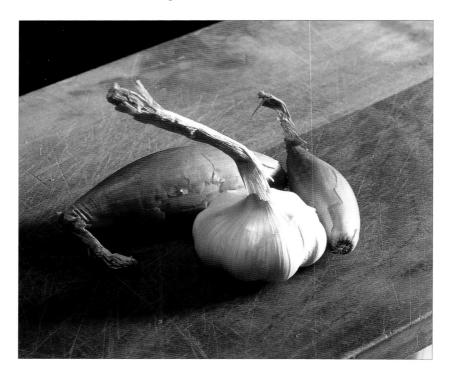

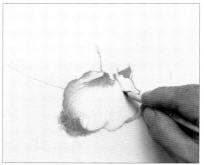

1 Lightly sketch your subject. Start from the base of the garlic stalk and work outwards: this will enable you to establish the relative positions and sizes much more easily than an outline drawing would. Lightly shade the darkest areas of the garlic bulb and indicate the cast shadow to the left. Use a torchon to blend the graphite and create smooth areas of tone. Also use the torchon to 'draw' the individual cloves of garlic.

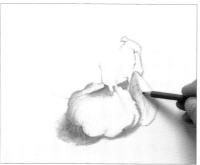

2 Using an H pencil, outline the shallot on the right and its papery stem. Start to shade underneath the garlic bulb and put in the deep area of shadow that lies between the garlic and the shallot. Using the side of the pencil, begin shading the darkest side of the shallot. Try to make sure your pencil strokes run in the same direction as the striations in the skin of the shallot.

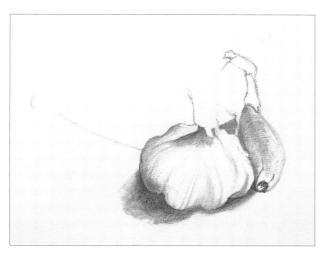

3 Working downwards (and making sure you keep within the outline), smooth out the graphite on the shaded area of the shallot with a torchon.

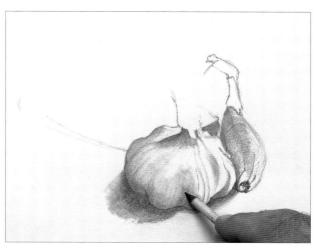

4 Using an H pencil, draw the veining on the papery outer covering of the garlic. Put more shading on the dark areas of the garlic and smooth out the marks with a torchon.

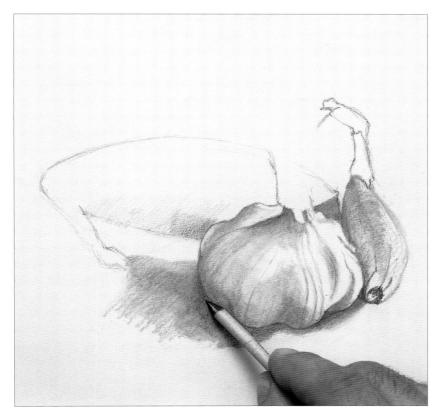

5 Outline the stalk and the lower part of the shallot on the left, where it cuts across behind the garlic, and shade in the underside of the shallot. Lightly hatch in more of the shadow cast by the garlic and blend with the torchon. (Shadows need to look considerably less substantial and solid than the objects that cast them.) Make sure, however, that you retain the crisp line around the edge of the garlic so that there is a clear distinction between it and the shadow; if necessary, reinforce the outline.

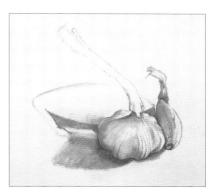

 $\label{eq:continuous} 6 \text{ Reinforce the twisting line of the } \\ \text{garlic stalk, using an irregular, } \\ \text{slightly broken line which helps to } \\ \text{convey the texture.}$

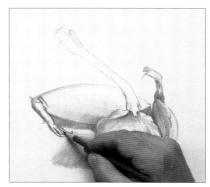

Z Using an HB pencil, put in the linear detailing around the top of the stalk of the shallot on the left. It almost looks like a small claw reaching forwards.

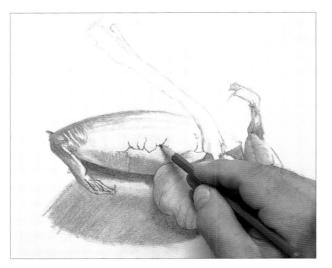

Shade the stalk of the shallot on the left and darken the shadow underneath. Use the torchon to 'draw' soft horizontal lines across the shallot, and then the H pencil to put in sharper, linear marks on the shallot's papery covering.

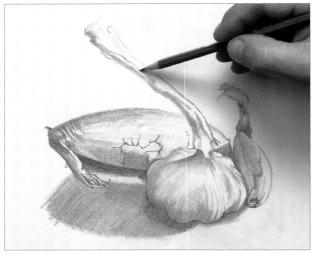

9 Shade the left-hand side of the garlic stalk, which is furthest away from the light. Note how the stalk twists and turns, and is irregular in width; convey this in the way that you shade it.

Assessment time

The drawing is progressing well, but the objects do not stand out clearly enough in relation to each other or to the shadows. More tonal contrast is needed, as is more contrast of texture.

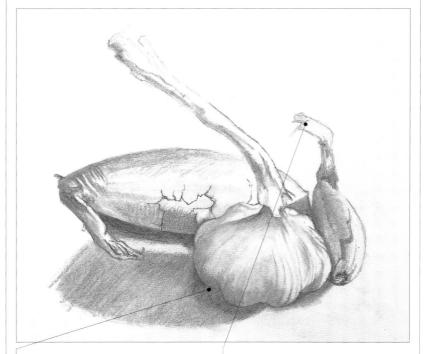

The shadow is almost as strong in tone as the object that casts it.

The stalks of both the shallot and the garlic are not strong enough.

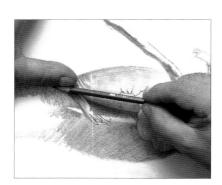

10 Extend and darken the shadows cast by both the garlic and the shallot on the left. Blend the marks to a soft shadow using a torchon.

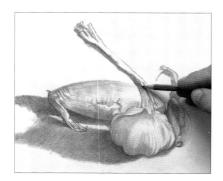

1 1 Darken the shaded areas of the shallot on the right and complete the linear detailing on the garlic. Clean off any smudges with a kneaded eraser.

Objects in this still life are not particularly interesting in themselves, but they have been carefully arranged so that the stalks lead our eye around the picture in a circle. The soft shadows anchor the subjects on the surface. The artist used a range of pencil techniques, from crisp linear detailing on the

stalks to soft shading using the side of the pencil, and smooth blending of the graphite using a torchon. He also used the torchon as a drawing tool in its own right, to put in the segments of the garlic that can be seen under the papery outer covering. The result is a simple but effective still life.

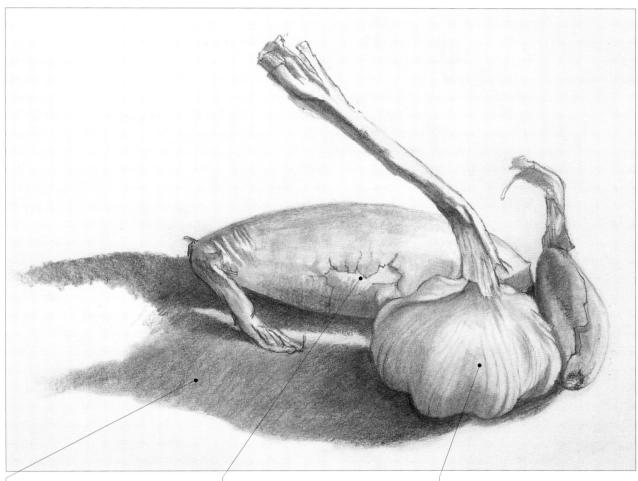

The shadow has been blended and softened so that it appears less substantial than the object that casts it.

Linear details, such as this split in the covering of the shallot, add a contrast in texture.

These subtle striations in the papery outer covering of the garlic are made by 'drawing' lines with the torchon.

Still life with pears

Fruit is ideal for still-life drawings, with simple shapes and subtle textures and colours that are perfect for rendering in coloured pencil. Select fruit that is not over-ripe, as any blemishes will soon start to deteriorate and you will be in a race against time to complete the drawing before the fruit starts to shrivel. This particular project uses slightly under-ripe pears with smooth surfaces that have a few marks and blemishes to add texture. and a soft blush of warmth on the skin. To keep the arrangement simple, the artist placed the pears on a plain, darkblue background which contrasts effectively with the pale-green fruit and adds depth to the shadows.

The key to the success of this drawing is to work slowly, carefully building up the tones and textures of the fruit with gentle pencil marks. The depth and range of colours found on the pear skins are achieved through several layers, starting with the lightest tone and adding light pencil strokes on top, with any spots or blemishes added at a later stage to enhance texture and emphasize the rounded shapes. When working with a group of objects, keep checking their relationships and use their cast shadows to create a convincing visual link.

Materials

- Smooth drawing paper
- · HB pencil
- Coloured pencils: pale yellow, bright green, warm yellow, olive green, dark brown, raw umber, burnt umber, pale brown, bronze, midbrown, mid-blue, dark blue, rich dark blue, ultramarine blue
- Eraser

The set-up

A rich blue fabric background complements the yellow-green of the pears. Try out different arrangements to find what works best. Here, the shadows cast by the foremost pear add interest to the composition. The foremost pear is also laid on its side so that we can see the dimpled base, adding variety to the composition.

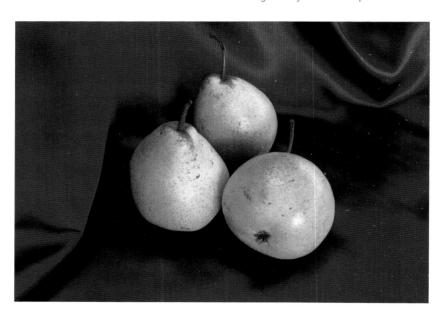

1 Using an HB pencil, lightly sketch the outlines of the pears, making sure you allow enough space on either side for the folds in the background fabric. Map out the positions of the stalks and the corresponding base on the pear at the bottom right of the composition. To make it easier, look at the angle of the stalk. This helps you to establish the central axis that runs all the way through the fruit.

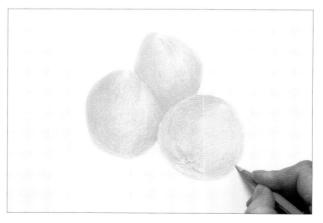

2 Very lightly apply a layer of pale yellow over all the pears, including the highlight areas. Apply a bright green over the green areas of the pears, using gentle pressure and loose strokes. Reapply the pale yellow and then add a warmer yellow, such as Naples yellow, around the edges of the back pear where it is tinged with pink. Use the same colour where the cast shadow falls on the middle pear.

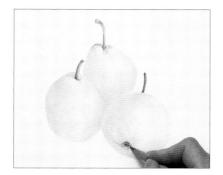

3 Start to build up tones to develop the form of the pears. Use a combination of pale vellow and bright green on the foreground pear to add the darker tones. Use loose strokes when applying the bright green so that the underlying yellow shows through. Combine pale yellow and an olive green to fill in the colour of the stalks, using darker browns, such as raw umber and Vandyke brown, on the shadow side. Use the same browns to sketch in the details of the dimple at the base of the foreground pear, using olive green for the darker areas of skin surrounding it, and a dark brown such as burnt umber for the darkest areas.

' Finish the back pear by adding 6 green along the edges where the shape curves. Use short marks to add texture, avoiding the highlight areas. Emphasize the shadow with light touches of dark brown. Start to build up the colour on the middle pear, with an olive green for the area of shadow cast by the foreground pear, following the form of the pear with more upright, vertical strokes. Add brown along the edges with yellow over the top to knock it back. With a dark brown, such as Vandyke brown, add the details at the base of the stalk, using tiny strokes to follow the contours of the recess to give the impression of a dip. Add any tiny blemishes or rough patches of skin using the same dark brown.

Tip: Use a sheet of tracing paper beneath your hand to protect the lower half of the drawing.

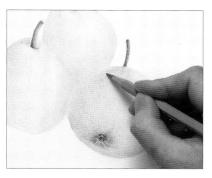

Continue gradually building up the colours and tones on the foreground pear. Use loose, light scribbles of olive green to develop a sense of texture as well as colour. To give an impression of the rounded form of the fruit, apply the strokes in the same direction as the curves.

Tip: Don't make the stalks too dark at this stage, as they will need to stand out against the background.

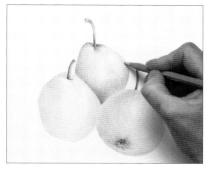

Next, build up the colours and **5** texture on the background pear. Use pale brown to define the edge where the foreground pear overlaps it, then apply loose, even strokes of the same colour, following the form of the pear. Work around the highlights and add a light layer of bright green with a slightly darker brown on top. Define the outer edge in olive green to ensure that it will stand out against the background. Add a hint of a warm pink glow by combining bronze and mid-brown on the lower half of the pear, fading out to a soft edge on the shadow area. To bring all the colours together, apply a layer of pale yellow.

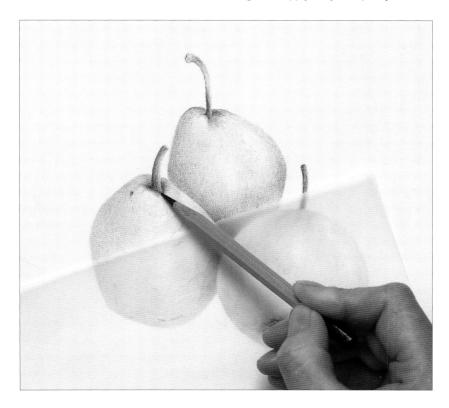

Assessment time

At this stage the pears appear to have form and texture, defined by the light highlights and the darker shadows. To complete the subtleties of the pears' skin colours, you need to build up more layers of pale yellow and green.

Fill in around the highlights to finalize their shape with a light yellow. Use mid- to dark browns to add any blemishes or areas of rough skin, keeping the pencil marks light.

Work over all the pears with a final layer of yellow and a little olive green on the darker tones. You can then start to add in the blue background; this will be a long, slow process, as you need to apply several layers, but it's worth taking your time over it in order to achieve the right density of colour.

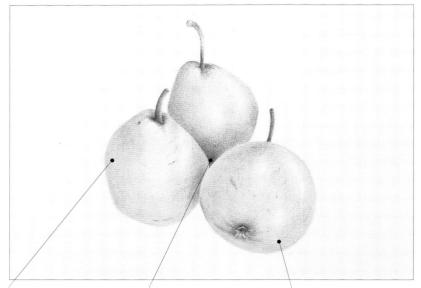

Using a pencil on its side gives broader strokes that bring out the tooth of the paper.

The intensity of the dark shadow area has been built up very gradually with light strokes. A combination of pale yellow and bright green gives depth to the base of the pear.

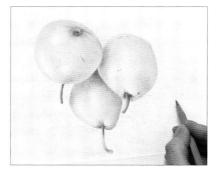

Zstart to add the blue background using a mid-blue, such as Prussian blue, applied with very light strokes using the tip of the pencil. Try to achieve an even layer of colour with no variations, working from the outside in to the edge of the pears for better control. Turn the drawing as you work, but keep the pencil strokes running in the same direction.

Tip: Use a soft eraser, or a piece of reusable putty adhesive, to soften or remove any hard edges along the folds.

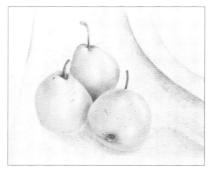

8 Using a slightly darker blue, continue to build up the colour, mapping out the folds of the material. Roughly sketch in the edge of the long vertical fold on the left, a soft diagonal fold in the lower right-hand corner, and swathes of fabric in the top right-hand corner. To emphasize the way the fabric is draped, build up the colour on the shadow side of the folds using strokes that follow the drape. Build up the shadows at the base of the pears with the same colour, to establish a visual link between the pears and the background fabric, and apply a crisp line around each pear with a very sharp pencil point.

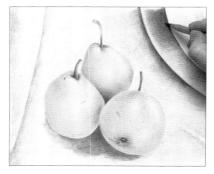

O With a dark, rich blue, such as indigo, start to intensify the colour of the background, applying more pressure in the deepest shadows. To accentuate the folds, build up colour on the edge of the fold, turning the paper if necessary to follow the direction of the curve. Where the light hits the top of the fold leave a lighter edge, using a rich blue such as ultramarine with a mid-blue underneath. The lines of the folds should give a sense of the weight of the fabric and the effect of gravity. Use a very dark blue in the darkest shadow areas between the two foreground pears and the recessed fold on the left.

With the background completed, an intensity is added to this subject which brings the pears to life. The pleasing composition is enhanced by the subtle effect of the contrasting colours of blue and green. To ensure that the pears aren't overshadowed by the rich blue of the fabric, the artist

reassessed the whole drawing, adding more strength to the fruit to reinforce any light areas. The stalks and blemishes or shadows on the top of the pears were also redefined with a dark brown to give them a crisper edge, and the texture of the skin was further highlighted with some additional speckles.

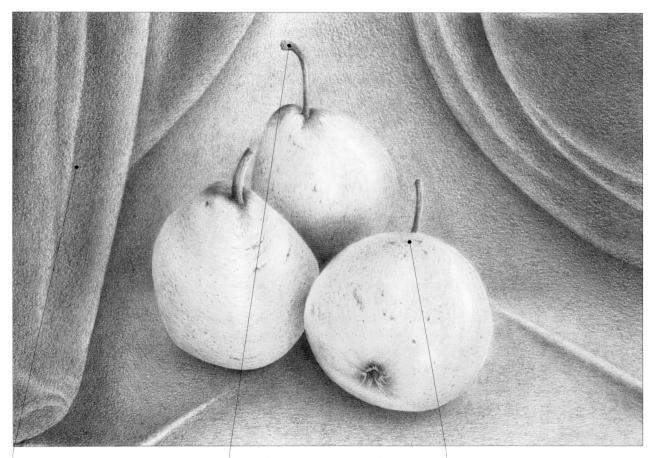

The folds of fabric are created by leaving a bright highlight with soft edges that blend to a deep blue in the recess of the fold.

A dark brown has been used to define the stalks so that they stand out against the blue background.

The brown speckles on the fruit are closer together on the edges to give the impression of rounded form.

Small objects drawn large

This project, which uses everyday household objects such as keys, nuts, bolts and screws, is easy to replicate at home and produces a graphic, contemporary-looking image that would look wonderful hung on a plain white wall.

The point of the exercise is two-fold. First, although the arrangement appears random, when you set it up you really have to think about the negative shapes in the composition – that is, the spaces between the objects. Compositionally, the spaces help the viewer's eye to move through the composition to alight on the positive shapes – that is, the metal objects themselves.

Second, this is an exercise in loosening up and freeing both your eye and your hand. When you are drawing small objects, there is sometimes a tendency for your hand to tighten up as you try to put in every tiny detail, and this can make a drawing look very dull and lifeless. Drawing things larger than life size, as here, forces you to move your hand and your wrist as you work, producing a looser, freer image. It also makes you look at your subject in a different way: you're more likely to view the composition as a whole, instead of getting bogged down in individual items. and to concentrate on the overall shapes and how they relate to one another.

To give you some idea of the scale involved, the large key towards the bottom of the image was about 7cm (just under 3in) long in reality, whereas in the finished drawing, it is about 15cm (6in) long – so the objects were drawn at roughly twice life size.

Materials

- Smooth drawing paper
- Thin charcoal stick
- Charcoal pencil
- Kneaded eraser

Tip: To make the measuring easier, imagine lines running horizontally and vertically through the composition and work out where the small household objects intersect them.

The set-up

Scatter your chosen objects loosely on a white background, such as a large piece of paper or a white tablecloth. You'll find you get a better result if you just throw the objects down and see what shape they make rather than attempting to place each one precisely – although you'll almost certainly need to spend time creating the right balance and adjusting the positions before you start drawing. To create some modelling on the objects, place a table lamp to one side.

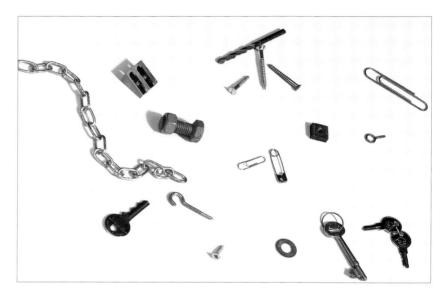

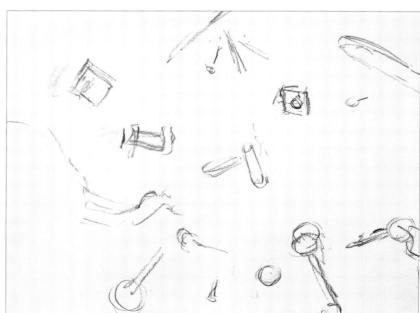

1 Using a thin charcoal stick, map out the shapes, carefully measuring both the objects and the spaces between them. Here, the artist decided to allow some of the objects to disappear off the edge of the paper, as she felt this created a more dynamic image than keeping everything within the rectangle of the paper.

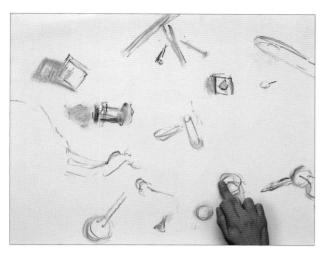

2 Using the side of the charcoal stick, block in the shapes of the shadows cast by the objects and smooth out the charcoal with your fingers. Putting in the shadows helps to give the objects solidity.

3 Gradually begin to refine the shapes of the objects, sharpening the edges with darker, linear marks. Blend the marks with your fingers, as before, to create the smooth, metallic finish.

4 Continue refining the shapes. This is a gradual process, but the objects soon begin to 'emerge' from the paper as three-dimensional forms.

5 Using the tip of the charcoal, introduce some detailing, such as the threads of the screws and the notches on the keys. Work across the drawing as a whole, so that you can continually assess each object in relation to its neighbours.

6 Continue the process of refinement and detailing. The process is akin to a photographer zooming in on his or her subject: initially you're looking at just the overall shapes, but as you add detailing the subject pops into sharper focus.

Assessment time

The shapes of the objects and their shadows are in place, but they still look rather indistinct. The edges, in particular, need to be more clearly defined. Overall, the tone is too uniform. Increasing the contrast between the dark and the light areas will make the objects look more three-dimensional.

Much crisper detailing is required on some objects.

Although the basic shape is there, some objects are too pale and lack the contrast that is needed to make them look realistic and three-dimensional.

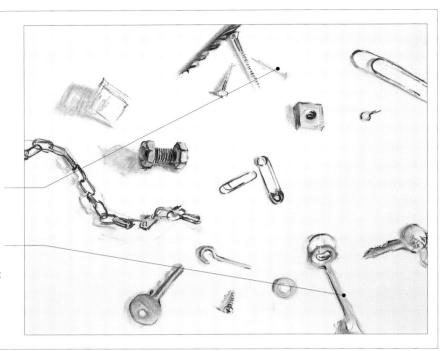

Working over the drawing as a whole, continue defining the edges of the objects and blending to create smooth, metallic surfaces.

Susset he tip of a charcoal pencil to sharpen up the edges of the objects and put in very fine details such as the screw threads.

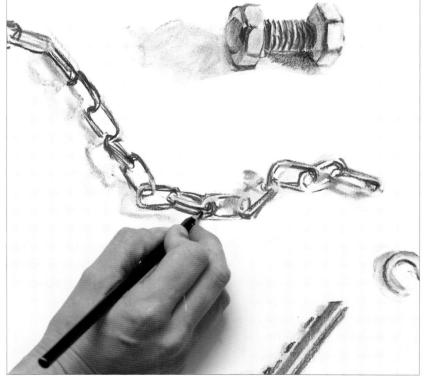

The chain is one of the few objects that look rather indistinct. Define the edges with the charcoal pencil, observing carefully how the links are connected. Remember to note where the highlights fall on the chain and allow the white of the paper to show through here. Clean up any smudges with a kneaded eraser.

This is a graphic and realistic drawing that shows how even the most humble of objects has potential as an artistic subject. The composition has been carefully planned: note how all the objects are placed diagonally on the paper so that they lead the viewer's eye into the picture. Although all the objects are small, some, such as the bolt and pencil sharpener, are deeper than others and cast shadows that add interest and another texture to the image. Crisp, linear marks and soft blending of the charcoal combine to depict the hard-edged metal objects and the smooth surfaces.

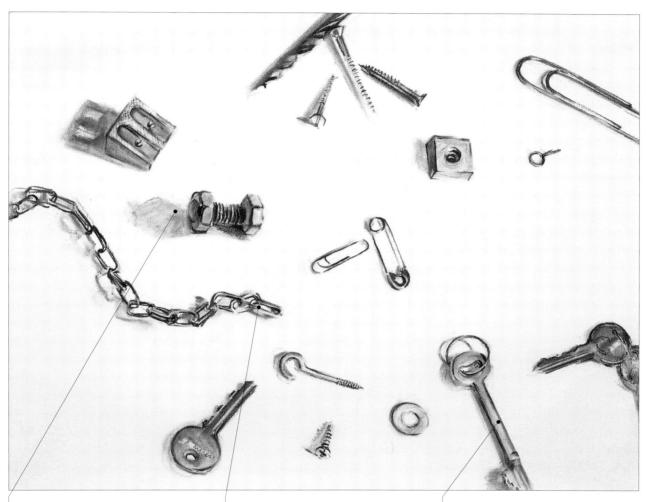

The cast shadows reveal that some objects are deeper than others.

The highlights on the twisted metal chain reveal the direction of the light.

Blending charcoal with the fingers creates a smooth texture.

Quick sketches of buildings: Church façade

Drawing a façade is a good way to start sketching buildings as, since you're only dealing with one side, there is no need to get involved in the complications of two-point perspective. Here, the light and shade on the building and the lovely rough texture of the stonework provide plenty of interest. Beware of putting in too much textural detail, though, as it can make a drawing look dead and lifeless; a suggestion of the texture in a few key parts of the image is normally sufficient.

These sketches were made in pen and ink, or pen and ink plus water-soluble pencils. Pen and ink is a popular choice for architectural studies, as fine lines are often required. Ink is difficult to erase if you make a mistake – so it's a good idea to start in pencil and then reinforce the lines in pen once you're sure the measurements and proportions are correct. Though the water-soluble pencils were used dry on this occasion, blending the colours of the stonework with water would be very effective without destroying the textural pen-and-ink work.

The scene

This viewpoint offers several possible compositions: the façade of the church, the details of the arches on the left, and even textural studies of the stonework.

5-minute sketch: pen and ink

With a relatively simple shape like this church, you should be able to map out the basic structure of the building in a matter of minutes. The key, of course, is to measure all the elements and their relative positions very carefully. A thumbnail sketch like this is a good warm-up exercise when you're drawing on location. It also gives you the chance to work out the composition of a larger drawing.

10-minute sketch: pen and ink

In ten minutes, you have time to indicate the texture of the stonework and the heavy wooden door. A few simple pen lines are enough to show the shape of the stones set into the walls; don't overdo it or you'll deaden the overall effect. A sketch made *in situ* like this provides very useful reference material for a larger drawing that you can work up in more detail at a later date.

15-minute sketch: pen and ink, plus water-soluble pencils

Here, the artist decided to concentrate on the arches to the left of the church. With a little more time at your disposal, you can explore the effects of light and shade and try to capture more of the texture and character of the stonework. As in the other sketches on these two pages, the basic composition was mapped out in pencil before any penand-ink work was done, with hatched pen lines indicating the most deeply shaded parts of the scene. Finally, water-soluble pencils were used to block in the colour of the stonework. Sketches such as this are a very good way to explore the tonal relationships in a scene.

25-minute sketch: pen and ink, plus water-soluble pencils

This is a more elaborate version of the sketch above, and shows the relationship between the church and the ruined building next to it. The artist was able to get closer to the true

colours of the scene, using warm, purplish blues for the shadow areas. There was also time to place the building in a setting by including trees and foreground grass.

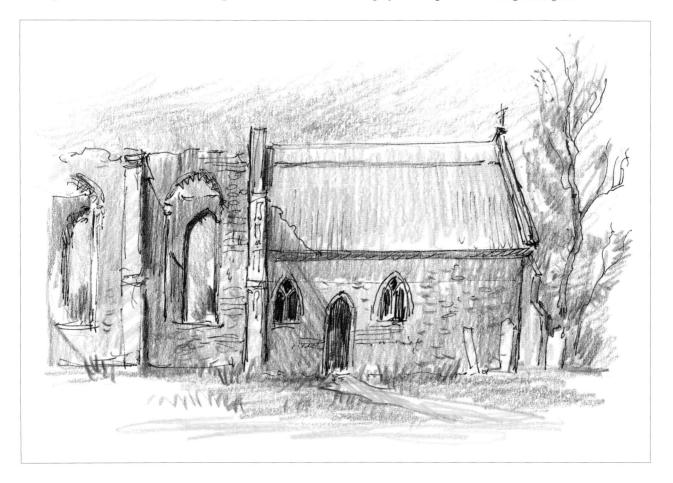

Quick sketches of buildings: Doorway

Old, dilapidated buildings provide a great opportunity to practise sketching different textures. Crumbling stonework and tiles, sun-bleached wood with the grain exposed, worn carvings: all are full of texture for the artist. And if the building happens to be in an exotic location, so much the better. When it comes to capturing the essence of a foreign country, architectural styles are as evocative as costumes or landscapes. Look for interesting details when you're on your travels. You'll be amazed at how effectively a few quick sketches made *in situ* can bring back memories.

When you are sketching textures, do not put in too many details or they will dominate the image. Imply the textures rather than putting in every single brick and crack. Allow the shapes and textural contrasts to speak for themselves.

The scene

Coming across this doorway into a courtyard in Beijing, China, the artist was attracted by the contrast between the rather grandiose entrance and the much more humble-looking abode within. Although the subject is almost monochromatic, it provided enough visual interest to prompt her to make a few quick sketches.

5-minute sketch: charcoal

In this sketch, the artist has managed to create a convincing impression of depth through her use of tone. Strong linear marks for the shaded undersides of the arch and doorway combine with smudged charcoal for the shadow areas. The artist has put in just enough linear detail to hint at the shapes of the bricks and roof tiles, without detracting from the tonal study.

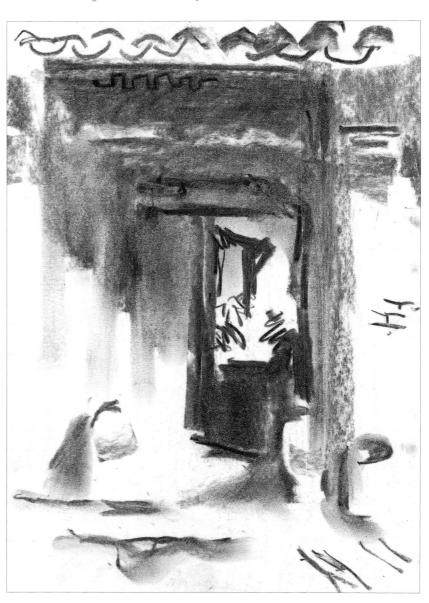

Tip: If you don't measure up carefully, the proportions will look wrong — particularly if you can see two sides of the building and want to use two-point perspective. Imagine lines running horizontally and vertically through the image and work out where the different elements, such as a window, or a decorative detail such as a door knocker, intersect them.

15-minute sketch: pen and ink, plus brush

Overlapping roof tiles make an attractive graphic study. Here, the scratchy, irregular lines produced by using a dip pen seem appropriate for the rather rough-textured, hand-made tiles. The artist wanted to retain the lines of the tiles, so she drew them in waterproof ink before applying a dilute wash of ink over the top for the shadow areas.

25-minute sketch: pastel

This sketch is built up of blocks of colour and tone which get progressively lighter the nearer they are to the foreground of the scene. The tooth of the paper helps to convey the texture of the stonework.

40-minute sketch: pencil and graphite

Having explored the composition of the scene and some of the textures in the previous two sketches, the artist then settled down to making a more detailed sketch. She used a 6B pencil for the darkest parts, including the deep cracks in the bricks on the right, and a graphite stick (blended with a torchon) for the areas in shadow. Note how much of the brickwork is left untouched: nonetheless, the texture is conveyed very effectively.

Quick sketches of buildings: Farmhouse

A viewpoint that shows two sides of a building almost inevitably creates a more interesting drawing than one that shows only the front façade. It also allows you to exploit contrasts of light and shade, as one side will be more brightly lit than its neighbour. Bear in mind the rules of two-point perspective. You can plot the perspective lines to their vanishing points if you wish, but careful observation and measuring are generally sufficient.

5-minute sketch: 2B pencil

Here, the artist drew the farmhouse from a slightly higher eye level than that from which the photo on the right was taken. As a result, the front façade of the house is virtually square on and the line of the roof does not slope downward. When you're drawing a building, it's well worth making a quick sketch such as this simply to measure and check the placement of the different elements.

The scene

In this winter scene, the dark hedge in front of the building and the skeletal trees by the side stand out well against the snowy ground and provide a contrast of texture with the flat stonework. The hedge also echoes the shape of the building, as the lines of the hedge run more or less parallel to the building's sides. In this instance, the artist chose to make a series of monochrome sketches — but the bright red door and little outbuilding or porch would provide an uplifting splash of colour in a study made in coloured pencil or chalk.

15-minute sketch: burnt umber coloured pencil

When you've established the basic lines of the composition, you can begin to explore the tonal relationships in more detail. Here, we've shown the tonal study as a separate sketch; in reality, you might choose to make this the second stage of the sketch shown on the opposite page. The artist has also begun to put some detail into the stonework, being careful not to overdo things and deaden the overall effect.

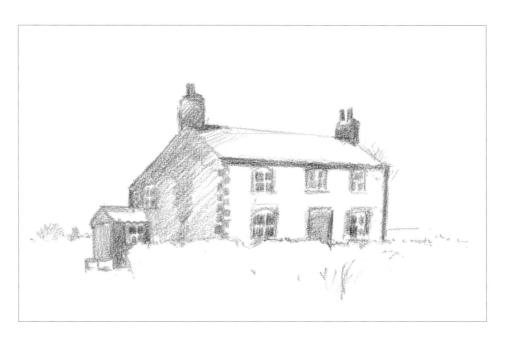

30-minute sketch: ballpoint pen

Although only the cornerstones are drawn in any detail, the artist has nonetheless created the texture of the building very well by means of simple shading. One of the most common mistakes that beginners make is to underestimate the tonal

range in a scene; make sure that the darkest areas, such as the window recesses, are really dark, as this will make the snow-covered areas really sparkle. The brightest parts, such as the roof, can be left virtually untouched.

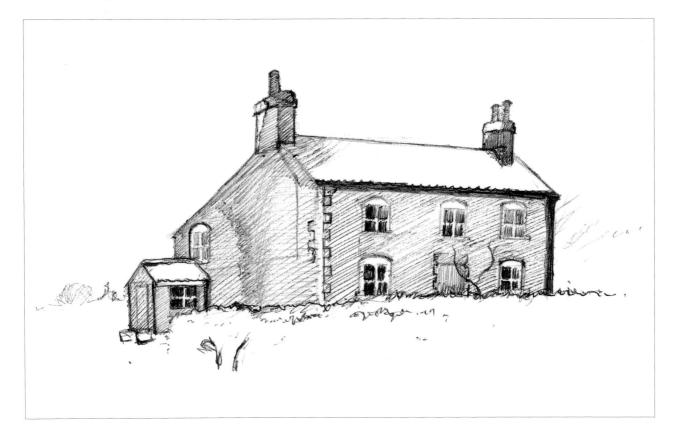

Old wooden gateway

There is something very appealing about drawing distressed wood and peeling paint. Rusting nails and bolts, differences in tone where the sun has bleached and faded the paintwork, the grain and texture of the wood underneath – all these things are far more interesting to look at than a pristine, gloss-painted surface. Perhaps part of the fascination is that, as the paint begins to peel away, we catch glimpses into the past and a hint of how the subject once looked.

Soft pastel is a lovely medium to use for a project such as this. By using the pastel on its side and lightly applying a thin layer of colour that does not completely cover the paper or a previous layer of pastel (a technique known as scumbling), you can create wonderful textures and optical colour mixes. By blending the pastel with your fingertips, you can produce smooth textures and even tones.

This particular scene is also a study in light and shade. The bright patch of sunlight that can be seen through the gateway is balanced by the area of shade to its left, with the wedge-shaped shadow helping to lead the viewer's eye through the scene to the buildings at the back of the courtyard.

A drawing of the gateway alone might result in a soulless study of an architectural detail: by including the yard, we can speculate about the daily routine and living conditions of the inhabitants and bring the scene to life. However, too much emphasis on it would detract from the gateway, so subdue the detail and draw the buildings as blocks of colour.

Materials

- Terracotta-coloured pastel paper
- Soft pastels: reddish brown, black, white, pale mint green, dark mint green, greys, browns, yellow

The scene

This old wooden gateway, covered in peeling paint and bleached by the sun, offers both interesting textures and colours and an intriguing glimpse into the courtyard beyond.

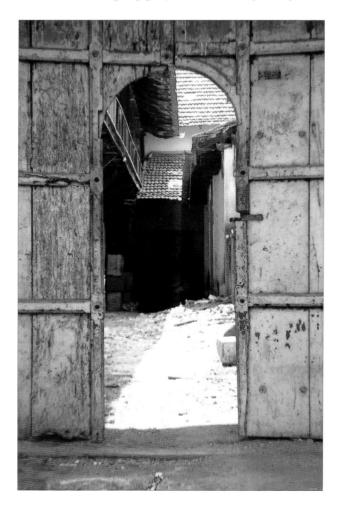

1 Using a reddish brown pastel on terracotta-coloured pastel paper, lightly sketch the main lines of the scene – the arch of the gate, the wooden panels, the roofline and the division between the shaded and sunlit parts of the ground that can be seen through the gate. The terracotta paper enhances the feeling of warmth and sunlight in the scene; it also provides the base colour both for the buildings in the courtyard and for the wooden gateway, which means that the paper does part of the work for you, without you having to apply the base colour separately.

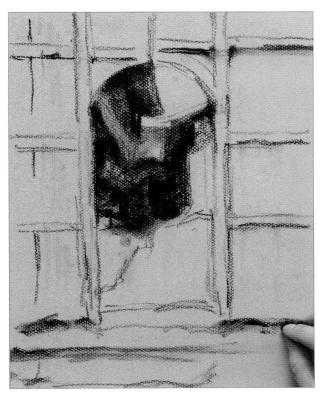

2 Using the side of a black pastel, block in the buildings. Note the differences in tone: some areas, such as the underside of the overhanging roof, are darker than others. Add the thin shadows cast by the wooden panels on the gate.

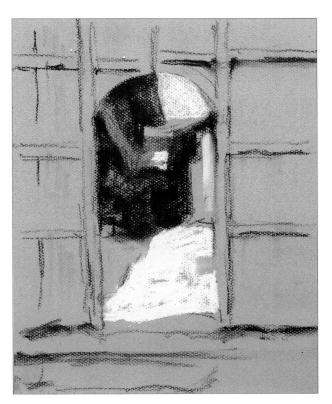

3 Using the side of a white pastel, block in the very bright highlight areas of the sunlit foreground and the sky above the building, as well as those parts of the building that receive the most light.

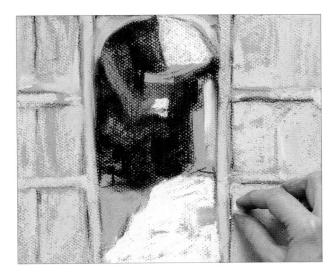

4 Using a pale mint green pastel (again using the side rather than the tip), block in the painted gateway. Allow some of the paper to show through so that it looks as if an earlier colour is showing through the peeling paint: with this kind of subject, it's important to keep the coverage loose and uneven so that you create the right kind of texture.

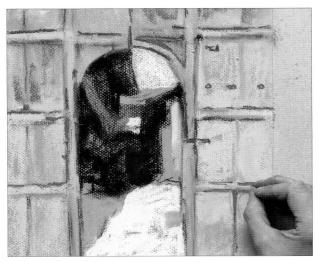

5 Use a reddish brown pastel to put in some of the exposed wood on the gateway, rubbing with your fingers to smooth out the colour. Roughly scumble a darker mint green over the paler green in places, allowing some of the lighter colour to show through. The successive layers of pastel help to develop more depth and texture on the gate.

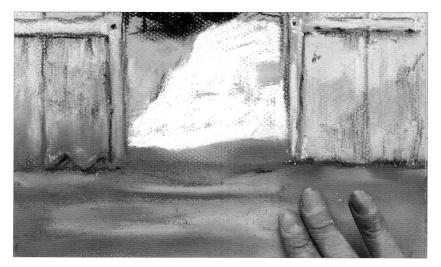

6 Stroke pale mint green followed by reddish brown over the foreground and blend the colours with your fingertips. Allow some of the mint green to remain visible: some parts of the foreground are cooler in tone than others.

Although the buildings in the courtyard are little more than blocks of colour, we can see the different facets: paying careful attention to the light and dark tones makes them look like three-dimensional forms. A little more depth of colour is needed on the gateway, as too much of the paper texture is visible.

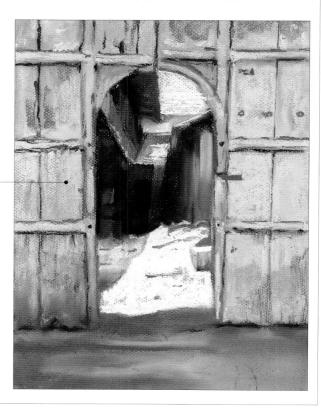

The paper texture is too prominent; this area does not look like painted wood.

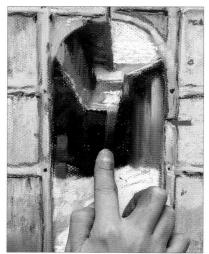

Block in the shaded part of the ground in the yard with pale grey and white, blending the colours a little with your fingers but taking care that they retain their individuality. Reinforce the different facets of the courtyard buildings using mid-browns and greys for the shaded sides and applying light touches of white, smoothed out with your fingers, for the more brightly lit parts and the shafts of light.

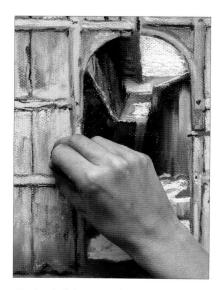

Apply light vertical strokes of mint green, with tiny touches of yellow, over the individual panels of the gate and blend with your fingers. Remember to allow a little of the paper colour to show through, to give the impression of underlying layers of paint.

The finished drawing

This drawing exploits two important soft pastel techniques - scumbling and finger blending. The main focus of interest is the sunbleached, painted gateway, which forms a natural frame for the scene of the courtyard beyond. Although detail is subdued and the buildings are little more than blocks of colour, there is a delightful sense of light and shade in the scene. The shafts of sunlight, which are created by stroking a thin line of white pastel across the paper, are balanced by blocks of shadow, so neither one dominates.

The arch of the gate is positioned almost centrally in the picture space, which creates a calm mood. However, this is balanced by the lines of the buildings and the wedge-shaped patches of sunlight and shadow, which help to break the symmetry and make the composition more dynamic.

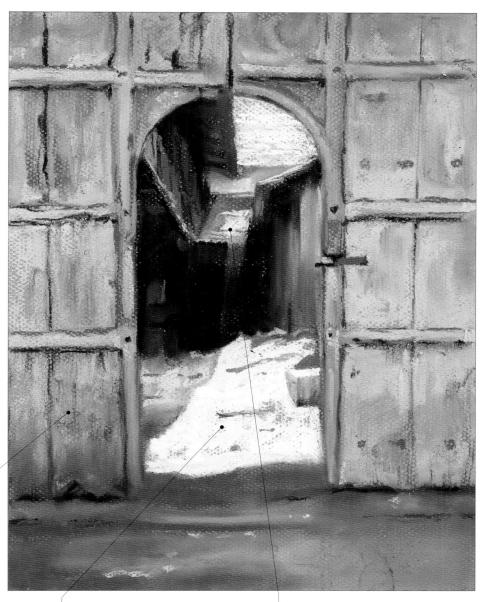

Scumbling allows the paper colour to show through and, at the same time, suggests the texture of the wood.

The bright, wedge-shaped patch of sunlight leads our eye through the picture to the buildings at the back of the courtyard.

Blocks of tone – light versus dark – reveal the form of the buildings and the direction from which the light comes.

Venetian building

This project is an exercise in perspective. The bottom of the balcony is more or less at the artist's eye level – so this is the horizon line. If you look at the initial pencil sketch in Step 1, you will see that the artist has drawn the bottom of the balcony to form a straight, horizontal line across the centre of the image. Any parallel line above this point (such as the line of the roof) will appear to slope down towards the vanishing point, while anything below it (such as the base of the building) appears to slope upwards. Take time over your initial pencil sketch to make sure you get the angles and

proportions right. Texture is important, too, and the rough texture of the ancient brickwork is very pleasing to the eye. Don't try to draw every single brick, as this would make the image too 'busy' and detract from the overall effect. Leaving some areas empty gives much-needed contrast of texture and implies the smooth render that would once have covered the whole façade of the building.

Pen and ink is an ideal medium for architectural drawings, as it allows you to make very precise marks. Here, both permanent and water-soluble inks are used, creating a combination of crisp,

linear details and ink washes, which soften the overall effect. For this project, the artist chose to use sepia ink, rather than black, as it is a much softer colour and helps to give the drawing a rather nostalgic, old-fashioned feel.

Materials

- Heavy drawing paper
- HB pencil
- Permanent and water-soluble sepia inks
- Steel-nibbed pens
- Fine paintbrush
- · Gouache paint: white

The scene

Old buildings such as this one, with the canal lapping at its foundations, are common in Venice, and can evoke a strong sense of the past. The decorative lines of the balconies are not overly ornate, but they hold our interest, and the beautiful arched doors and windows form a repeating pattern that runs through the whole image.

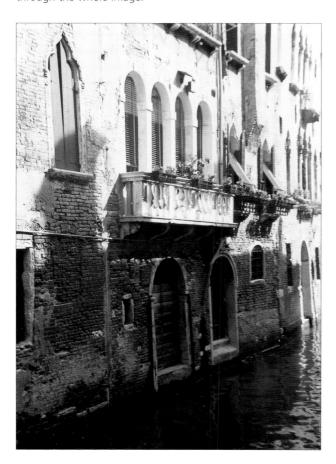

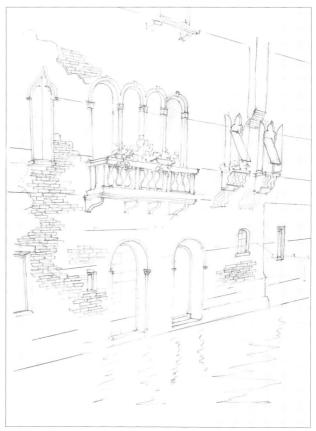

1 Using an HB pencil, make a light, detailed sketch of the scene, making sure you measure all the different elements.

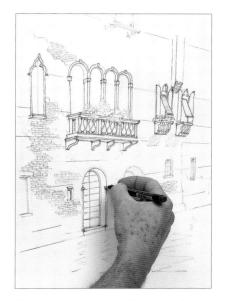

2 Following your pencil lines and using permanent sepia ink, carefully ink in the windows and balconies. It is very important not to use water-soluble ink here, as you want to retain all the crisp detail of these lines in the finished drawing.

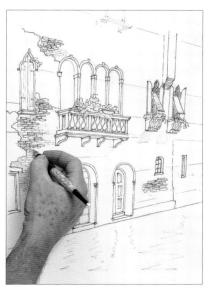

Continue with the ink work, using water-soluble sepia ink for the foliage and brickwork. Also hatch the windows behind the open shutters on the top right of the drawing in water-soluble ink, drawing the lines close together as this area is very dark.

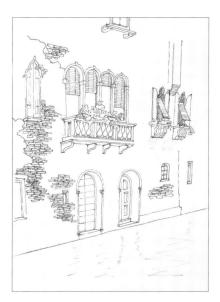

Continue working on the brickwork, alternating between permanent and water-soluble sepia inks. Put in the lines of the Venetian blinds in permanent ink. Here the artist has put the blinds in at different heights to add interest.

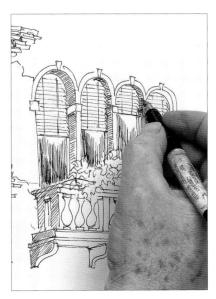

5 Using water-soluble ink, put in some light hatching around the window recesses, in the windows below the blinds, and under the balconies to introduce some shading. (The ink will be washed over at a later stage, so that the hatching marks blend together to create an area of solid tone.)

The main lines are now in place. However, although there is some indication of the shading around the windows and balconies, the image overall looks rather flat and two-dimensional. From this point onwards, concentrate on creating more depth and texture.

Although there is some texture and detail, the image as a whole is rather lifeless. Washes of colour will help to counteract this.

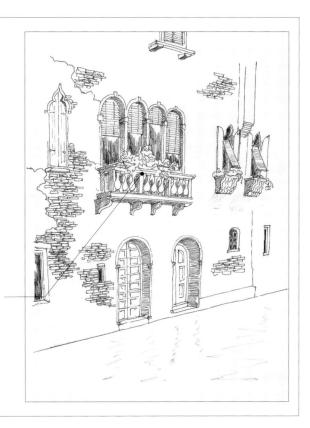

6 As the light is coming from the right of the scene, the balconies cast oblique shadows on the façade of the building. Put them in lightly, using an HB pencil. (The pencil lines act as a positional guide – they should be covered up by washes of ink later.)

Zusing permanent ink and zigzagging vertical lines, draw the ripples in the water. Hatch the darkest areas of the water, using water-soluble ink. The ripples will remain visible when a wash is applied, while the hatching will blend to an area of solid tone.

Brase all the remaining pencil lines, apart from the cast shadows that you put in in Step 6. Load a paintbrush with water and brush over the shaded parts of the building. The lines drawn in water-soluble ink will dissolve, allowing you to create areas of solid tone.

Ontinue brushing water over the water-soluble ink, including the canal. Brush colour over the doors, darkening them with more ink if necessary. Dilute some sepia ink (or use sepia watercolour paint) and brush it over the cast shadows on the building, keeping within the pencil marks.

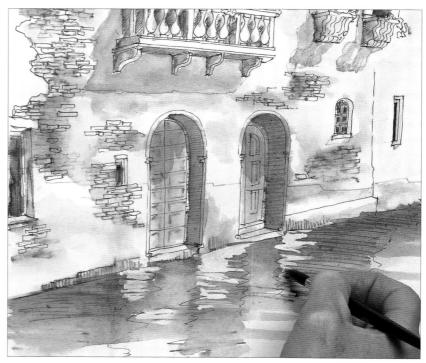

 10° Using a fine paintbrush and white gouache, paint in the reflections of the doors in the water. Gouache paint used straight from the tube can be quite thick so only dip the tip of your brush into it.

The finished drawing

This is an evocative and elegant penand-ink study of a classic Venetian building. Permanent ink was used for the linear details in the most important areas, while brushing water over the water-soluble ink has helped to create areas of tone that soften the harshness of the pen work, transforming an architectural study into something much more picturesque. Although only one colour of ink was used, a good range of tones was created by washing water over different densities of hatched marks.

Both permanent and water-soluble ink were used here, creating a combination of linear detail and soft tonal washes.

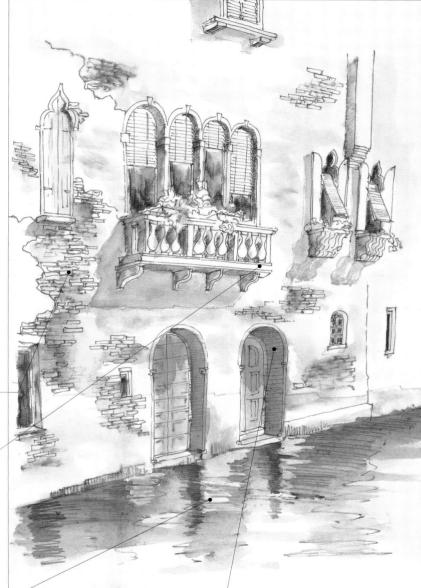

The linear detailing of the building, as in the balcony, was drawn using permanent ink.

White gouache paint, which is opaque, is used to paint the light reflections on top of the dark patches of water.

Washing water over hatched lines produces an area of solid tone – the closer together the lines, the darker the tone.

Cityscape

Although a construction site might not seem the most obvious choice of scene for a drawing project, if you choose your viewpoint carefully, the bold colours and graphic shapes can give you the chance to create a modern-looking, semi-abstract drawing. It will also test your ability to draw straight lines — always important when drawing buildings, whatever era they date from.

Scenes such as this can be found in towns and cities all over the world and recording a new building at all stages of its construction, from site clearance through to completion, makes an interesting long-term project. Moreover, many companies are waking up to the investment potential of buying original art – so who knows? If there's a prestigious building project going on near your home and your work is good enough, you might even be able to persuade them to buy it to display in the reception area or to use in promotional literature.

Oil pastels are not renowned for their subtlety of colour, but for a subject such as this, which relies on the bold, primary colours of the building cranes for much of its impact, they are ideal. You need to press quite firmly on the oil pastels, so use a heavy drawing paper or an oil-painting paper for this project to avoid the risk of tearing the support.

Materials

- Heavy drawing paper or oil-painting paper
- 4B pencil
- Oil pastels: pale greys (warm- and cool-toned), bright blue, red, yellow, white, lilac, Naples yellow, black
- Scraperboard tool or craft (utility)

The scene

The brightly coloured cranes stand out dramatically against the cloudless blue sky, while the straight lines of the cranes and the buildings under construction create a graphic, almost abstract composition. The diagonal lines of some of the cranes make the composition more dynamic.

1 Using a soft pencil, mark out the lines of the cranes and the buildings under construction. There's no need to put in any of the internal lines at this stage, but do make sure you measure all the angles and distances carefully.

2 Using pale grey oil pastels, block in the building on the right. Note that the shaded sides are cooler in tone than those in full sunlight, so alternate between warm- and cooltoned greys as required.

Block in the sky, using the side of a bright blue oil pastel and making sure you don't go over the lines of the cranes. Putting in the negative shapes of the background sky at this early stage makes it easier to see any thin lines of the cranes that you have not yet drawn.

4 Begin putting in the red lines of the cranes, using bold, confident strokes and pressing quite hard on the tip of the pastel. Lightly stroke the side of the pastel over the warm-toned shadow areas of the buildings.

5 Now put in the bright yellow of the cranes, filling in the spaces between the rungs with blue. Work white oil pastel over part of the sky and blend it with your fingers.

6 Using the side of a lilac oil pastel, roughly block in the shaded sides of the buildings on the right. (Note, in particular, the shadow cast on the building on the far right of the image.) Apply the same colour to some of the shaded interior floors of the building on the left. Work Naples yellow, which is a pale, warm yellow, over the warm-toned area of the building in the centre and add small dashes of red on the tall foreground building.

Vising the tip of a black oil pastel to make strong, bold marks, draw the reinforced steel joists of the building in the background. Establish the different storeys of the building on the left, using a range of shadow colours (blue, lilac, black) as appropriate. Use the side of the pastels to make broad, lightly textured marks; you can then go over them with other pastels to blend the colours optically and create a more interesting shadow colour.

The drawing is nearing completion and only a few minor adjustments are needed. In places, the cranes are lost

against the building or the sky and need to be more sharply defined. Some of the shadows need to be darkened slightly.

This crane merges into the building behind it and needs to be a little more clearly defined.

The lines of the white crane are quite delicate and will be hard to draw with a thick oil pastel.

8 Using a scraperboard tool or the tip of a craft knife, scratch off blue oil pastel to create the lines of the white crane in the centre of the image.

9 Scratch into the red crane on the left to create some highlight areas, and strengthen the red diagonal line so that the crane really stands out against the building.

The finished drawing

This artist has matched the medium to the subject beautifully. The bold, vibrant colours of oil pastels, which might be too brash and unsubtle for many subjects, are perfect for the bright, primary colours of the cranes and sky. Although it is difficult to draw fine details with oil pastels, they are the ideal drawing tool for the solid, graphic lines of this scene. Using

the side of the pastels for the façades of the buildings brings another quality to the image and creates a lighter texture. Overlaying one colour on another, particularly in the shadow areas, has created interesting optical colour mixes that are much more lively and interesting than a flat application of a single colour could ever be.

Optical colour mixes create lively shadow colours.

The sgraffito technique allows you to scratch off the pastel and create fine lines.

Finger blending in the sky softens both the colour and the texture.

Sunshine and shadow

When you're drawing buildings, you can opt either for a very detailed approach that captures every single element, rather like an architectural drawing, or for something more atmospheric, as here, where the effects of light and shade are as important a part of the image as the buildings themselves.

In this project, the light is very strong and is illuminating the front of the buildings. If the light were coming from the side, the differences in tone between the shaded and brightly lit areas would be more pronounced. Nonetheless, there are still areas of deep shadow within the scene, particularly around the arched doorway - and it is these shadows that give depth to the façade. There is also a large shadow on the left of the scene, cast by a building behind the artist's viewpoint. This shadow occupies almost one-quarter of the drawing. Although it is dark, some detail is still visible within it so don't allow it to dominate the image completely.

Creating a strong enough contrast between very bright and very dark areas is the key to this drawing. As this is a charcoal drawing, the white of the paper is left untouched for the brightest areas. You can't make the light areas any lighter than they already are so, in order for the brightest areas to look really bright, you need to make the dark areas really dark.

Because the light on the brightest parts of the buildings is so strong, much of the detail is subdued. In many ways this is a bonus: when you're drawing a complicated subject like this, it's very easy to get obsessed with detail and put in so much that it detracts from the essential elements of the scene – the lively interplay between light and shade.

Materials

- Smooth, heavy drawing paper
- Thin willow charcoal stick
- · Clean rag or kitchen paper
- Kneaded eraser

The scene

There is an interesting balance between light and dark in this scene, with the top of the buildings bathed in sunlight and the bottom half deep in shadow.

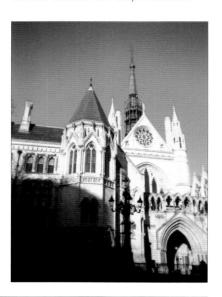

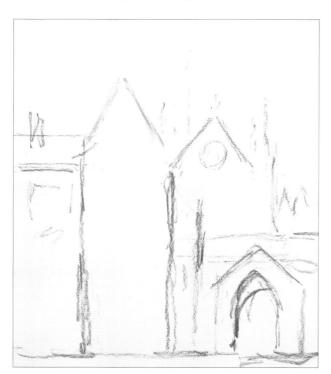

1 Using a thin charcoal stick, map out the shapes and proportions of the buildings, checking your measurements as you work. Use line only: there is no point in putting in any shading until the basic structure has been established.

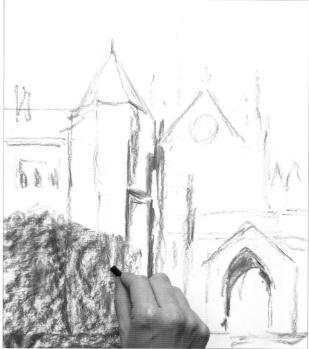

 $2^{\rm Block}$ in the dark recesses of the windows and the arched main door. Using the side of the charcoal stick, block in the shadow on the left-hand side, which is cast by a building behind the artist.

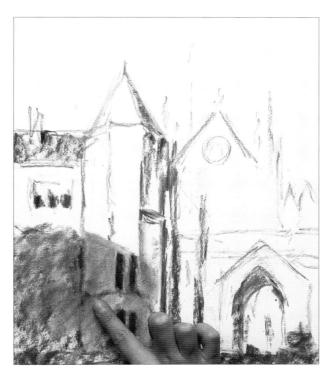

3 Using the tip of the charcoal, lightly block in the windows on the left-hand building. At this stage you are still establishing the basic shapes of the different architectural elements; refining the dark and light areas will come later. Smooth out the cast shadow with your fingertips.

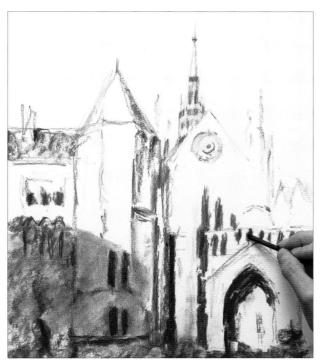

A Begin to put more detail on the buildings, such as the windows above the arched doorway and the rose window on the front façade. The windows above the arch are among the darkest areas, so you can afford to press quite hard on the charcoal as you block in the shapes of these elements.

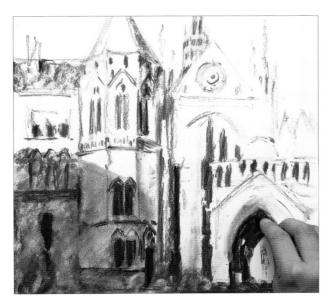

 $\mathbf{5}$ Continue adding dark details to the buildings. Using the side of the charcoal stick to get a broad, even coverage, darken the shadows at the base of the image and in the archway, and then gently smooth out the charcoal with your fingertips.

6 Lightly sweep the side of the charcoal stick over the sky area. Using a clean rag or a piece of kitchen paper and a gentle circular motion, smooth out the charcoal to give a soft tone. Note how the brightest parts of the right-hand building are beginning to stand out against the darkened sky.

This is the time to stand back and assess the tonal values, as the drawing depends for its success on there being sufficient contrast between the very dark and the very light areas. You can't make the lightest areas any lighter, because the white of the paper is as light as you can get so the only way to make the light areas really stand out is to darken the darks.

The shadows on the building look too light and hazy.

The lightest parts of the buildings are almost lost against the sky.

It's almost inevitable that you will have muddied the edges of the buildings when putting in the sky so, using a kneaded eraser, gently wipe around the edges of the buildings to give them a sharp outline. If your eraser is worn, shape a section with your fingertips to create a clean, sharp edge.

Adjust the tones across the image, darkening the sky slightly if necessary so that the buildings stand out more. The shadows in the bottom left need to be really dark, too. Draw the lamppost in the foreground, making it very dark so that it comes forwards in the image.

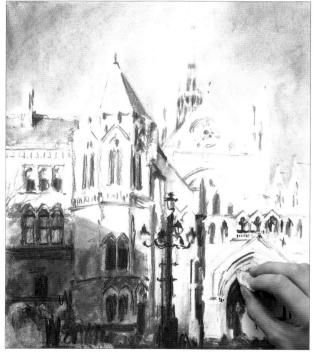

Ontinue refining the lights and darks across the whole image, and use the kneaded eraser to accentuate highlights and sharpen edges. The adjustments are minor at this stage, but you need to keep assessing the tonal values of the drawing overall.

This is an atmospheric drawing that captures the fleeting effects of light and shade extremely well. The contrast between the solidity of the buildings and the smoothed-out, insubstantial-looking shadow areas is particularly effective. The artist has used the white of the paper to good effect for

the brightly lit parts of the buildings; they are almost dazzlingly bright when compared with the deep shadows in the bottom left of the image. Although much of the detail is subdued because of the lighting conditions, we can see enough to know how grand and imposing the buildings are.

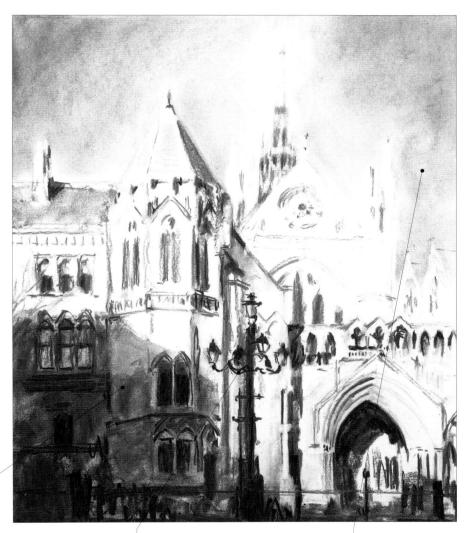

Smoothing out the shadow areas makes them appear less solid.

The lamppost is very dark, which brings it forwards in the image.

There is just enough tone in the sky to allow the brightly lit buildings to stand out.

Quick sketches of animals: Cows in a field

Of all the domesticated animals that one could draw, cows are probably the most docile – and, particularly when there's a plentiful supply of fodder, the most likely to stay in the same place for a reasonable amount of time. With luck, therefore, you may have time to work up a reasonably detailed sketch before they amble off to pastures new.

When you're drawing any group, be it a group of animals, people, or objects in a still life, you need to observe the spatial relationships between the different elements very carefully. Use grid lines (real or imaginary) to work out where things should be positioned, and remember to look at the negative shapes (the spaces between different elements), both to get the shapes right and to make sure that your composition is balanced.

One of the difficulties of working on location is that the light can change dramatically in the course of a few hours, so it's a good idea to make a note of the direction from which the light is coming. In the ten-minute sketch (below), the artist drew a small arrow to remind herself of the direction and angle of the sun.

The scene

Within a large group such as this, there are a number of potential scenes to draw. Rather than drawing the whole scene, try isolating different elements, as the artist has done in the sketches shown here, to find a grouping that you like. Remember that you may have to reposition other elements, such as the fence posts, in order to get the composition to work.

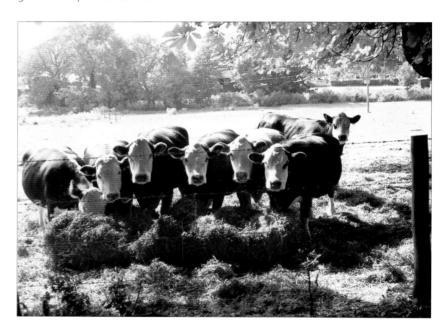

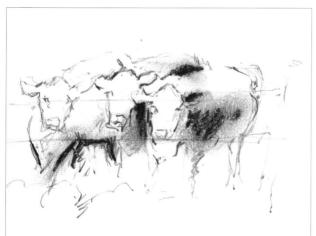

5-minute sketch: graphite and pastel pencils

Look for elements within the scene that you can use to help yourself position things. Here, the line of the barbed wire fence is a useful guide: the top wire is level with the eyes of the cow on the left while the bottom wire is level with the nose of the cow on the right. Even in just a few minutes, you can apply some colour to the basic shapes — either as a colour note to refer to later or simply to block in areas of dark tone.

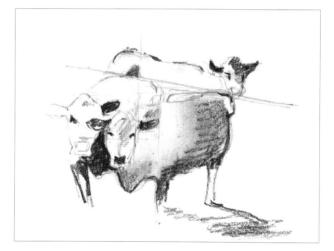

10-minute sketch: graphite and pastel pencils

When you draw a line across the rumps of the two foreground cows, you can see that it runs parallel to the back of the cow in the background. (Guidelines would be rubbed out but have been left in here to show what was done.) Also, if you look down from the tip of the right-hand cow's left ear, you will see that it's level with the animal's left foreleg: by drawing in a faint line, you can place the leg accurately.

15-minute sketch: graphite and pastel pencils

Even though the cows' bodies are a single colour, look for differences in tone that will tell us about the form of the animal. In this scene, the sun is quite high in the sky and is hitting the animals' backs. By blocking in the tops of the backs in a lighter tone than the flanks, the artist has created some modelling that conveys the rounded shape of the cows' bellies.

20-minute sketch: graphite and pastel pencils

Building on the previous three sketches, this sketch conveys more of the texture of the animals' coats. Vigorous scribbles of pastel pencil hint at the semi-rough texture and indicate the direction in which the hairs grow.

Quick sketches of animals: Leopard

Whatever your views on the morality of keeping animals in zoos, they certainly give you the opportunity to study at first hand animals that are extremely difficult to get close to in the wild. Just like domestic cats, big cats spend a lot of their time drowsing or sleeping, which is the perfect time to sketch them. Even in this situation, however, you need to convey a sense of their strength and power – so think about the skeleton underneath the fur and about where the largest muscle groups are situated. And as in any portrait, human or animal, the eyes are vital in conveying the character.

When you drawing fur or hair, always look at the direction in which it grows and make sure your pen or pencil marks run in the same direction. Think about the quality of the fur and alter your marks accordingly: are the hairs small and tightly compacted, as on the top of the animal's head, or longer and farther apart, as around the bridge of the nose? Remember that you do not need to put in every single hair: a suggestion is enough, as the viewer's brain will fill in the missing details.

10-minute sketch: soft pastels

Soft pastels are a wonderful medium for portraying the beautiful markings and the soft texture of the fur, as you can overlay one colour on top of another and blend the marks with your fingertips to create subtle optical mixes, while also putting down stronger marks for the dark spots. If you are pushed for time, try sketching just part of the face as a practice exercise, as the artist did here. Note how including just one eye immediately brings the 'portrait' to life.

The 'relaxed pose'

This apparently relaxed pose, with the leopard draped over the branch of a tree from where it can survey its surroundings, is characteristic of this large cat – and there's no mistaking the alertness in the eyes or the power of those huge neck muscles and jaws.

15-minute sketch: pen and ink

This is an exercise in creating the texture of fur using the harsh, linear medium of pen and ink. The sketch is incomplete, which is fine for a quick practice exercise in which you want to concentrate on just one aspect – but note how the artist has put in faint pencil guidelines marking the position and shape of the eyes. Getting the eyes right is critical in any portrait, human or animal.

30-minute sketch: charcoal

Like soft pastels, the powdery medium of charcoal is perfect for rendering the texture of fur. Here, the artist worked on a pale but warm-toned grey pastel paper, so that she could start from a mid-tone. A brilliant white paper would have been too stark and unsympathetic. Note how she has captured the shape and form of the animal's skull through her use of shading: the left-hand side of the head and what we can see of the body are in shade, while the left eye is more deeply recessed still. As in the pastel drawing opposite, the artist has blended the charcoal marks with her finger or a torchon to create the softness of the fur, while adding dark scribbles on top for the actual markings.

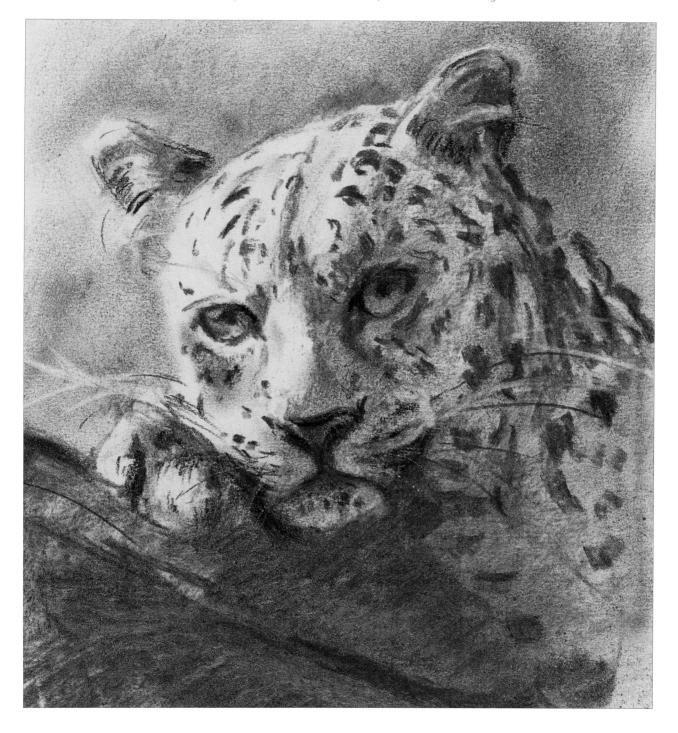

Quick sketches of animals: Short fur

This breed of dog has relatively short fur, which means that the muscles and bone structure are more obvious than in long-haired species. But the fur is also quite thick and you need to convey a sense of this in your drawing. The best way to achieve this is to build up the texture gradually, using light, short pencil or pen strokes until you have the desired effect.

As for colour and tone, even areas that, on first glance, appear to be pure white or a solid black will contain other tones. Observe this carefully: the fur follows the contours of the animal, so capturing changes in tone will help you to convey the shape of the animal, be it a stocky body, as here, or the streamlined silhouette of a greyhound.

Start from the eyes because once you have placed the eyes, it is easier to map out the rest of the head and its features. When you have completed the head, you can use it as a guide to work out how big the body is in relation to the head.

5-minute sketch: B pencil

Even in a very short space of time, you can put down the essentials of the animal's 'pose'. Look at the dog's stance: here the legs are planted four square on the ground, but in a moving animal the balance would be very different. Measure the size of the head and legs in relation to the body and roughly scribble in the darkest patches of fur to give some indication of the position of the markings.

The 'pose'

This alert stance, with head and tail erect and feet planted squarely on the ground, is typical of the breed. The side-on viewpoint gives you the opportunity to study both the anatomy of the animal and the markings and texture of the fur, while the lolling red tongue adds a splash of colour to an otherwise muted range of browns and blacks.

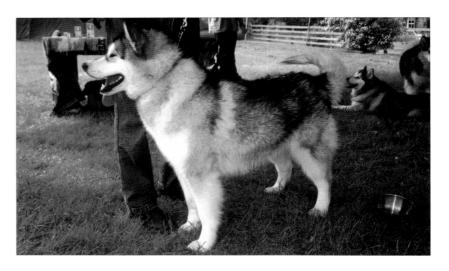

15-minute sketch: coloured pencils

Here, the artist has added more texture and detailing to the animal's fur (as well as adding colour to the dog's tongue). Note the short, jagged strokes around the edges, rather than a smooth outline, and how the pencil marks follow the direction in which the fur grows. A range of browns was used in this sketch, starting with the lightest and moving on to the darkest in order to build up the colours and tones gradually.

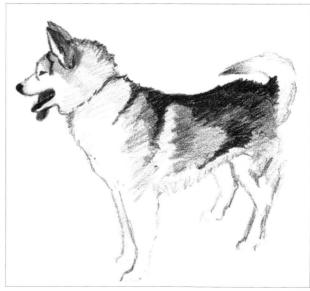

30-minute sketch: black ballpoint pen

Even with an ordinary ballpoint pen, which does not allow you to vary the width of the line that you produce, it's amazing how much variety of tone you can achieve if you take the time and trouble to build up the drawing gradually. Note how much more textured the fur is in this sketch than in the ones on the opposite page. It also has depth: light marks in the brightest areas (on the dog's shoulder, for example) indicate the shadows within the fur and tell us that the individual hairs are relatively short.

- **Tips**: When drawing fur, make sure that your pencil or pen marks follow the direction in which the fur grows.
- Remember that fur rarely, if ever, lies completely flat: use sharp, spiky marks around the edge of the animal's body to convey the texture and length of the fur.
- Within areas that appear at first glance to be a single tone, look for subtle differences that will help you to convey the underlying shape of the animal and the direction of the light.

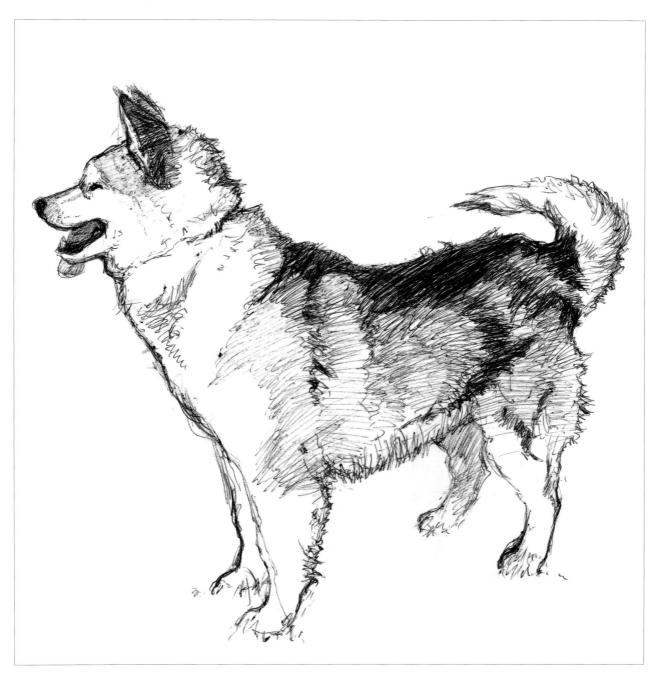

Old English Sheepdog

The breed of Old English Sheepdogs are delightful and their faces (or the little that you can see underneath the animal's shaggy hair) are full of character. A textural study seems particularly appropriate for this breed, whose whole character is defined by its long, flowing fur. For a short-haired breed such as a Whippet or a Great Dane, a more linear drawing that emphasizes the muscles might be more suitable.

When you're drawing long-haired animals such as this, however, it's very easy to be seduced into concentrating on the wispy, flyaway fur and to forget about the bone structure of the animal underneath. Always start by establishing the underlying structure, and then add the decorative and textural detail on top. The way to do this is to start by drawing prominent features such as the eyes, nose, mouth and any bony protuberances near the surface. Once you've got their shape, size and position right, the rest will follow much more easily.

When drawing any kind of portrait, be it human or animal, it is a good idea to begin by positioning the facial features. Think of the eyes and nose as an inverted triangle: establish the outer point of each, as this will make it easier to get the rest of the features in the right place. If you start by drawing the outline of the head, you may find that you haven't left enough space to fit in the features.

In a monochrome drawing, you also have to think carefully about tone. Monochrome might seem ideal for an animal whose coat consists almost entirely of white and grey tones, but a very common beginner's mistake is to make the greys too light: consequently, the whole image can appear to be lacking in contrast. Reassess the tones continually, and be prepared to adjust them as you work and to darken the darks in order for the light tones to sparkle and shine through.

Materials

- Smooth drawing paper
- · Graphite pencils: HB, 6B
- Torchon
- Plastic eraser

The subject

When you're drawing an animal (or a person, for that matter) always look for a characteristic pose or expression. The lolling pink tongue is typical of this breed of dog and gives the animal a quizzical, slightly comical expression that is very appealing. You can't rely on animals to stay still for long, however, so (unless you're an experienced artist and can draw quickly) you'll probably find it easiest to work from a reference photograph.

1 Using an HB pencil, lightly sketch your subject. Start with the facial features, as once you get these right, the rest will follow relatively easily. Note that the eyes and nose form an inverted triangle and begin by putting down the outer points of each as a guide. Roughly shade the eyes, nose and tongue, and indicate the direction in which the fur grows around the head.

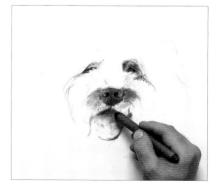

2 Using a 6B pencil, darken the nose and the sockets of the eyes. Note that, because the dog's head is turned ever so slightly to one side, one eye appears to be fractionally larger than the other. Use a torchon to blend the graphite on the nose and tongue to get a smooth, soft coverage. Also use the torchon as a drawing tool to apply some tone to the fur around the nose

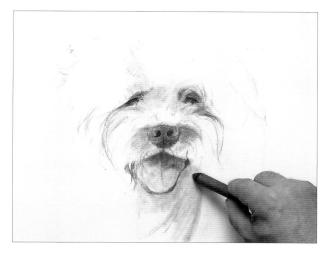

 $\bf 3$ Again using the 6B pencil, draw the mouth (which can just be glimpsed around the tongue) more clearly. As in the previous step, use the torchon as a drawing tool to apply some tone to the fur on the dog's face and body. Your strokes should follow the direction in which the fur grows.

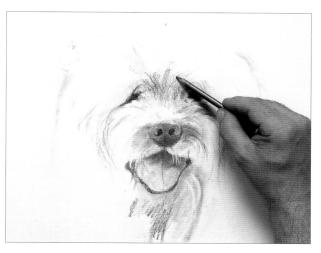

4 Loosely define the outer limits of the fur around the head to give yourself a boundary towards which to work. Using a 6B pencil, put in the darkest areas of fur on the dog's face, always making sure your pencil strokes follow the direction in which the fur grows.

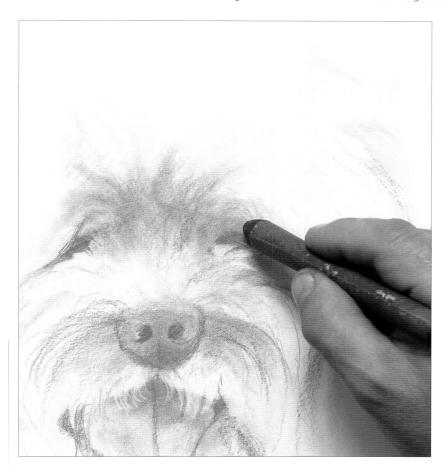

 $\bf 5$ Blend the graphite marks with a torchon to create smooth areas of tone between the eyes and on the face.

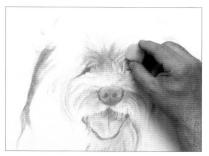

6 Using the edge of a plastic eraser, wipe off fine lines of graphite to create the white hairs around the eyes. (It is easier to wipe off white details than to apply dark tones around them.)

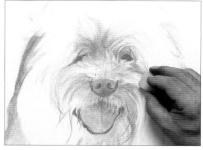

Zusing an HB pencil, draw more mid-toned hairs around the mouth. Wipe the eraser across the dog's face above the mouth to create the lightertoned fur in this part of the face.

The sheepdog's eyes, nose and mouth areas are prominent points that establish the structure of the dog's skull; the surrounding shaggy fur, by comparison, can be regarded as little more than decorative detail. For the rest of the

drawing, concentrate on looking at the tones within the fur. Your shading in this area will convey the colour of the fur and also, because of the way the fur falls, imply the bony structure of the skull underneath.

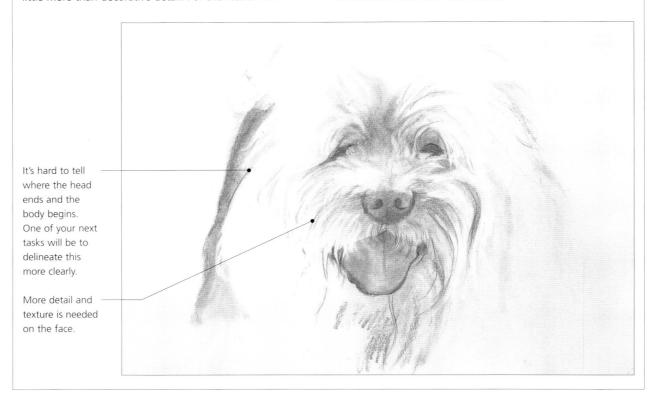

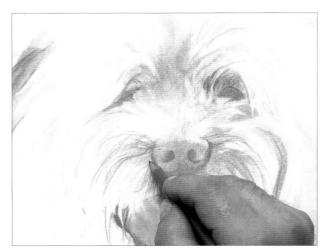

Now you can complete the textural detail of the fur. Using an HB pencil with a fine point, draw more individual wispy hairs – particularly around the nose and eyes. Beware of applying too much detail to the body; this would detract from the head, which is the most important part of the drawing.

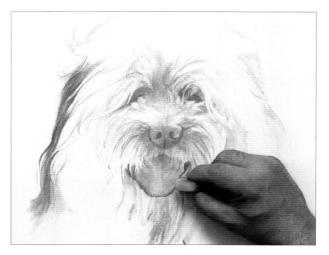

Using a 6B pencil, reinforce the dark line on the left-hand side to try to make it clearer where the head ends. Assess the drawing as a whole and readjust tones by blending graphite with a torchon or lifting out tone with an eraser wherever you judge it to be necessary.

The finished drawing

This is a charming study of a well-loved family pet, and an interesting exercise in texture. The texture of the fur is created through a combination of softly blended pencil marks and

more linear strokes for individual hairs on the face. The fact that the dog is looking directly at us immediately engages us in the portrait.

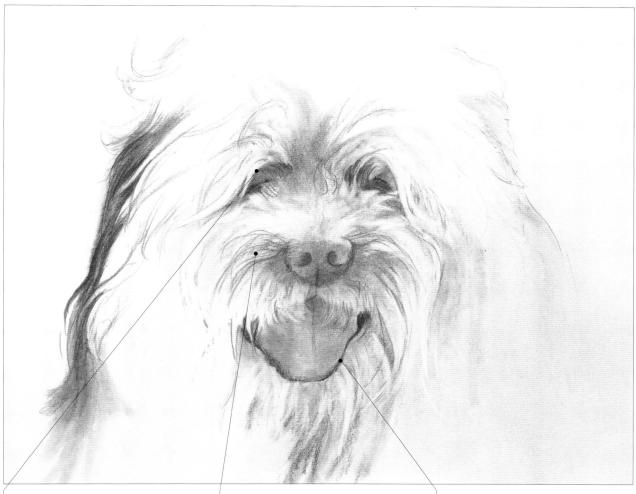

The eye socket has depth; it appears as a rounded form rather than a flat circle on the surface of the face.

The texture of the fur is created through a combination of marks blended with a torchon and individual linear strokes.

The dark line of the lower lip helps to make the lolling tongue stand out more clearly in the drawing.

Short-eared Owl

Feathers and fur make wonderful subjects for a drawing. You don't even need to draw the whole animal: close-up details concentrating on the wonderful colours and patterns can make very striking semi-abstract works of art.

This drawing is made using coloured pencils, the fine tips of which enable you to capture the subtle coloration to perfection. Although on first glance it looks as if the bird is predominantly white and brown, there are many different colours within the dark areas blue-greys and blacks as well as a range of browns. Paying attention to these differences will give your drawing depth and form, as they reveal the shaded areas within the feathers. Beware of using pure black for the very darkest areas, however: it's a very harsh, unforgiving colour and a combination of indigo and a very dark brown will give you a softer, more sympathetic result.

Take plenty of time to build up the texture. Get it right and you'll almost feel as if you could ruffle the feathers with your fingertips. Use short pencil strokes that follow the direction in

which the feathers grow. The highlights are not very obvious in the reference photo, so you need to work out where they would appear: as any light source is likely to be above the subject, they are normally in the upper part of the eye. Note also that the owl's head is turned slightly to one side, so we can see more of one eye than the other.

The most important thing in a drawing like this is to keep referring to your reference photo to ascertain the lights and darks. Stand back from your drawing at regular intervals and assess it as a whole. It's easy to get caught up in detail and concentrate on the tip of your pencil rather than on the overall effect.

Materials

- Smooth, heavy drawing paper
- 2B pencil
- Coloured pencils: primrose yellow, olive green, gold or mid-yellow, gunmetal or charcoal grey, blue-grey, indigo, chocolate brown, sepia
- Tracing paper
- Pencil sharpener
- Kneaded eraser

The subject

You'd have to be very lucky to get so close to such a magnificent bird in the wild. This owl was photographed at an owl sanctuary. Whatever you think about zoos and wildlife parks, they do provide an opportunity to admire and draw specimens that might otherwise be difficult to see.

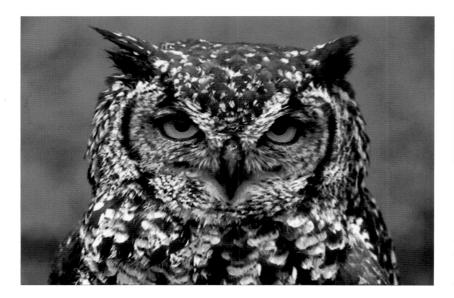

1 Using a 2B pencil, lightly sketch the subject. Map out the blocks of dark-coloured feathers across the bird's head and body with light, gentle strokes.

2 Using a primrose yellow pencil, colour in the iris of the eye and put tiny strokes of olive green over the darkest part (the part immediately below the pupil) to darken the yellow. Go over the iris again with gold or a mid-yellow pencil.

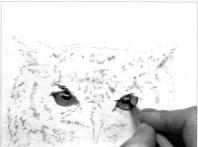

Colour in the pupils of the eyes, using a gunmetal or charcoal grey pencil and leaving a highlight in each pupil untouched. Go over the pupil again with a blue-grey pencil. Using an indigo pencil, put down the first indication of the feathers that grow around the eyes.

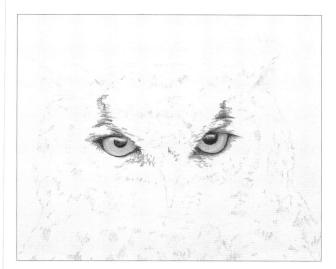

4 Go over the pupil again with indigo and the iris with mid-yellow. Note how these successive layers build up, creating a smooth, almost glossy surface colour. Outline the eyes with an indigo pencil and put in some of the feather detail around the eyes with the same colour.

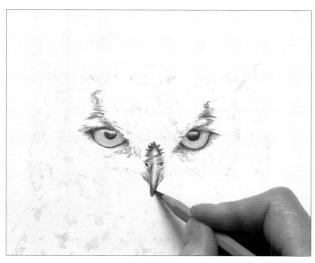

5 Put in the beak with a blue-grey pencil, leaving the bright highlight untouched. Go over the darkest part with a chocolate brown pencil. Use tiny pencil strokes for the feathers that overlap the top of the beak. Take care not to make the beak too dark or it will overpower the whole image.

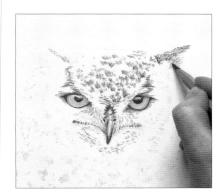

6 Using a sepia pencil, put in the dark feathers on the owl's face and head. Use little, jagged scribbling strokes that follow the direction in which the feathers grow so that you begin to get some realistic-looking texture into the feathers. Look at the relative length of the feathers, too: those around the ears are longer, so make long pencil strokes, using the side of the pencil rather than the tip.

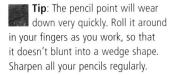

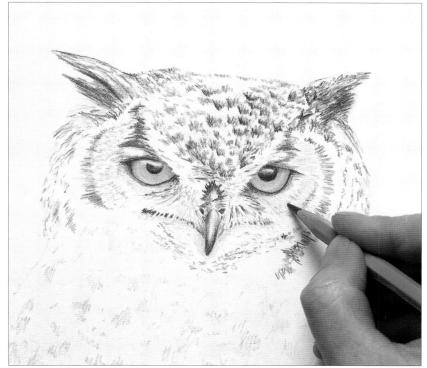

At this point you need to define the outline of the bird without creating a rigid line. Use short, wispy, horizontal strokes around the edge of the face and vertical strokes for the body behind, as the difference in direction helps to define the form, and leave some gaps around the outline for the white feathers. Continue mapping out the dark areas of feathers on the face, using blue-grey and sepia pencils as before.

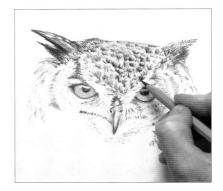

Continue working around the top of the head, using jagged, scribbling strokes as in Step 6 and alternating between charcoal grey and sepia pencils as appropriate. For the very darkest feathers, use chocolate brown. This immediately gives the feathers more depth and we can begin to see the different layers.

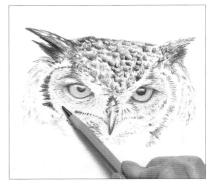

Darken the side of the face with sharp, jagged strokes of indigo, so that it stands out more clearly from the body. Some areas within the face are still completely empty of pencil marks. Using the side of the pencil, make light strokes for the feathers in this area. Although the feathers are largely white, you need to introduce some tones of pale grey here as there are shadows within them.

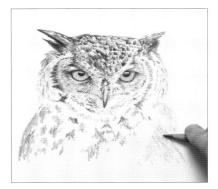

Build up the colours on the owl's 10 face using the same pencils as before - indigo and chocolate brown for the very darkest areas, and bluegrey and charcoal grey elsewhere. The area around the eyes is particularly important: build up the dark feathers here so that you see the eyeball as a rounded form rather than as a flat circle on the surface of the face. Begin mapping out the darkest blocks of feathers on the body, using the side of a chocolate brown pencil. The feathers are bigger here than on the face, so you can be less precise about their placement and shape.

The drawing is progressing well, but more detailing is needed on the side of the head and the body. Work slowly and deliberately: it is amazing how much texture you can create by building up the layers of pencil work.

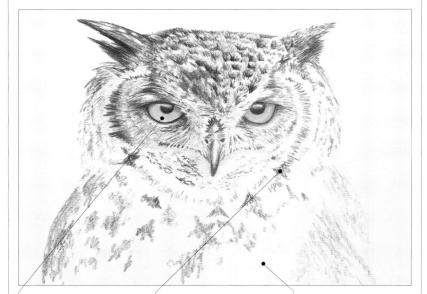

Our attention is drawn to the eyes, but the vivid yellow needs to be still more vibrant.

The face is in danger of merging into the body and needs to stand out more clearly.

Only the main blocks of feathers have been put in on the body. More detail and texture are required.

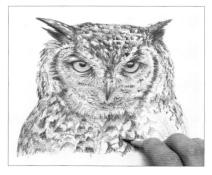

1 1 Go over the irises again with another layer of primrose yellow and olive green to intensify the colour and create a smooth, glossy surface that contrasts well with the soft ruffles of the feathers. Reinforce the dark feathers on the owl's face with indigo and chocolate brown. Repeat the process on the body, using the side of the pencil rather than the tip to create broader marks. (The clumps of feathers are larger here, so you can be less precise with your marks.)

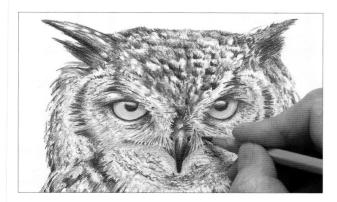

12 Darken the beak with indigo, so that it stands out from the feathers, taking care not to obliterate the highlights. Use long, smooth pencil strokes to create the hard, bony texture. Reassess the feathers on the face, and add more definition if necessary.

The finished drawing

This drawing is a perfect demonstration of how successive layers of coloured pencil marks can create detailed textures and depth of colour. The key is patience: if you rush a drawing like this, you will not achieve such subtlety and detailing. Contrasts of texture – the hard, shiny beak versus the soft, ruffled feathers and the shiny, moist eyes – are vital.

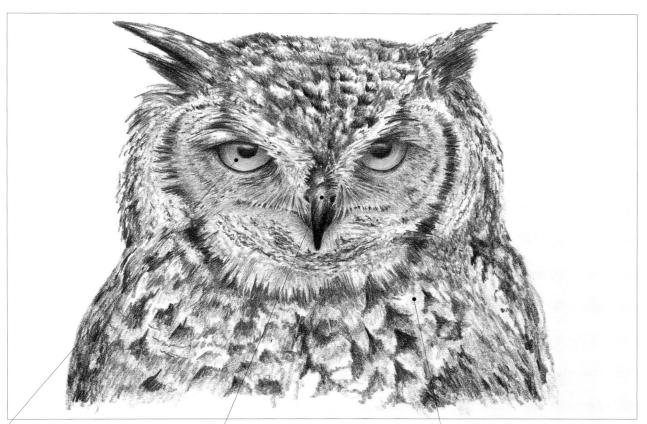

Note the intensity of colour created by gradually building up successive layers of different colours.

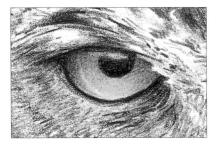

The highlight on the beak helps to indicate its curving shape, hard, bony texture and slightly shiny surface.

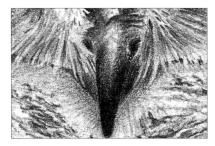

The face stands out well from the body, thanks to the jagged pencil marks used for the feathers in this area.

Chickens

When you're drawing birds, you can opt either for a very detailed and painstaking rendition of the feathers or for a more impressionistic approach that attempts to recreate the lovely sheen. This project takes the latter route and relies on a combination of building up layers of water-soluble oil pastel to give a rich sheen and making linear, textural marks with both oil pastel and water-soluble pencil.

The project also involves brushing water over the pigment in order to blend it on the support and create the right colour mixes – so use a medium-weight or heavy watercolour paper which will be absorbent enough for you to be able to apply water without it cockling. Work with your drawing board flat for these stages, so that the colour doesn't run where you don't want it to go.

Look carefully and you will see that, even in areas that at first glance appear to be a single colour, there are many different colours within the birds' feathers – rich browns, oranges and yellows, with blues and violets in the darkest, most shaded parts. The feathers also have a slight iridescence, which is very hard to convey accurately. However, applying layers of colour on top of one another creates lively optical colour mixes that give something of the effect.

Materials

- Watercolour paper
- Water-soluble pencils: grey, dark brown
- Ruling drawing pen
- Masking fluid
- Water-soluble oil pastels: dark olive green, yellow ochre, grass green, pinkish brown, bright yellow, orange, burnt sienna, violet, bright green, red, blue, brown
- Brush
- Kitchen paper

The scene

This artist spotted these two chickens in a local farmyard and was attracted by the colourful plumage and lovely rounded shapes. She had to take a reference photo quickly, since the chicken on the left was about to walk away. She decided to swap the birds around in her drawing so that they would be facing one another, as this made a more pleasing composition.

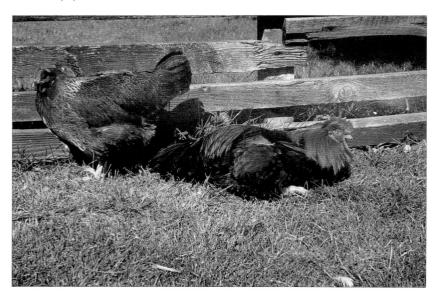

1 Lightly sketch the scene using a grey water-soluble pencil. To give yourself a guide when you apply the colour, draw some light lines within the outline of the birds to indicate the positions of the main blocks of feathers, such as the wings.

2 Using a ruling drawing pen, apply masking fluid over the lightest parts of the image, where you want to preserve the white of the paper – the white feathers, the chickens' legs and the tall stems of grass in the foreground.

3 Loosely scribble dark olive green water-soluble oil pastel over the background, working around the chickens. Work some yellow ochre and grass green oil pastel over the top.

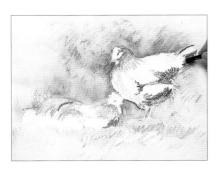

Now you can begin applying colour to the chickens. Work bright yellow water-soluble oil pastel around the neck and tail feathers, making vertical marks that follow the direction in which the feathers grow. Overlay orange oil pastel for the darkest orange parts. Use burnt sienna for the dark browns and add violet for the very darkest parts so that you begin to develop a sense of the depth of the feathers.

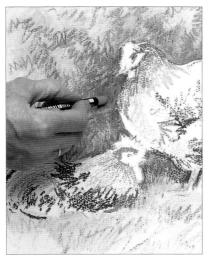

7 Darken the background behind the birds so that they stand out more, making jagged strokes of bright green to give a grass-like texture.

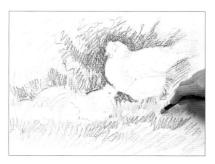

4 Scribble yellow ochre and dark olive green oil pastel over the foreground, adding pinkish brown oil pastel where the dry, dusty earth can be seen under the grass stems.

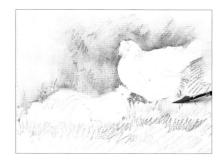

5 Brush clean water lightly over the foreground and background, blending the colours on the support and making sure that no colour spills over on to the chickens.

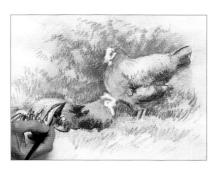

8 Carefully brush clean water over the birds. Keep a piece of absorbent kitchen paper to hand to dab off any excess water so that you can control where the colour goes.

Tip: Rinse your brush frequently so that you don't contaminate the light orange areas with dark violet or brown.

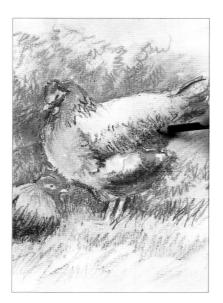

Put in the red combs, using both red and orange water-soluble oil pastels to get the right shade of orangey-red. Wash over with clean water to blend. Dip the tip of a dark brown water-soluble pencil in water and, using short feathery strokes, draw in the ruffle at the base of the neck and the large feathers that lie around the base of the wing. (Dipping the pencil in water intensifies the colour, while the linear pencil strokes add texture.)

Assessment time

The drawing is nearing completion and contains an interesting mix of linear marks, which create texture in the grass, and softly blended colour. However, more detail is needed on the chickens' feathers, both to add texture and to increase the depth of colour and create a realistic-looking sheen.

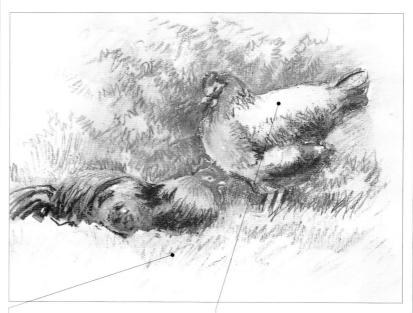

The grass in the foreground needs more colour and texture, as this will help to imply that it is closer to the viewer.

Although this area is the most brightly lit part of the chicken, it looks too stark at present; it needs more texture and detail.

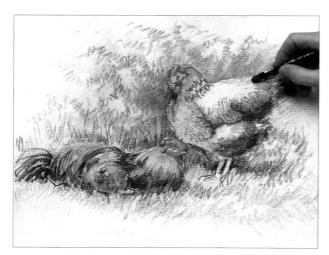

10 Gently rub over the drawing with your fingertips to remove the masking fluid that you applied in Step 2. Using the dark brown water-soluble pencil, put more detail into the feathers, as in Step 9. Scribble blue oil pastel into the darkest parts of the feathers. Darken the birds' upper bodies by applying short, linear marks with a brown oil pastel.

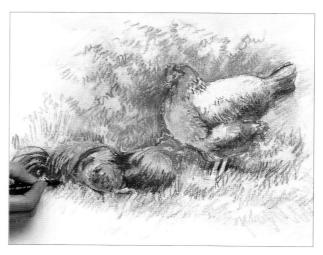

1 1 If any of the highlights look too big or bright now that you've removed the masking fluid, dot in any appropriate feather colours to subdue them and make them less obtrusive. Add any final linear detailing on the feathers, using the same colours as before in either oil pastel (for thicker marks) or water-soluble pencil (for fine lines).

This is a colourful and lively drawing that demonstrates that you don't need to put in every minute detail to achieve a realistic-looking image. The artist has exploited the soft, buttery consistency of the water-soluble oil pastels to create

blended layers that convey the sheen on the feathers, while linear marks made using both the oil pastels and watersoluble pencils convey the texture of both the feathers and the grasses.

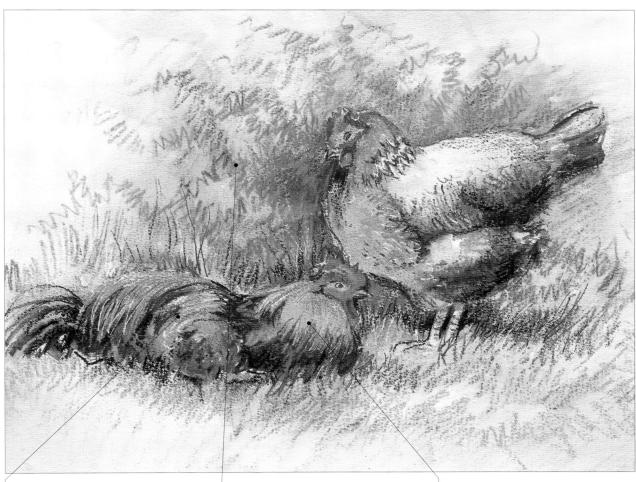

Masking fluid preserves the highlights on the feathers, allowing you to work freely without fear of covering them up.

Linear marks overlaid on blended areas of water-soluble oil pastel create the texture of the grasses.

The waxy consistency of the oil pastels helps to create a rich, glossy sheen on the birds' feathers.

Swimming fishes

This colourful project combines elements of both drawing and painting. In the early stages, water-soluble pencils are used in a linear fashion as drawing tools; later, they are washed over with clean water, so that the pigment spreads on the support just like watercolour paint. You can also apply dry water-soluble pencil over wet washes to deepen the colour, either by using the pencils directly or by brushing water over the tip of the pencil so that the brush picks up a little pigment. The benefit of this technique is that you don't create hard edges.

As you'll be applying water to the paper, use watercolour paper, which is absorbent enough not to tear under the weight of the water. When you start applying water, work on one part of the image at a time – first the fishes, then the water – so that the colours don't all blur together.

One of the most attractive aspects of this project is the sense of movement in the water. Observe how the ripples catch the light as this will help you to convey the movement. Use curved pencil strokes that follow the ripples and look at how the water breaks around the fishes.

Materials

- Watercolour paper
- Water-soluble pencils: orange, bright yellow, dark blue, olive green, yellow ochre, warm brown, reddish brown, red, blue-green
- · Masking fluid and old dip pen
- Paintbrush
- Kitchen paper

The subject

The colouring on the fishes is spectacular – strong, saturated reds, yellows and oranges. Note how the shape of the fishes is slightly distorted by the ripples in the water. The ripples themselves catch the light from above, which creates a glorious sense of movement and shimmering light.

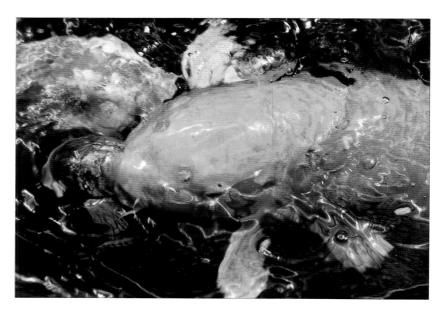

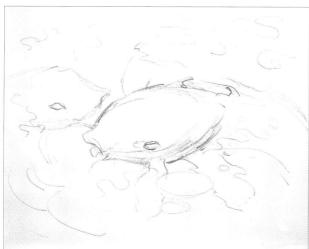

1 Using an orange water-soluble pencil, lightly sketch the outline of the fishes, making a clear distinction between the top of the larger fish's head, which is just poking out of the water, and the rest of the body. Draw a few of the largest ripples in the water, too.

2 Using masking fluid and an old dip pen, mask out the white highlights on the water and the fishes. Leave to dry.

Tip: You can speed up the drying process by using a hairdryer.

3 Lightly scribble bright yellow over all except the white parts of the fishes. Apply orange to the reddest areas, pressing guite hard on the pencil.

A Now start putting some colour into the water, using dark blue with a few touches of olive green for the very darkest parts.

5 Colour in the submerged fins of the large fish using a yellow ochre pencil and go over the reddest part of both with a warm brown. Continue adding colour to the water, using the same colours as before and making curved strokes that follow the shape of the ripples.

Assessment time

You've now put down virtually all the linear detail that you need. Once you start applying water, however, there's a risk that you might lose some of the detail: it's important, for example, to retain some of the ripples in the water – so decide in advance where you want the pigment to spread and, if the colours run into areas where you don't want them to go, be ready to mop them up with a piece of absorbent kitchen paper.

Although the shape of the fish is clear, it's hard to tell which parts are submerged and which are above the water.

Confident, flowing linear marks capture the ripples in the water – and at least some of these marks should be visible in the finished drawing.

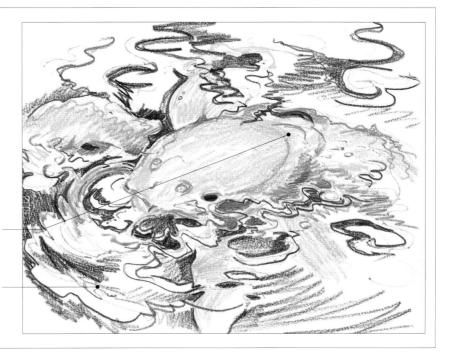

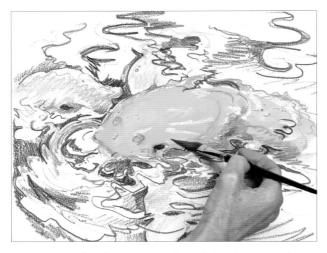

6 Dip a paintbrush in water and gently brush over the large fish. Note how intense and vibrant the colour becomes.

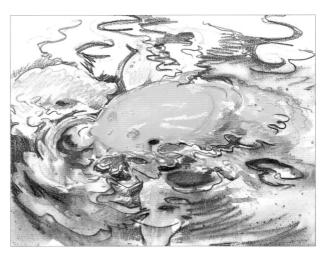

7 Brush clean water over the painted water, following the lines of the ripples and leaving some highlight ripples white.

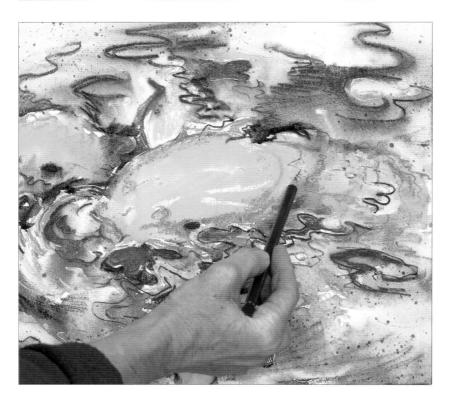

Brush clean water over the small fish. Allow the support to dry slightly, but not completely, and go over the reddest parts of the fishes with a reddish brown pencil. The colour will intensify. It will also blur and spread, so you won't get any hard edges. The blurred orangey-red will look as if it is under water – so it will become clearer which parts of the large fish are jutting up above the water's surface.

Dip a red pencil in water and darken the red of the fishes where necessary. Reinforce the outlines of the fishes with a blue pencil. Leave to dry.

10 Rub off the masking fluid. Scribble blue-green into the darkest parts of the water, pressing quite hard with the pencil to create the necessary depth of colour.

This drawing demonstrates the potential and versatility of water-soluble pencils and combines linear detailing with

lovely, fluid washes that intensify the colours and blend them together on the support.

Masking fluid can be used to keep the highlights white.

Curved pencil strokes create a sense of movement in the water.

The transition from one colour to the next is almost imperceptible.

Quick sketches of people: Artists at work

People who are engrossed in what they're doing make great subjects, as they'll probably be unaware that you're drawing them – a far less daunting prospect than asking someone to pose for you.

When you're drawing people, remember that the limbs are not separate entities: they're part of a linked, articulated skeleton. Even when your subjects are fully clothed, you must try to get a sense of the underlying structure and form of the body and of how the different parts interconnect. Creases in the fabric and distortions in any printed pattern on the cloth will give you clues about the shape of the body underneath.

When it comes to getting the proportions right, the only way to do it is to measure. You may have read that the head of an adult is equal to one-seventh of the total height. This is a generalization: the head is a useful unit to use to work out the height of the torso, but the proportions can vary considerably from one person to another – so always measure things for yourself.

The scene

These sketches (and on the next page) are of some of the artist's students hard at work in an outdoor painting class.

5-minute sketch: HB pencil

The artist here chose to draw just the outer two figures. You might be tempted to start by drawing the outlines of the figures, but you'll get a much better result if you think of the forms that lie under the hats and clothes. Lightly draw the whole oval of the skull, for example, and then superimpose the hat on top. Look at the tilt of the shoulders, the curve of the back and the angles at which the knees and arms are bent, as these will give you the dynamics of the pose. Loosely indicate which areas are in shadow.

10-minute sketch: HB pencil

In a slightly longer sketch (this time of the two right-hand figures), more detail is introduced, such as more precise shaping of the legs and an indication of where the sleeves and trouser legs end. You can take a bit longer to assess the shading so that the figures begin to look more rounded. It's often a good idea to make a monochrome sketch first, before you attempt to do the same thing in colour – otherwise you can find that you're distracted by the colours and don't properly assess how light or dark the tones need to be.

15-minute sketch: HB pencil, watercolour pencils and pen and ink

This sketch is a nice combination of penand-ink work for linear details, such as the lines of figures and the sketching stools, and coloured pencil for some simple patterning and shading on the clothes. Note the use of a cool blue for the areas of white clothing that are in shadow. The artist has also blocked in the background, allowing the figures to stand out more.

25-minute sketch: HB pencil, watercolour pencils and pen and ink

In 20 minutes or more, you have time to put more pattern on the clothes and to make the figures look rounded by indicating creases in the fabric of their clothes or through differences in tone. Here, the artist brushed over the water-soluble pencil work to create areas of soft tone.

Quick sketches of people: At the beach

The idea of sketching in public might seem rather daunting at first, but a beach or park is a great place to start. It's easy to find a quiet corner to hide away in – and there is usually so much going on that no one takes any notice anyway. In addition to drawing the whole scene, try pulling out individual figures from the crowd, too, for quick practice sketches. This is a great way of sharpening your observational skills.

When you are sketching people quickly, look for the essence of the 'pose' – the tilt of the head, the curve of the back, the angle of the shoulders. Remember this subtle but important clue to get a stance right: a movement in one part of the body is counter-balanced by a movement on the opposite side, in the opposite direction. So, if someone rests their weight on one leg, the opposite hip and shoulder will be thrust slightly upwards.

5-minute sketch: pencil

This is a preliminary compositional sketch for a painting. The curving path naturally leads our eye through the scene. The foreground umbrella and the lamp on the left balance each other; both are placed on the third, which is a strong position for features of interest in a drawing, and together they form a strong diagonal line across the composition.

The scene

This artist selected a viewpoint from the esplanade above the beach. Looking down on a crowded scene makes it much easier to separate the different elements from each other and to work out a pleasing composition. Drawing the same scene from beach level would have resulted in a confusing jumble of shapes and figures.

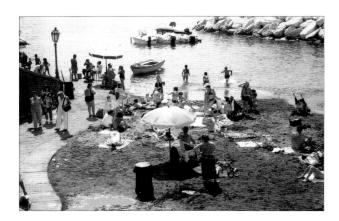

10-minute sketch: oil pastel

This sketch was made in oil pastels on beige-coloured pastel paper, which is similar to the colour of the sand. It imparts a warm mood to the image while a loose smear of blue hints at the sea beyond. Oil pastels are a handy tool for making quick sketches: although they're fairly chunky, which means you cannot make very fine, detailed sketches, they enable you to block in large areas quickly. Note how the artist has captured the young woman's stance with just a few swift marks: the brown marks laid over the pale blue of her T-shirt show how the fabric creases and give important information about her posture. The colour is smudged to create the shadows beneath the figures. The shadows give the image immediate depth and help to 'anchor' the figures.

25-minute sketch: pen and ink, wash

This sketch was made using a dip pen – which gives a fresh, spontaneous quality of line – and waterproof ink. Washes of dilute ink are used to create areas of tone, such as the shadow under the umbrella and the boat, the wedge-shaped wall on the left and the flesh tones. Note the different textures created by using different kinds of line: straight horizontal and vertical lines for the hard stonework and paving, small circles and squiggles for the soft sand.

Quick sketches of people: Al fresco lunch

Informal gatherings of family and friends are a great place to sketch people, as the atmosphere is relaxed and people behave naturally – but if you're nervous about sketching in front of other people, use the opportunity to take a few photos that you can use as reference material and then make your sketches later. With a large group, you may find that you need to direct the proceedings, in much the same way as a photographer at a wedding, in order to get the composition that you want. Don't feel intimidated about doing this - but remember that the people are there to enjoy themselves, not to pose for long periods of time while you try to capture their likeness on paper!

5-minute sketch: ballpoint pen

With a large group it can be hard to know where to start. Here the artist began by sketching the man in the hat, positioned just off centre, and then worked outwards in each direction. This helps to avoid the risk of making the first figure too big and running out of paper for the remaining figures.

The scene

Here, the artist selected his viewpoint carefully to create a balanced composition, with none of the heads overlapping. He felt that if everyone was looking directly at the camera the image would look too self-conscious and posed, so he asked the man and woman on the far left and right to look at each other, rather than at the camera. There is a good mix of full-face views (the three people at the back of the group), side profiles, and three-quarter views, giving you the chance to practise placing the facial features with the head turned at different angles.

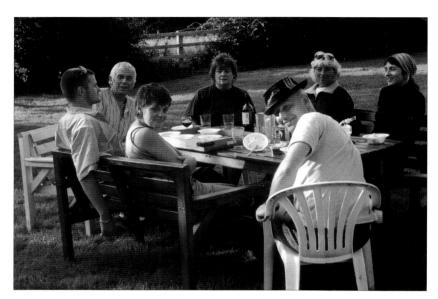

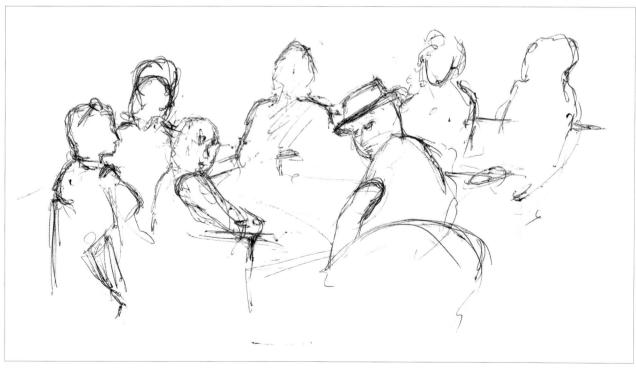

15-minute sketch: pencil

Here, too, the artist began with the man in the hat. He then used the straight lines of the hat as a guide to help him assess the angles at which the sitters' heads were tilted. Light shading, done using the side of the pencil, introduces some tone into the image, while stronger crease lines in the clothing suggest the folds in the fabric and begin to give the image some form.

15-minute sketch: coloured pencils

This was made to provide the artist with rough colour notes that he could elaborate on later in a more detailed drawing. Note how the intensity of the blue in the men's shirts varies, with a deeper tone being used for the shaded creases. Even the white T-shirt of the man in the hat contains a surprising amount of blue, as his back is largely in shadow and there are many wrinkles in the fabric.

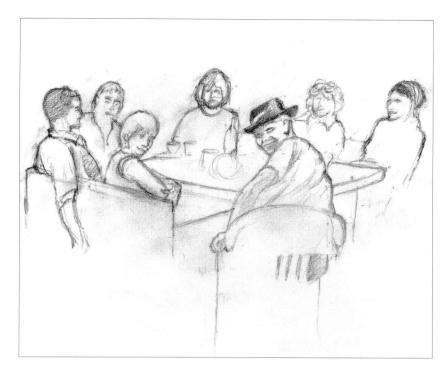

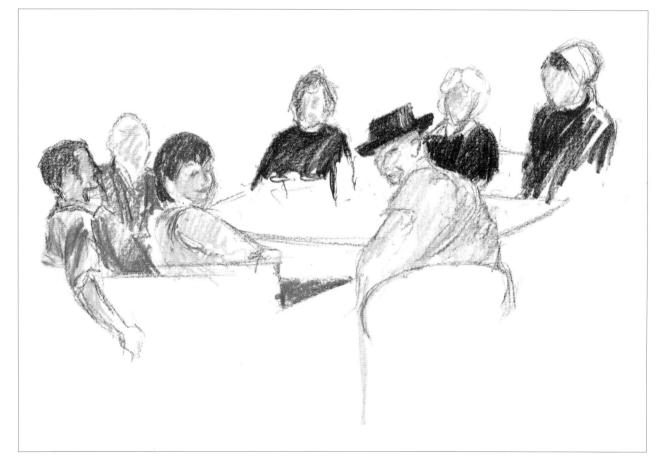

Male portrait

Drawing a portrait can be challenging but, as with all subjects, it helps if you can start by reducing things to basic shapes. Think of the face as an egg shape, with the wider end of the egg as the top of the head and the narrower end representing the chin.

The thing that beginners tend to find most difficult is placing the facial features accurately. Putting in a few guidelines – a central line through the forehead and down to the bottom of the chin, and lines across the face to mark the level of the eyes, nose and mouth – will help with this. As a general rule (although everyone is slightly different), the bottom of the eye socket is halfway down the face and the base of the nose is halfway between the eyes and the chin. The tops of the ears align with the eyebrows and the base of the nose.

Remember that when the model's head is tilted slightly to one side, as here, you will be able to see more of one side

of the face than the other — so the central line will not be centrally positioned. Moreover, as the head turns away, some features may overlap one another while others may be hidden from view altogether. In a three-quarters pose, for example, you will often find that the inner corner of the far eye is obscured by the top of the nose.

Rely on observation, not on your preconceptions about the relative sizes of features and where they sit in relation to one another.

Check your measurements, and then check them again, before you commit pencil to paper.

Materials

- Drawing paper
- Thin charcoal stick
- Kneaded eraser
- Soft pastels: pewter grey, Naples yellow, dark brown, reddish brown, blue-grey, orangey brown, white

The pose

This model has a strong profile, which the three-quarters pose (the head turned slightly to one side) shows off to advantage. As any portrait requires the same pose to be held for a long time, make sure your model is comfortable and, if he has to take a break, can resume the same position easily.

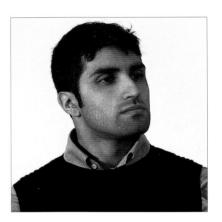

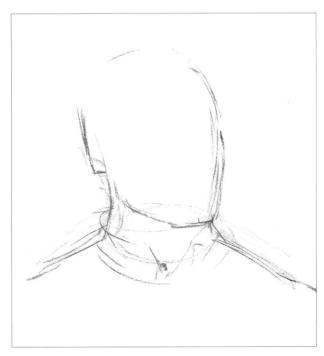

1 Using a thin charcoal stick, map out the head and shoulders. Think of the head as a three-dimensional geometric shape; all too often, beginners make the mistake of drawing a circular or oval outline for the face and forgetting that the head is a solid, three-dimensional form.

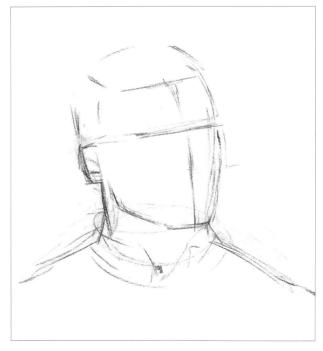

2 Draw a faint line down the centre of the face, from the top of the forehead to the chin. Then draw a line across the face to mark the level of the eyes. (Because of the tilt of the head, this line tilts up slightly here.) This line can also be used to indicate the level of the visible ear.

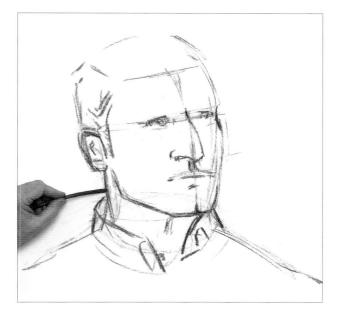

3 Establish the line of the nose, noting where it sits on either side of the central guideline, and the lips. You may find it helps to draw two inverted triangles – one from the outer edge of the eyes down to the tip of the nose and one from the outer edge of the eyes to the chin – as it is easier to judge positions within the triangles than by eye alone. Put in the eyes, remembering that the eyeballs must look rounded.

A Now that you've established the positions of the features, you can erase your guidelines. Strengthen the line of the shoulders and the jaw. Using a pewter grey soft pastel, put in the eyebrows. Block in the lightest area of flesh tone – the cheek, the left of the forehead and the side of the neck – using the side of a Naples yellow pastel, which is a warm yellow well suited to this model's complexion.

5 Using the side of a pewter grey soft pastel, lightly put in the stubble and shadows on the face and around the inner edge of the shirt collar. Now put in some of the hair, using a very dark brown pastel. Look at how the hair grows over the skull and make your pastel strokes follow the direction in which the hair grows.

6 Continue working on the hair, noting that it grows in straight lines that go in different directions. Define the eyes more, noting how the lid wraps around the eye and preserving the catchlight – the lights reflected in the pupil. Using the pewter grey pastel again, introduce more tone on the shaded side of the face and in the hair.

Zuse a dark reddish brown pastel to put in the lips. Use a thin charcoal stick to refine the shape of the nostril, the cleft in the chin and the overall line of the nose against the cheek. Using your fingertips, gently blend the grey charcoal on the areas of hair and stubble that are not quite as dark.

Assessment time

All the facial features are in place but more modelling is needed – particularly on the cheekbones as the shadows are not strong enough to reveal their form.

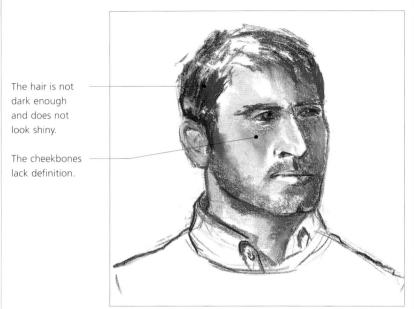

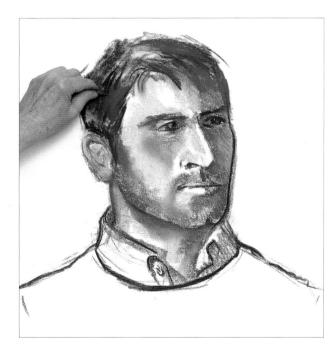

Roughly scribble in the hair, using a dark brown pastel. Remember to leave some areas lighter to show where the highlights fall and create a sheen on the hair. Lightly blend the marks with your fingertips, following the direction in which the hair grows.

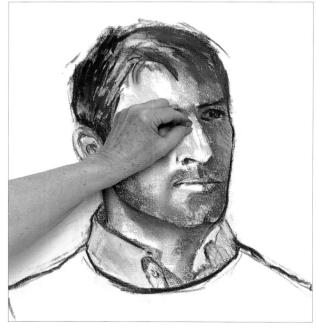

9 Using a blue-grey pastel, hatch and blend the blue collar of the shirt. Use the same colour on the hair to give a slight blue-black sheen. Shape the nose, using an orangey brown pastel for the dark, shaded parts and the tip of a white pastel for the highlights.

A strong profile is enhanced by the side lighting, which throws one side of the face into shadow. Although only a limited range of pastel colours was used, subtle blending captures the evenly coloured skin tones very well. The same technique creates the modelling on the face. Here, the artist chose not to colour in the model's sweater as she wanted to concentrate the viewer's attention on his face, but you could put in more colour if you wish.

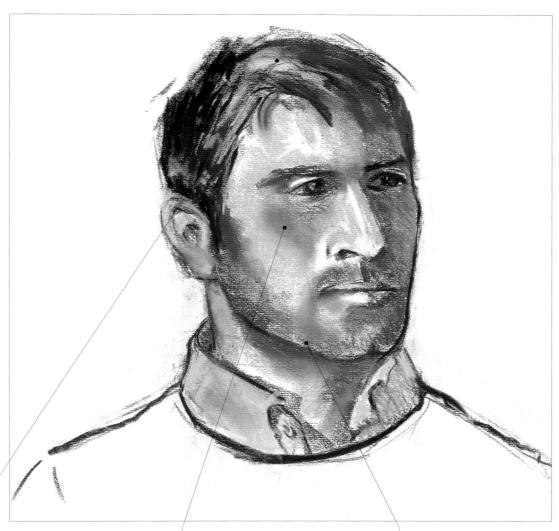

Touches of blue-grey give the hair a smooth, glossy sheen.

Blended pastel marks create shadows on the cheeks and neck and under the chin.

Linear charcoal work is used to define the jawline.

Character portrait

Markets are a great place to make quick sketches or take snapshots of people going about their daily business, which you can then work up into more detailed portraits at a later date. People are so engrossed in what they're doing that they're unlikely to take much notice of you – so your photos and sketches may be much more informal and natural.

Here, the artist decided to omit both the background and the woman on the left and to concentrate on making a character portrait of the man – although you could, of course, include the setting, too, provided you keep the main emphasis of the drawing on his face.

This particular portrait gains much of its strength from the fact that there is direct eye contact between the subject and the artist, which immediately brings the portrait to life and makes the viewer feel involved in the scene. His gaze is quizzical, perhaps even slightly challenging, and even without the inclusion of the market setting, his slightly hunched pose and wrinkled face indicate that he leads a hard life.

Charcoal is a lovely medium for character portraits and, like black-and-white reportage or documentary-style photographs, a monochrome drawing has a strength and immediacy that works particularly well with this kind of subject. The same drawing in colour would have a very different feel – and probably far less impact. Why not try the same project in coloured pencil, too, to see the difference?

Materials

- Fine pastel paper
- Thin charcoal stick
- Compressed charcoal stick
- Kneaded eraser

The pose

In this scene two market traders in Turkey were spotted by chance rather than asked to pose formally. So these are character portraits. The artist concentrated on the man on the right, as the three-quarters pose, with direct eye contact, is more interesting than the head-on view of the lady. He has a strong profile, while the woman's face is more rounded and her features less clearly defined. The plastic sheeting could be confusing so it was omitted.

1 Using a thin stick of charcoal, map out the lines of the pose. Look at the angle of the shoulders and back and at where imaginary vertical lines intersect, so that you can place elements correctly in relation to one another. Here, for example, the peak of the man's cap is almost directly in line with his wrist.

2 Still using the thin charcoal stick, lightly put in guidelines to help you place the facial features. Draw a line through the forehead and down to the bottom of the chin, lines across the face to mark the level of the eyes, the base of the nose and the mouth, and an inverted triangle from the eyes down to the nose.

Refine the facial features and roughly block in the fur collar on the man's jacket. (It provides a dark frame for the face.)

4 Lightly draw the curve of the top of the skull. Although you can't actually see the skull beneath the cap, you can use the tilt of the head and the features you've already put in to work out where it should be. Remember that the base of the eye socket is generally about halfway down the face, so the top of the skull is likely to be higher than you might think.

5 Now you can draw the cap. Without the faint guideline of the skull that you drew in the previous step, you'd probably make the cap too flat and place it too low on the head. Draw the eyes and eyebrows and the sockets of the eyes. Already you can see how the form is beginning to develop.

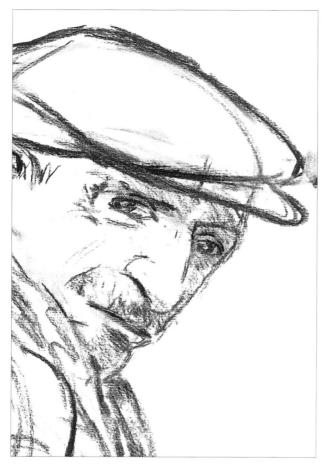

 $6 \\ \text{Sharpen the line of the far cheek and apply loose} \\ \text{hatching on the far side of the face (which is in shadow)} \\ \text{and on the forehead, where the cap casts a shadow.} \\$

7 Using a compressed charcoal stick, which is very dense and black, put in the line of the mouth.

Assessment time

The facial features are in place and most of the linear work has been completed, although the details need to be refined and the eyes darkened. Now you can begin to introduce some shading, which will make the figure look three-dimensional and bring the portrait to life.

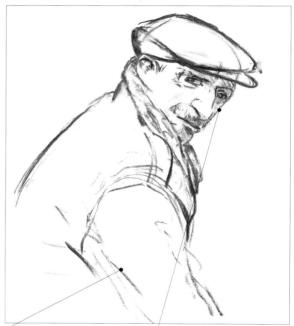

The jacket looks flat. There is nothing to tell us how heavy it is or what kind of fabric it is made from.

Shading has introduced some modelling on the far side of the face, but more is needed.

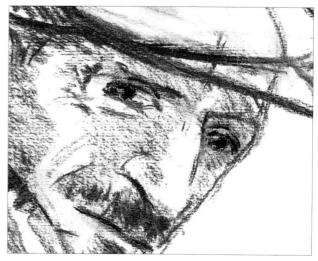

8 Again using the compressed charcoal stick, put in the pupils of the eyes, remembering to leave tiny catchlights.

Ousing the side of a thin stick of charcoal, very lightly shade the right-hand side of the man's face. The shadow is not as deep here as on the far side of the face, but this slightly darker tone serves two purposes as it helps to show how tanned and weatherbeaten his face is and also creates some modelling on the cheeks.

 10° Using the tip of your little finger, which is the driest part of your hand, carefully blend the charcoal on the right cheek to a smooth, mid-toned grey.

11 Using a kneaded eraser, pick out the highlighted wrinkles on the face, and the whites of the eyes.

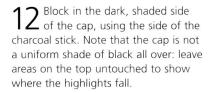

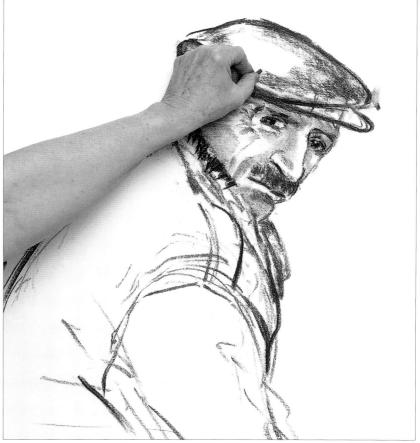

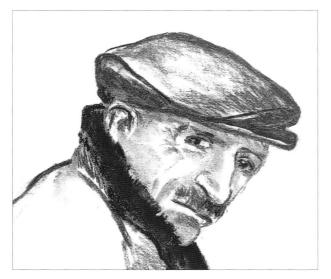

13 Using compressed charcoal, block in the fur collar on the jacket and smooth out the marks with your fingers. By making slightly jagged marks, you can suggest the texture of the fur. Note how the face immediately stands out more strongly when framed by the dark fur.

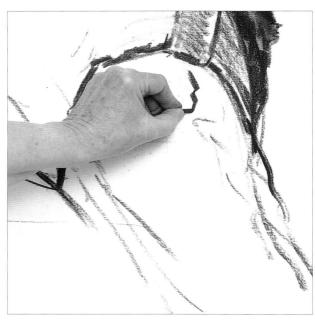

14 Put in the dark crease lines of the folds in the jacket.
The deep creases help to show the weight of the fabric.

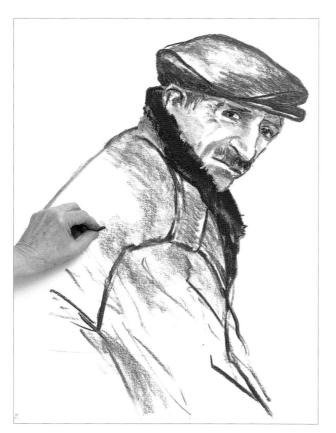

15 Using the side of the charcoal, apply tone over the jacket, leaving highlights on the sleeve untouched.

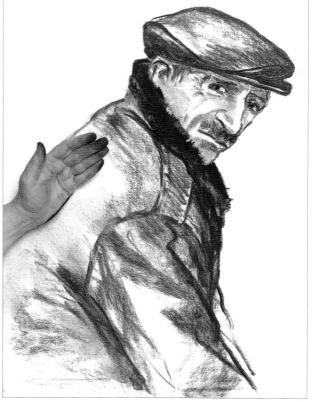

16 Using the side of your hand in a circular motion, blend the charcoal to a smooth, flat tone.

This portrait is full of character. Note the classic composition, which draws our attention to the face. The overall shape of the portrait is triangular, with the strong line of the back leading up to the face and forming the first side of the triangle, and a straight line down from the peak of the cap to the arm forming the second side. In addition, the face is positioned roughly 'on the third' – a strong placement for the most important element in the drawing.

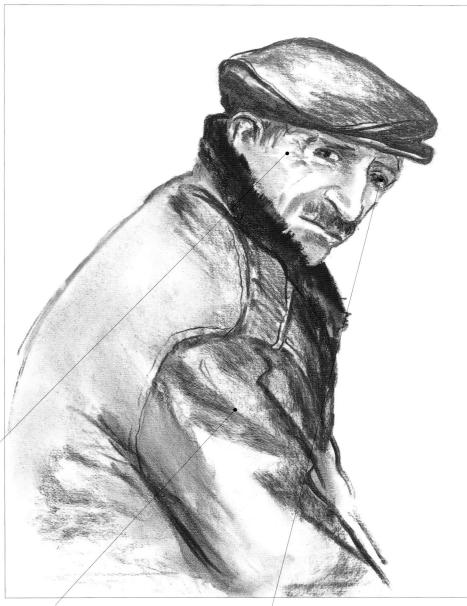

Wrinkles in the skin are picked out using the sharp edge of a kneaded eraser.

The crease lines and variations in tone show the weight and bulkiness of the fabric.

The direct eye contact between sitter and viewer makes this a very strong portrait.

Dancing couple

When drawing a moving subject, it's helpful to take a photograph to use as reference. You have two options. You can use a fast shutter speed to 'freeze' the action and risk losing the sense of movement that you wanted to capture. Alternatively, you can use a slower shutter speed so that there is some blur in the photo – but then you risk not being able to see all the detail as clearly as you would like. Here the artist wanted to see the detail clearly and elected to freeze the movement in the reference photo.

The challenge in this scenario is how to create that all-important sense of movement. Sometimes, even when the action is frozen, we know that the subject must be moving because the 'pose' itself is so precarious that we know it simply couldn't be held for more than a second or two. (Think, for example, of a ballerina in mid-pirouette.) Here the dancers have both feet touching the ground and the movement is not obvious at first glance, so you need to find other ways of conveying a sense of movement.

In this drawing the artist used two techniques to give a sense of movement: a 'ghost' image, indicating the position from which the limbs have just moved, and curved lines in the background, which follow the contours of the bodies.

The same techniques could be applied just as well to other moving objects, for instance a horse racing at full stretch. a rally car speeding past on a country road, or any sporting action. Manikin Also called a lay figure, a manikin (available from art supply stores), is a very handy tool for working out the lines

> of a pose. Use it to help you to work out the 'ghost' image.

Materials

- Pastel paper
- HB pencil
- Pastel pencils: brown, spectrum orange, black, light sepia, pale brown, red, orange, pale blue, cream or pale yellow, red-brown

The pose

Although the action has been 'frozen' in this photo, the woman's flowing hair and the fact that the right foot of both dancers is in the process of lifting off the ground indicate that they are, in fact, moving.

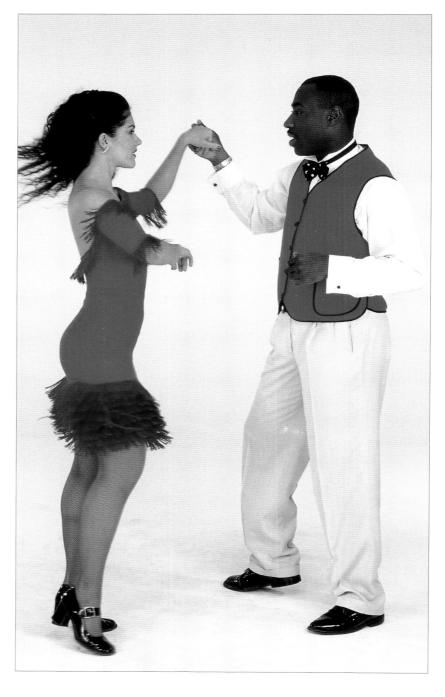

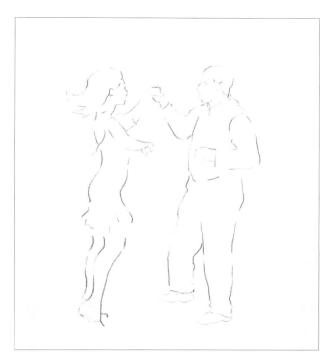

1 Sketch the scene, using an HB pencil. Imagine guidelines running across and down the image to help you: the man's left hand, for example, is roughly in line with his right heel.

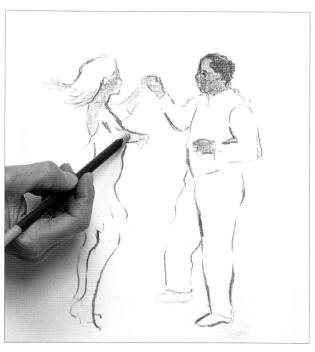

 $2^{\ \ \text{Block in the man's flesh tones and hair in brown and}\\ \text{emphasize the strongest lines of the pose. Using spectrum}\\ \text{orange, block in the woman's flesh tones}.$

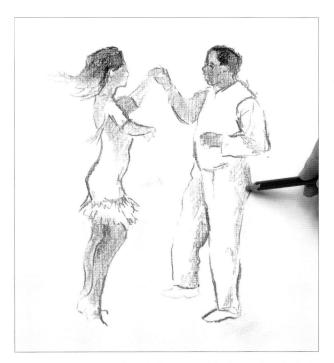

Block in the hair of both dancers in black. For the shaded parts of the man's trousers and shirt and the woman's dress, apply light sepia. Use the same colour to draw the frill around the bottom of her dress.

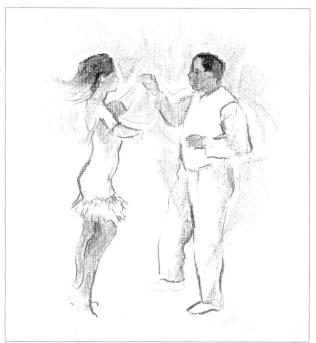

4 Using the side of a pale brown pastel pencil, block in the background. Begin to put in stronger, curved lines in the background to emphasize the movement of the figures, echoing the curves of the moving arms.

Assessment time

With the same pale brown pencil, put in a 'ghost' image of the moving legs and arms. This, along with the curved lines in the background which echo the shape of the woman's back, helps to give an impression of movement. Now that the main lines of the drawing have been established, you can begin to refine the detail and add some colour to bring the drawing to life.

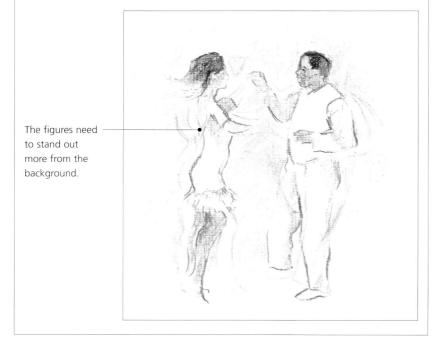

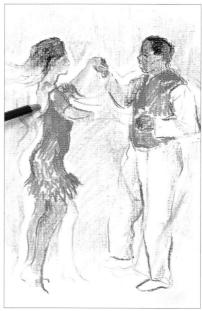

5 Using the same colours as before, darken the flesh tones so that the figures stand out from the background. Block in the woman's dress and the man's waistcoat in red overlaid with orange. (This optical mix of two colours creates a much more lively and interesting effect than a solid application of a single colour.)

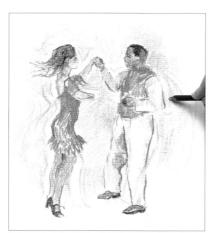

6 Using a very pale blue pencil, put in the creases in the man's shirtsleeve and shade his right leg. Block in the shoes in black, leaving the highlights. Working around the 'ghost' image, put in some stronger curved lines that follow the contours of the bodies to enhance the sense of movement.

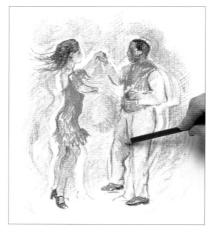

Parken the creases on the trousers and go over the trousers very lightly with a cream or very pale yellow pastel pencil. (Leaving the paper white would look too stark.) Draw the woman's hair, which is streaming out behind her as she moves, with quick flicks of a black pastel pencil.

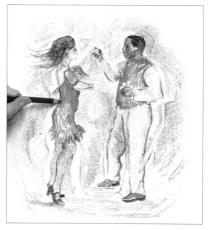

Susing horizontal marks, put in the floor. It is on a different plane to the background and using horizontal, rather than vertical, strokes helps to make this clear. Using a red-brown pencil, sharpen the edges of the figures – the hands, faces, and the line of the woman's body and legs.

The sense of movement in this drawing comes as much from the way the background has been handled as from the way the dancing couple has been drawn. The pastel pencil marks are light and free, which gives the drawing a feeling of energy.

The hair streams out, making it obvious that the dancers are moving quickly.

The 'ghost' images imply that this is the position the figure has just moved from.

Curved pencil strokes in the background also help to imply movement.

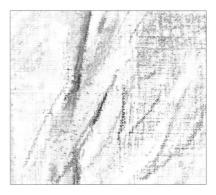

Male nude

People come in all kinds of shapes and sizes! Nonetheless, we can make some generalizations about the differences between men and women and you should bear these in mind when drawing a male nude. The main differences to note are that, generally, men have less fat tissue than women and look more angular. Men's shoulders are usually broader and their hips narrower. Typically, a man's neck looks shorter than a woman's and his feet and hands are larger in proportion with the rest of the body.

When making your initial sketch, it's tempting simply to outline the pose – but if you imagine the skeleton of the body underneath the skin as you draw, you will undoubtedly find it much easier to get the shapes right.

Materials

- Grey pastel paper
- Thin willow charcoal stick
- Kneaded eraser
- Soft pastel: pale cream

The pose

This sofa provides support, making the pose easy to hold for a long time. Even so, it's a good idea to mark the position of the feet and hands with pieces of masking tape, in case the model moves. The back is slightly bent and the stomach is convex, creating interesting shading on the torso. Note the slight foreshortening: the legs are closest to the viewer and so appear slightly larger than they would if the model were standing up.

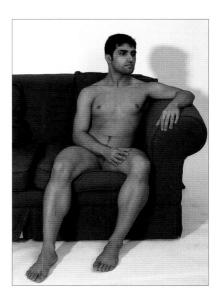

1 Sketch the figure using a thin stick of charcoal, making sure you allow space for the sofa on either side. Measure and mark where each part of the body is positioned in relation to the rest; the face, for example, is in line with the model's left knee. Also look at the slope of the shoulders and at where the elbow is positioned in relation to the chest.

2 Begin searching out the form, making angular marks that establish the three-dimensional shape of the head and torso. Put in faint guidelines running vertically and horizontally through the centre of the face to help you position the facial features. Lightly mark the shape of the sofa – the curve of the arm and the cushion behind the model.

3 Once you've mapped out the basic composition, you can begin to strengthen the lines and put in the facial features in more detail. Draw the eyes, noting how the upper lids fold over the lower ones at the outer corners and how the line of the nose obscures the inner corner of the far eye. Roughly scribble in the hair line. Put in some shading under the chin, on the legs and arms, and on the left of the torso.

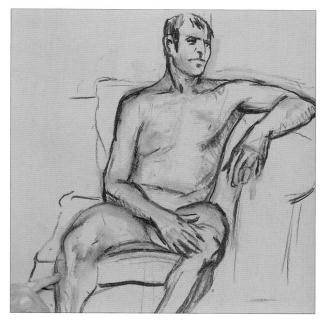

4 Using the tip of the charcoal, draw the muscle that runs diagonally along the side of the neck. This is a very strong, pronounced muscle and putting it in helps to emphasize the tilt of the head. Using the tip of your little finger, smooth out some of the shading on the torso and legs to create more subtle modelling. The figure is already beginning to look more three-dimensional.

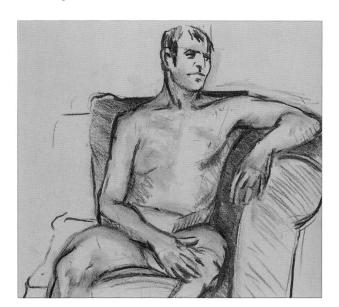

5 Loosely scribble over the sofa, so that the figure stands out. Look at the negative shapes – the shape the sofa makes against the body – rather than at the body itself. This makes it easier to see if any adjustments need to be made to the outline of the body. Alter the direction of the hatching lines to make the different planes of the sofa more obvious.

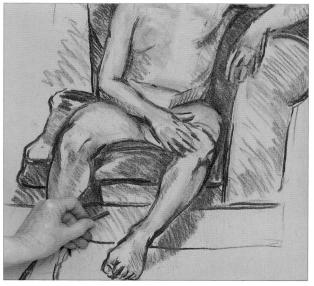

6 Draw the model's left foot. (Try to think of it as a complete unit rather than a series of individual toes.) Shade one side, and indicate the spaces between the toes with very dark marks. Loosely scribble in the shadow cast on the base of the sofa by the model's legs, and hatch the different facets of the cushions.

Zuse a kneaded eraser to gently clean up and create more contrast between the lightest and darkest parts. Darken the spaces between the fingers and indicate the segments of the fingers to show how they articulate.

Assessment time

Assess the tonal contrast of the figure as a whole to see where more shading or highlights are needed. For example, the lower part of the torso is slightly shaded by the ribcage as the model slumps back on the sofa, and this area needs to be darkened.

The upper part of the torso is a little too bright.

More shading is needed on the model's left leg.

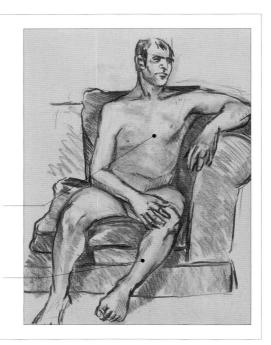

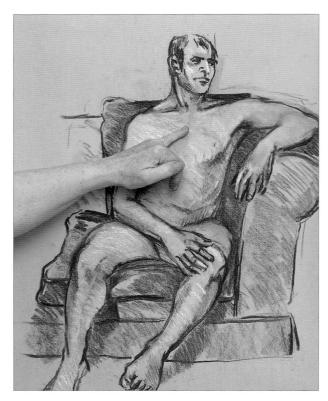

Susing a very pale cream pastel, put in the highlights on the face, right arm and leg. (Cream is a more sympathetic colour for flesh tones than a stark white.) Even though the limbs are rounded forms, the highlights help to define the different planes. Blend the pastel marks with your fingertip.

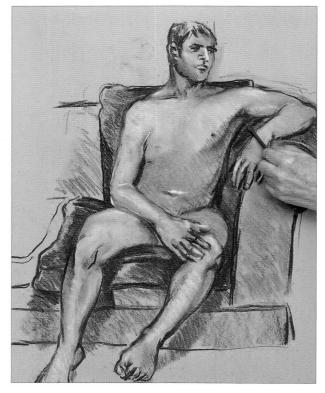

Apply more charcoal shading on the lower part of the torso, again blending the marks with your fingertip. (Use your little finger for blending, as it is the driest part of the hand and the risk of smudging the charcoal is reduced.) Darken the sofa under the model's arm, so that he stands out more.

Although this is not an overly elaborate drawing, it conveys the muscular nature of the model's body. The calves and thighs, in particular, are well developed (this particular model is a professional dancer). Subtle shading reveals the different planes of the body and the combination of dark, intense charcoal marks and soft pastel works well.

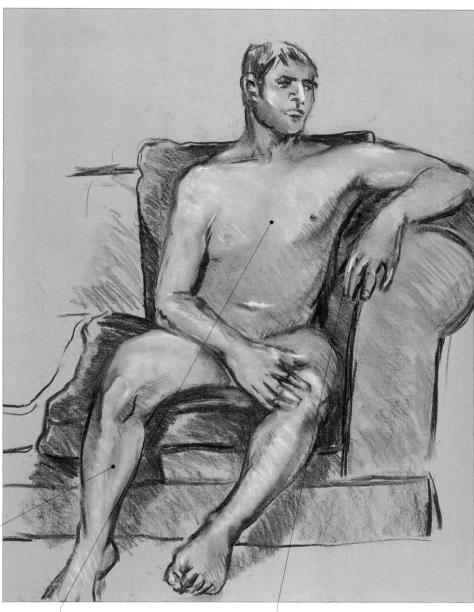

Note how effectively shading conveys the muscles in the calf.

The pastel marks on the torso are blended to convey the smooth skin texture.

The figure stands out well against the dark background of the sofa.

Grandmother and young child

Family portraits, particularly of very young children, are always popular - and a project like this would make a wonderful present for a doting grandmother. Soft pastels capture the skin tones beautifully, and you can smooth out the marks with your fingers or a torchon to create almost imperceptible transitions from one tone to another. Build up the layers gradually. You can spray with fixative in the latter stages to avoid smudging the colours, but be aware that this may dull or darken the colours that you've already put down. Soft pastel is also a lovely medium for drawing hair, as you can put down many different colours within the hair mass to create depth and an attractive sheen. When drawing hair, look at the overall direction of the hair growth.

Young children have very short attention spans and they certainly can't hold the same pose for the time it takes to draw a detailed portrait. You'll be lucky if they sit still for long enough for you to do anything more than a very quick sketch – so working from a photograph is almost certainly your best option. Even then, it's very hard to get a young child to do exactly what you want. If you try to tell them what to do, the chances are you'll either get a very stilted shot, with the child staring grumpily at the camera, or he or she will wriggle and squirm, making an attractive shot virtually impossible.

One simple solution is to make the photo session into a game by pulling faces, clapping your hands, holding up a favourite toy and generally interacting with the child so that he or she forgets all about the camera. Above all, take lots of shots so you have plenty of reference material to choose from. Then you can combine material from several shots — invaluable if you can't get a shot in which both sitters are smiling at the same time.

Materials

- Pale grey pastel paper
- Soft pastels: pinkish beige, white, dark brown, mid-brown, orangey beige, pale yellow, pinkish brown, reddish brown, dark blue, red, pale blue, grey, pale pink, black

The pose

This is a happy pose, with both child and grandmother smiling broadly. To help them relax for the shot, the photographer got them to make a little game out of clapping their hands together which, in addition to helping them forget that they're having their photo taken, imparts a sense of movement to the pose.

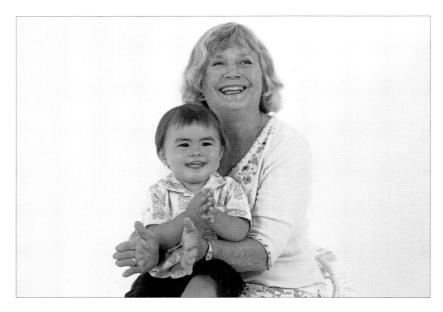

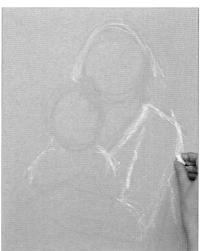

1 Using a pinkish beige soft pastel map out the basic shapes – the heads of the two sitters and the position of the arms. Draw the sleeves and neckline of the grandmother's sweater in white pastel, putting in the most obvious creases in the fabric, and put in the slant of the little boy's shoulders in white, too.

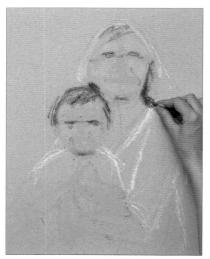

2 Using the pinkish beige pastel again, indicate the position of the facial features by marking a central guideline with the eyes approximately halfway down. The grandmother's head is tilted back, so her eyes are a little above the halfway point. Roughly block in the child's hair and the shadows in the woman's hair in dark brown.

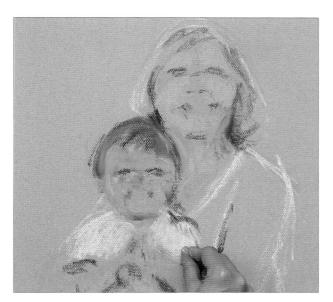

3 Still using the dark brown pastel, put in more of the hair, smudging the pastel marks with your fingers. Indicate the darkest parts of the facial features – the recesses of the eye sockets and nostrils. Apply some flesh tone to the child's face, using mid-brown for the darker parts and a more orange version of the beige used in Step 1 for the lighter parts. Using the side of a pale yellow pastel, roughly block in the base colour of the little boy's shirt.

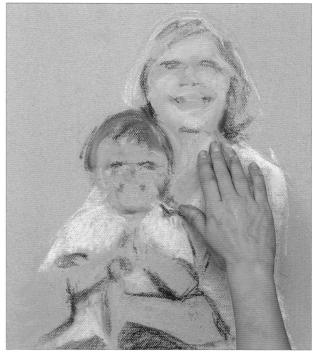

4 Using the side of a white pastel, block in the grandmother's sweater. Apply a pinkish beige to her face and neck, blending the marks with your fingers.

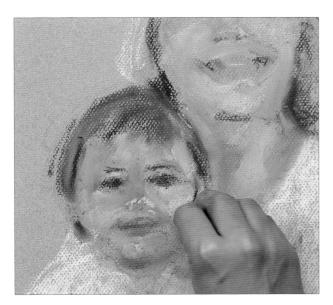

5 The grandmother's neck is slightly warmer in tone than her face. Use a reddish brown for the slightly darker tones in this area, again blending the marks with your fingers. Use the same colour for the child's lips. Using your fingertips, smooth out the mid-brown on the child's face, leaving the orangey beige for the lighter parts. Use a very dark brown for the child's eyebrows and eyes.

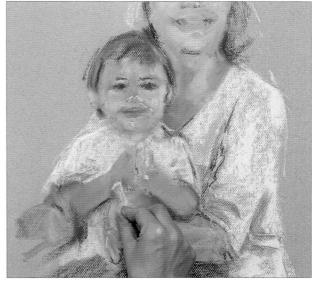

6 Using a dark blue pastel, put in the creases in the fabric of the grandmother's sweater. Block in the arms, using a pinkish brown for the grandmother and a reddish brown for the little boy. Overlay various flesh tones – pinkish beige, orangey beige, red – as appropriate, blending the marks with your fingers. Flesh is not a uniform colour; look closely and you will see warm and cool tones within it.

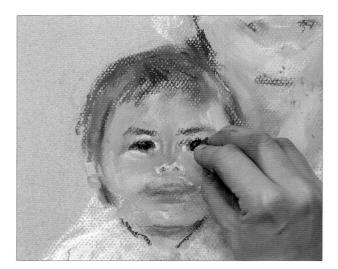

With a dark brown pastel, put in the shadow under the child's chin and around the collar of his shirt. Put in some jagged strokes on the hair so that you begin to develop something of the spiky texture. Darken the child's eyes.

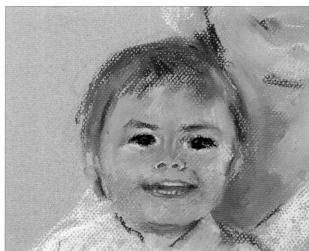

Susing the same flesh colours as before, continue building up the modelling on the little boy's face. Add some red to the cheeks, blending the marks with your fingers. Like most toddlers, he has a fairly chubby face, so there are no deep recesses under the cheekbones, but with the mix of light and darker-coloured tones the flesh is starting to look more natural. Using the tip of a white pastel and dabbing on small marks, lightly draw his teeth and apply some tiny, glossy highlights to the lips.

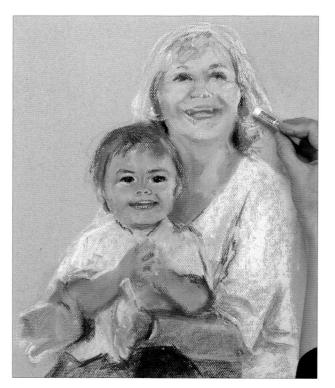

9 Repeat the process of building up modelling on the grandmother's face. Apply pale yellow to her hair.

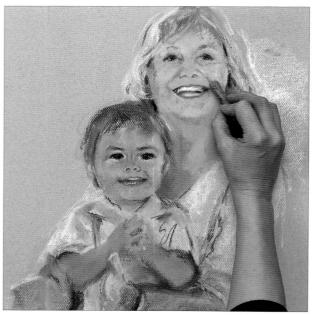

10 Continue working on the hair, putting in browns and greys to get some tonal variation within the hair. Note, too, how the hair casts a slight shadow on her face. Use a brown pastel to draw in the creases in the little boy's shirt. Draw in the crease lines around the grandmother's nose and mouth with a reddish brown pastel.

Assessment time

The expressions and pose have been nicely captured, but in places the skin tones appear as blocks of colour and need to be smoothed out more. A little more modelling is also needed on the faces and hands. The eyes need to sparkle in order for the portrait to come alive.

The pupils and irises have been carefully observed, but there is no catchlight to bring the eyes to life.

The child's hands, in particular, appear somewhat formless.

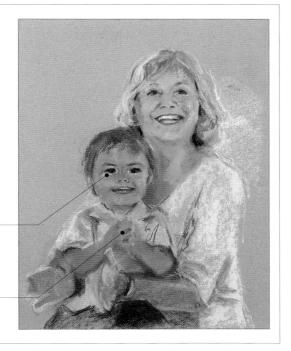

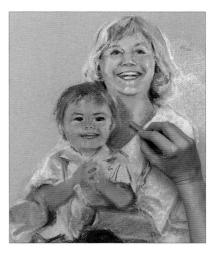

11 Continue the modelling on the grandmother's face and neck, gradually building up the layers and fleshing out the cheeks. Use the same colours and blending techniques as before. The adjustments are relatively minor at this stage.

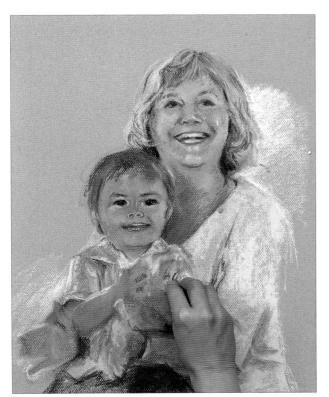

12 Apply more yellow to the boy's shirt, scribbling it in around the dark crease marks. Smudge more brown over the yellow for the stripes in the fabric. A hint of the pattern is sufficient; too much detail would detract from the face.

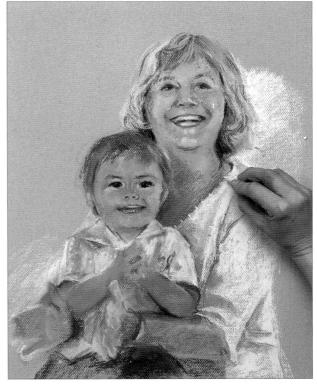

13 Using the side of the pastel, block in the grandmother's sweater with a very pale blue. Reinforce the dark blue applied in Step 6 to define the folds in the fabric. Apply tiny pale-blue dots around the neckline of the sweater.

14 Draw the little boy's fingernails with a pale pink pastel and apply light strokes of reddish brown between the fingers to separate them. Like his face, the fingers are fairly chubby so you don't need to put too much detail on them. Blend the marks with your fingertips if necessary to create soft transitions in the flesh tones.

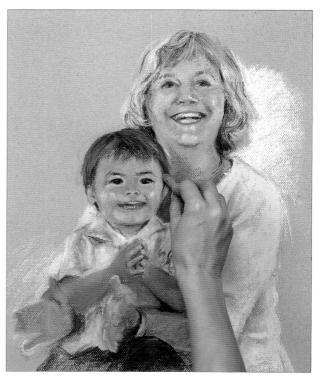

15 If necessary, adjust the flesh tones on the boy's arms and fingers. Here, the artist judged that the face was too dark, so she applied some lighter flesh tones – a very pale orangey beige – to the highlights to redress the balance. Apply a range of browns to his hair to build up the texture and depth of colour.

16 Add a thin white line for the grandmother's necklace.

Darken her lips and inner mouth; adjust the flesh tones.

Redefine the creases around the nose and mouth if necessary.

17 The final stage is to put in some detail in the eyes – the black pupils and some tiny dots of white for the catchlights.

This is a relaxed and informal portrait that captures the sitters' moods and personalities. Using soft pastel has allowed the artist to build up the flesh tones gradually, achieving a convincingly lifelike effect. Leaving the grandmother's hands slightly unfinished helps to create a sense of movement as she claps her hands together – in much the same way as a blurred photograph tells us that a subject is moving.

Leaving the hands unfinished creates a sense of movement.

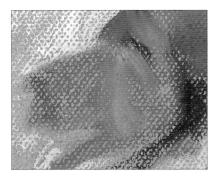

The eyes sparkle: a tiny dot of white is sufficient to bring them alive.

Note how many different tones there are within the hair.

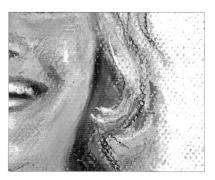

Glossary

Blending

Merging adjacent colours or tones so that they merge into one another. In dry, powdery drawing media, such as charcoal or soft pastel, blending is usually done with your fingers or with a torchon.

Charcoal

Charcoal is made by charring willow, beech or vine twigs at very high temperatures in an airtight kiln. It is available in powder form and as sticks. It can also be mixed with a binder and pressed into sticks ('compressed' charcoal), creating a form that is stronger than stick charcoal and does not break so easily. Charcoal pencils, made from compressed charcoal encased in wood, are also available.

Colour mixing

Optical colour mixing: applying one colour on top of another in such a way that both remain visible, although the appearance of each one is modified by the other. Also known as broken colour. Optical colour mixes tend to look more lively and interesting than their physical counterparts.

Physical colour mixing: blending two or more colours together to create another colour. Physical colour mixes tend to looks duller than their optical counterparts.

Cool colours

Colours that contain blue and lie in the green-violet half of the colour wheel. Cool colours appear to recede.

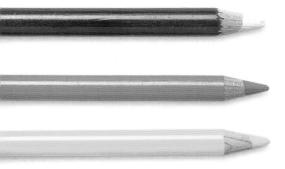

Composition

The way in which the elements of a drawing are arranged within the picture space.

Conté crayon

A drawing medium made from pigment and graphite bound with gum. Conté crayons are available as sticks and as pencils. They create an effect similar to charcoal but are harder, and can therefore be used to draw fine lines.

Eye level

Your eye level in relation to the subject that you are drawing can make a considerable difference to the composition and mood of the drawing. Viewing things from a high eye level (that it, looking down on them) separates elements in a scene from one another; when viewed from a low eye level (that is, looking up at them), elements tend to overlap.

Fixative

A substance sprayed on to drawings made in soft media such as charcoal, chalk and soft pastels to prevent them from smudging.

Foreshortening

The illusion that objects are compressed in length as they recede from your view.

Form

See Modelling.

Format

The shape of a drawing or painting. The most usual formats are landscape (a drawing that is wider than it is tall) and portrait (a drawing that is taller than it is wide), but panoramic (long and thin) and square formats are also common.

Graphite

Graphite is a naturally occurring form of crystallized carbon. To make a drawing tool, it is mixed with ground clay and a binder and then moulded or extruded into strips or sticks. The sticks are used as they are; the strips are

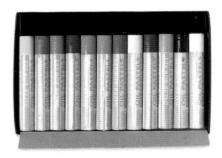

encased in wood to make graphite pencils. The proportion of clay in the mix determines how hard or soft the graphite stick or pencil is; the more clay, the harder it is.

Ground

A coating such as acrylic gesso or primer, which is applied to a drawing surface.

Hatching

Drawing a series of parallel lines, at any angle, to indicate shadow areas. You can make the shading appear more dense by making the lines thicker or closer together.

Crosshatching: a series of lines that crisscross each other at angles.

Highlight

The point on an object where light strikes a reflective surface. Highlights can be drawn by leaving areas of the paper white or by removing colour or tone with an eraser.

Line and wash

The technique of combining pen-andink work with a thin layer, or wash, of transparent paint (usually watercolour) or ink.

Manikin

A jointed wooden figure that can be moved into almost any pose, enabling the artist to study proportions and angles. Also known as a *lay figure*.

Mask

A material used to cover areas of a drawing, either to prevent marks from

touching the paper underneath or to allow the artist to work right up to the mask to create a crisp edge. There are three materials used for masking – masking tape, masking fluid and masking film (frisket paper). You can also simply cover up the relevant part of the drawing by placing a piece of paper over it.

Medium

The term has two very different meanings in art techniques:

- 1. The material in which an artist chooses to work pencil, pen and ink, charcoal, soft pastel and so on. (The plural is 'media'.)
- 2. In painting, 'medium' is also a substance added to paint to alter the way in which it behaves to make it thinner, for example. (The plural in this context is 'mediums'.)

Modelling

Emphasizing the light and shadow areas of a subject through the use of tone or colour, in order to create a three-dimensional impression.

Negative shapes

The spaces between objects in a drawing, often (but not always) the background to the subject.

Perspective

A system whereby artists can create the illusion of three-dimensional space on the two-dimensional surface of the paper.

Aerial perspective: the way the atmosphere, combined with distance, influences the appearance of things. Also known as atmospheric perspective.

Linear perspective: this system exploits the fact that objects appear to be smaller the further away they are from the viewer. The system is based on the fact that all parallel lines, when extended from a receding surface, meet at a point in space known as the vanishing point. When such lines are plotted accurately on the paper, the relative sizes of objects will appear correct in the drawing.

Single-point perspective: this occurs when objects are parallel to the picture plane. Lines parallel to the picture plane remain parallel, while parallel lines at 90° to the picture plane converge.

Two-point perspective: this must be used when you can see two sides of an object. Each side is at a different angle to the viewer and therefore each side has its own vanishing point. Parallel lines will slant at different angles on each side.

Picture plane

A imaginary vertical plane that defines the front of the picture area and corresponds with the surface of the drawing.

Positive shapes

The tangible features (figures, trees, buildings, still-life objects etc.) that are being drawn.

Recession

The effect of making objects appear to recede into the distance, achieved by using aerial perspective and tone. Distant objects appear paler in tone than those close by.

Sgraffito

The technique of scratching off pigment to reveal either an underlying colour or the white of the paper. The word comes from the Italian verb graffiare, which means 'to scratch'.

Sketch

A rough drawing or a preliminary attempt at working out a composition.

Support

The surface on which a drawing is made – usually paper, but board and surfaces prepared with acrylic gesso are also widely used.

Tint

A colour that has been lightened. In pure watercolour a colour is lightened by adding water to the paint.

Tone

The relative lightness or darkness of a colour.

Tooth

The texture of a support. Some papers are very smooth and have little tooth, while others – particularly those used for pastel drawings – have a very pronounced texture.

Torchon

A stump of tightly rolled paper with a pointed end, using for blending powdery mediums such as soft pastel, charcoal and graphite. Also known as paper stump or tortillon.

Vanishing point

In linear perspective, the vanishing point is the point on the horizon at which parallel lines appear to converge.

Viewpoint

The angle or position from which the artist chooses to draw his or her subject.

Warm colours

Colours in which yellow or red are dominant. They lie in the red-yellow half of the colour wheel and appear to advance.

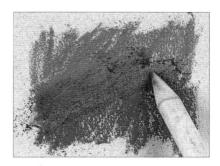

Suppliers

Manufacturers

Daler-Rowney UK Ltd Peacock Lane Bracknell RG12 8SS United Kingdom

Tel: (01344) 461000

Website: www.daler-rowney.com

Derwent Cumberland Pencil Co. Derwent House Lillyhall Business Park Workington Cumbria CA14 4HA Tel: (01900) 609590

Website: www.pencils.co.uk

Sennelier Max Sauer S.A.S. 2, rue Lamarck BP 204 22002 St-Brieuc Cedex

France

Tel: 02 96 68 20 00 Fax: 02 96 61 77 19 Website: www.sennelier.fr

Winsor & Newton The Studio Building 21 Evesham Street London, W11 4AJ United Kingdom Tel: (020) 8424 3200

Website: www.winsornewton.com

Stockists United Kingdom

Cass Art 66-67 Colebrooke Row, London, N1 8AB United Kingdom Tel: (020) 7619 2601 Website: www.cassart.co.uk

Atlantis Art Materials Britannia House, 68-80 Hanbury Street London E1 5JL

Tel: (020) 7377 8855

Website: www.atlantisart.co.uk

Ken Bromley Art Supplies Unit 13 Lodge Bank Estate Crown Lane, Horwich Bolton BL6 5HY Tel: (01204) 690 114 Fax: (01204) 673 989 E-mail: info@artsupplies.co.uk

Website: www.artsupplies.co.uk

Stuart Stevenson 68 Clerkenwell Road London EC1M 5QA Tel: (020) 7253 1693

Email: info@stuartstevenson.co.uk Website: www.stuartstevenson.co.uk

Hobbycraft

Hobbycraft specialize in arts and crafts materials and own 78 stores around the UK. Tel: (0330) 026 1400 Website: www.hobbycraft.co.uk

Jackson's Art Supplies Ltd 1 Farleigh Place, London N16 7SX Tel: (0844) 499 8430 Email: sales@jacksonsart.co.uk Website: www.jacksonsart.com

Paintworks 99–101 Kingsland Road London E2 8AG Tel: (020) 7729 7451 E-mail: shop@paintworks.biz Website: www.paintworks.biz

Dodgson Fine Arts Ltd t/a Studio Arts 50 North Road, Lancaster LA1 1LT Tel: (01524) 68014 Email: enquiries@studioarts.co.uk

Email: enquiries@studioarts.co.u Website: www.studioarts.co.uk

SAA Home Shopping PO Box 50 Newark, Notts NG23 5GY Freephone: (0800) 980 1123 Email: info@saa.co.uk Website: www.saa.co.uk

Turnham Arts & Crafts 2 Bedford Park Corner Turnham Green Terrace London W4 1LS Tel: (020) 8995 2872 Fax: (020) 8995 2873

Website: www.artistmaterial.co.uk

United States

Many of the following companies operate retail outlets across the USA. For details of stores in your area, phone the contact number below or check out the relevant website.

Mister Art 913 Willard Street, Houston, TX 77006 Tel (toll-free): (800) 721-3015 Website: www.misterart.com

The Art Supply Warehouse 6104 Maddry Oaks Ct Raleigh NC 27616 Tel: (919) 878-5077

Fax: (919) 878-5077

Website: www.aswexpress.com

Dick Blick Art Materials PO Box 1267, Galesburg IL 61402-1267 Tel: (800) 828-4548 Website: www.dickblick.com

Website: www.dickblick.com (More than 60 stores in 25 states.)

Hobby Lobby

Website: www.hobbylobby.com (More than 550 stores nationwide.)

Madison Art Shop 17 Engleberg Terrace Lakewood

New Jersey 08701 Tel: (732) 961-2211 Fax: (732) 961-1511

E-mail: mail@madisonartshop.com Website: www.madisonartshop.com

Michaels Stores 8000 Bent Branch Drive

Irving Texas 75063

Tel: (1-800) 642-4235 Website: www.michaels.com (More than 1000 stores in 49 states.)

New York Central Art Supply 62 Third Avenue New York NY 10003

Tel: (212) 473-7705 Fax: (212) 475-2513

Website: www.nycentralart.com

Rex Art 3160 SW 22nd Street Miami FL 33145

Tel: (305) 445-1413 Fax: (305) 445-1412 Website: www.rexart.com

Canada

Colours Artist Suppliers 10660-105 Street NW Edmonton Alberta

Canada T5H 2W9 Tel: 1-800-661-9945

E-mail: info@artistsupplies.com Website: www.artistsupplies.com

Curry's Art Store 490 Yonge Street

Toronto

Ontario M4Y 1X5 Tel: 416 967-6666 E-mail: info@currys.com Website: www.currys.com Island Blue Print 905 Fort Street

Victoria

British Columbia V8V 3K3 Tel: 250-385-9786 Fax: 250-385-1377

E-mail: art.supplies@islandblue.com Website: www.islandblue.com

Kensington Art Supply 120, 6999 – 11th Street SE

Calgary

Alberta T2H 2S1 Tel: 403-283-2288

E-mail: info@kensingtonartsupply.com Website: www.kensingtonartsupply.com

The Paint Spot 10032 81st Avenue NW Edmonton Alberta T6E 1W8 Tel: 780-432-0240

Fax: 780-439-5447 Website: www.paintspot.ca

Australia

Art Materials

Website: www.artmaterials.com.au

The Art Shop Unit 4, 21 Power Road Bayswater Victoria 3153

Tel: (09) 758 3266 Toll Free: (1800) 444 419 Fax: (03) 9758 3466

Email: sales@theArtshop.com.au Website: www.theartshop.com.au

North Shore Art Supplies 10 George Street Hornsby New South Wales 2077

New South Wales 207 Tel: (02) 9476 0202

Email: supplies@northshoreart.com.au Website: www.northshoreart.com.au

Eckersley's Art and Craft 223-225 Oxford St Darlinghurst New South Wales 2010 Tel: (02) 9331 2166

Email: customerservice@eckersleys.com.au Website: www.eckersleys.com.au (More than 20 stores nationwide.)

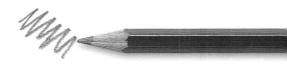

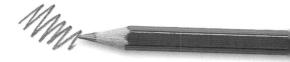

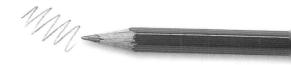

Premier Art Supplies 75 King William Street Kent Town South Australia 5067 Tel: (618) 8362 7674 Fax: (618) 8362 3173

Website: premierartorders.com.au

New Zealand

Draw Art Supplies Ltd PO Box 24-022 Royal Oak Auckland 1345 Tel: (09) 636 4862 Fax: (09) 636 5162

Website: www.draw-art.co.nz

Fine Art Supplies PO Box 58018 Botany Auckland 2163 Tel: (09) 274 8896

Website: www.fineartsupplies.co.nz

Art Supplies.co.nz Meadowlands Shopping Plaza, Corner Meadowlands Drive and Whitford Road Auckland Tel: (09) 533 6219

Website: www.artsupplies.co.nz

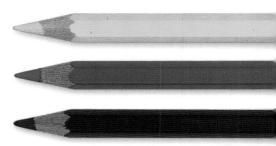

Index

applying a glaze 58 artists at work 220–1 autumn leaf 116–19

bamboo pens 15
battery-powered sharpeners
18
beach scene 222–3
blending tools 19
blending with a solvent 58
blending with water-soluble
pencils 64–5
brush drawing 66–7
poppies 67–9
brushing over water-soluble
ink 70
brushing over waterproof ink
70

carré sticks 21 chalks mid-toned around 33 character portrait 230-5 charcoal 7, 9 blending 32 character portrait 230-5 dots and dashes 32 landscape on a large scale 140 - 3male nude 240-3 male portrait 226-9 mid-toned ground 33 rocky canyon 144-9 small objects drawn large 172 - 5snow scene 132-5 sunshine and shadow 194 - 7chickens 212-15 cityscape 190-3 clips 19

coloured media 10–11
coloured papers 17
coloured pencils 7
blending 54–7
field of sunflowers 108–11
metal detail 160–3
reflections in rippling
water 136–9
short-eared owl 208–11
still life with pears 168–71
Conté sticks 11
handling 21
cows in a field 198–9
craft knives 18
cross-hatching 58

dancing couple 236–9
dark tone, creating 71
dip pens 14
dog, short fur 202–3
drawing boards 19
drawing paper 16
drawing rough textures 88
pitted stone 90–1
weathered driftwood 88–9
drawing smooth textures 84
metal olive oil pourer 86–7
smooth leather ball 84–5
drawing soft textures 92
crumpled fabric 92–3
feathers 94–5

easels 19 equipment 7 blending tools 19 coloured drawing media 10-11 drawing boards 19 easels 19 erasers 18 fixative 19 monochrome media 8-9 paper 16-17 pastels 12-13 pen and ink 14-15 sharpeners 18 eraser drawing 78 still life 79-80 erasing tools 18 using 78 exercises blending coloured pencils 55-7

combining permanent and

water-soluble inks 71-3 crumpled fabric 92–3 drawing a straight-sided object using negative shapes 40-1 feathers 94-5 metal olive oil pourer 86–7 pitted stone 90-1 poppies 67-9 reducing a simple still life to basic shapes 26-7 seascape in soft pastels 59-61 shading rounded objects 36-7 shading straight-sided objects 34-5 simple landscape viewed as geometric shapes 28-9 simple line drawing 22–3 smooth leather ball 84–5 still life 79-80 still life in oil pastels 62–3 using torn and cut masks 74 - 7weathered driftwood 88-9 woodland scene 81-3 exotic flowers 156-9

farmhouse 180–1 fibre-tip pens 15 field of sunflowers 108–11 finger blending 58 fixatives 19 flower-filled alleyway 112–15 flowers, poppies 102–3 foliage masses, trees, 100–1 fountain pens 15 grandmother and young child 244-9 graphite pencil 7 cows in a field 198–9 contour shading 32 cross hatching 32 metal detail 160-3 Old English sheepdog 204-7 potted plant 150-1 scribbled tone 32 short-eared owl 208-11 still life with garlic and shallots 164-7 storm-damaged tree 98-9 water-soluble 8 graphite sticks 9 handling 20 grids 39

hard pastels 13

ink 7, 14 combining permanent and water-soluble inks 71–3 controlled hatching 33 pen and wash 33 potted plant 150–1

kneaded erasers 78

landscape on a large scale 140–3 layering 58 leopard 200–1 line and wash 70–1 combining permanent and water-soluble inks 71–3 line drawing 22–3 simple shapes 24–5 simple still life 26–7 lunch, al fresco 224–5

male nude 240–3
male portrait 226–9
marker pens 15
marks 20–1
brush drawing 66–7
masking 74–5
erasers 78
potted plant 151
measuring systems 38–9
Mediterranean seascape
126–31

metal detail 160–3 monochrome media 8–9 trees in winter 104–7 mountain track 122–3

negative shapes 40–1 drawing rounded objects 42–3 nibs 14

oil pastels 7, 13 blending 58, 62–3 cityscape 190–3 flower-filled alleyway 112–15 Old English sheepdog 204–7 old wooden gateway 182–5 owl, short-eared 208–11

paper 16-17 pastel papers 17 pastel pencils 13 cows in a field 198-9 dancing couple 236-9 pastels 12-13 pen and ink 7, 14-15 artists at work 220-1 church façade 176-7 storm-damaged tree 99 Venetian building 186-9 pencil sharpeners 18 pencils artists at work 220-1 grades 8 handling 20 using a pencil to measure 39 people, al fresco 224-5 perspective, 44-53 aerial 44 circular forms 53 coastline 44 curved forms 52 distant trees 45 ellipses 53 horizontal planes 49

multi-point 48

single-point 48

two-point 48

vertical 45

sketch-plotting 49

vanishing 48, 49

plant, potted 150-1

Pointillist technique 58

portable table easels 19

preparing surfaces 17

projects 97 autumn leaf 116-19 character portrait 230-5 chicken 212-15 cityscape 190-3 dancing couple 236-9 exotic flowers 156-9 field of sunflowers 108-11 flower-filled alleyway 112 - 15grandmother and young child 244-9 landscape on a large scale 140 - 3male nude 240-3 male portrait 226-9 Mediterranean seascape 126-31 metal detail 160-3 Old English sheepdog 204-7 old wooden gateway 182-5 reflections in rippling water 136-9 rocky canyon 144-9 short-eared owl 208-11 small objects drawn large 172 - 5snow scene 132-5 still life with garlic and shallots 164-7 still life with pears 168-71 still life with wine glasses 53 sunshine and shadow

quill pens 15

194 - 7

swimming fish 216-19

Venetian building 186-9

trees in winter 104-7

reed pens 15
reflections in rippling water
136–9
riverbank 120–1
rocky canyon 144–9
rollerball pens 15

seaside scene 222-3

sepia 120-1

sgraffito 81 woodland scene 81-3 shading 32-3 rounded objects 36-7 straight-sided objects 34-5 shapes 24-5 drawing a straight-sided object using negative shapes 40-1 masking 74-7 reducing a simple still life to basic shapes 26-7 simple landscape as geometric shapes 28-9 shaping erasers 78 sharpening tools 18 short-eared owl 208-11 sketchbooks 16 sketches, quick artists at work 220-1 beach scene 222-3 church facade 176-7 cows in a field 198-9 dog, short fur 202-3 farmhouse 180-1 flowers, poppies 102-3 leopard 200-1 mountain track 122-3 people, al fresco 224-5 potted plant 150-1 riverbank 120-1 still-life 154-5 tree, storm-damaged 98-9 trees, foliage on 100-1 sketching pens 15 small objects drawn large 172-5 snow scene 132-5 soft pastels 7, 12 autumn leaf 116-19

blending 58-61

child 244-9

126-31

exotic flowers 156-9

male portrait 226-9

grandmother and young

Mediterranean seascape

old wooden gateway 182-5 rocky canyon 144-9 spatial depth 44 see also perspective square-profile graphite sticks still life, with garlic and shallots 164-7 pears 168-71 potted plant 150-1 pots (found objects) 154-5 straight lines: masking 74 sunflowers 110-11 sunshine and shadow 194-7 suppliers 252-3 supports 16-17 swimming fish 216-19

table easels 19
technical pens 15
textural marks 21
tone 30–1
shading 32–3
torchons 19
blending 58
trees 98
in winter 104–7
storm-damaged 98–9

Venetian building 186-9

water-soluble pencils 10 chickens 212–15 church facade 177 potted plant 151 riverbank 120–1 swimming fish 216–19 water-soluble sepia ink potted plant 150–1 watercolour pencils artists at work 220–1 white papers 16

Acknowledgements

Special thanks to the following artists for step-by-step demonstrations: Diana Constance: pages 34-5, 62-3, 144-9, 156-9, 226-9, 230-35, 240-43.

Douglas Druce: page 30-1. Abigail Edgar: pages 22-3, 36-7, 40-1, 42-3, 59-61, 74-7, 81-3, 100-1, 112-15, 122-3, 126-31, 152-3, 172-5, 178-9, 182-5, 190-3, 194-7, 200-1, 222-3, 230-5, 244-9. Suzy Herbert: pages 55–7, 160–3, 168-71, 208-11. Wendy Jelbert: pages 65, 66-9, 98-9, 104-7, 108-11, 120-1, 136-9, 150-1, 176-7, 198-9, 212-15, 216-19, 220-221, 236-9.

Melvyn Petterson: pages 102–3; 116-19, 124-5, 132-5, 140-3, 154-5, 164-7, 180-1, 202-3, 204-7.

Paul Robinson: pages 70-3, 186-9. lan Sidaway: pages 20-1, 24-5, 26-7, 28-9, 32-3, 38-9, 54, 58, 64, 74, 78-80, 81 (top), 84-95. Effie Waverlin: 44-52.

Thanks to the following for permission to reproduce copyright photographs: Phil Dean: page 144 (left). Jon Hibberd: pages 116 (bottom left), 190 (top), 200 (top), 204 (top), 208 (bottom left), 216 (top), 230. Anthony Pickhaver: page 236 (right). Megan Fishpool: page 154 (top). Keith at Imageworks: page 244 (top) with thanks to Valerie and Ben Lorenz for modelling. Also thanks to Francesco Mangiacasale for modelling.